SO-AQM-118

Mosby's
Anatomy & Physiology
Coloring Book

2nd
EDITION

Rhonda Gamble, PhD

Mineral Area College
Park Hills, Missouri

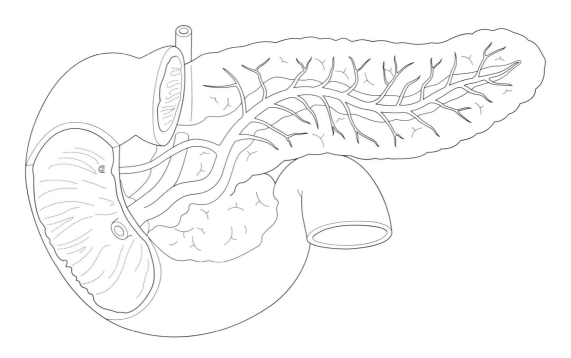

3251 Riverport Lane
St. Louis, Missouri 63043

MOSBY'S ANATOMY & PHYSIOLOGY COLORING BOOK,
SECOND EDITION ISBN: 978-0-323-22611-0

Copyright © 2014, 2004 by Mosby, an imprint of Elsevier Inc.

All rights reserved. No part of this publication may be reproduced or transmitted in any form or by any means, electronic or mechanical, including photocopying, recording, or any information storage and retrieval system, without permission in writing from the publisher. Details on how to seek permission, further information about the Publisher's permissions policies and our arrangements with organizations such as the Copyright Clearance Center and the Copyright Licensing Agency, can be found at our website: www.elsevier.com/permissions.

This book and the individual contributions contained in it are protected under copyright by the Publisher (other than as may be noted herein).

Notices

Knowledge and best practice in this field are constantly changing. As new research and experience broaden our understanding, changes in research methods, professional practices, or medical treatment may become necessary.

Practitioners and researchers must always rely on their own experience and knowledge in evaluating and using any information, methods, compounds, or experiments described herein. In using such information or methods they should be mindful of their own safety and the safety of others, including parties for whom they have a professional responsibility.

With respect to any drug or pharmaceutical products identified, readers are advised to check the most current information provided (i) on procedures featured or (ii) by the manufacturer of each product to be administered, to verify the recommended dose or formula, the method and duration of administration, and contraindications. It is the responsibility of practitioners, relying on their own experience and knowledge of their patients, to make diagnoses, to determine dosages and the best treatment for each individual patient, and to take all appropriate safety precautions.

To the fullest extent of the law, neither the Publisher nor the authors, contributors, or editors, assume any liability for any injury and/or damage to persons or property as a matter of products liability, negligence or otherwise, or from any use or operation of any methods, products, instructions, or ideas contained in the material herein.

International Standard Book Number: 978-0-323-22611-0

Vice President and Content Strategy Director: Linda Duncan

Executive Content Strategist: Kellie White

Content Developmental Specialist: Joe Gramlich

Publishing Services Manager: Catherine Albright-Jackson

Design Direction: Jessica Williams

Printed in USA

Last digit is the print number: 9 8 7 6 5 4 3 2

Working together to grow
libraries in developing countries

www.elsevier.com | www.bookaid.org | www.sabre.org

ELSEVIER BOOK AID
 International Sabre Foundation

Contents

About the Coloring Book

Welcome to the second edition of *Mosby's Anatomy & Physiology Coloring Book!* We have greatly expanded this edition to include physiological processes, many more coloring exercises, and case studies. This coloring book is intended to be supplemental for students taking an anatomy and physiology course, but it also contains enough background information to work for those who are simply curious about the structures of the body and some of its basic physiological functions. Nearly every piece of art is accompanied by a brief overview, especially useful for some of the more challenging physiology sections. Pages including physiology content are denoted by .

HOW TO USE THIS BOOK

- Nearly all coloring exercises are accompanied by a color key at the bottom of the page. When provided, color in the key and then fill in the corresponding structures (and sometimes, functions) accordingly. Once the coloring of a piece is complete, you can block the color key with your hand or a piece of paper and challenge yourself to identify what you've just colored in. Take note of the ones you have trouble remembering and be sure to review them. The answers are always at the bottom of the page for you to reference.
- Many of the physiological illustrations feature arrows for you to color in. These "action arrows" will help guide you through a particular physiological process. It is important to grasp the movement of these processes, whether it's at the macroscopic level, such as how a piece of pizza would move through your digestive system, or at the microscopic level, such as transport within a cell. Following along and coloring the arrows and structures will help you remember the steps of each process.
- Labeling exercises challenge you to use knowledge you've picked up in class and in the text. Make use of all resources at your disposal, including your textbook, an anatomy atlas, or trusted websites.
- Case studies provide an extra opportunity to reflect on a body system and put "real-world" problem-solving skills to work. Use what you've learned in the text and in class to answer the case study questions.

Mosby's Anatomy and Physiology Coloring Book
Copyright © 2014 by Mosby, an imprint of Elsevier Inc

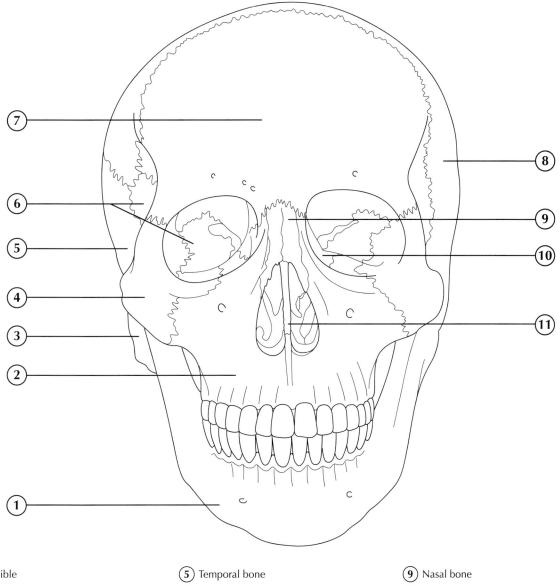

(1) Mandible (5) Temporal bone (9) Nasal bone

(2) Maxilla (6) Sphenoid bone (10) Lacrimal bone

(3) Mastoid process (7) Frontal bone (11) Vomer

(4) Zygomatic bone (8) Parietal bone

Fill in the color key.
Color the illustration.
Cover the key and quiz yourself on the structures.
Can you identify all of the structures, without peeking?

ILLUSTRATION CREDITS

Mosby's Anatomy & Physiology Coloring Book 2e includes black and white versions of artwork from other well-established Elsevier textbooks on anatomy and physiology:

Applegate: *The Anatomy and Physiology Learning System*
Herlihy: *The Human Body in Health and Illness*
Patton and Thibodeau: *Anatomy & Physiology*
Solomon: *Introduction to Human Anatomy and Physiology*

Mosby's Anatomy and Physiology Coloring Book
Copyright © 2014 by Mosby, an imprint of Elsevier Inc

1 Organization of the Body

ANATOMY

Anatomy is the study of the structure of an organism and the relationships of its parts. Students of anatomy still learn about the structure of the human body by literally cutting it apart. This process, called *dissection*, remains a principal technique used to isolate and study the structural components or parts of the human body.

Biology is defined as the study of life. Both anatomy and physiology are subdivisions of this very broad area of inquiry. Just as biology can be subdivided into specific areas for study, so can anatomy and physiology. For example, the term *gross anatomy* is used to describe the study of body parts visible to the naked eye. Before the discovery of the microscope, anatomists had to study human structure using only their eyes during dissection. These early anatomists could make only a *gross*, or whole, examination. With the use of modern microscopes, many anatomists now specialize in microscopic anatomy, including the study of cells, called *cytology*, and tissues, called *histology*.

Other branches of anatomy include the study of human growth and development (*developmental anatomy*) or the study of diseased body structures (*pathological anatomy*). In this coloring book, the body is presented by systems—a process called *systemic anatomy*. Systems are groups of organs that have a common function, such as the bones in the skeletal system and the muscles in the muscular system.

PHYSIOLOGY

Physiology is the science of the functions of the living organism and its parts. It is the study of physiology that helps us understand how the body works. Physiologists attempt to discover and understand, through active experimentation, the intricate control systems and regulatory mechanisms that permit the body to operate and survive in an often hostile environment. As a scientific discipline, physiology can be subdivided according to (1) the type of organism involved, such as human physiology or plant physiology; (2) the organizational level studied, such as molecular or cellular physiology; or (3) a specific or *systemic* function being studied, such as neurophysiology, respiratory physiology, or cardiovascular physiology.

GET TO KNOW THE BODY REGIONS

It is important to become familiar with the terminology used to describe the many parts and regions of the body. Review the table and focus on learning terms you are not too familiar with, such as, you may know *nasal* refers to your nose, but did you know *axillary* refers to your armpit?

LEVELS OF ORGANIZATION

The smallest parts of the body are the atoms, which make up the chemicals, or molecules, of the body. Molecules, in turn, make up microscopic parts called organelles, which fit together to form each cell of the body. Groups of similar cells are called tissues, which combine with other tissues to form individual organs. Groups of organs that work together are called systems. All the systems of the body together make up an individual organism. Knowledge of the different levels of organization will help you understand the basic concepts of human anatomy and physiology.

Descriptive Terms for Body Regions

BODY REGION	AREA OR EXAMPLE
Abdominal (ab-DOM-i-nal)	Anterior torso below diaphragm
Antebrachial (an-tee-BRAY-kee-al)	Forearm
Antecubital (an-tee-KYOO-bi-tal)	Depressed area just in front of elbow
Axillary (AK-si-lair-ee)	Armpit
Brachial (BRAY-kee-all)	Arm
Buccal (BUK-all)	Cheek
Carpal (KAR-pul)	Wrist
Cephalic (seh-FAL-ik)	Head
Cervical (SER-vi-kal)	Neck
Cranial (KRAY-nee-all)	Skull
Crural (KROOR-all)	Leg
Cubital (KYOO-bi-tall)	Elbow
Cutaneous (kyoo-TAYN-ee-us)	Skin (or body surface)
Digital (DIJ-i-tal)	Fingers or toes
Dorsal (DOHR-sal)	Back
Facial (FAY-shal)	Face
Femoral (FEM-or-al)	Thigh
Frontal (FRUN-tal)	Forehead
Gluteal (GLOO-tee-al)	Buttock
Inguinal (ING-gwi-nal)	Groin
Lumbar (LUM-bar)	Lower back between ribs and pelvis
Mammary (MAM-ar-ee)	Breast
Nasal (NAY-zal)	Nose
Occipital (ock-SIP-it-al)	Back of lower skull
Olecranal (oh-LEK-rah-nal)	Back of elbow
Oral (OR-al)	Mouth
Orbital *or* **ophthalmic** (OR-bi-tal *or* of-THAL-mik)	Eyes
Palmar (PAHL-mar)	Palm of hand
Pedal (PEED-al)	Foot
Pelvic (PEL-vik)	Lower portion of torso
Perineal (per-i-NEE-al)	Area (perineum) between anus and genitals
Plantar (PLAN-tar)	Sole of foot
Popliteal (pop-li-TEE-all)	Area behind knee
Supraclavicular (soo-prah-klah-VIK-yoo-lar)	Area above clavicle
Tarsal (TAR-sal)	Ankle
Temporal (TEM-poh-ral)	Side of skull
Thoracic (tho-RASS-ik)	Chest
Umbilical (um-BIL-i-kul)	Area around navel or umbilicus
Volar (VOH-lar)	Palm or sole
Zygomatic (zye-go-MAT-ik)	Upper cheek

Color in the illustration and quiz yourself on the levels of organization.

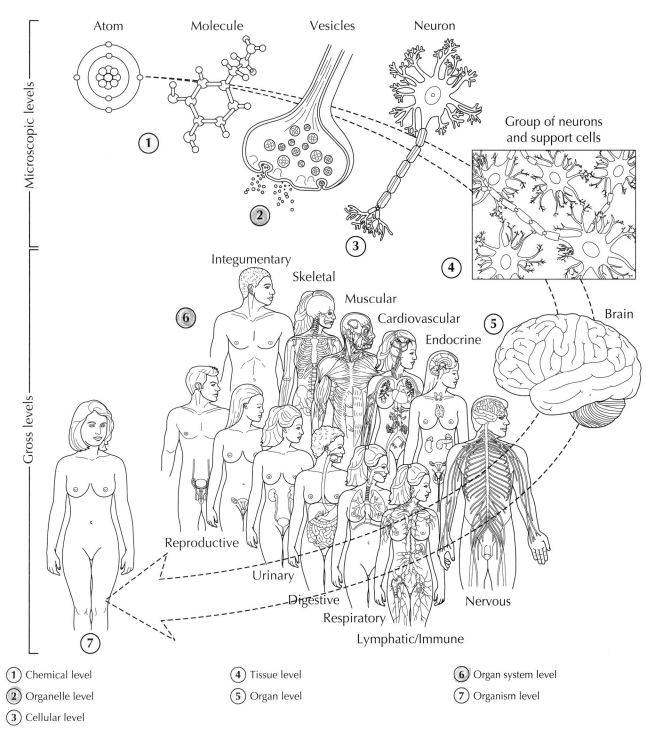

① Chemical level ④ Tissue level ⑥ Organ system level

② Organelle level ⑤ Organ level ⑦ Organism level

③ Cellular level

MAJOR BODY CAVITIES

The dorsal body cavity is in the dorsal (back) part of the body and is subdivided into a cranial cavity above and a spinal cavity below. The ventral body cavity is on the ventral (front) side of the trunk and is subdivided into the thoracic cavity above the diaphragm and the abdominopelvic cavity below the diaphragm. The abdominopelvic cavity is subdivided into the abdominal cavity above the pelvis and the pelvic cavity within the pelvis. The thoracic cavity is subdivided into the mediastinum in the center and pleural cavities to the sides.

Color in the key then color in the corresponding cavities.

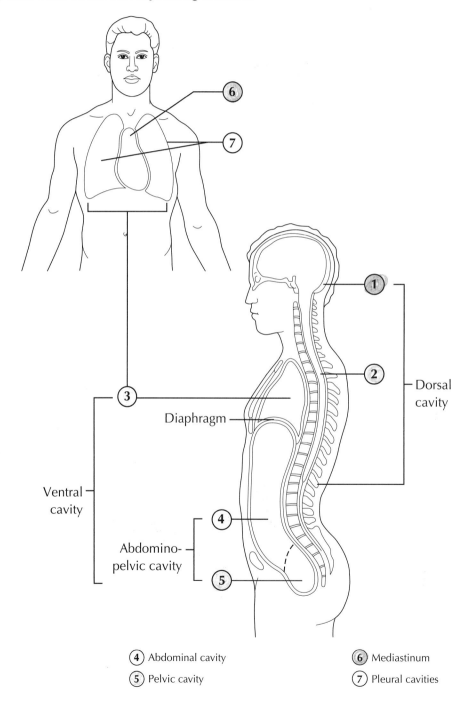

1 Cranial cavity

2 Spinal cavity

3 Thoracic cavity

4 Abdominal cavity

5 Pelvic cavity

6 Mediastinum

7 Pleural cavities

DIRECTIONS AND PLANES OF THE BODY

To minimize confusion when discussing the relationship between body areas or the location of a particular anatomical structure, specific terms are used. Arrows in the figures below highlight directional terms and the planes. There are three major body planes that lie at right angles to each other. They are called the sagittal, frontal, and transverse (or horizontal) planes.

Color in the key and then the corresponding arrows and planes.

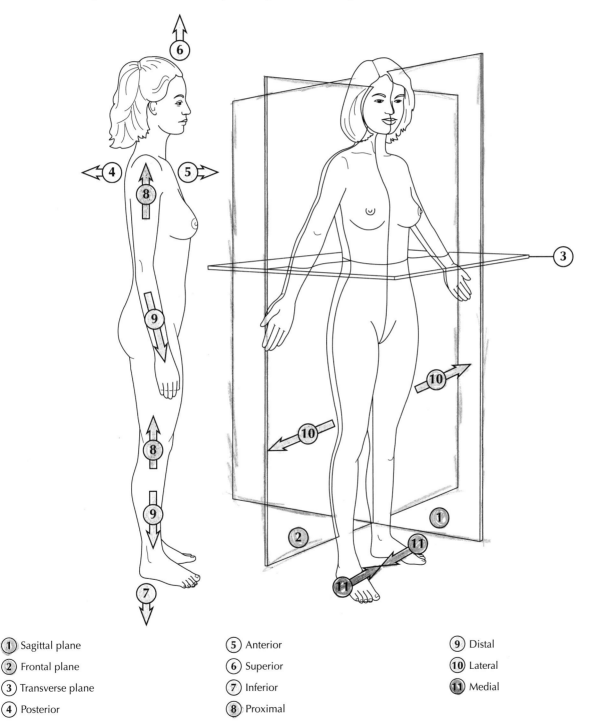

1 Sagittal plane **5** Anterior **9** Distal

2 Frontal plane **6** Superior **10** Lateral

3 Transverse plane **7** Inferior **11** Medial

4 Posterior **8** Proximal

NINE REGIONS OF THE ABDOMINOPELVIC CAVITY

For convenience in locating abdominopelvic organs, anatomists divide the abdominopelvic cavity into a grid with nine imaginary regions.

DIVISION OF THE ABDOMEN INTO FOUR QUADRANTS

Often, a simpler method is used, dividing the abdomen into four quadrants. This method can be used to describe the site of abdominopelvic pain or locate some type of internal pathology, such as a tumor or abscess.

Fill in the keys and then color in both diagrams.

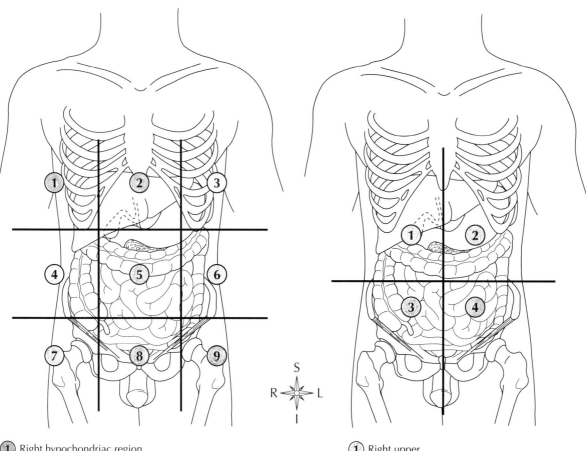

(1) Right hypochondriac region

(2) Epigastric region

(3) Left hypochondriac region

(4) Right lumbar region

(5) Umbilical region

(6) Left lumbar region

(7) Right iliac (inguinal) region

(8) Hypogastric region

(9) Left iliac (inguinal) region

(1) Right upper

(2) Left upper

(3) Right lower

(4) Left lower

DIAGRAM OF THE BODY'S INTERNAL ENVIRONMENT

The human body is like a bag of fluid separated from the external environment. Tubes, such as the digestive and respiratory tracts, bring the external environment to deeper parts of the bag where substances may be absorbed into the internal fluid environment or excreted into the external environment. All the "accessories" somehow help maintain a constant environment inside the bag that allows the cells that live there to survive.

Fill in the key and color in the body systems (and the cells) represented in the internal environment diagram.

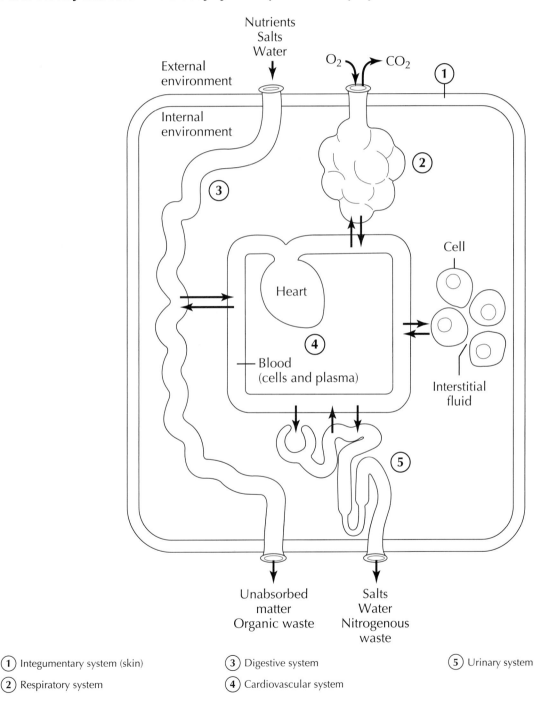

(1) Integumentary system (skin) (3) Digestive system (5) Urinary system

(2) Respiratory system (4) Cardiovascular system

Mosby's Anatomy and Physiology Coloring Book
Copyright © 2014 by Mosby, an imprint of Elsevier Inc

HOMEOSTASIS

Homeostasis is a key word in modern physiology. It means the maintenance of relatively constant internal conditions despite changes in either the internal or the external environment. For example, even if external temperatures vary, homeostasis of body temperature means that it remains relatively constant at about 37 degrees C (98.6 degrees F), although it may vary slightly above or below that point and still be considered "normal."

NEGATIVE FEEDBACK LOOP

This illustration below shows how a relatively constant body temperature (controlled condition) can be maintained. The brain (control center) receives feedback information from nerve endings called *cold receptors* (sensors) and responds by counteracting a change from normal by activating shivering by muscles (effectors).

Fill in the key and color in the following components for this negative feedback loop.

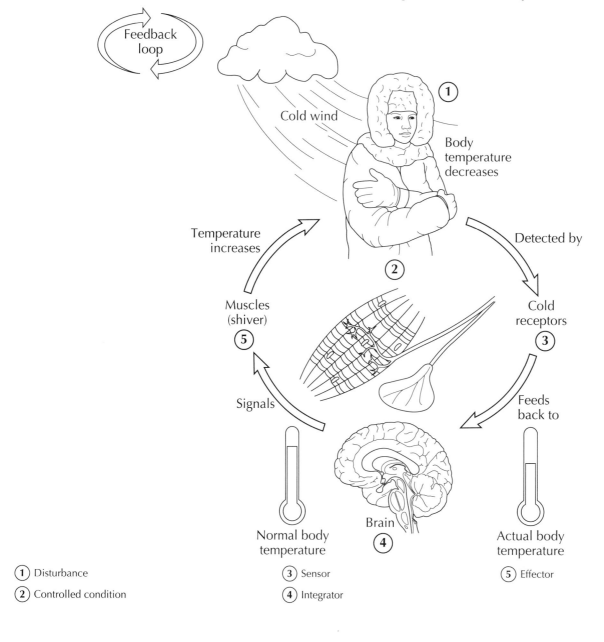

(1) Disturbance (3) Sensor (5) Effector

(2) Controlled condition (4) Integrator

INSULIN NEGATIVE FEEDBACK LOOP

Insulin operates in a negative feedback loop that prevents blood glucose concentration from increasing too far above the normal range. Insulin promotes uptake of glucose by all cells of the body, enabling them to catabolize and/or store it. The liver and skeletal muscles are especially well adapted for storage of glucose as glycogen. Thus excess glucose is removed from the bloodstream, as the graph in the box demonstrates. If the glucose level falls below the normal range, hormones such as glucagon promote the release of glucose from storage into the bloodstream.

Color each step in the insulin negative feedback loop.

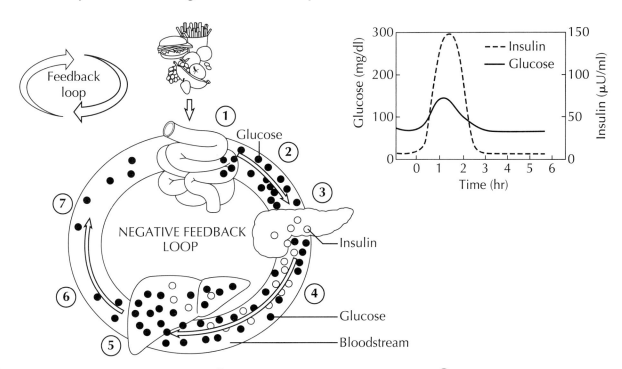

1. Intestines absorb glucose after a meal.
2. Glucose level increases.
3. Pancreas responds to high glucose levels by secreting insulin.
4. High levels of glucose.
5. Insulin causes liver, skeletal, muscle, and other tissues to take up more glucose.
6. Homeostasis is restored.
7. Back to normal glucose level.

CASE STUDY

Mr. Sam Rider, age 46, came to the clinic complaining of pain in the lower inside part of his right leg, below his knee. Physical examination reveals an obese gentleman measuring 5 foot 9 inches with a weight of 235 pounds.

1. Which of the following correctly describes the location of Mr. Rider's injury?
 A. Right medial leg pain, distal to the patella
 B. Right lateral leg pain, proximal to the patella
 C. Right anterior leg pain, distal to the patella
 D. Right inferior leg pain, proximal to the patella
2. What is the name of the joint that is proximal to the right knee?
 A. Right ankle C. Right toe
 B. Right hip D. Left knee
3. It was determined that Mr. Rider also suffered a lower back strain, which compressed nerves involving the right leg. The lumbar vertebrae of the lower back are found on what part of the body?
 A. Lateral C. Superior
 B. Anterior D. Posterior

2 The Chemical Basis of Life

To best understand anatomy and physiology, we must appreciate and understand certain basic principles of biochemistry. Biochemistry is defined as the field of chemistry that deals with living organisms and life processes such as growth, muscle contraction, and transmission of nerve impulses.

PERIODIC TABLE OF ELEMENTS

There are 26 elements represented on the periodic table of elements that make up the human body. Of these 26, 11 are designated as "major" because they make up the greatest portion of the human body.

Based on the table, color in the major elements in one color, the trace elements in another color, and the rest in another color.

MAJOR ELEMENTS (11)		TRACE ELEMENTS (15)	
Oxygen (O)	Potassium (K)	Silicone (Si)	Boron (B)
Carbon (C)	Sulfur (S)	Aluminum (Al)	Cobalt (Co)
Hydrogen (H)	Sodium (Na)	Iron (Fe)	Zinc (Zn)
Nitrogen (N)	Chlorine (Cl)	Manganese (Mn)	Selenium (Se)
Calcium (Ca)	Magnesium (Mg)	Fluorine (F)	Molybdenum (Mo)
Phosphorous (P)		Vanadium (V)	Tin (Sn)
		Chromium (Cr)	Iodine (I)
		Copper (Cu)	

Mosby's Anatomy and Physiology Coloring Book
Copyright © 2014 by Mosby, an imprint of Elsevier Inc

Interestingly, of the 11 major elements it is carbon, oxygen, hydrogen, and nitrogen that comprise approximately 96% of the material in the human body.

Color in the atoms that make up 96% of the material in the human body. Based on the periodic table, can you determine which elements each represents?

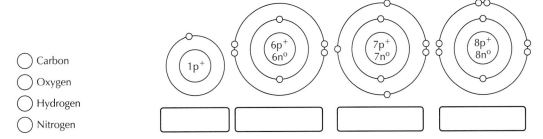

- ◯ Carbon
- ◯ Oxygen
- ◯ Hydrogen
- ◯ Nitrogen

ATOMIC STRUCTURE

Atoms contain several different kinds of smaller (or subatomic) particles that are found in either the nucleus or its surrounding energy levels. The three subatomic particles are called protons (p^+), neutrons (n_0), and electrons (e^-). Protons are contained in the nucleus and are positively charged, thus the + designation. Neutrons, also located in the nucleus, have no charge. Electrons have a negative charge (−) and "orbit," or move around, the nucleus. The number of electrons is equal to the number of protons, and therefore the two opposing charges "neutralize" each other.

Using different colors, shade in the structures of the atom.

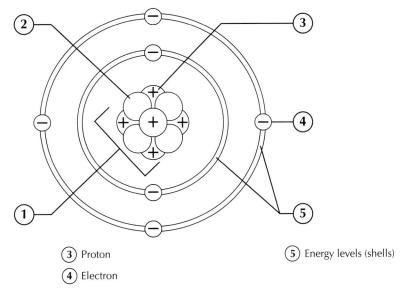

- ① Nucleus
- ② Neutron
- ③ Proton
- ④ Electron
- ⑤ Energy levels (shells)

CHEMICAL BONDS

A chemical bond is best described as an energy relationship that occurs when two or more atoms join by either the sharing or exchanging of electrons. Previously, we learned that each subatomic particle has an electrical charge. Because atoms are in a constant state of trying to become stable, they seek other atoms that will "complete" them. These chemical reactions between electrons occur because of the unpaired electrons. With the exception of hydrogen, the innermost energy level of all atoms contains a maximum of two electrons. After that innermost shell, an energy field does not consider itself "stable" until it has its outermost shell filled with eight electrons. *The three types of chemical bonds are (a) ionic, (b) covalent, and (c) polar covalent.*

IONIC BOND

An ion is an electrically charged atom. An ionic bond occurs when one atom transfers its electrons to another. In the figure below, an ionic bond occurs when the sodium atom transfers the single electron in its outer shell to the chlorine atom, which has 7 electrons in its outer shell. *REMEMBER*—atoms want to complete their outermost shell by having a maximum of 8 electrons. In this case, sodium has 1 electron in its outer shell and chlorine has 7 in its outer shell—thus they are attracted. When the bond forms, sodium chloride (table salt) is formed.

Fill in the electrons of the sodium atom with one color and fill in the electrons of the chlorine atom with a different color.

Fill in the electrons of the sodium ion one color and fill in the electrons of the chloride ion with a different color. Note the transfer of electrons that forms the ionic bond.

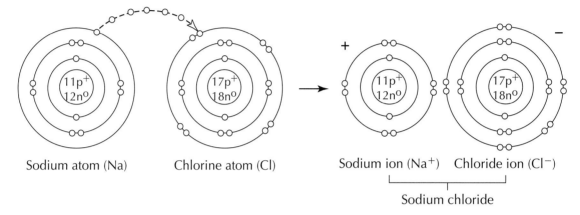

Sodium atom (Na) Chlorine atom (Cl) Sodium ion (Na^+) Chloride ion (Cl^-)

Sodium chloride

COVALENT BOND

This is a chemical bond that is formed by the sharing of one or more pairs of electrons between the outer energy levels of two atoms. This type of bond has great significance in physiology.

In the diagram below, color the electrons of each atom one color and the nuclei a different color. Note where the sharing of electrons occur and how the covalent bond is formed.

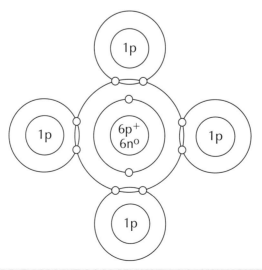

POLAR COVALENT BONDS

This type of covalent bond still allows for the sharing of electrons. However, because the electrical charge from the electron is not evenly distributed, one side of the resulting polar molecule is said to be more positive or negative than the other side. This makes for a very volatile or unstable bond.

Choose one color to shade in the nucleus and electrons of the oxygen atom. Choose a different color to shade in the nuclei and electrons of the hydrogen atoms. Where the diagram illustrates that the three atoms are now a single molecule, draw circles where the electrons should be placed, then determine and answer which side has a partial positive charge, and which side has a partial negative charge. Using another color, shade in the area where the polar covalent bonds occur.

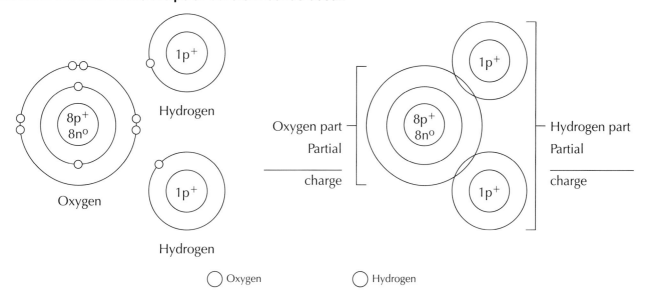

Oxygen part —

Partial

charge

Hydrogen part —

Partial

charge

○ Oxygen ○ Hydrogen

POLAR COVALENT (AKA HYDROGEN BONDS) BETWEEN WATER MOLECULES

Hydrogen bonds serve to weakly attach the negative (oxygen) side of one water molecule to the positive (hydrogen) side of a nearby water molecule. This diagram depicts a few bonded molecules, as one would expect in liquid water.

Fill in the key and then color in the hydrogen, oxygen, and hydrogen bonds (dotted lines).

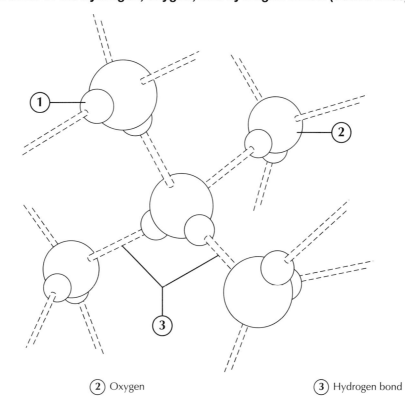

① Hydrogen ② Oxygen ③ Hydrogen bond

THE pH RANGE

pH is an abbreviation for a phrase meaning "the power of hydrogen." The varying pH levels indicate the relative H^+ ion concentration in a solution. The pH range is 1–14. Note that the higher the pH level, the more basic (alkaline) the solution. The lower the pH level, the more acidic the solution becomes. As the scale is 1–14, a solution with a pH of 7 is considered neutral.

Choose three different colors and fill in the key for acidic, basic, and neutral. Next, fill the beakers with the correct acid/base ratio to represent where it is positioned on the scale. (Hint: There are 14 bubbles in each beaker.)

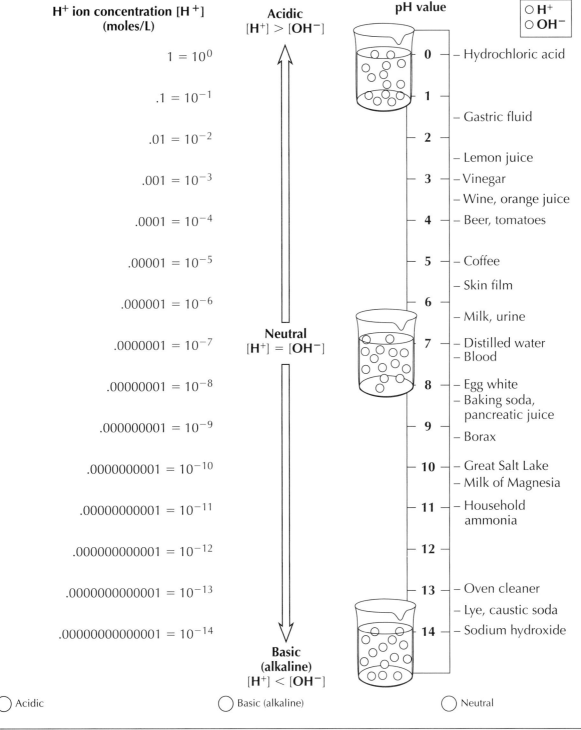

H^+ ion concentration $[H^+]$ (moles/L)

$1 = 10^0$	
$.1 = 10^{-1}$	
$.01 = 10^{-2}$	
$.001 = 10^{-3}$	
$.0001 = 10^{-4}$	
$.00001 = 10^{-5}$	
$.000001 = 10^{-6}$	
$.0000001 = 10^{-7}$	
$.00000001 = 10^{-8}$	
$.000000001 = 10^{-9}$	
$.0000000001 = 10^{-10}$	
$.00000000001 = 10^{-11}$	
$.000000000001 = 10^{-12}$	
$.0000000000001 = 10^{-13}$	
$.00000000000001 = 10^{-14}$	

Acidic $[H^+] > [OH^-]$

Neutral $[H^+] = [OH^-]$

Basic (alkaline) $[H^+] < [OH^-]$

pH value

○ H^+
○ OH^-

0 – Hydrochloric acid
1 –
 – Gastric fluid
2 –
 – Lemon juice
3 – – Vinegar
 – Wine, orange juice
4 – – Beer, tomatoes
5 – – Coffee
 – Skin film
6 –
 – Milk, urine
7 – – Distilled water
 – Blood
8 – – Egg white
 – Baking soda, pancreatic juice
9 –
 – Borax
10 – – Great Salt Lake
 – Milk of Magnesia
11 – – Household ammonia
12 –
13 – – Oven cleaner
 – Lye, caustic soda
14 – – Sodium hydroxide

○ Acidic ○ Basic (alkaline) ○ Neutral

Copyright © 2014 by Mosby, an imprint of Elsevier Inc

CARBOHYDRATES

Carbohydrates are organic compounds containing carbon, hydrogen, and oxygen in certain specific proportions; for example, sugars, starches, and cellulose. The three types of carbohydrates are:

Monosaccharides (single sugars)
Disaccharides (double sugars)
Polysaccharides (complex sugars)

Choose a color and outline each of the three monosaccharides.

Fructose Glucose Galactose

Now, let's look at disaccharides, which are "double sugars." Below we have sucrose, lactose, and maltose. Can you tell which single sugars have bonded to create double sugars?

Outline the below with the colors you used for the monosaccharides.

Sucrose Lactose

Maltose

MORE ON CARBS: POLYSACCHARIDES

Polysaccharides (*poly-* means many) consist of many monosaccharides, chemically joined to form straight or branched chains. Cellulose is a linear chain, starches are branched, and glycogen is highly branched. Using the color key, color in the polysaccharides.

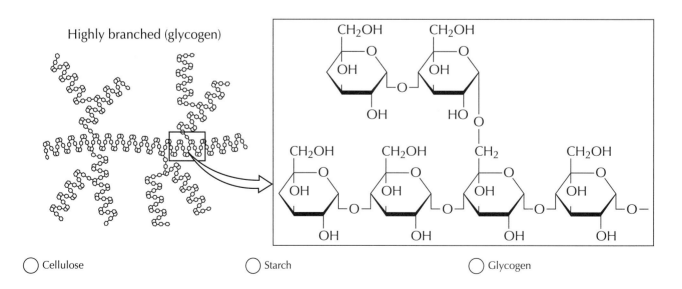

Linear (cellulose)

Branched (starch)

Highly branched (glycogen)

◯ Cellulose ◯ Starch ◯ Glycogen

AMINO ACID STRUCTURE

Below is the basic structural formula for an amino acid. Also below are the components of the structure, which will serve as a color key. The basic structural formula consists of:

A *carbon atom* (known as the *alpha carbon*)
Bonded to a positive amino group (NH_3^+)
A negative carboxyl group (COO^-)
A hydrogen atom
And a side group of elements (denoted as R). The R group is how an amino acid is identified.

Select three different colors and shade in the key below. Using that key, fill in the formula depicted in the graphic.

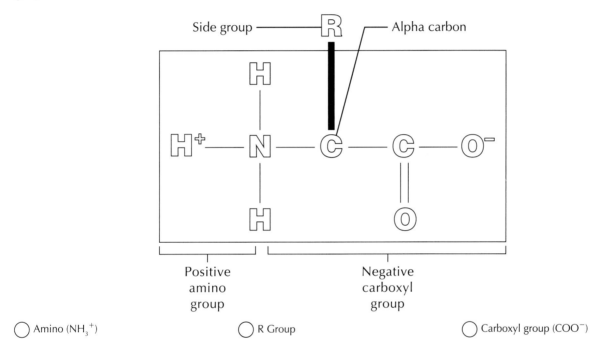

○ Amino (NH_3^+) ○ R Group ○ Carboxyl group (COO^-)

AMINO ACIDS

The elements that make up a protein molecule are bonded together to form chemical units called *amino acids*. Proteins are composed of 21 naturally occurring amino acids, and nearly all 21 are present in every protein. There are 8 essential amino acids that cannot be produced in the human body, and therefore must come from the diet.

Fill in the key, then color the box containing the structural formula of the essential and nonessential amino acids.

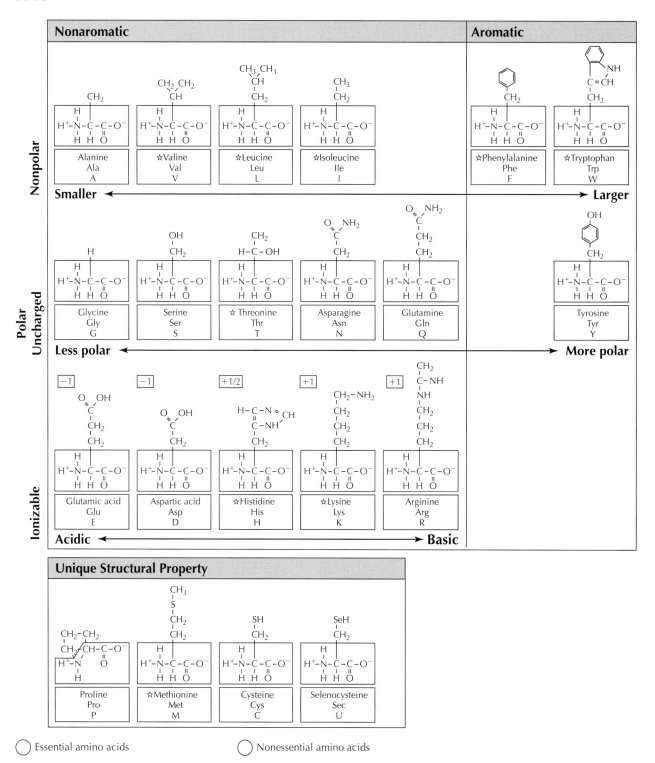

○ Essential amino acids ○ Nonessential amino acids

DEHYDRATION SYNTHESIS

This anabolic process occurs when molecules are joined to form larger molecules. This is often referred to as "condensation" because it joins molecules together into a denser mass. Note in the first figure line that each molecule has the ability to form a water molecule at polar ends. When the H_2O molecule is formed, the molecules move together.

Color in the dotted areas to identify the $H^+H^+O^-$ atoms that form the water molecule. Next, shade in the areas where the molecules join together absent of the $H^+H^+O^-$ atoms.

Dehydration synthesis

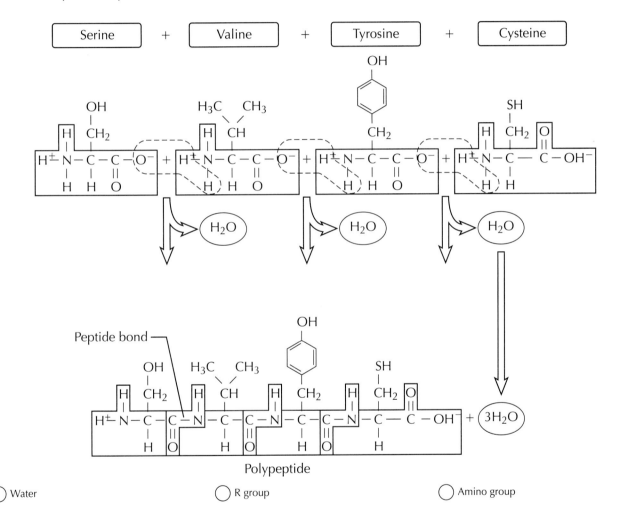

Polypeptide

○ Water ○ R group ○ Amino group

HYDROLYSIS

This catabolic process occurs when a compound is split by the addition of the H^+OH^- molecule. Where dehydration synthesis removes $H^+H^+O^-$ by an anabolic (or building-up) process to create a more dense mass (think anabolic steroids), hydrolysis uses a catabolic (breaking-down) process to create a less dense mass (think cannibalism) by introducing the water molecule.

Choose two different colors and fill in the key below for water and amino acids. Note that when the water is introduced in the top figure, the result is the separation of the dense bond into the four original amino acids that created the polypeptide.

Hydrolysis

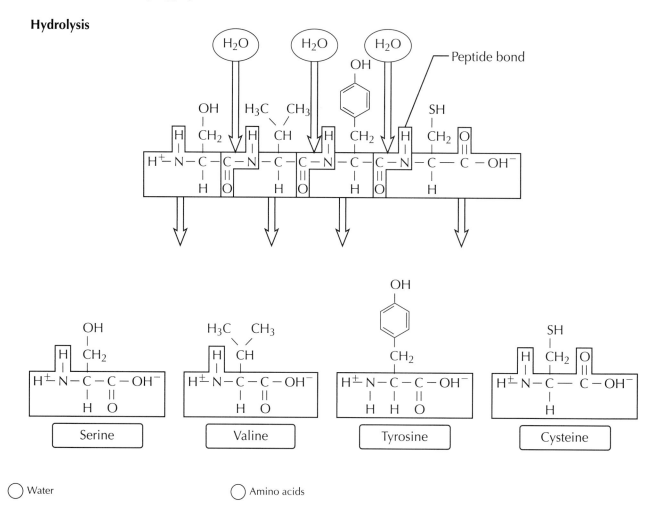

○ Water ○ Amino acids

FORMATION OF FATS (TRIGLYCERIDES)—THE BODY'S MOST CONCENTRATED SOURCE OF ENERGY

In order to build a fat molecule, two types of building blocks are necessary: *glycerol* and *fatty acids*. In the below picture, we can see the creation of a triglyceride known as glycerol tricaproate. It is a composite molecule made up of three molecules of caproic acid (a 6-carbon fatty acid) coupled in a dehydration synthesis reaction to a single glycerol backbone. In addition to the triglyceride, this process results in the formation of three molecules of water. Fatty acid chains may be of varying lengths.

Copyright © 2014 by Mosby, an imprint of Elsevier Inc

Using four different colors, shade in the four different components below.

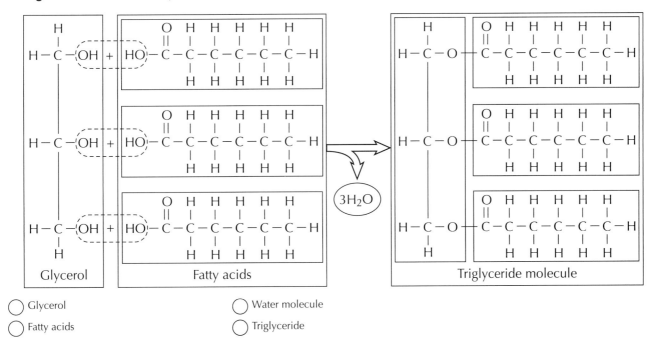

Glycerol Fatty acids Triglyceride molecule

○ Glycerol ○ Water molecule
○ Fatty acids ○ Triglyceride

NUCLEOTIDES—THE COMPONENTS OF DNA

DNA is the genetic master code that makes the process of protein synthesis possible. Protein synthesis—creation of proteins—is required for growth of cells and their maintenance. DNA is composed of millions of pairs of nucleotides. We can see the basic formation of a nucleotide below. The components of a nucleotide include a phosphate group, a pentose sugar, and a nitrogenous base.

Fill in the color key below, then color in the figure to match the key.

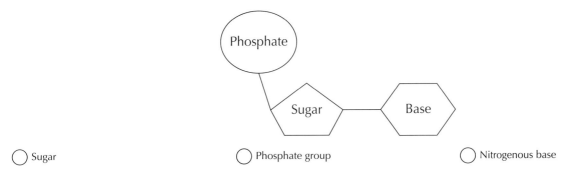

○ Sugar ○ Phosphate group ○ Nitrogenous base

DNA (DEOXYRIBONUCLEIC ACID)

DNA functions as the "blueprint" of the entire body. The previous figure showed the composition of a nucleotide as having a phosphate group, a sugar, and a base. In DNA, the nucleotide is called deoxyribonucleotide. It is composed of a phosphate group, deoxyribose (sugar), and a nitrogenous base (either adenine, cytosine, guanine, or thymine). DNA molecules are the largest molecules in the body. They are very large polymers that are joined together (sugar to phosphate) by dehydration synthesis to form a long sugar-phosphate backbone. Two of those long chains make up a single DNA molecule. The chains coil around each other to form a double helix.

Fill in the color key below using six different colors. Shade in the various structures in the figure below, and notice that the two bases always pair with the same base. Notice the pattern?

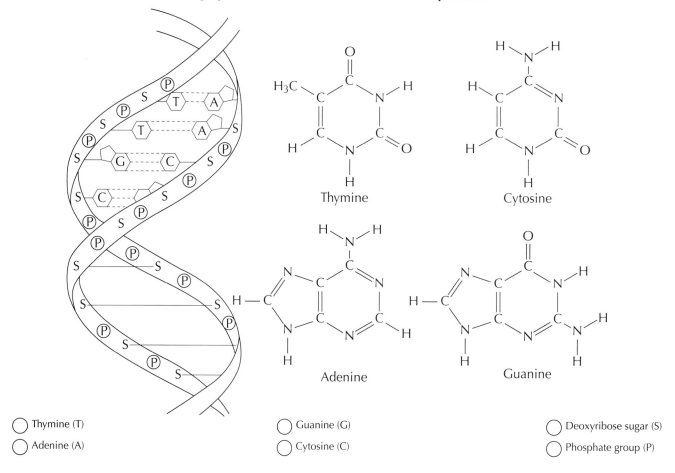

Thymine

Cytosine

Adenine

Guanine

○ Thymine (T)

○ Adenine (A)

○ Guanine (G)

○ Cytosine (C)

○ Deoxyribose sugar (S)

○ Phosphate group (P)

CASE STUDY

This year, during her college's spring break, Calleigh and her friends went to Florida for the first time. One the first night of the vacation, she and her friends went to dinner. Calleigh decided to try raw oysters as an appetizer. Unfortunately, the oysters had high concentrations of bacteria, and 24 hours later, Calleigh's vacation was interrupted by a bad case of food poisoning. Her symptoms include nausea, abdominal pain, vomiting, and diarrhea.

1. With continued vomiting, Calleigh keeps losing _____ from her stomach, which could make her entire body too

_____.

 A. acid; acidic

 B. base; basic

 C. acid; basic

 D. base; acidic

2. When we measure the pH of a substance, we are measuring the concentration of:

 A. oxygen ions

 B. carbon ions

 C. phosphate ions

 D. hydrogen ions

3. When Calleigh feels well enough to eat something, she should eat primarily _____, because they provide a high level of energy and they are easily digested.

 A. protein

 B. carbohydrates

 C. triglycerides

 D. deoxydextrose

3 Cells and Tissues

Despite their distinctive anatomical characteristics and specialized functions, the cells of your body have many similarities. But there is no cell that truly represents or contains all of the various components found in the many types of human cells.

In the table below, color in the various cells and study the characteristics of these five types of cells. Can you name parts of the body where these types of cells would be found?

TYPE	STRUCTURAL FEATURES	FUNCTIONS
Nerve cells	• Surface that is sensitive to stimuli • Long extensions	• Detect changes in internal or external environment • Transmit nerve impulses from one part of the body to another
Muscle cells	• Elongated, threadlike • Contain tiny fibers that slide together forcefully	• Contract (shorten) to allow movement of body parts
Red blood cells	• Contain hemoglobin, a red pigment that attracts then releases oxygen	• Transport oxygen in the bloodstream (from lungs to other parts of the body)
Gland cells	• Contain sacs that release a secretion to the outside of the cell	• Release substances such as hormones, enzymes, mucus, and sweat
Immune cells	• Some have outer membranes able to engulf other cells • Some have systems that manufacture antibodies • Some are able to destroy other cells	• Recognize and destroy "nonself" cells such as cancer cells and invading bacteria

THE TYPICAL CELL

Each cell is surrounded by a plasma membrane that separates the cell from its surrounding environment. The inside of the cell is composed largely of a gel-like substance called cytoplasm. The cytoplasm is made of various organelles and molecules suspended in a watery fluid called cytosol, or sometimes intracellular fluid. The cytoplasm is crowded with large and small molecules, and various organelles. The drawing below of a typical cell shows structures including mitochondria, known as the "power plants of the cell." Note the dots bordering the endoplasmic reticulum. These are ribosomes, also called the cell's "protein factories."

Fill in the key circles with different colors, then shade in the corresponding circles and structures.

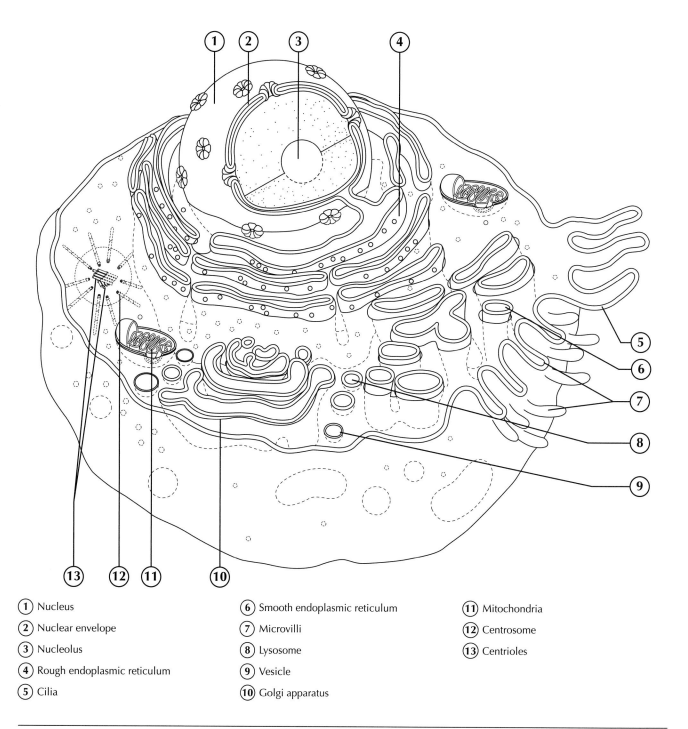

1. Nucleus
2. Nuclear envelope
3. Nucleolus
4. Rough endoplasmic reticulum
5. Cilia

6. Smooth endoplasmic reticulum
7. Microvilli
8. Lysosome
9. Vesicle
10. Golgi apparatus

11. Mitochondria
12. Centrosome
13. Centrioles

Copyright © 2014 by Mosby, an imprint of Elsevier Inc

STRUCTURES OF THE CELL: RIBOSOMES

The function of ribosomes is protein synthesis—recall, protein synthesis is the main building process for cell growth and maintenance. A ribosome is composed of a small subunit and a large subunit. After the small subunit attaches to a messenger RNA (mRNA) strand containing the genetic "recipe" for a polypeptide strand, the subunits come together to form a complete ribosome. Transfer RNA (tRNA) brings amino acids into the cavity between subunits, where they are assembled into a strand according to the mRNA code. As the polypeptide strand elongates, it moves out through a tunnel and a tiny exit hole in the large subunit.

Using two separate colors, fill in the large subunit and the small subunit in each view.

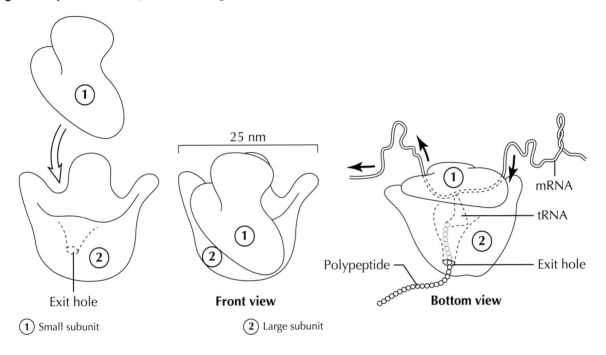

Exit hole

Front view

Polypeptide

Bottom view

mRNA

tRNA

Exit hole

① Small subunit ② Large subunit

25 nm

STRUCTURES OF THE CELL: PLASMA MEMBRANE

Cells contain a variety of different boundaries, or membranes, such as the nuclear membrane and the plasma membrane. The plasma membrane below is made of a bilayer of phospholipid molecules arranged with their nonpolar "tails" pointing toward each other. Cholesterol molecules help stabilize the flexible bilayer structure to prevent breakage. Protein molecules (integral membrane proteins, or IMPs) and protein-hybrid molecules may be found on the outer or inner surface of the bilayer—or extending all the way through the membrane.

Using different colors, shade in the key, then color in the corresponding number and structure in the diagram.

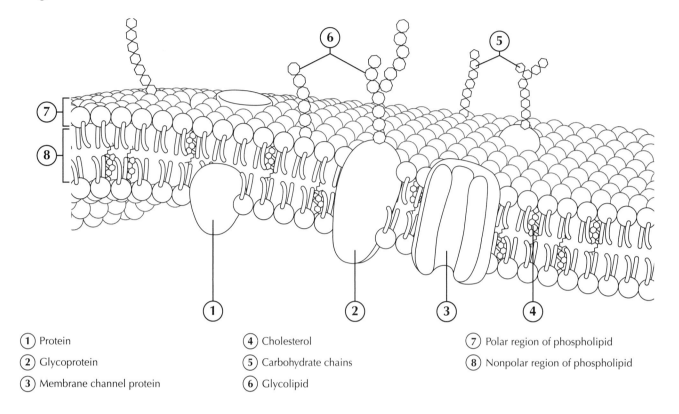

(1) Protein

(2) Glycoprotein

(3) Membrane channel protein

(4) Cholesterol

(5) Carbohydrate chains

(6) Glycolipid

(7) Polar region of phospholipid

(8) Nonpolar region of phospholipid

MEMBRANE CHANNELS

One way molecules pass through the phospholipid bilayer is through the membrane channels. Gated channel proteins form tunnels through which only specific molecules may pass—as long as the "gates" are open. Molecules that do not have a specific shape and charge are never permitted to pass through the channel. Notice that the transported molecules move from an area of high concentration to an area of low concentration. The cell membrane is said to be permeable to the type of molecule in question.

Color each structure listed a different color with a different color.

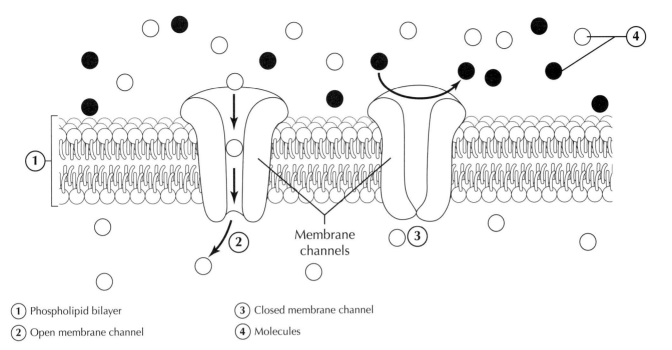

Membrane channels

(1) Phospholipid bilayer (3) Closed membrane channel

(2) Open membrane channel (4) Molecules

MEMBRANE CARRIER

Another way molecules pass through the phospholipid bilayer is through carrier-mediated passive transport. In this process, a membrane-bound carrier protein attracts a solute molecule to a binding site (A) and changes its shape in a manner that allows the solute to move to the other side of the membrane (B). Passive carriers may transport molecules in either direction, depending on the concentration gradient.

Color each structure listed below with a different color.

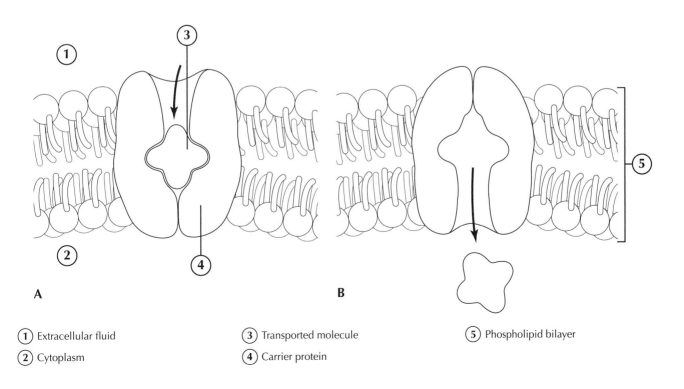

A B

(1) Extracellular fluid (3) Transported molecule (5) Phospholipid bilayer

(2) Cytoplasm (4) Carrier protein

CALCIUM PUMP

The examples of transport on the previous pages were both passive processes, meaning the force of movement from one side of the membrane to the other was due to the concentration gradient. It was a physical force of nature that did the heavy lifting. Now we will turn to an active transport process, meaning that the driving force for the transport comes from the cell using its own energy to force molecules across the membrane. Below we witness transport through the calcium pump, an important process within muscle cells. **A**, Two calcium ions (Ca^{++}) enter the pump, and then adenosine triphosphate (ATP) associates with the activating center of the pump. **B**, As the energy released from ATP (forming adenosine diphosphate [ADP] + phosphate [P]) changes the shape of the pump, the Ca^{++} ions are released on the opposite side of the membrane. The overview shows a simplified view of a calcium pump's action.

Color each of the structures below using different colors. Notice that calcium ions and adenosine triphosphate (ATP) enter the pump, but the energy released changes to adenosine diphosphate (ADP).

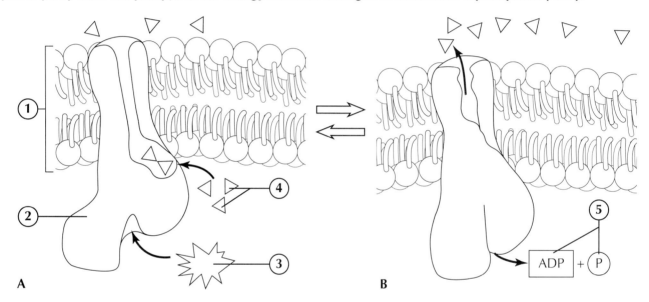

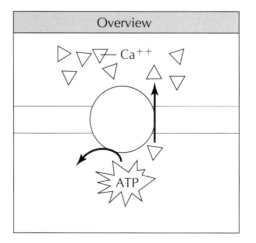

(1) Phospholipid bilayer

(2) Calcium pump

(3) ATP

(4) Calcium (Ca^{++})

(5) By-product of energy released from ATP (adenosine diphosphate [ADP] + phosphate [P])

SODIUM-POTASSIUM PUMP

Another type of active transport pump—the sodium-potassium pump—is critical for the cell to survive. The pump transports sodium ions and potassium ions, but in different directions. Sodium ions are transported out of and potassium ions are transported into the cell. Three sodium ions (Na⁺) bind to sodium binding sites on the pump's inner face. At the same time, an energy-containing adenosine triphosphate (ATP) molecule produced by the cell's mitochondria binds to the pump. The ATP breaks apart, and its stored energy is transferred to the pump. The pump then changes shape, releases the three Na⁺ ions to the outside of the cell, and attracts two potassium ions (K⁺) to its potassium binding sites. The pump then returns to its original shape, and the two K⁺ ions and the remnant of the ATP molecule are released to the inside of the cell. The pump is now ready for another pumping cycle.

Shade in the arrows showing how the sodium-potassium pump moves sodium and potassium ions into and out of the cell. Next, color the different structures listed below. Make sure to be consistent with the colors because not all of the structures appear in all four sections of the graphic.

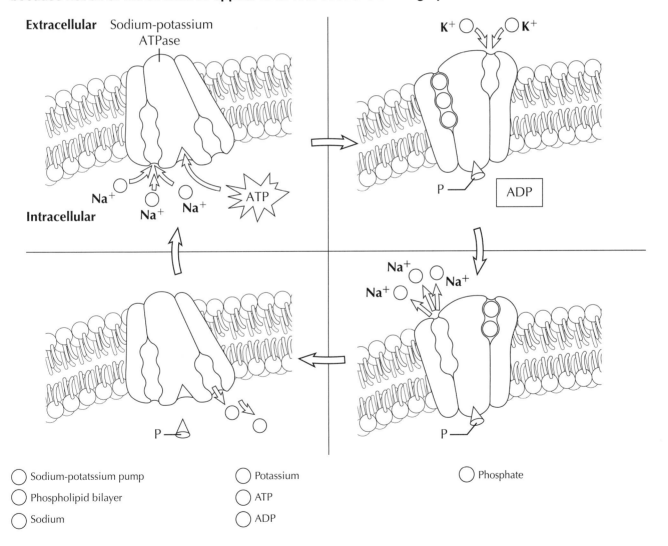

◯ Sodium-potatssium pump	◯ Potassium	◯ Phosphate
◯ Phospholipid bilayer	◯ ATP	
◯ Sodium	◯ ADP	

BULK TRANSPORT BY VESICLES

This drawing summarizes the essential difference between endocytosis, which moves substances into the cell by means of a vesicle, and exocytosis, which moves substances out of the cell by means of a vesicle. The type of endocytosis shown here is phagocytosis, in which the endocytic vesicle fuses with a lysosome to allow digestive enzymes to break down the ingested material. Exocytosis is the process by which molecules that are too large to leave through the plasma membrane (notably, proteins) exit by being "packaged" in membranous vesicles by the Golgi apparatus and then are pulled out of the plasma membrane by the cytoskeleton. The vesicles fuse with the plasma membrane and the contents are released.

Shade in the arrows showing endocytosis one color; shade in the arrows showing exocytosis another color. Fill in the remaining structures in the diagram, making sure to note the different ways bulk transport occurs in the cell.

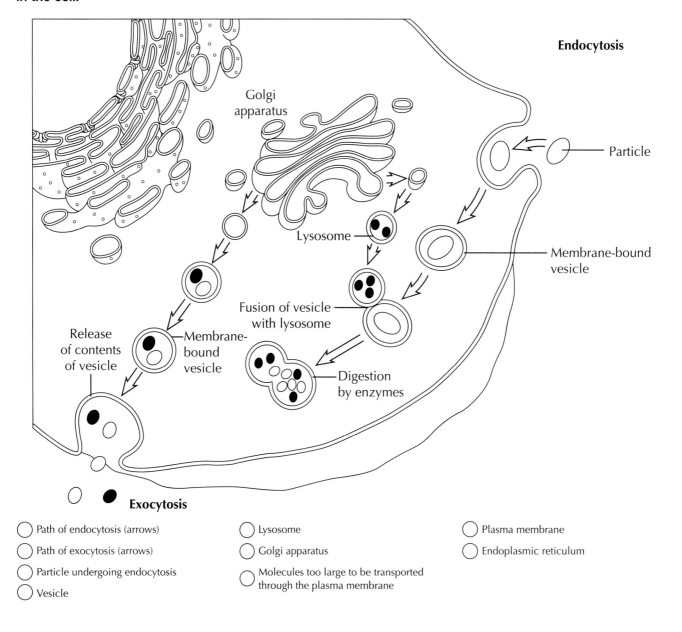

○ Path of endocytosis (arrows)

○ Path of exocytosis (arrows)

○ Particle undergoing endocytosis

○ Vesicle

○ Lysosome

○ Golgi apparatus

○ Molecules too large to be transported through the plasma membrane

○ Plasma membrane

○ Endoplasmic reticulum

Copyright © 2014 by Mosby, an imprint of Elsevier Inc

PASSIVE TRANSPORT

This process occurs when substances are moved through the cell membrane using energy supplied by the cell, or its membrane. There are three different types of passive transport: diffusion, osmosis, and filtration.

Diffusion

Diffusion is the movement of particles through a membrane, from an area of high concentration to an area of low concentration.

Color in the particles and the arrow showing movement of the particles from high to low concentration, through a membrane.

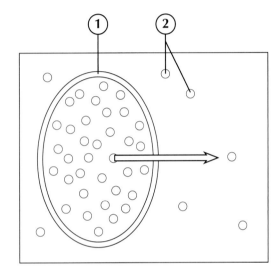

① Membrane

② Particles

Osmosis

Osmosis occurs when water moves from an area of lower solute concentration to an area of higher solute concentration.

Color in the membrane, the water molecules, and the impermeant solute. Also shade in the arrow showing the movement.

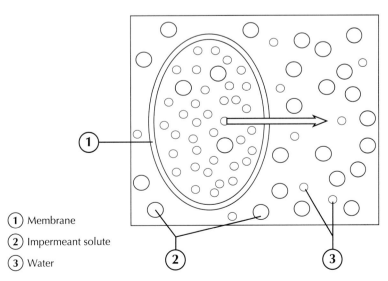

① Membrane

② Impermeant solute

③ Water

Filtration

Filtration refers to the movement of water and solutes through a membrane because of a higher hydrostatic pressure on one side. (*Think coffee filter.*)

Using different colors, shade in the various structures below, as well as the arrows indicating the movement outside of the cell.

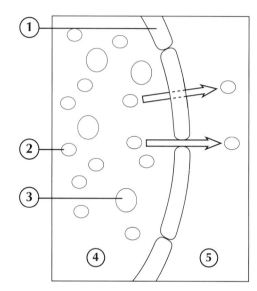

(1) Filtration membrane

(2) Small solute particles

(3) Large particles
(do not move through membrane)

(4) High pressure area

(5) Low pressure area

MOVEMENT OF PARTICLES AND MOLECULES THROUGH THE CELL MEMBRANE: ACTIVE TRANSPORT

As we discussed earlier, active transport is the "uphill" movement of a substance through a cell membrane, meaning energy is required for the transport to take place. There are three types of active transport that we will review: phagocytosis, pinocytosis, and exocytosis.

Phagocytosis (Endocytosis)

This type of active transport involves the ingestion and digestion of particles by a cell. (*Think cell eating.*)

Color in the large particle as it goes through the process entering the cell membrane and being engulfed in a membrane-bound vesicle.

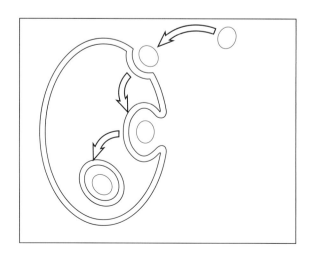

◯ Membrane

◯ Cell/large particle

◯ Intracellular vesicle

Pinocytosis (Endocytosis)

This active transport system mechanism is used to transfer fluids or dissolved substances into cells. (*Think cell drinking.*)

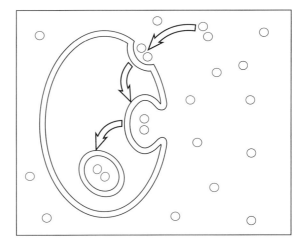

○ Membrane
○ Fluid/dissolved molecules
○ Intracellular vesicle

Exocytosis

This process allows large molecules to leave the cell without actually passing through the cell membrane, but rather through a vesicle (similar to endocytosis, but the molecule is leaving the cell as opposed to entering). (*Think cell vomiting.*)

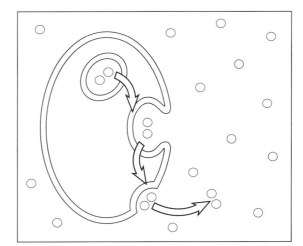

○ Membrane
○ Proteins/cell products
○ Intracellular vesicle

GLYCOLYSIS

Glucose is broken down under the following two conditions: with oxygen present or with oxygen absent. With oxygen present, the process is referred to as aerobic catabolism. With oxygen absent, it is known as anaerobic catabolism. When glucose is broken down without oxygen (A), little ATP is produced, because most of the energy is still retained in the end product, which is lactic acid. But when oxygen is included, glucose is eventually completely broken down in the mitochondria, the powerhouses of the cell, to form carbon dioxide, water, and ATP (B).

Mosby's Anatomy and Physiology Coloring Book
Copyright © 2014 by Mosby, an imprint of Elsevier Inc

Color the anaerobic catabolism figure blue. Color the aerobic catabolism figure red. Note which cycle produces the most energy, and at what stage.

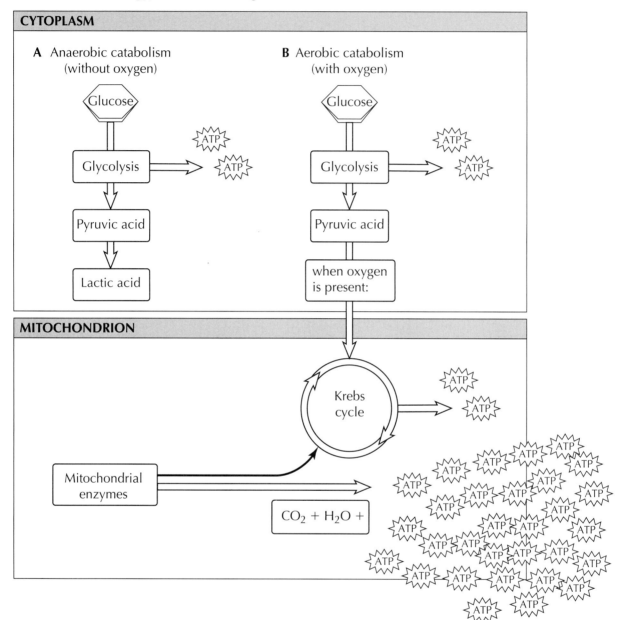

PROTEIN SYNTHESIS

The most important anabolic pathway in human A&P to understand is protein synthesis. It is required for cell growth and maintenance. It influences all cell structures and functions either directly as structural elements themselves, or indirectly by influencing the synthesis of other functional proteins.

Protein synthesis begins with reading (transcription) of the genetic code in the cell's DNA. To make this happen, an mRNA molecule forms from the DNA molecule. Then it is edited. Next, it leaves the nucleus through the large nuclear pores. Once outside the nucleus, ribosome subunits attach to the beginning of the mRNA molecule and begin the process of translation. While in translation, transfer RNA (tRNA) molecules deliver specific amino acids—encoded by each mRNA codon—into place at the site of the ribosome. As the amino acids are brought into their proper sequence, they are joined together by peptide bonds. Several peptide bonds form long strands called polypeptides. If required, several polypeptide chains may be required to create a complete protein molecule.

Mosby's Anatomy and Physiology Coloring Book
Copyright © 2014 by Mosby, an imprint of Elsevier Inc

Using the *italicized* paragraph, enter the proper numbers 1–10 in the circles, based on the sequence provided. You may find it helpful to figure out the process by using the analogy of building a house; that is, first, you begin with reading the blueprints.

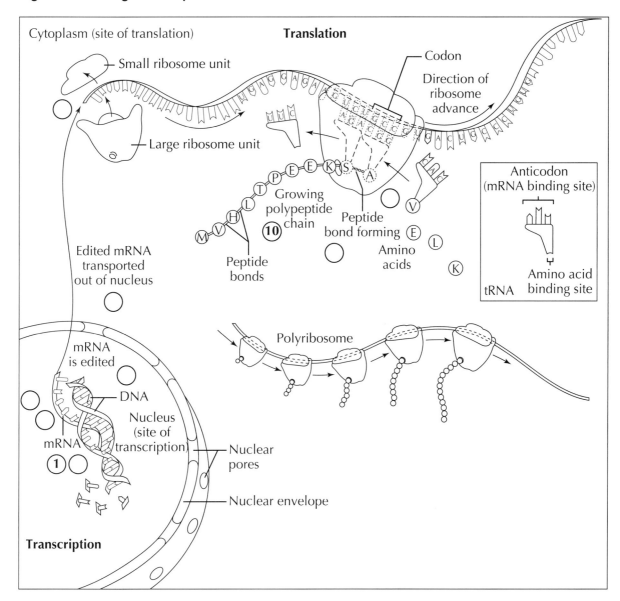

MITOSIS

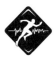

Mitosis is defined as "a complex process in which a cell's DNA is replicated and divided equally between two daughter cells." At first, there is one cell, then the cell divides with the same DNA in each. To accomplish the act of mitosis, a cell must go through four separate stages, following a "preparation stage."

Pre-Mitosis: Interphase: Mitotic phase immediately before visible condensation of the chromosomes during which the DNA of each chromosome replicates itself.

Stage 1: Prophase: Chromosomes shorten and thicken from the DNA molecules coiling; each chromosome consists of 2 chromatids attached at the centromere. Centrosomes move to opposite poles of the cell. Spindle fibers appear. Nucleoli and nuclear membrane disappear.

Stage 2: Metaphase: Stage of mitosis during which the nuclear membrane and nucleolus disappear and the chromosomes align on the equatorial plane.

Stage 3: Anaphase: Stage of mitosis in which duplicate chromosomes move to poles of dividing cell. Each centromere splits, thereby detaching 2 chromatids from each other, elongating during the process. (DNA molecules start uncoiling.) Sister chromatids (now chromosomes) move to opposite poles; there are now twice as many chromosomes as before mitosis started.

Stage 4: Telophase: Last stage of mitosis. New chromosomes start elongating. DNA starts uncoiling. A nuclear envelope forms again to enclose each new set of chromosomes.

Using the descriptions of the four phases that produce mitosis, identify each phase, then color the organelles within each phase.

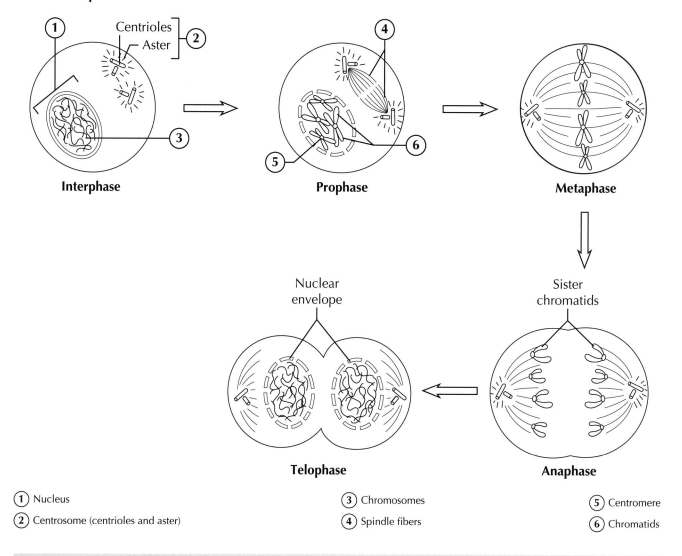

| ① Nucleus | ③ Chromosomes | ⑤ Centromere |
| ② Centrosome (centrioles and aster) | ④ Spindle fibers | ⑥ Chromatids |

COMPARING MITOSIS TO MEIOSIS

All somatic cells of the body contain 46 chromosomes. Where mitosis results in an exact duplication of a cell resulting in a full 46 chromosomes, meiosis is nuclear division in which the number of chromosomes is reduced to half their original number (23). The only example of meiosis in the human body is when the primitive sex cells (spermatozoa in males and oogonia in females) are in the process of becoming mature sex cells (sperm in males

and ovi in females). This is necessary because a sperm or ovum that had a complete 46-chromosomal makeup could not allow for fertilization of the ovum by the sperm to occur.

Color in the two different processes of cell division below.

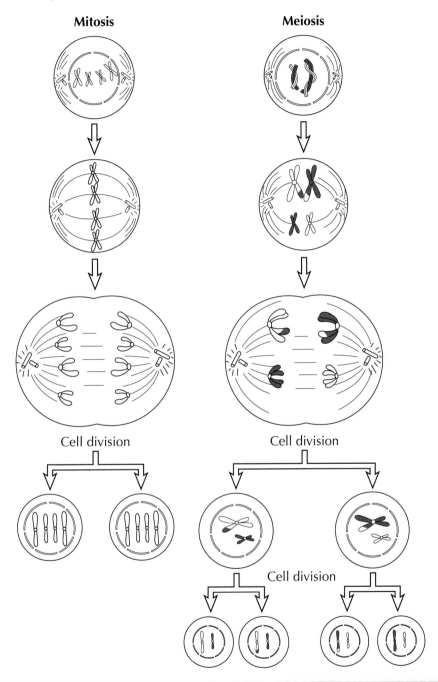

LIFE CYCLE OF THE CELL

The processes of growth and reproduction of successive generations of cells exhibit a cyclic pattern. Newly formed cells grow to maturity by synthesizing new molecules and organelles (G_1 and G_2 phases), including the replication of an extra set of DNA molecules (S phase) in anticipation of reproduction. Mature cells reproduce (M phase) by first distributing the two identical sets of DNA (produced during the S phase) in the orderly process of mitosis, then by splitting the plasma membrane, cytoplasm, and organelles of the parent cell into two distinct daughter cells (cytokinesis). Daughter cells that do not go on to reproduce are in a maintenance phase (G_0).

Color in the corresponding phases.

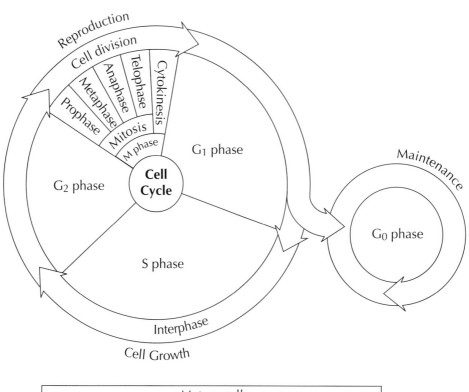

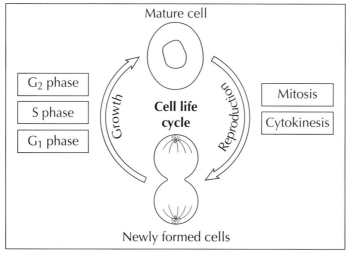

◯ G₁ phase	◯ Mitosis	◯ Telophase
◯ S phase	◯ Prophase	◯ Cytokinesis
◯ G₂ phase	◯ Metaphase	◯ G₀ phase
◯ M phase	◯ Anaphase	

MAJOR TISSUES OF THE BODY

Tissues of the body can be classified by their structure and function into four principal types:

Epithelial: The structure consists of one or more layers of densely arranged cells with very little extracellular matrix. It covers and protects the body surface, lines body cavities, transports substances, and produces some glandular activity. Examples in the body include the outer layer of skin and the lining of the respiratory, digestive, urinary, and reproductive tracts.

Copyright © 2014 by Mosby, an imprint of Elsevier Inc

Connective: These sparsely arranged cells are surrounded by a large proportion of extracellular matrix often containing structural fibers and sometimes mineral crystals. Connective tissue supports body structures and transports substances throughout the body. Examples include bones, cartilage, tendons, ligaments, blood, and fat.

Nervous: This tissue is formed by a mixture of many cell types, including several types of neurons and neuroglia. Nervous tissue supports communication and allows for the integration and regulation of body functions. Examples include the brain, spinal cord, nerves, and sensory organs.

Muscle: These long fiber-like cells sometimes branch, are capable of pulling loads, and have extracellular fibers that hold the tissue together. They produce body movements and movements of organs such as the stomach and heart. Muscle tissue also produces heat. Examples include the heart muscle; muscles of the head, neck, arms, legs, and trunk; and the walls of hollow organs such as the stomach and the intestines.

Using the information above, identify and label the four types of tissues using the information about the structure and function as your clues, then color in the tissues.

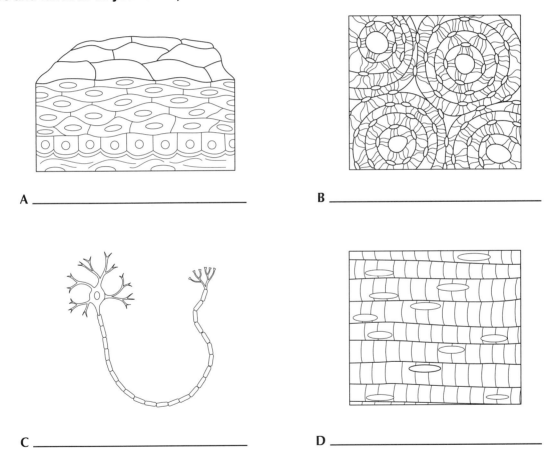

A _____

B _____

C _____

D _____

EPITHELIAL TISSUES

These tissues are classified according to the shape and arrangement of cells. Squamous cells resemble scales; they are flat and platelike. Cuboidal cells are cube shaped. Columnar cells have more height than width. A single layer of cells is called "simple." When several layers of cells are stacked on top of each other, they are call "stratified."

Color in the different types of epithelial cells and tissues.

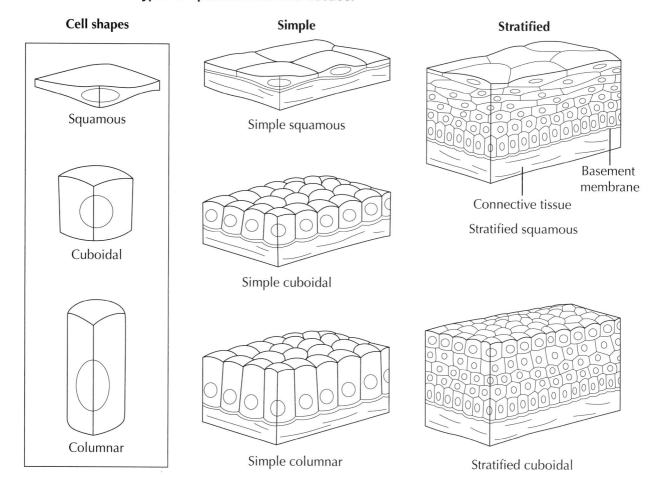

Cell shapes

Squamous

Cuboidal

Columnar

Simple

Simple squamous

Simple cuboidal

Simple columnar

Stratified

Basement membrane

Connective tissue

Stratified squamous

Stratified cuboidal

CONNECTIVE TISSUE

Connective tissues can be categorized according to the structural characteristics of the intercellular material. There are five major types of connective tissues: fibrous, dense fibrous, bone, cartilage, and blood.

TISSUE TYPE	DESCRIPTION
Fibrous	Serves as connecting material, for protection, support, padding, and filtration. The matrix of loose fibrous connective tissue contains numerous fibers and cells interwoven.
Dense fibrous	Serves as connecting material and for support; flexible. The matrix is densely packed and has a high degree of strength.
Bone	Serves as a support tissue and for protection; also provides a framework for blood production. The matrix has fibers and a hard mineralized extracellular matrix (ECM).
Cartilage	Firm but flexible support; functions as connecting material between structures. Its matrix has a specialized ECM that can trap water to form a firm gel.
Blood	Transportation and protection. It has no fibers in its matrix.

MUSCLE TISSUE

Three types of muscle tissue are present in the body: skeletal muscle, smooth muscle, and cardiac muscle. Skeletal muscle tissue makes up most of the muscles attached to bones. Smooth muscle (aka visceral muscle) is found in the viscera (walls of hollow internal organs). Cardiac muscle tissue makes up the wall of the heart. *Striated* refers to the striped appearance of the tissue. *Voluntary* indicates that the muscle tissue is under voluntary or willed control. (i.e., the person controls the movement).

TISSUE TYPE	DESCRIPTION
Skeletal (striated voluntary)	Moves muscle that attaches to bones, eye muscles, and the first part of swallowing
Smooth (nonstriated, involuntary, or visceral)	Moves substances along the digestive, respiratory, and genitourinary tracts; changes blood vessel diameter, moves substances along ducts, changes diameter of pupils and shape of lens; causes the erection of hairs (gooseflesh)
Cardiac (striated involuntary)	Causes heart muscle contraction; tissue has cross striations

Based on the descriptions, can you label which is skeletal, smooth, and cardiac?

_____　　_____　　_____

NERVOUS TISSUE

Nervous tissue is composed of two cell types: neurons, which provide rapid communication and control of the body, and glia (aka neuroglia), which provide support (glue) for the neurons. The basic function of nervous tissue is to rapidly regulate and thereby integrate the activities of different parts of the body. This is possible because nervous tissue has a much more developed excitability (the ability to send and receive stimuli) and conductivity (the ability to selectively transmit a wave of excitation from one part of the body to another).

Fill in the key and then color in the corresponding structures.

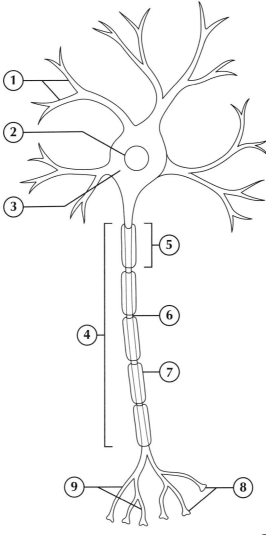

(1) Dendrites (4) Axon (7) Myelin sheath

(2) Nucleus (5) Schwann cell (8) Synaptic knobs

(3) Cell body (6) Node of Ranvier (9) Telodendria

CASE STUDY

Antonio Garza, age 64 years, has been brought to the rural health clinic by his granddaughter. Forty-eight hours ago, Antonio sustained a burn on his right foot while burning trash. The affected area is blistered, swollen, hot, and tender to the touch. The area surrounding the burn has an increased redness.

1. Based on the structure and function of tissue types, what type of tissue did Antonio injure?
 A. Epithelial
 B. Connective
 C. Muscle
 D. Nervous
2. Which of the functions of this tissue type is likely to be most affected by this injury?
 A. Transport of substances through the body
 B. Protection of the body surface
 C. Production of movement
 D. Coordination of body movements

Integumentary System

THE SKIN

The largest, thinnest, and one of the most important organs of the body—the skin forms a self-repairing and protective boundary between the internal environment of the body and the external world. The surface of the skin for an average-size adult measures approximately 17–20 square feet and ranges from 1/50–1/8 of an inch thick. There are two primary layers of the skin: (1) epidermis—superficial thinner layer; and (2) dermis—deep, thicker layer. A third layer below the dermis is called the hypodermis (aka, subcutaneous layer or superficial fascia). It interacts directly with the dermis above it; however, it is not considered part of the skin.

Fill in the color key below, then shade in the corresponding numbered circle on the diagram, as well as the structure with the same color. Next, fill in the brackets on the right side of the diagram indicating the layer of skin using the information above as clues.

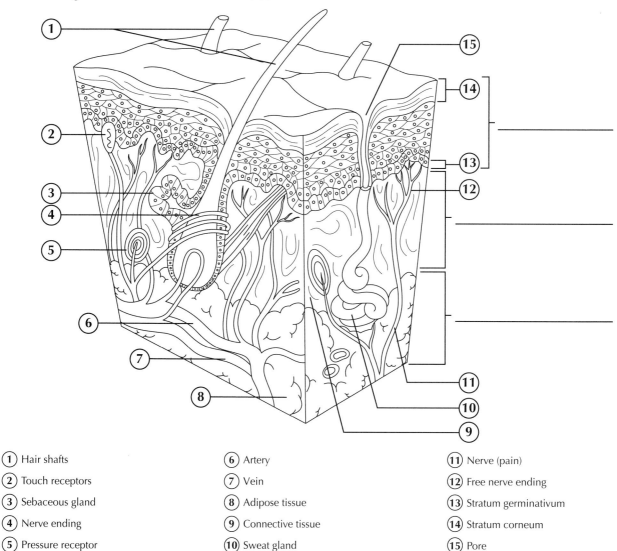

(1) Hair shafts	(6) Artery	(11) Nerve (pain)
(2) Touch receptors	(7) Vein	(12) Free nerve ending
(3) Sebaceous gland	(8) Adipose tissue	(13) Stratum germinativum
(4) Nerve ending	(9) Connective tissue	(14) Stratum corneum
(5) Pressure receptor	(10) Sweat gland	(15) Pore

Mosby's Anatomy and Physiology Coloring Book
Copyright © 2014 by Mosby, an imprint of Elsevier Inc

STRUCTURE OF THE SKIN

The cells of the epidermis are found in up to five distinct layers (strata). Each stratum is named for its structural or functional characteristics. The dermis is composed of two layers—a thin papillary layer and a thicker reticular layer. The dermis is much thicker than the epidermis. The hypodermis (aka, subcutaneous layer or superficial fascia) is not included in this diagram.

Select colors for the key to represent the various layers and structures in the diagram. Next, shade in the corresponding number in the diagram and color in the structure. Finally, fill in the brackets with either "epidermis" or "dermis."

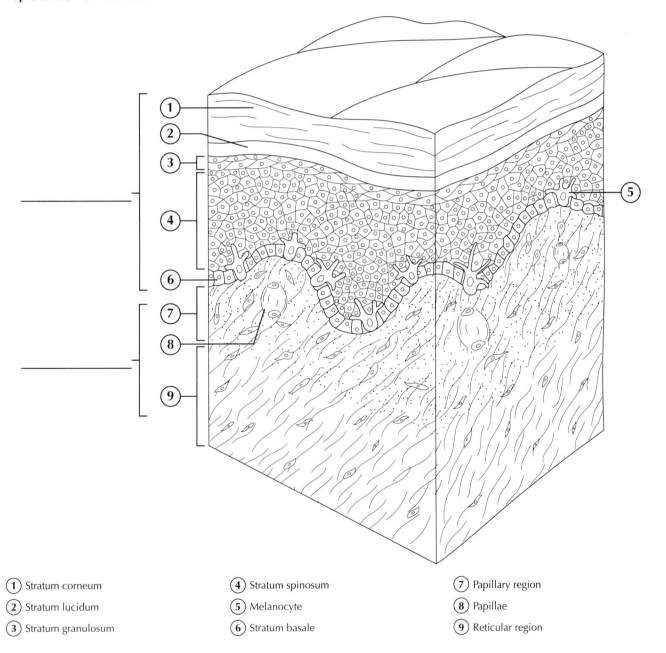

(1) Stratum corneum

(2) Stratum lucidum

(3) Stratum granulosum

(4) Stratum spinosum

(5) Melanocyte

(6) Stratum basale

(7) Papillary region

(8) Papillae

(9) Reticular region

CELLS OF THE EPIDERMIS

Next, let's explore epidermal cell types. Keratinocytes, most of the cells seen here, begin their life in the deepest layer of the epidermis and are pushed upward as more keratinocytes are formed. Melanocytes produce pigments. Epidermal dendritic cells (DCs) have a function in immunity. Tactile epithelial cells (Merkel cells) attach to sensory nerve endings to form "light touch" receptors. Corneocytes compose the uppermost portion of the epidermis and are removed through desquamation, or "skin rubbing."

Using the information above, color the various structures and numbers associated as well as the corresponding numbers in the key.

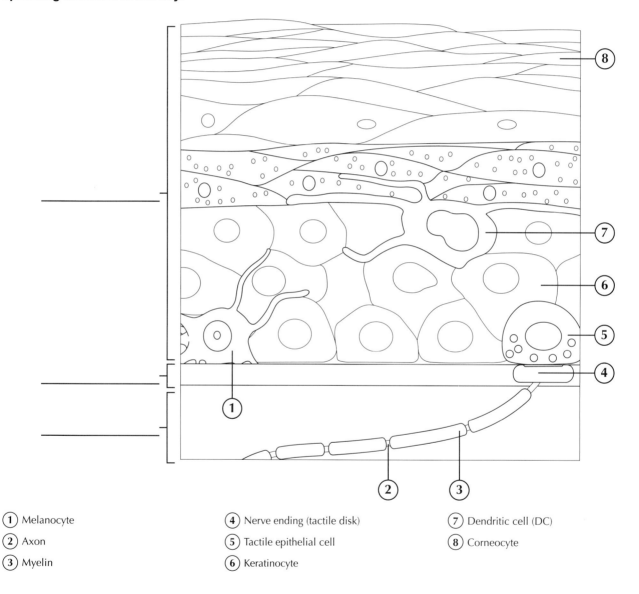

(1) Melanocyte (4) Nerve ending (tactile disk) (7) Dendritic cell (DC)

(2) Axon (5) Tactile epithelial cell (8) Corneocyte

(3) Myelin (6) Keratinocyte

DERMAL REPAIR

Unlike the epidermis, the dermis does not continually shed and regenerate. Rapid regeneration of connective tissue in the dermis occurs only during unusual circumstances, as in the healing of wounds. For example, after a minor cut has occurred, blood clots form to stop bleeding and fibroblasts activate to fill in the gap with an unusually dense mass of fibrous connective tissue. This new connective tissue replaces the epithelium, forming a scar.

Using the information above, label each image describing what happens in each stage and draw the changes that are occurring.

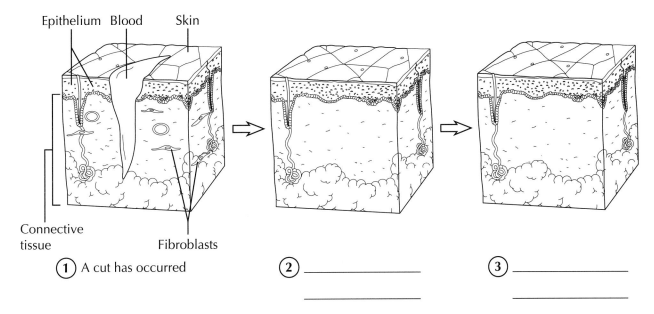

Epithelium Blood Skin

Connective
tissue Fibroblasts

① A cut has occurred

② _____

③ _____

APPENDAGES OF THE SKIN

The three appendages of the skin are hair, nails, and skin glands. We will review these different structures separately.

Hair: We have approximately 5 million hairs on the skin of our body. The visible part of the hair is called the hair shaft. Beneath the surface of the skin, numerous activities take place to grow and maintain hair. Hair growth begins at the base of the follicle. A vein and an artery supply the follicle via a dermal blood vessel (capillary). Repeated mitosis pushes upward on the follicle, which becomes keritinized to form a hair. The hair root lies hidden in the follicle. Two or more small sebaceous glands secrete sebum, an oily substance, into the hair follicle to lubricate and condition the hair and surrounding skin to keep it from becoming dry, brittle, and easily damaged. The arrector pili muscle is a smooth muscle of the skin that is attached to a hair follicle. When contraction occurs, the hair stands up, resulting in a "goose bump."

Fill in the key with different colors, then shade in the corresponding number and structure in the diagram. Next, fill in the two layers of the skin and a third layer directly below.

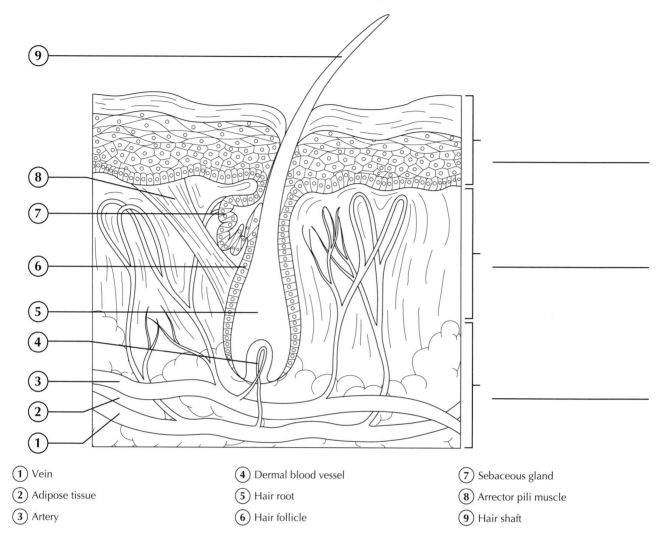

1 Vein	**4** Dermal blood vessel	**7** Sebaceous gland
2 Adipose tissue	**5** Hair root	**8** Arrector pili muscle
3 Artery	**6** Hair follicle	**9** Hair shaft

Nails: Fingernails and toenails are composed of heavily keratinized epidermal cells. The visible part of each nail is called the nail body. The rest of the nail, namely, the root, lies in a flat sinus hidden by a fold of skin bordered by the cuticle. The crescent-shaped white area on the nail bed is called the lunula. We see the fingernail as viewed from above (A), and a sagittal section of a fingernail and associated structures (B).

Shade in both color keys. If a structure is identified in both diagrams, use the same color for each. Color in the structure that corresponds with the color key.

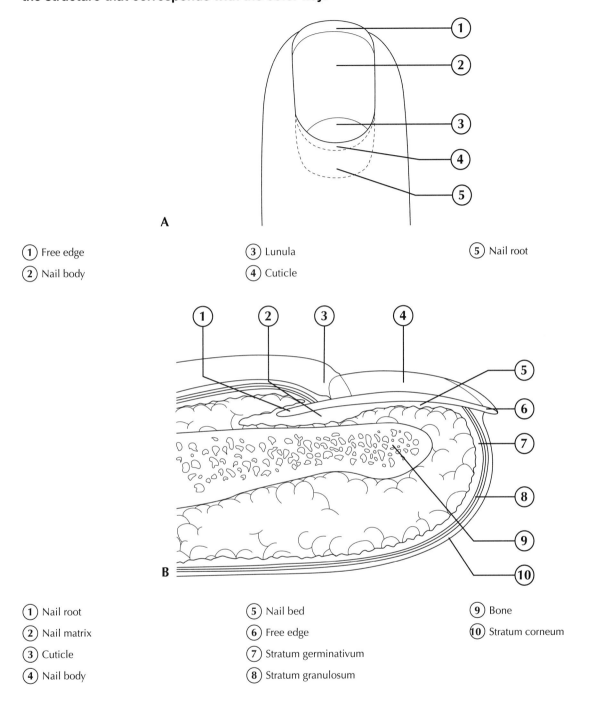

A

(1) Free edge (3) Lunula (5) Nail root

(2) Nail body (4) Cuticle

B

(1) Nail root (5) Nail bed (9) Bone

(2) Nail matrix (6) Free edge (10) Stratum corneum

(3) Cuticle (7) Stratum germinativum

(4) Nail body (8) Stratum granulosum

Glands of the Skin: There are three types of skin glands, each performing a very vital function of homeostasis. *Sweat (sudoriferous) glands* are the most numerous. They are further divided into apocrine and eccrine sweat glands, depending on their type of secretion and nervous system connection. *Sebaceous glands* secrete oil for the hair and skin. There are at least two sebaceous glands for each hair. *Ceruminous glands* are a specialized form of apocrine gland. Their secretions mix with sebaceous gland secretions to form a brown waxy substance called cerumen.

Shade in the color key then color the corresponding numbers and structures/layers in the diagram.

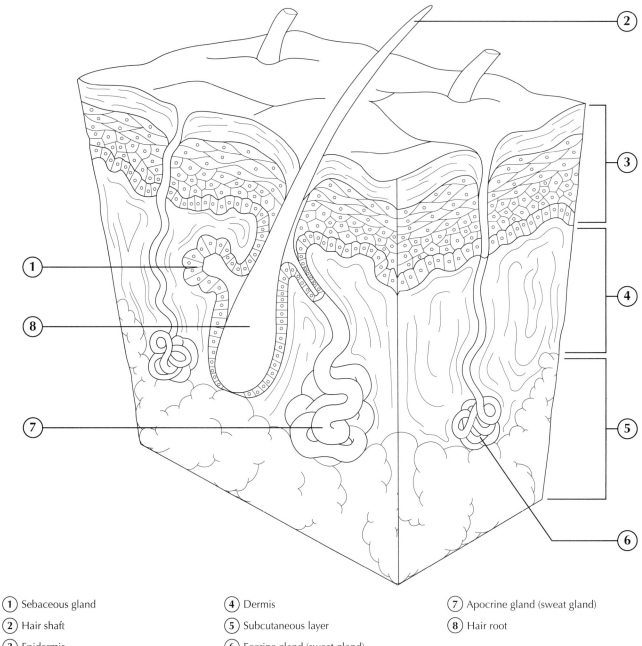

(1) Sebaceous gland (4) Dermis (7) Apocrine gland (sweat gland)

(2) Hair shaft (5) Subcutaneous layer (8) Hair root

(3) Epidermis (6) Eccrine gland (sweat gland)

THE RULE OF NINES

This "rule" is an accurate method to determine the amount of skin surface burned in an adult. The body is divided into 11 areas, equally 9% each, with the perineum representing the additional 1%.

Use the values listed below and the clues above to fill in the boxes with the correct percentages, then color in the illustrations using the key.

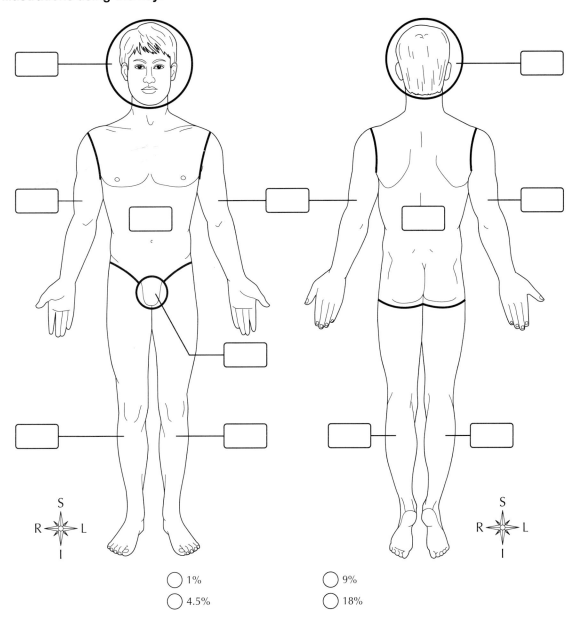

○ 1%
○ 4.5%

○ 9%
○ 18%

CLASSIFICATION OF BURNS

Burns are classified by the depth of the injury: partial thickness (first and second degree) and full thickness (third degree). A first-degree burn (typical sunburn) causes minor discomfort and some reddening of the skin. No blistering occurs and epidermal tissue destruction is minimal. A second-degree burn involves both dermis and epidermis. In a deep second-degree burn, some damage can occur to sweat glands, hair follicles, and sebaceous glands. Blisters, severe pain, generalized swelling, and scarring are common. Full-thickness burns destroy the

epidermis and dermis. Tissue death extends below the hair follicles and sweat glands. If underlying muscles, fascia, or bone are burned, this can be called a fourth-degree burn. Unlike first and second-degree partial-thickness burns, there is no pain immediately after the injury because the nerve endings are destroyed. Scarring and infection are serious problems.

Using the information above, correctly identify the three stages of a burn injury in the diagram. Color each in.

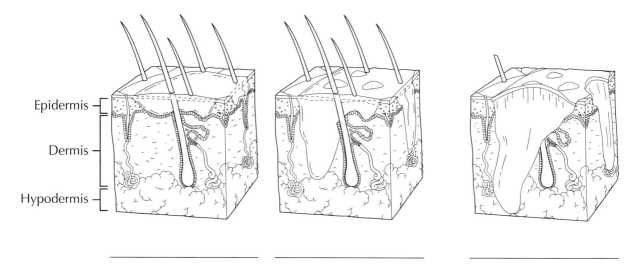

SKIN CANCERS
=

Abnormal growths in the skin as a result of changes at the cellular level—skin cancers—are the most common form of cancer in humans. Basal cell carcinoma and squamous cell carcinoma (*carcinoma* is a malignant tumor that originates from the epithelium) account for over 95% of all reported cases of skin cancer. These seldom spread if treated properly and are generally responsive to treatment. Malignant melanoma is a much more serious form of skin cancer because it has a tendency to metastasize (or spread). Last, Kaposi sarcoma is a form of skin cancer that appears in individuals with immune deficiencies such as AIDS. The skin appears with blue or purple papules. Lymph nodes and internal organs become infected.

Using the information above, color the four types of skin cancer in the diagram below.

Basal cell carcinoma

Squamous cell carcinoma

Melanoma

Kaposi sarcoma

CASE STUDY

One afternoon, twelve-year-old Aiden was playing in his tree house. While running his fingers along the railing, he suddenly yelled, snatching his hand back off the rail. When he looked down, he saw a small sliver of wood sticking out of his middle finger. The splinter hurt, but his finger wasn't bleeding.

1. What primary layer or layers of the cutaneous membrane has the splinter gone through? (HINT: There's no bleeding.)
 A. Epidermis only
 B. Dermis only
 C. Both epidermis and dermis
 D. Stratum basale only

2. If the splinter went into Aiden's arm instead of his finger, which of these layers would the splinter NOT have pierced?
 A. Stratum corneum
 B. Stratum granulosum
 C. Stratum spinosum
 D. Stratum lucidum

3. The puncture has broken Aidan's intact skin barrier and now may allow bacteria or other pathogens to enter. What cells will help identify these pathogens and mark them for destruction?
 A. Keratinocytes
 B. Melanocytes
 C. Dendritic cells
 D. Lamellar corpuscles

CHAPTER

5 Skeletal System

Bones are the primary organs of the skeletal system. They provide shape, support the body, and assist in the co-ordination of movement. Bones are living organs and are classified by their identifying characteristics.

ENDOCHONDRAL BONE FORMATION

First we will look at how bones are formed. Most bones are formed from cartilage in a process known as endo-chondral ossification. **Color in the steps of the formation as you read the description of what is occurring.**

A, Bone formation begins with the cartilage model. B and C, The diaphysis—the bone shaft—is invaded by blood vessels. The combined efforts of the osteoblasts (bone-forming cells) and osteoclasts (bone-absorbing cells) result in cavity formation, calcification, and the appearance of bone tissue. D and E, The centers of ossification also appear in the ends of the bone (the epiphyses). Note the formation of the epiphyseal plate. The presence of the plate means that the bone is not yet mature and additional growth is possible. G, Mature bone—only a faint epiphyseal line marks where the cartilage once was. This indicates the centers of ossification—"formed in cartilage"—have fused together.

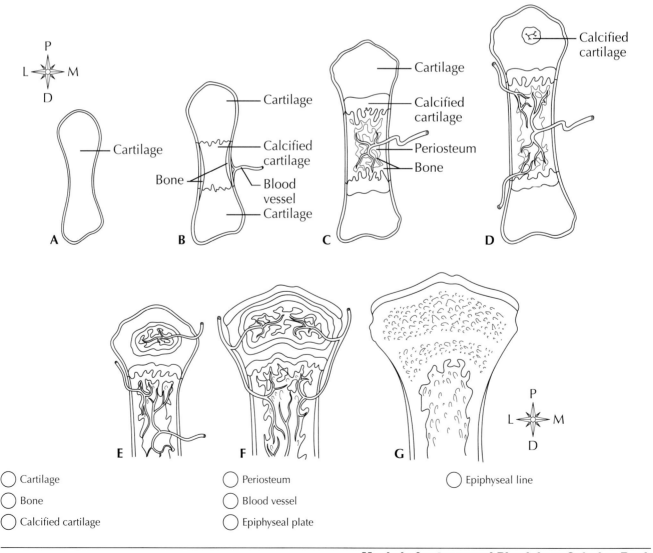

- ◯ Cartilage
- ◯ Bone
- ◯ Calcified cartilage
- ◯ Periosteum
- ◯ Blood vessel
- ◯ Epiphyseal plate
- ◯ Epiphyseal line

Mosby's Anatomy and Physiology Coloring Book
Copyright © 2014 by Mosby, an imprint of Elsevier Inc

INTRAMEMBRANOUS BONE FORMATION

Flat bones such as parts of the skull are formed in a process known as intramembranous ossification, which takes place in the connective tissue membranes. Layers of bone matrix build up to form a lattice of branched trabeculae, which are tiny branchlike threads in bone tissue that surround a network of spaces. These layers form the diploe of a flat bone. Eventually, a layer of compact bone forms under the periosteum to form the tables of a flat bone.

Color in the layers.

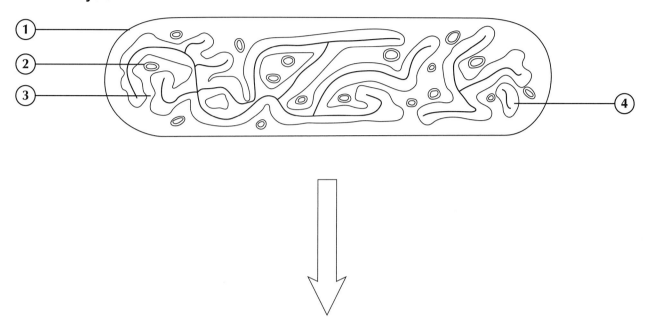

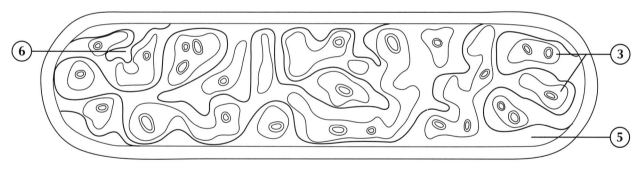

① Periosteum ③ Marrow spaces ⑤ Dense bone
② Capillaries ④ Trabeculae ⑥ Bony trabeculae covered with osteoblasts

FIVE MAIN BONE TYPES

These include long bones (such as the humerus), short bones (such as the carpal bones in your wrists), irregular bones (such as the vertebrae in your spine), flat bones (the sternum); and the sesamoid bones (such as the patella at your knee or the sesamoid of your thumb).

Identify and color the five different types of bones in the diagram below.

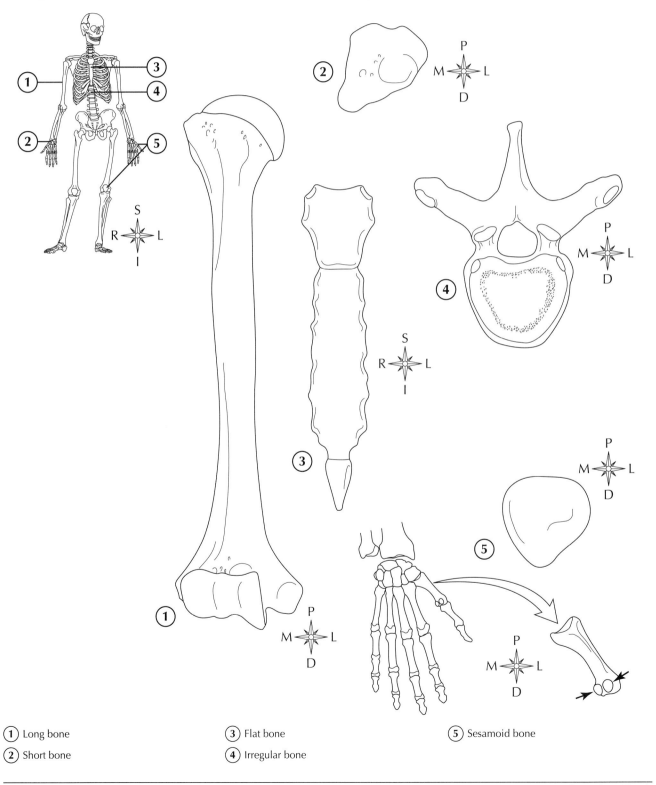

(1) Long bone

(2) Short bone

(3) Flat bone

(4) Irregular bone

(5) Sesamoid bone

INSIDE THE LONG BONE

Below is an illustration of a long bone. This means it is longer than it is wide. Notable long bones include arms, fingers, thighs, and legs. Observe the different bone tissues that make up this long bone: it is composed of compact bone (meaning dense bone tissue, primarily in the shaft of the bone) and spongy bone (meaning less dense bone tissue, usually found in the ends and center of a bone). Take note of these important qualities of bone tissue and familiarize yourself with other bone features.

Color the different parts of the long bone.

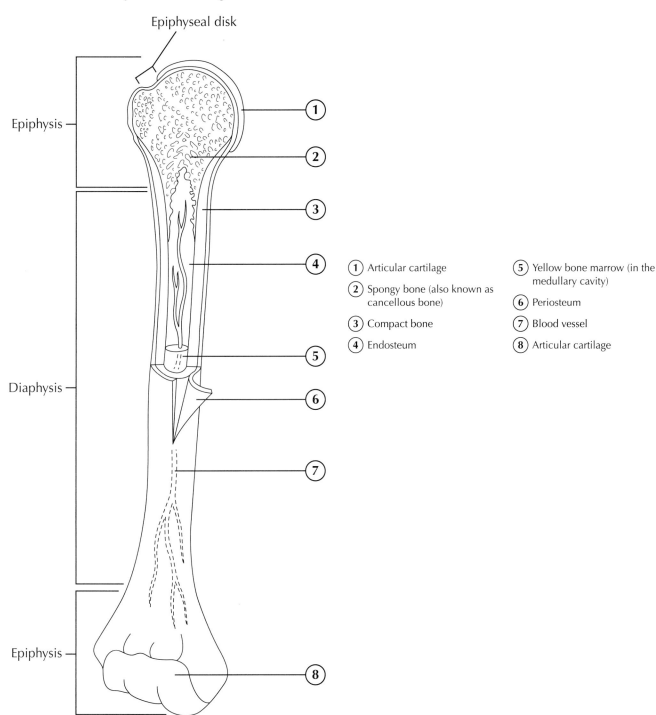

1. Articular cartilage
2. Spongy bone (also known as cancellous bone)
3. Compact bone
4. Endosteum
5. Yellow bone marrow (in the medullary cavity)
6. Periosteum
7. Blood vessel
8. Articular cartilage

FLAT BONE

Next, let's look at a section of flat bone. Below we have a horizontal section of a flat bone of the skull (frontal bone) showing both spongy and compact bone. The spongy bone is sandwiched between two walls of compact bone, known as the external table and the internal table. Other flat bones to be aware of include the ribs and the sternum.

Color the different parts of the flat bone.

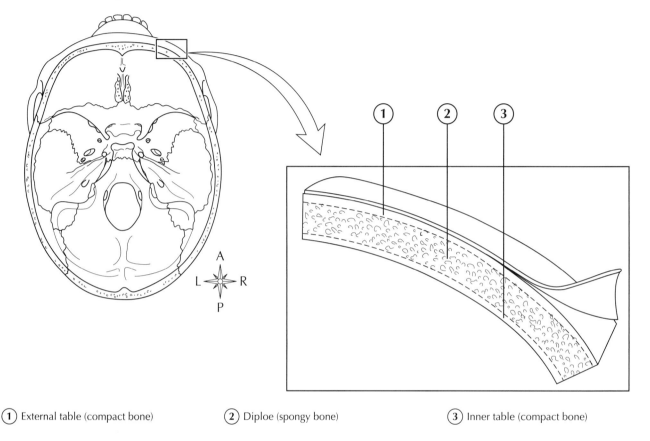

(1) External table (compact bone) (2) Diploe (spongy bone) (3) Inner table (compact bone)

THE AXIAL AND THE APPENDICULAR SKELETONS

The human skeleton consists of 206 bones and is divided into 2 main divisions. The axial skeleton contains 74 bones that form the upright axis of the body and 6 tiny middle ear bones. The appendicular skeleton contains 126 bones that form the appendages to the axial skeleton.

Color the anterior view of the bones of the axial skeleton and the bones of the appendicular skeleton in two different colors below.

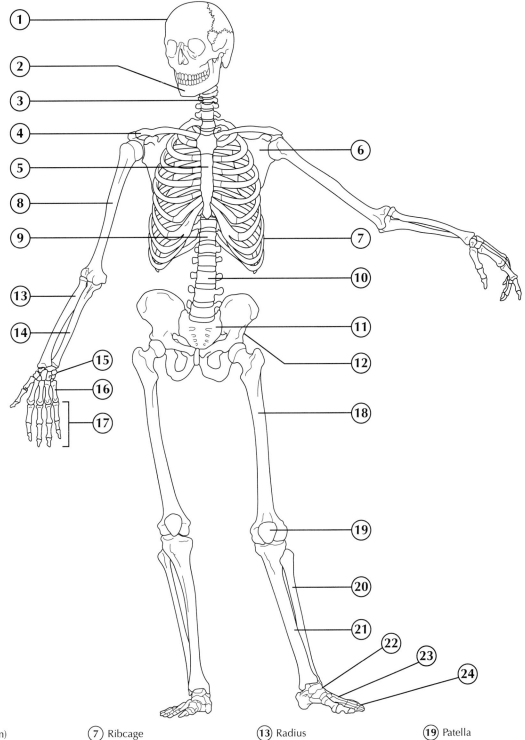

1. Skull (cranium)
2. Mandible
3. Cervical vertebrae
4. Clavicle
5. Sternum
6. Scapula
○ Axial skeleton

7. Ribcage
8. Humerus
9. Thoracic vertebrae
10. Lumbar vertebrae
11. Sacrum
12. Pelvic bone
○ Appendicular skeleton

13. Radius
14. Ulna
15. Carpals
16. Metacarpals
17. Phalanges
18. Femur

19. Patella
20. Fibula
21. Tibia
22. Tarsals
23. Metatarsals
24. Phalanges

Mosby's Anatomy and Physiology Coloring Book
Copyright © 2014 by Mosby, an imprint of Elsevier Inc

Color the posterior view of the bones of the axial skeleton and the bones of the appendicular skeleton in two different colors below.

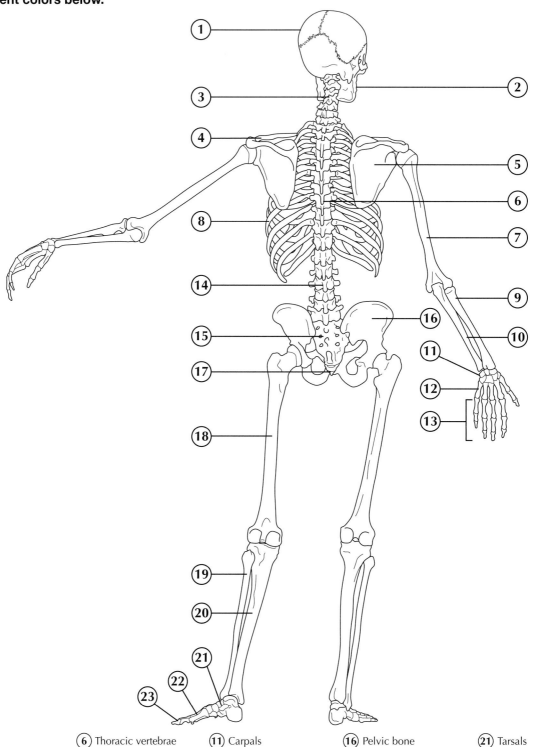

(1) Skull

(6) Thoracic vertebrae

(11) Carpals

(16) Pelvic bone

(21) Tarsals

(2) Mandible

(7) Humerus

(12) Metacarpals

(17) Coccyx

(22) Metatarsals

(3) Cervical vertebrae

(8) Ribcage

(13) Phalanges

(18) Femur

(23) Phalanges

(4) Clavicle

(9) Radius

(14) Lumbar Vertebrae

(19) Fibula

(5) Scapula

(10) Ulna

(15) Sacrum

(20) Tibia

◯ Axial skeleton ◯ Appendicular skeleton

Mosby's Anatomy and Physiology Coloring Book
Copyright © 2014 by Mosby, an imprint of Elsevier Inc

LATERAL VIEW OF THE SKULL

Twenty-eight irregularly shaped bones form the skull. The skull consists of two major divisions: the cranium and the facial bones. The cranium has eight bones: one frontal, two parietal, two temporal, one occipital, one sphenoid, and the ethmoid. The fourteen facial bones are: two maxilla, one mandible, two lacrimal, two palatine, two inferior nasal conchae, two zygomatic bones, two nasal bones, and the vomer.

Shade in the color key below, then color the corresponding numbers and structures in the lateral view of the skull.

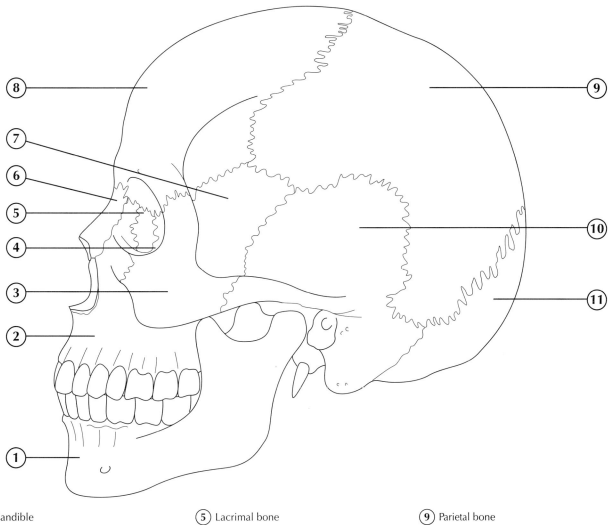

(1) Mandible (5) Lacrimal bone (9) Parietal bone

(2) Maxilla (6) Nasal bone (10) Temporal bone

(3) Zygomatic bone (7) Sphenoid bone (11) Occipital bone

(4) Ethmoid bone (8) Frontal bone

ANTERIOR VIEW OF THE SKULL

Shade in the key below, then fill in the corresponding numbers and structures in the anterior view of the skull.

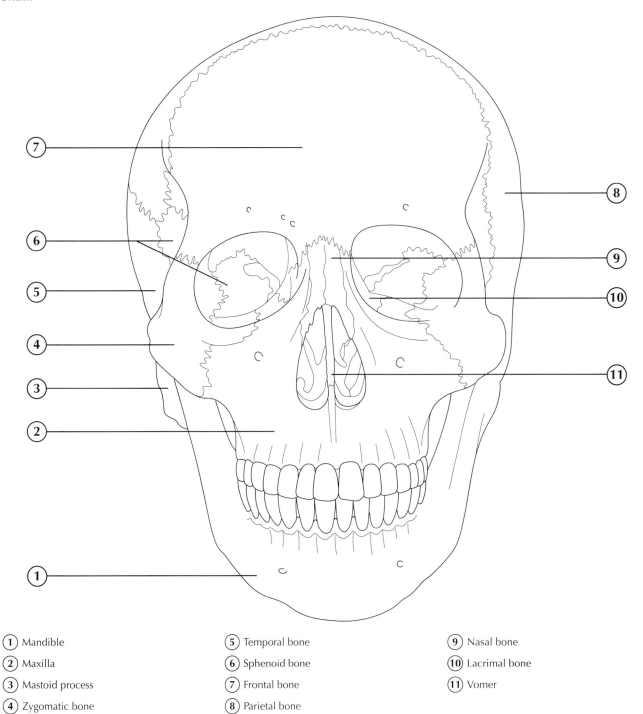

(1) Mandible

(2) Maxilla

(3) Mastoid process

(4) Zygomatic bone

(5) Temporal bone

(6) Sphenoid bone

(7) Frontal bone

(8) Parietal bone

(9) Nasal bone

(10) Lacrimal bone

(11) Vomer

FLOOR OF THE CRANIAL CAVITY—SUPERIOR VIEW

Shade in the key below, then shade in the corresponding numbers and structures in the floor of the cranial cavity.

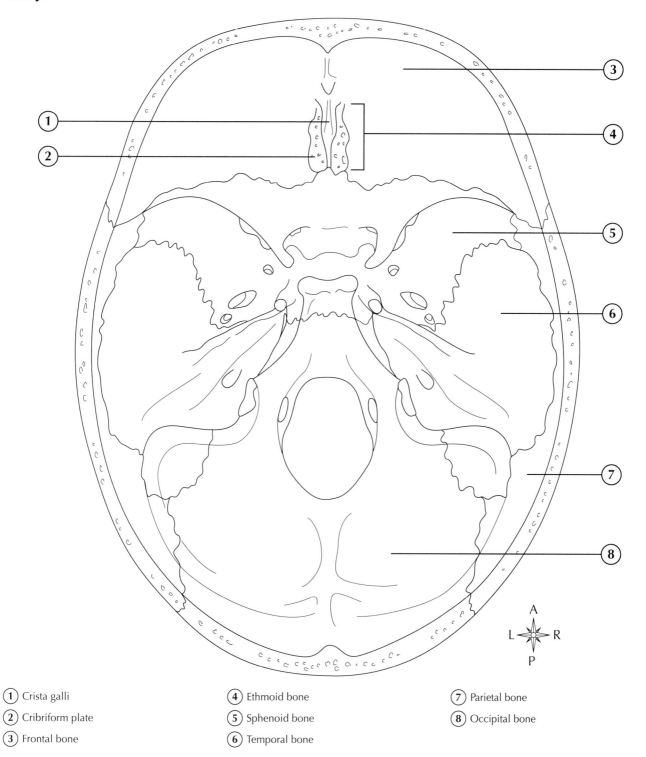

(1) Crista galli

(2) Cribriform plate

(3) Frontal bone

(4) Ethmoid bone

(5) Sphenoid bone

(6) Temporal bone

(7) Parietal bone

(8) Occipital bone

FETAL SKULL

The skulls of both a fetus and a newborn infant have unique anatomical features not seen in an adult. For example, placement of the cranial bones in the fetal skull allows it to change shape during the birth process. The fontanels provide additional space as the baby passes through the birth canal. They also allow rapid brain growth to occur in infancy without causing damage related to intracranial pressure.

Shade in the color key below, then fill in the corresponding numbers and structures in the fetal skull.

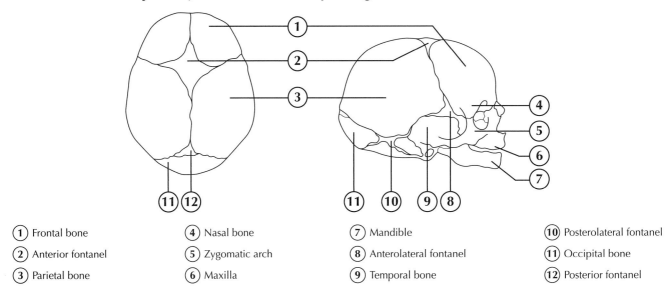

① Frontal bone	④ Nasal bone	⑦ Mandible	⑩ Posterolateral fontanel
② Anterior fontanel	⑤ Zygomatic arch	⑧ Anterolateral fontanel	⑪ Occipital bone
③ Parietal bone	⑥ Maxilla	⑨ Temporal bone	⑫ Posterior fontanel

TEETH

The teeth are the organs of mastication, or chewing. They are designed to cut, tear, and grind ingested food so that it can be mixed with saliva and swallowed. Dentition is a term used to define the type, number, and arrangement of teeth. **Deciduous teeth** (aka primary or baby teeth) typically number 20 and appear early in life. Later, they are replaced by 32 **permanent teeth**.

Shade in the color key below, then fill in the corresponding numbers and structures for both illustrations below. Correctly label one image Deciduous and the other Permanent.

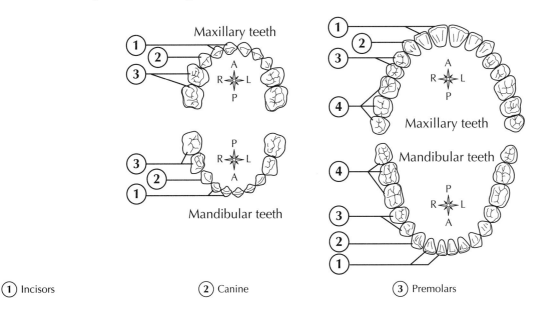

① Incisors	② Canine	③ Premolars	④ Molars

TOOTH

A typical tooth can be divided into three main parts: crown, neck, and root. The crown is the exposed portion of a tooth. It is covered by enamel, which is the hardest and most chemically stable tissue in the body. In addition to enamel, the outer shell of each tooth is composed of dentin and cementum. The neck is the narrow portion of the tooth that is surrounded by the gingivae (gums). The periodontal membrane suspends the root into the socket of the alveolar process of either the maxilla or mandible.

Shade in the color key below. Then fill in the corresponding numbers and structures in the diagram below.

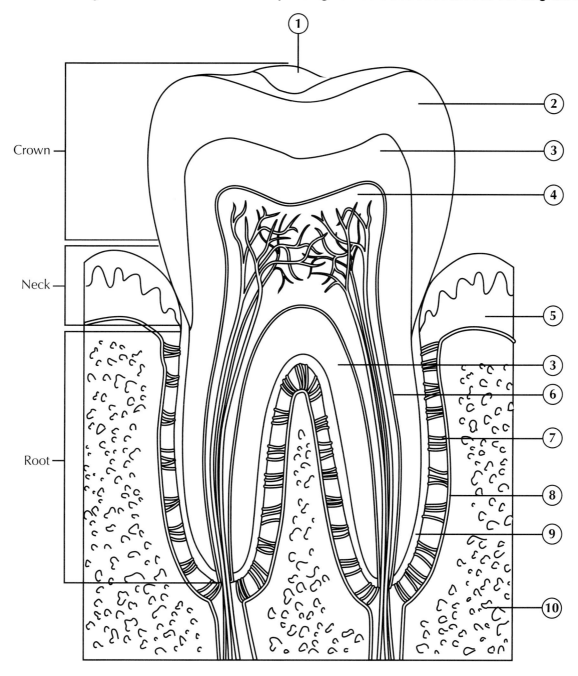

① Cusp	③ Dentin	⑤ Gingiva (gum)	⑦ Periodontal ligament	⑨ Cementum
② Enamel	④ Pulp cavity with nerves and vessels	⑥ Root canal	⑧ Periodontal membrane	⑩ Bone

THE VERTEBRAL COLUMN

The vertebral column (aka spinal column) forms the longitudinal axis of the skeleton. It is a flexible column due to its segmentations. The first 7 vertebrae (cervical) provide the framework to the neck; the 12 thoracic vertebrae form the framework of the thoracic region and are attachment sites for the ribs; the 5 lumbar vertebrae are much larger and support the low back. The sacrum is composed of 5 separate vertebrae in an infant but later fuse to become a single structure in adults. The coccyx is a single bone in an adult but is formed from 4 to 5 vertebrae that fuse as the child grows. The bones of the vertebral column are numbered according to their location in the vertebral column, not as a cumulative number. For example, the 7 cervical vertebrae are numbered C1–C7, thoracic T1–T12, and lumbar L1–L5. Often, the sacrum is simply illustrated as one bone; however (it will become apparent in a later section), it is important to remember that while the 5 separate bones are fused into one, there are small openings which allow for important nerves to pass. In an adult, the coccyx (tailbone) is simply counted as one.

Shade in the color key below. In each of the three vertebral column diagrams below (lateral, anterior, and posterior views) use the same colors in the color key for each section of the vertebrae.

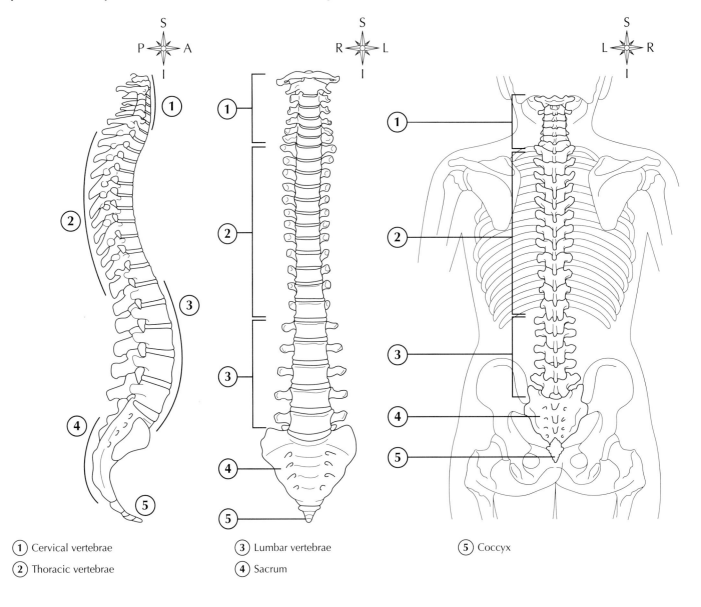

① Cervical vertebrae ③ Lumbar vertebrae ⑤ Coccyx

② Thoracic vertebrae ④ Sacrum

VERTEBRAL BONES

The individual vertebral bones are shaped according to their location and function. Note that in the case of the cervical vertebrae, there are three distinct shapes. For example, C1 (see p. XXX) is named the atlas because its unusual shape allows for the occipital bone to rotate (as in shaking your head no). C2 (see p. XXX) is named the axis because it has a specialized prominence called the dens (ondontoid process) that serves as a pivot point to allow for the rotation.

Label the various diagrams below by using an anatomy text as a reference or go online. Color each vertebrae a different color.

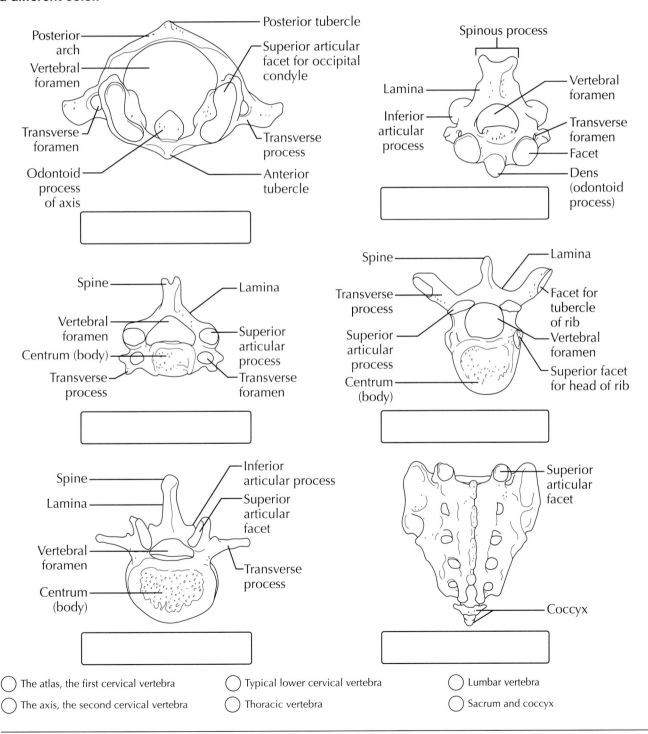

○ The atlas, the first cervical vertebra

○ The axis, the second cervical vertebra

○ Typical lower cervical vertebra

○ Thoracic vertebra

○ Lumbar vertebra

○ Sacrum and coccyx

THORACIC CAGE

This cage contains most of the vital organs of the human body. It is composed of the sternum (necktie: manubrium, body, and xiphoid process); the 12 sets of ribs (true ribs—upper 7; false ribs—lower 5, with the last 2 called "floating"); and the thoracic vertebrae. Some anatomy texts will also include the clavicles. However, the clavicle is typically considered as the anterior articulation between the axial and appendicular skeleton. **Note:** Ribs are identified as "true" because they attach directly to the sternum via the costal cartilage. "False ribs" do not attach directly to the sternum; rather the upper 3 false ribs attach via the costal cartilage of the seventh ribs. The lower two false ribs do not have an anterior attachment, but "float."

Shade in the color key below. Next, fill in the corresponding numbers and structures.

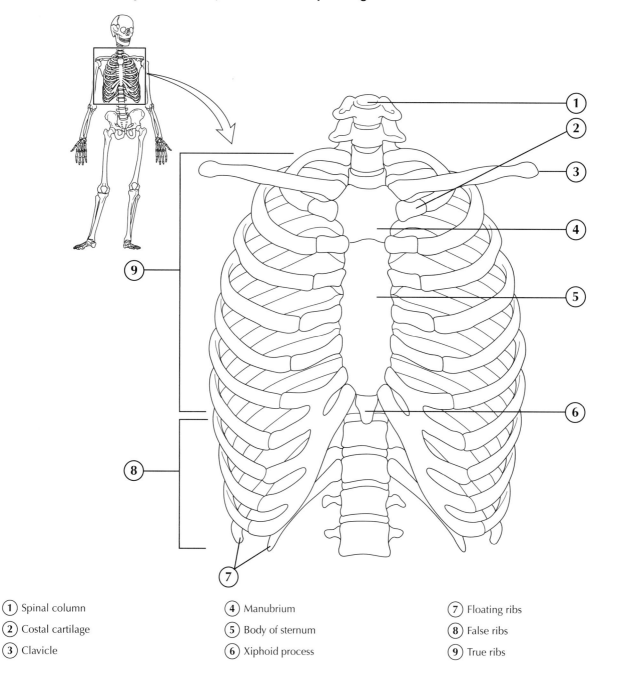

1. Spinal column
2. Costal cartilage
3. Clavicle
4. Manubrium
5. Body of sternum
6. Xiphoid process
7. Floating ribs
8. False ribs
9. True ribs

APPENDICULAR SKELETON

The appendicular skeleton contains the bones of the upper and lower extremities. We will discuss each of these appendages separately in the subsequent diagrams. The major bone sections of the upper limb include the shoulder girdle, arm, forearm, and hand.

Shade in the color key below. Next, fill in the corresponding numbers and structures.

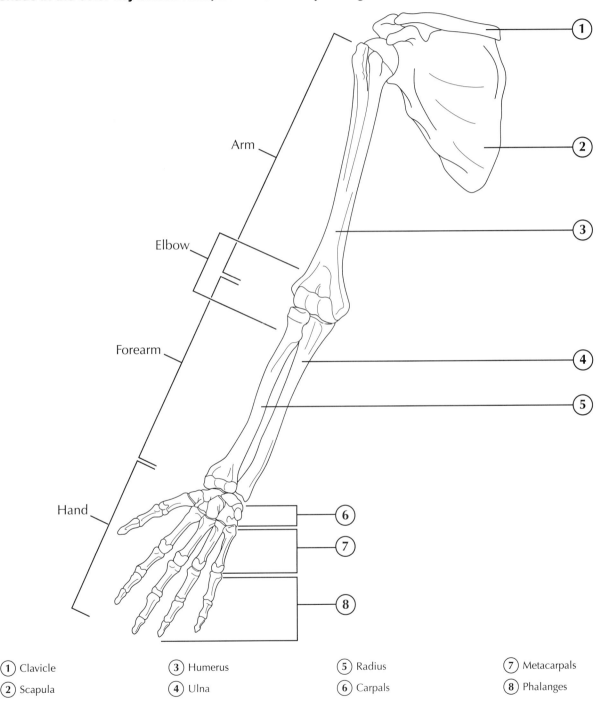

Arm

Elbow

Forearm

Hand

1. Clavicle
2. Scapula
3. Humerus
4. Ulna
5. Radius
6. Carpals
7. Metacarpals
8. Phalanges

SHOULDER JOINT

Below is an anterior cross-section view of the shoulder joint. The shoulder joint is known as a synovial joint. They are the most numerous kind of joint in the body, due to the fact that there are so many different kinds of body parts composed of synovial joints—elbows, forearms, wrists, hands, fingers, hips, knees, ankles, vertebral, and more.

Shade in the color key below. Next, fill in the corresponding numbers and structures.

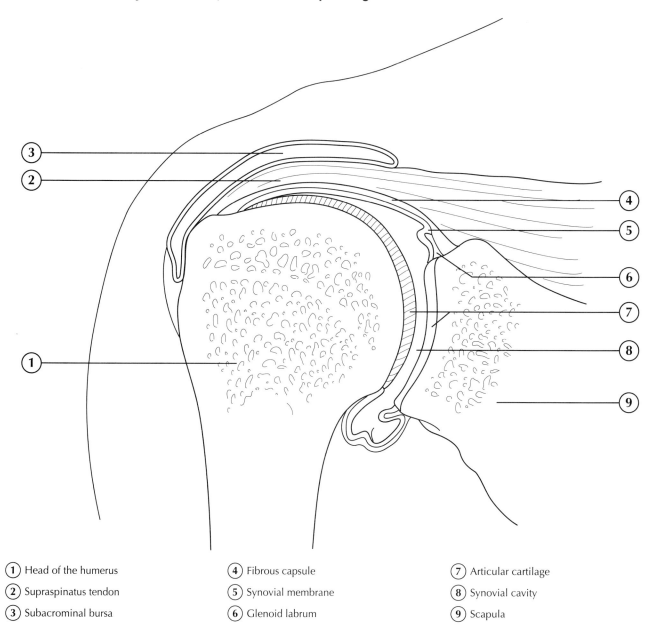

(1) Head of the humerus (4) Fibrous capsule (7) Articular cartilage

(2) Supraspinatus tendon (5) Synovial membrane (8) Synovial cavity

(3) Subacrominal bursa (6) Glenoid labrum (9) Scapula

BONES OF THE HAND AND WRIST

Below is a dorsal view of the right hand and wrist.

Shade in the color key below. Next, fill in the corresponding numbers and structures.

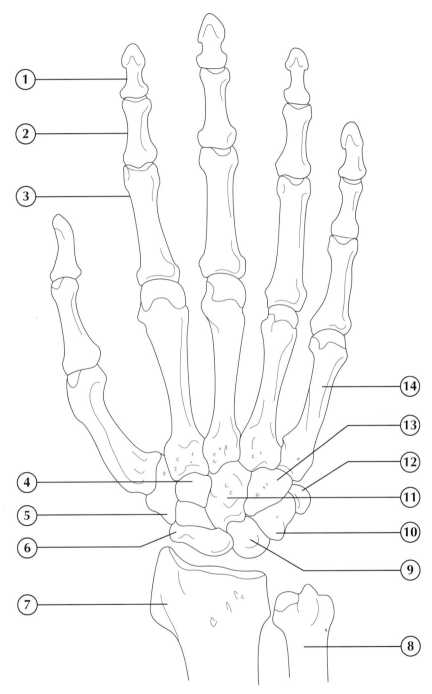

(1) Distal phalanx	(4) Trapezoid	(7) Radius	(10) Triquetrum	(13) Hamate
(2) Middle phalanx	(5) Trapezium	(8) Ulna	(11) Capitate	(14) Metacarpal bone
(3) Proximal phalanx	(6) Scaphoid	(9) Lunate	(12) Pisiform	

Next, we have a palmar view of the right hand and wrist.

Shade in the color key below. Next, fill in the corresponding numbers and structures.

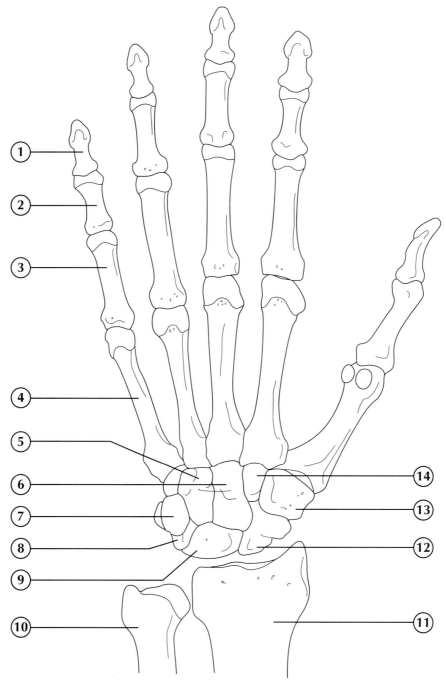

(1) Distal phalanx	(5) Hamate	(9) Lunate	(13) Trapezium
(2) Middle phalanx	(6) Capitate	(10) Ulna	(14) Trapezoid
(3) Proximal phalanx	(7) Pisiform	(11) Radius	
(4) Metacarpal bone	(8) Triquetrum	(12) Scaphoid	

BONES OF THE ARM

Shade in the color key below. Next, fill in the corresponding numbers and structures.

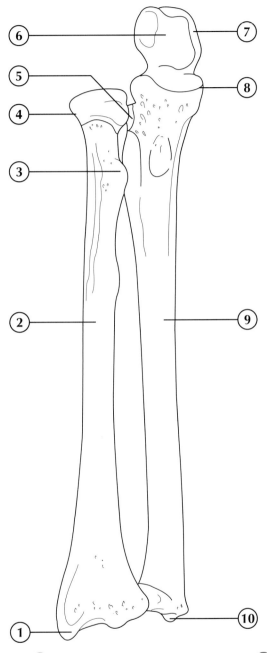

1. Styloid process of radius
2. Radius
3. Radial tuberosity
4. Head of radius

5. Radial notch
6. Trochlear notch
7. Olecranon process
8. Coronoid process

9. Ulna
10. Styloid process of ulna

BONES OF THE LOWER LIMB

Sections for the lower limb include the hip (or coxal) bone, thigh, leg, and foot.

Shade in the color key below. Next, fill in the corresponding numbers and structures.

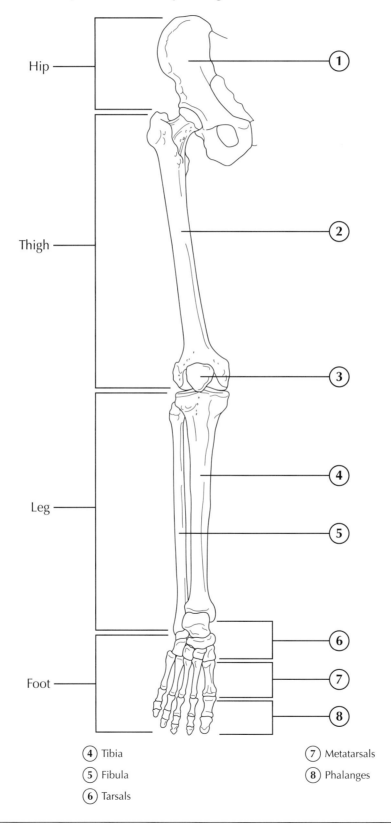

1 Coxal bone
2 Femur
3 Patella

4 Tibia
5 Fibula
6 Tarsals

7 Metatarsals
8 Phalanges

THE KNEE JOINT

Let's look at this complex intersection of bone and tissue—the knee joint.

Shade in the keys below then color the corresponding structures.

Anterior view

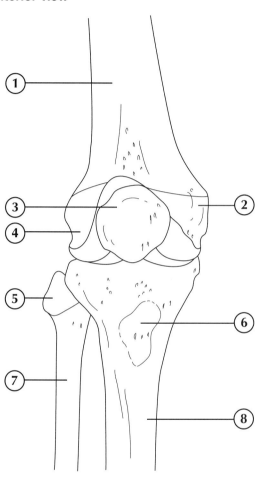

Posterior view

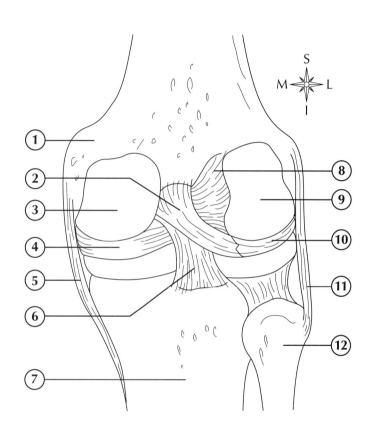

(1) Femur

(2) Medial epicondyle

(3) Patella

(4) Lateral epiconyle

(5) Fibular head

(6) Tibial tuberosity

(7) Fibula

(8) Tibia

(1) Femur

(2) Posterior menisofemoral ligament

(3) Medial condyle

(4) Medial meniscus

(5) Tibial collateral (medial) ligament

(6) Posterior cruciate ligament

(7) Tibia

(8) Anterior cruciate ligament

(9) Lateral condyle

(10) Lateral meniscus

(11) Fibular collateral (lateral) ligament

(12) Fibula

THE FOOT

Bones of the right foot viewed from above. The tarsal bones consist of the cuneiforms, navicular, talus, cuboid, and calcaneus.

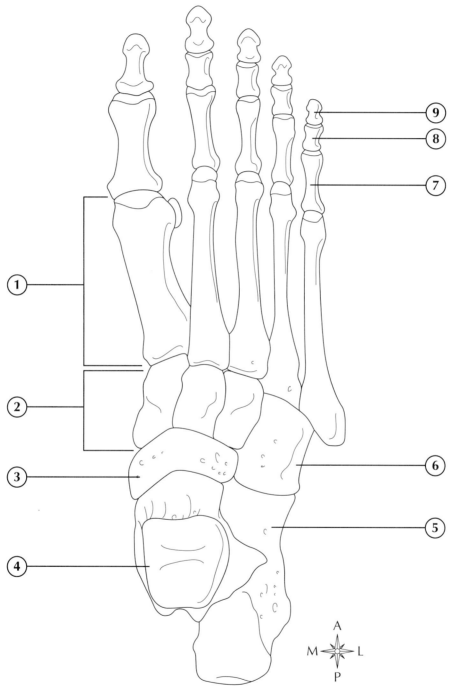

① Metatarsal bones (1–5)

② Cuneiform bones

③ Navicular bone

④ Talus

⑤ Calcaneus

⑥ Cuboid bone

⑦ Proximal phalanx

⑧ Middle phalanx

⑨ Distal phalanx

TYPES OF SYNOVIAL JOINTS

A joint, or an *articulation*, is a contact point between bones. Most joints that allow movement are classified as synovial joints. Synovial joints are freely movable and are associated with a joint capsule and synovial fluid. The amount and type of movement is determined by the bone shape as well as the strength and location of skeletal muscles. There are three major divisions within the synovial joints: the uniaxial (joints that allow movement around only one axis and in only one plane); the biaxial (joints that can move in two perpendicular axes in two perpendicular planes); and the multiaxial (joints that can move around in three or more planes). From the picture below, can you determine which are uniaxial, biaxial, and multiaxial?

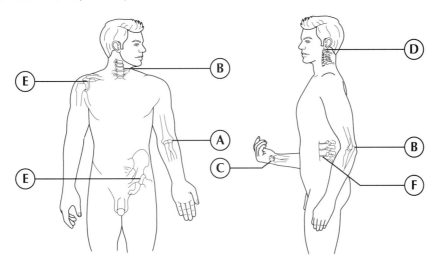

A HINGE JOINT

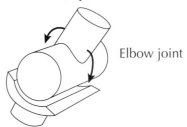

Elbow joint

B PIVOT JOINT

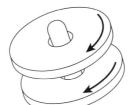

Dens of axis rotating against atlas

Head of radius rotating against ulna

C SADDLE JOINT

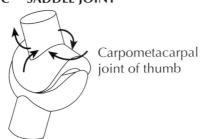

Carpometacarpal joint of thumb

D CONDYLOID JOINT

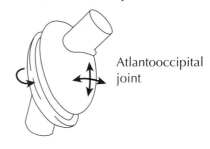

Atlantooccipital joint

E BALL-AND-SOCKET JOINT

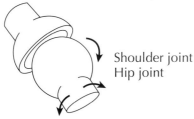

Shoulder joint
Hip joint

F GLIDING JOINT

Articular processes between vertebrae

BONE FRACTURE

A fracture is defined as a partial or complete break in the continuity of a bone. Most often, this occurs as a result of mechanical stress. The most common cause of a fracture is a traumatic injury; however, bone cancer, cysts, or metabolic bone disorders can also cause what are described as pathological or spontaneous fractures. There are several different types of fractures and all fractures have some specific features. A displaced fracture (also known as compound or simple) is one in which the broken bone projects through surrounding tissue and skin, thereby inviting the possibility of infection. A nondisplaced fracture (also known as closed or simple) does not produce a break in the skin. Fractures are also classified as **complete** or **incomplete**. A complete fracture involves a break across the entire section of bone, whereas an incomplete fracture involves only a partial break, with the bone fragments still being partially joined. Additional fracture classifications include:

Linear—when the fracture occurs in a line, usually down the axis of a bone

Transverse—when the fracture occurs across the bone perpendicular to its axis

Oblique—when the fracture occurs in a diagonal across the shaft of the bone

Using the information above, label the various classifications of fractures in the diagram below.

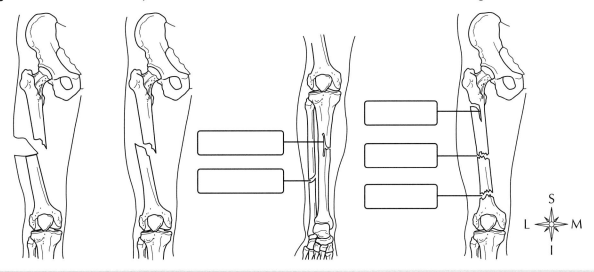

TYPES OF MOVEMENTS AT JOINTS

Let's return to the synovial joints and observe a few of their many movements. Just as it is essential to know the anatomical terminology so you can communicate effectively about positions and places on and inside the body, it is good to familiarize yourself with these terms in order to effectively communicate about how we move and disturbances that occur when certain movements are made. Below we will describe 14 different joint movements. You will need to write in the blanks the correct movement that applies, based on the description provided.

A. Abduction: movement away from the midline of body (hint: moving legs sideways, away from body)

B. Adduction: movement toward the midline of body

C. Circumduction: a combination of movements (flexion, extension, abduction, and adduction), in a circular manner

D. Dorisflexion: bending the foot up, toward the leg

E. Eversion: swinging the sole of the foot outward

F. Extension (use twice): straightening of a joint so that the angle between the bones increases (hint: straightening the leg, at the knee)

G. Flexion (use twice): bending a joint that decreases the angle between the bones (hint: bending the fingers)

H. Hyperextension: overextending the joint beyond the normally straight position

I. Inversion: swinging the sole of the foot inward so that it faces the opposite foot

J. Plantar flexion: bending the foot down

K. Pronation: turning the hand palm down

L. Supination: turning the hand palm up

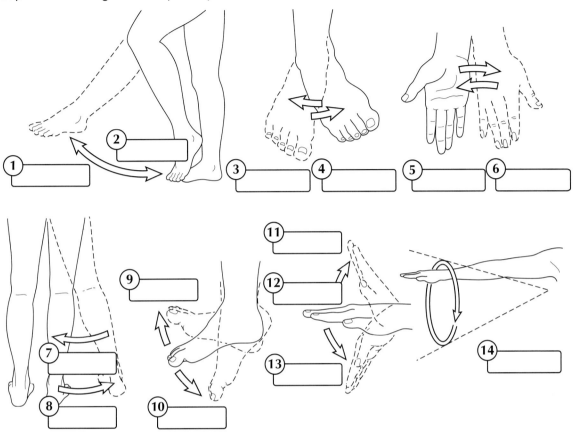

Answers: 1. F; 2. G; 3. E; 4. I; 5. L; 6. K; 7. B; 8. A; 9. D; 10. J; 11. H; 12. F; 13. G; 14. C

CASE STUDY

Joe Brown, age 15, is a running back on his high school football team. During practice, as he was running down the field, he was tackled from the side at knee level. Joe felt his knee "pop" and afterward was unable to walk off the field without assistance. Ice was applied to the injury and Joe was evaluated by the team athletic trainer, who found that the affected area was not swollen. The athletic trainer did note, however, that there was joint line tenderness on the medial side of the knee, limited flexion in the affected knee, and inability to completely extend the leg. When Joe was asked to bear weight on his knee, he stood and his injured knee "gave way on him." Joe was then referred to the orthopedist for evaluation and follow-up. The orthopedist examined the knee and took a series of radiographs and an MRI. He then scheduled Joe for arthroscopic surgery. The arthroscopy shows a tear in the medial meniscus. The surgeon repaired the tear, and Joe was placed in a hinged splint and began a program of rehabilitation with the sports medicine clinic.

1. Which of the following factors makes the medial meniscus more vulnerable than the lateral meniscus to the type of injury just described?
 A. The knee is relatively unprotected by muscle.
 B. The ligaments found there are very fragile.
 C. The knee is a weight-bearing joint.
 D. The medial meniscus is less mobile.
2. Why is Joe unable to fully extend his leg on the affected side?
 A. He may have a mechanical obstruction from the displaced meniscus.
 B. Muscle spasm in the thigh may prevent full extension.
 C. Joint effusion may prevent full extension.
 D. All of the above.

Copyright © 2014 by Mosby, an imprint of Elsevier Inc

6 The Muscular System

Movement is one of the most distinctive and easily observed "characteristics of life." When we walk, run, breathe, or engage in a multitude of other physical activities that are under the "willed" control of the individual, we do so by contraction of skeletal muscle. There are more than 600 skeletal muscles in the body. Collectively, they constitute 40–50% of our body weight. Together with the skeleton, muscles also determine the form and contours of our body.

As a result of the skeletal muscle movement, two additional functions are noted: Contractions of muscle cells produce a major share of the total body heat because they are highly active and very numerous. This is vital for maintaining homeostasis. Also, specific skeletal muscles maintain a continued partial contraction, which allows the body to sit, stand, maintain balance, and so on, while walking, running, or during other movements.

MUSCLE SHAPE AND FIBER ARRANGEMENT

The strength and type of movement produced by the shortening (contraction) of a muscle is related to the orientation of its fibers, its overall shape, its attachments to bone, and its involvement in joints. Six muscle shapes are often used to describe and categorize skeletal muscle.

Using the descriptions below as a key, choose the correct term and write it in above the diagram that best describes the muscle shape and fiber arrangement.

○ Parallel: This fiber arrangement is long and strap-like. Occasionally the long fibers are interrupted with tendinous intersections.

○ Convergent: The fascicles of this muscle radiate out from small to wider point of attachment.

○ Pennate: Pennate muscles have a feather-like appearance. Further, they are divided into three different types: Uni-pennate muscles have fascicles that anchor to only one side of the connective tissue shaft; Bi-pennate muscles have a double-feathered attachment of fascicles; Multi-pennate muscles have numerous interconnecting quill-like fascicles that converge on a common point of attachment.

○ Fusiform: The fusiform fascicles are similar to parallel in the center, but converge to a tendon at one or both ends.

○ Spiral: These muscle fibers twist between their points of attachment.

○ Circular: Also known as orbicular or sphincters, this muscle type often circles body tubes or openings.

Mosby's Anatomy and Physiology Coloring Book
Copyright © 2014 by Mosby, an imprint of Elsevier Inc

MUSCLE SYSTEM—ANTERIOR VIEW

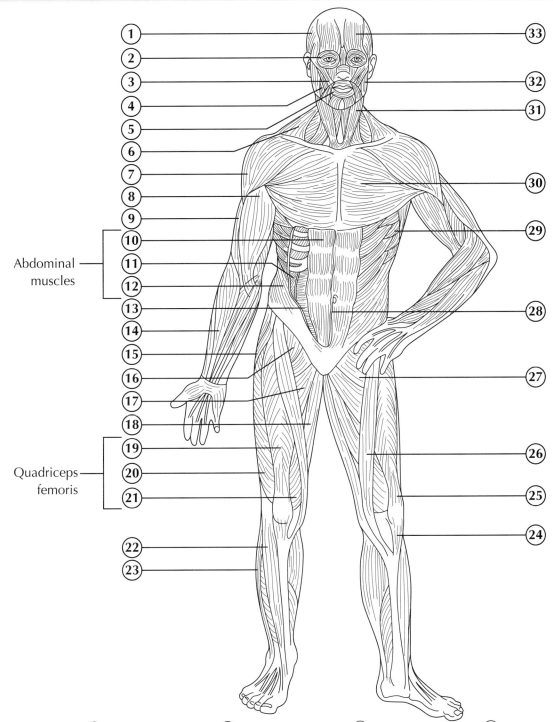

Abdominal muscles

Quadriceps femoris

① Temporalis

② Orbicularis oculi

③ Zygomaticus

④ Buccinator

⑤ Orbicularis oris

⑥ Trapezius

⑦ Deltoid

⑧ Biceps brachii

⑨ Brachialis

⑩ Rectus abdominis

⑪ Internal oblique

⑫ External oblique

⑬ Transversus abdominis

⑭ Brachioradialis

⑮ Tensor fasciae latae

⑯ Iliopsoas

⑰ Adductor longus

⑱ Adductor magnus

⑲ Rectus femoris

⑳ Vastus lateralis

㉑ Vastus medialis

㉒ Tibialis anterior

㉓ Peroneus longus

㉔ Quadriceps ligament

㉕ Quadriceps tendon

㉖ Sartorius

㉗ Pectineus

㉘ Linea alba

㉙ Serratus anterior

㉚ Pectoralis major

㉛ Sternocleidomastoid

㉜ Masseter

㉝ Occipitofrontalis

MUSCULAR SYSTEM—POSTERIOR VIEW

Color in the key and the corresponding muscles with colors of your choice.

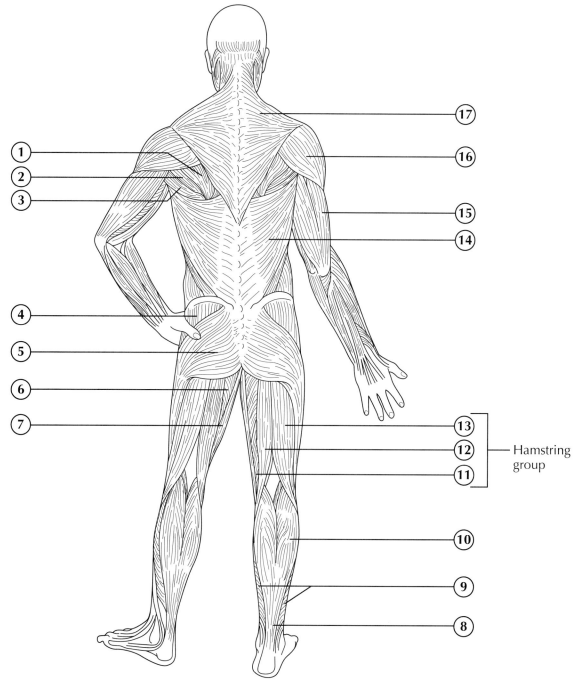

(1) Infraspinatus

(2) Teres minor

(3) Teres major

(4) Gluteus medius

(5) Gluteus maximus

(6) Adductor magnus

(7) Gracilis

(8) Achilles tendon (calcaneal tendon)

(9) Soleus

(10) Gastrocnemius

(11) Semimembranosus

(12) Semtendinosus

(13) Biceps femoris

(14) Latissimus dorsi

(15) Triceps brachii

(16) Deltoid

(17) Trapezius

Hamstring group

MUSCLES OF FACIAL EXPRESSION AND MASTICATION—ANTERIOR VIEW

Color in the key and the corresponding muscles with colors of your choice.

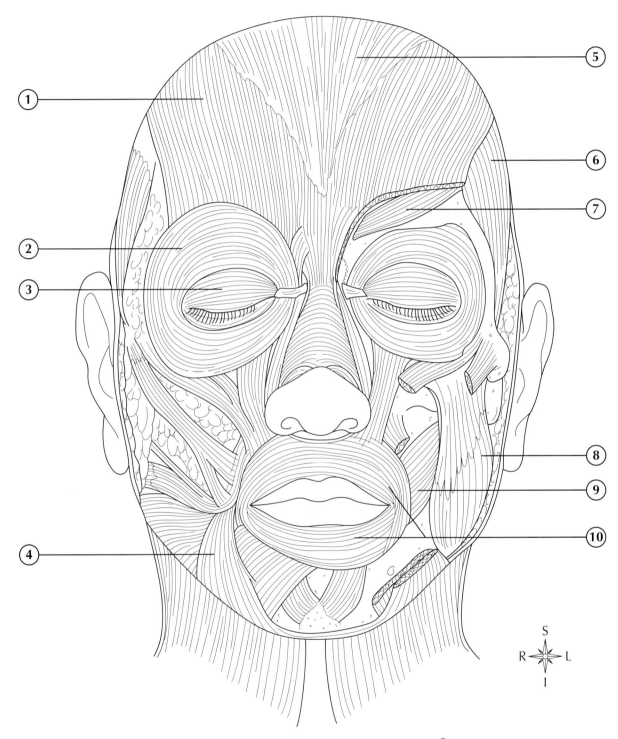

1. Occipitofrontalis (frontal portion)
2. Orbicularis oculi
3. Orbicularis oculi (palpebral portion)
4. Depressor anguli oris
5. Epicranial aponeurosis
6. Temporalis
7. Corrugator supercilii
8. Masseter
9. Buccinator
10. Orbicularis oris

MUSCLES OF FACIAL EXPRESSION AND MASTICATION—LATERAL VIEW

Color in the key and the corresponding muscles with colors of your choice.

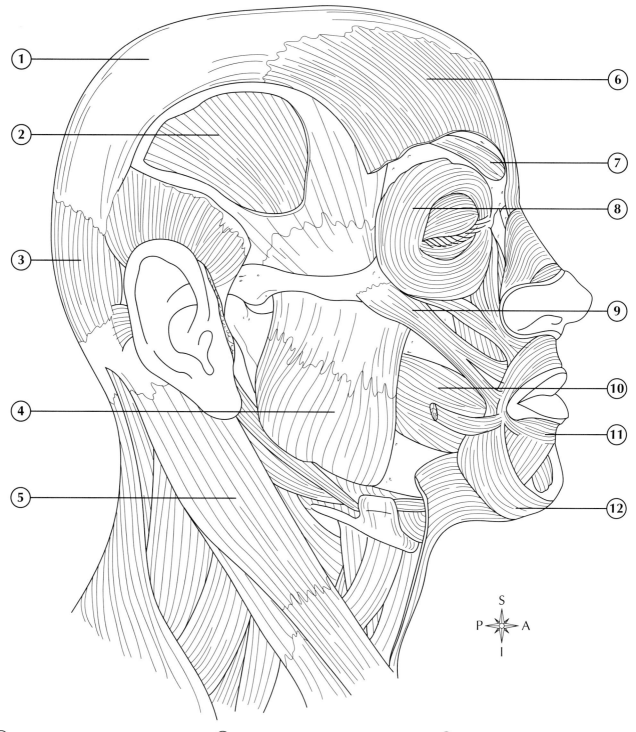

① Epicranial aponeurosis

② Temporalis

③ Occipitofrontalis (occipital portion)

④ Masseter

⑤ Sternocleidomastoid

⑥ Occipofronalis (frontal portion)

⑦ Corrugator supercilii

⑧ Orbicularis oculi

⑨ Zygomaticus major

⑩ Buccinator

⑪ Orbicularis oris

⑫ Depressor anguli oris

MUSCLES THAT MOVE THE HEAD

Paired muscles on either side of the neck are responsible for head movements.

Color in the key and the corresponding muscles with colors of your choice.

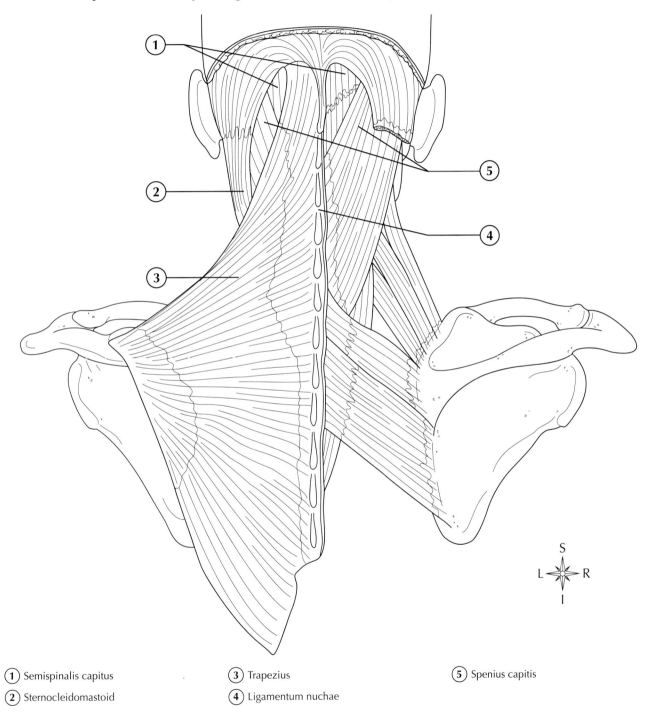

(1) Semispinalis capitus (3) Trapezius (5) Spenius capitis

(2) Sternocleidomastoid (4) Ligamentum nuchae

MUSCLES OF THE ABDOMINAL WALL

Superficial muscles are visible on the right side of the body and deeper muscles on the left side of the body.

Color in the key and the corresponding muscles with colors of your choice.

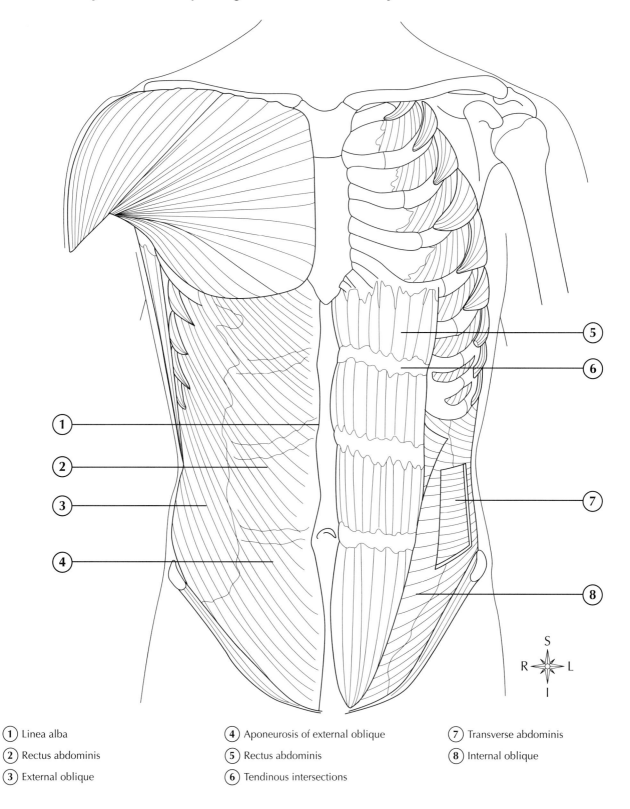

1 Linea alba

2 Rectus abdominis

3 External oblique

4 Aponeurosis of external oblique

5 Rectus abdominis

6 Tendinous intersections

7 Transverse abdominis

8 Internal oblique

MUSCLES OF THE BACK—POSTERIOR VIEW

Superficial (left) and intermediate (right) muscle dissection of the back. The illustration shows a two-stage dissection.

Color in the key and the corresponding muscles with colors of your choice.

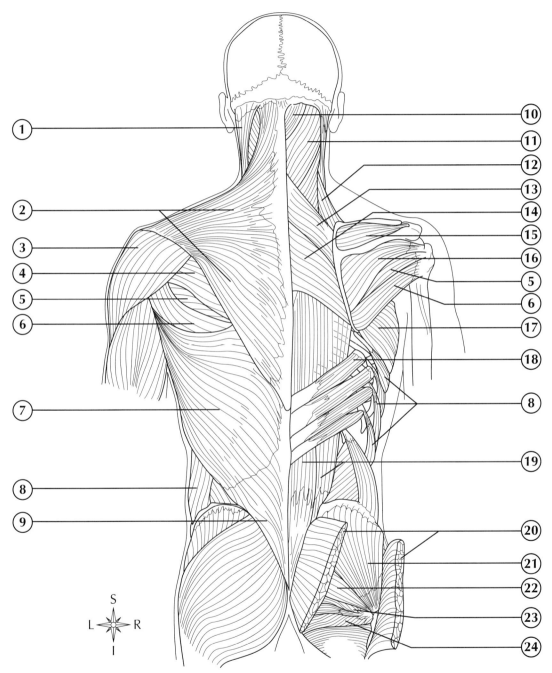

(1) Sternocleidomastoid (6) Teres major (11) Splenius capitis (16) Infraspinatus (21) Gluteus medius

(2) Trapezius (7) Latissimus dorsi (12) Levator scapulae (17) Serratus anterior (22) Piriformis

(3) Deltoid (8) External oblique (13) Rhomboid minor (18) Serratus posterior (23) Superior gemellus

(4) Infraspinatus (9) Thoracolumbar fascia (14) Rhomboid major (19) Erector spinae (24) Inferior gemellus

(5) Teres minor (10) Semispinalis capitis (15) Supraspinatus (20) Gluteus maximus

Mosby's Anatomy and Physiology Coloring Book
Copyright © 2014 by Mosby, an imprint of Elsevier Inc

DEEP MUSCLES OF THE BACK

The superficial and the intermediate muscles have been removed. The muscles in the gluteal region have been removed to explore the pelvic insertion of the multifidus.

Color in the key and the corresponding muscles with colors of your choice.

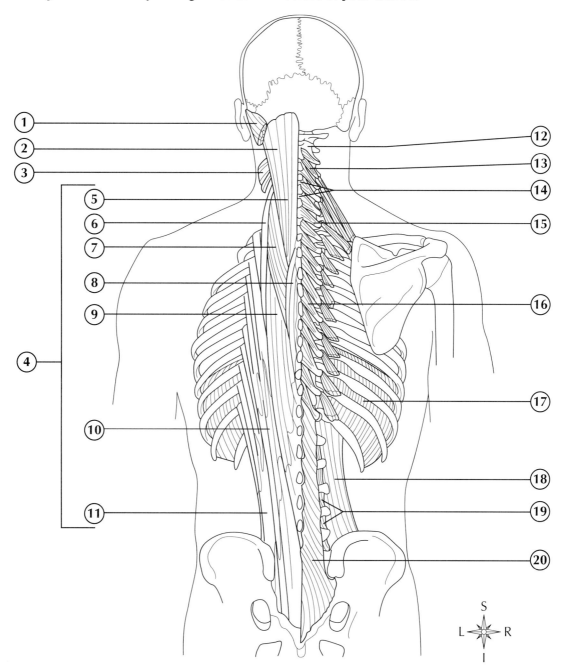

① Splenius capitis

② Semispinalis capitis

③ Levator scapulae

④ Erector spinae

⑤ Longissiumus capitis

⑥ Iliocostalis cervicis

⑦ Longissimus cervicis

⑧ Spinalis thoracis

⑨ Longissiumus thoracis

⑩ Iliocostalis thoracis

⑪ Iliocostalis lumborum

⑫ Third cervical vertebra

⑬ Multifidus (cervical portion)

⑭ Interspinales

⑮ Semispinalis cervicis

⑯ Semispinalis thoracis

⑰ Diaphragm

⑱ Quadratus lumborum

⑲ Intertransversarii

⑳ Multifidus (lumbar portion)

MUSCLES ACTING ON THE SHOULDER GIRDLE

The shoulder girdle (aka pectoral girdle) includes the scapula and clavicle bones. Six different muscles work on the shoulder girdle, bilaterally. These six muscles attach the upper extremity to the body, and do so in such a way that extensive movement is possible.

Color in the key and the corresponding muscles with colors of your choice.

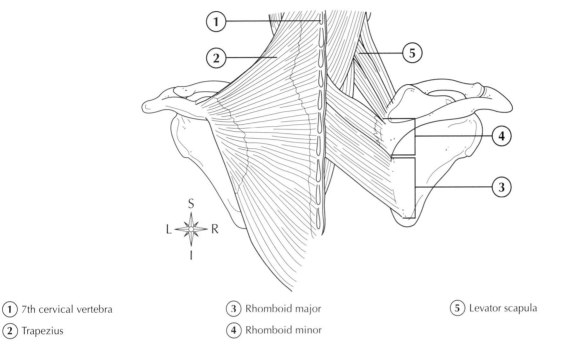

1) 7th cervical vertebra

2) Trapezius

3) Rhomboid major

4) Rhomboid minor

5) Levator scapula

MUSCLES THAT MOVE THE ARM—ANTERIOR VIEW

Color in the key and the corresponding muscles with colors of your choice.

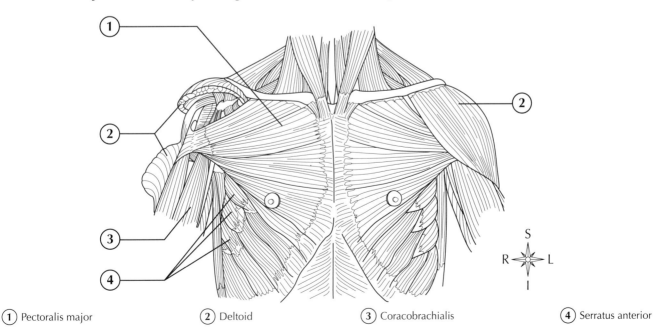

1) Pectoralis major

2) Deltoid

3) Coracobrachialis

4) Serratus anterior

MUSCLES THAT MOVE THE ARM—POSTERIOR VIEW

Color in the key and the corresponding muscles with colors of your choice.

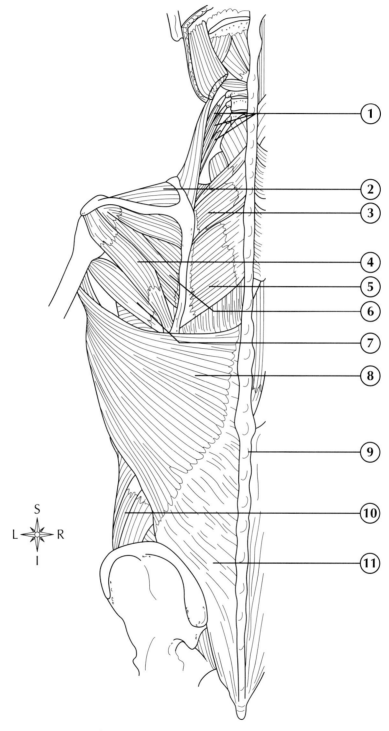

(1) Levator scapulae

(2) Supraspinatus

(3) Rhomboid minor

(4) Teres minor

(5) Rhomboid major

(6) Infraspinatus

(7) Teres major

(8) Latissiumus dorsi

(9) Twelth thoracic vertebra (of spine)

(10) External abdominal oblique

(11) Thoracolumbar fascia

ROTATOR CUFF MUSCLES

The rotator cuff is a collection of four muscles that assists in abduction of the arm (supraspinatus); rotates the arm outward (infraspinatus); rotates the arm outward (teres minor); and rotates the arm medially (subscapularis). A helpful acronym—SITS—can assist you in remembering this very important group of muscles. Note that all four actions of these muscles are independent, but they are critical in movements such as throwing a ball, eating, putting something on a shelf, combing hair, and toilet hygiene.

Color in the key and the corresponding muscles with colors of your choice.

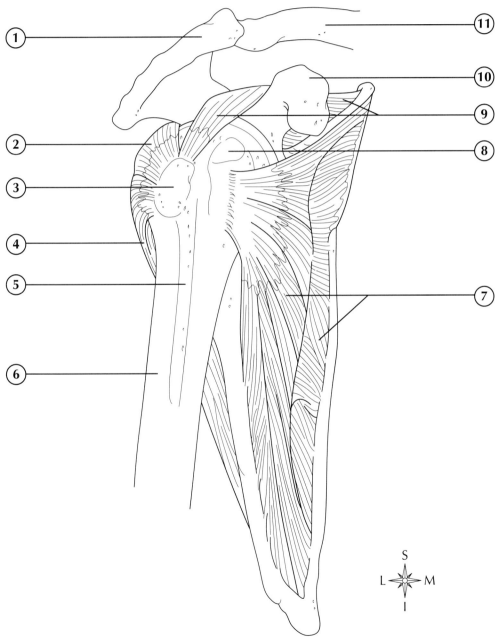

(1) Acromion process of scapula (bone)

(2) Infraspinatus

(3) Greater tubercle of humerus (bone)

(4) Teres minor

(5) Intertubercular groove of humerus (bone)

(6) Humerus (bone)

(7) Subscapularis

(8) Lesser tubercle (bone)

(9) Supraspinatus

(10) Coracoid process of scapula (bone)

(11) Clavicle (bone)

MUSCLES ACTING ON THE FOREARM—LATERAL AND ANTERIOR VIEW, DEEP

Color in the keys and the corresponding muscles with colors of your choice. Note in the anterior view, the deltoid and pectorails major have been removed to reveal the deeper structures.

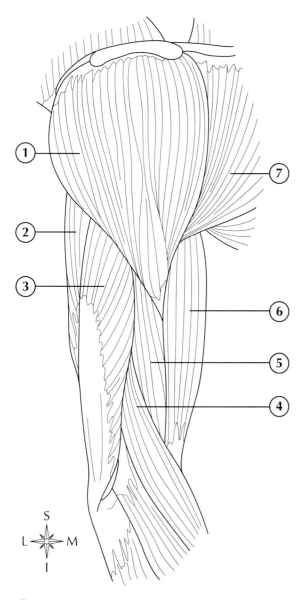

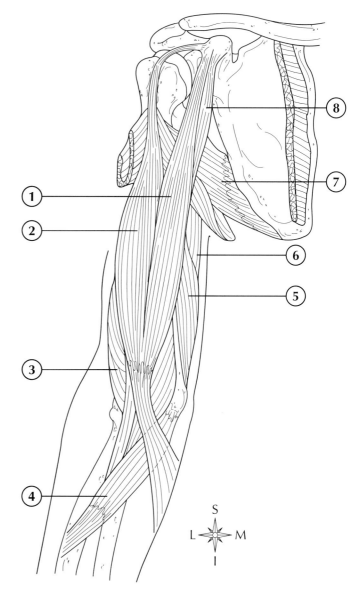

(1) Deltoid

(2) Triceps brachii (long head)

(3) Triceps brachii (lateral head)

(4) Brachioradialis

(5) Brachialis

(6) Biceps brachii (long head)

(7) Pectoralis major

(1) Biceps brachii (short head)

(2) Biceps brachii (long head)

(3) Brachialis

(4) Pronator teres

(5) Triceps brachii (medial head)

(6) Triceps brachii (long head)

(7) Teres major

(8) Coracobrachialis

MUSCLES THAT MOVE THE WRIST, HAND, AND FINGERS

Color in the key and the corresponding muscles with colors of your choice.

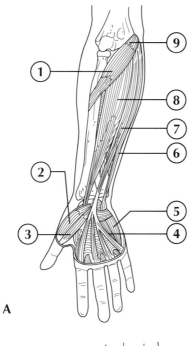

A

A

1 Pronator teres

2 Flexor pollicis brevis (superficial)

3 Opponens pollicis (deep)

4 Flexor digiti minimi

5 Abductor digiti minimi

6 Flexor carpi ulnaris

7 Palmaris longus

8 Flexor carpi radialis

9 Medial epicondyle of humerus

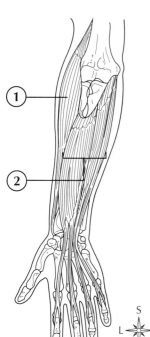

B

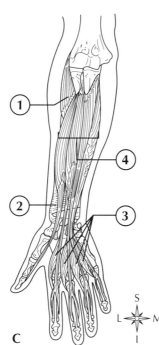

C

Medial epicondyle of humerus

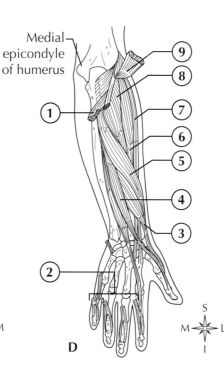

D

B

1 Brachioradialis

2 Flexor digitorum superficialis

C

1 Supinator

2 Pronator quadratus

3 Palmar interossei

4 Flexor digitorum profundus

D

1 Extensor carpi ulnaris (cut)

2 Cut tendons of extensor digitorum

3 Extensor pollicis brevis

4 Extensor pollicis longus

5 Abductor pollicis longus

6 Extensor carpi radialis brevis

7 Extensor carpi radialis longus

8 Supinator (deep)

9 Extensor digitorum (cut and reflected)

MUSCLES THAT MOVE THE THIGH AND LEG

Color in the key and the corresponding muscles with colors of your choice.

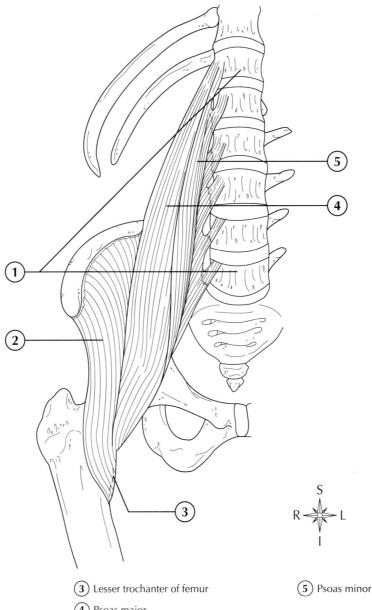

(1) Bodies of T12–L5 (3) Lesser trochanter of femur (5) Psoas minor

(2) Iliacus (4) Psoas major

MUSCLES OF THE ANTERIOR ASPECT OF THE THIGH

Color in the key and the corresponding muscles with colors of your choice.

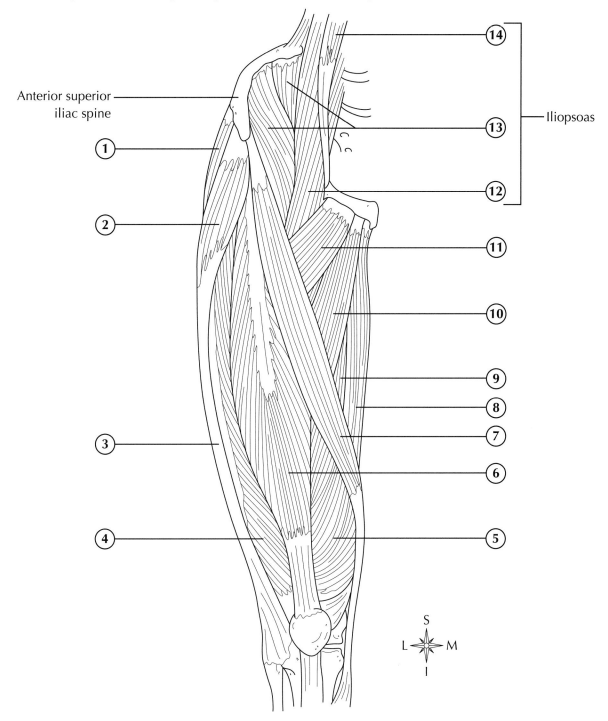

Anterior superior iliac spine

Iliopsoas

1. Gluteus medius
2. Tensor fasciae latae
3. Iliotibial tract
4. Vastus lateralis
5. Vastus medialis
6. Rectus femoris
7. Sartorius
8. Gracilis
9. Adductor magnus
10. Adductor longus
11. Pectineus
12. Psoas major
13. Illiacus
14. Psoas minor

SUPERFICIAL MUSCLES OF THE LEG—ANTERIOR VIEW, POSTERIOR, AND LATERAL

Color in the key and the corresponding muscles with colors of your choice.
Note: ① appears twice in A.

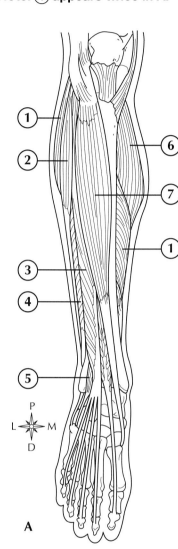

A

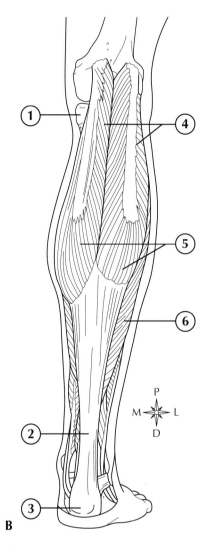

B

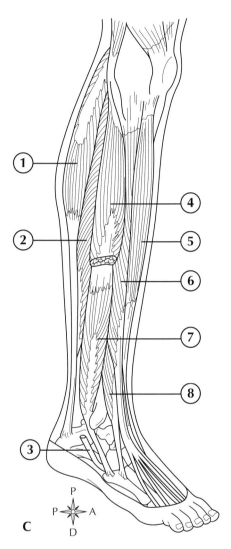

C

① Soleus

② Fibularis (peroneus) longus

③ Extensor digitorum longus

④ Fibularis (peroneus) brevis

⑤ Fibularis (peroneus) tertius

⑥ Gastrocnemius

⑦ Tibialis anterior

① Tibia

② Calcaneal (Achilles) tendon

③ Calcaneus

④ Two heads of gastrocnemius

⑤ Gastrocnemius

⑥ Soleus

① Gastrocnemius

② Soleus

③ Tendon of fibularis (peroneus) longus (cut)

④ Fibularis (peroneus) longus (cut)

⑤ Tibialis anterior

⑥ Extensor digitorum longus

⑦ Fibularis (peroneus) brevis

⑧ Fibularis (peroneus) tertius

EFFECTS OF EXCITATION ON A MUSCLE FIBER—PRODUCING A CONTRACTION

When an electrical impulse generated by the nervous system stimulates the sarcolemma, the impulse is transmitted through the T tubules. This causes a release of calcium ions from the sacs of the sacroplasmic reticulum (SR). Calcium is attracted to troponin, which holds tropomyosin in place. As troponin is "distracted" by the calcium ions, it "forgets" to hold the bond, thus, tropomyosin "slides" out of position. This exposes the active sites to actin. Because actin and myosin are chemically attracted, the excited myosin heads bind to actin. A temporary "cross bridge" is formed between the thin filament and thick filament. After forming the bridge, myosin continues to progress with great force, through the remaining actin filaments. This phenomenon is often called the sliding filament theory.

Color in the key and the corresponding structures with colors of your choice.

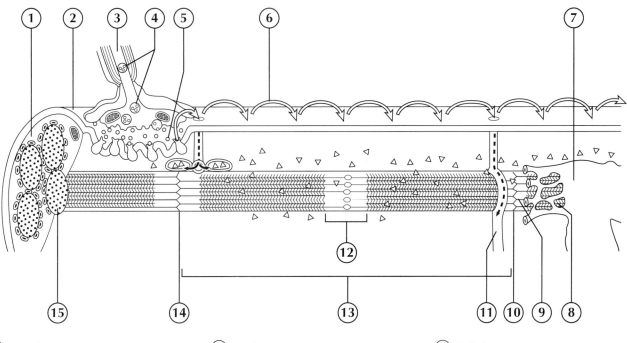

(1) Sacroplasm	(6) Impulse	(11) T tubule
(2) Sacrolemma	(7) Sacroplasmic reticulum (SR)	(12) H band
(3) Motor neuron	(8) Thick filament	(13) Sacromere (contracting)
(4) Vesicles (containing ACh)	(9) Thin filament	(14) Z disk
(5) ACh	(10) Z disk	(15) Myofibril

THE MOTOR UNIT

A motor unit is made up of a motor neuron plus all the muscle fibers to which it attaches. Some motor units consist of only a few muscle fibers, and other motor neurons branch to serve hundreds of muscle fibers.

In the diagram below, color each motor unit a different color. (Hint: remember the definition above. The number in the diagram is ONLY pointing to the nervous system portion of the motor unit.)

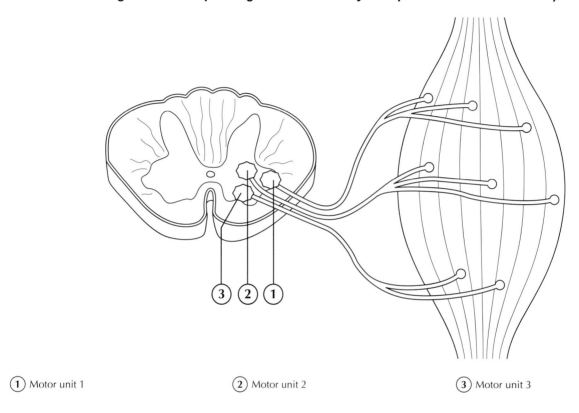

(1) Motor unit 1 **(2)** Motor unit 2 **(3)** Motor unit 3

TYPES OF MUSCLE CONTRACTION

Isotonic: This type of contraction occurs when the tone or tension within a muscle remains the same, while the length of the muscle changes. There are two types of isotonic contractions: 1) concentric: contractions, in which the movement results in shortening of the muscle (like picking up a book), and 2) eccentric: movement that results in lengthening of the muscle being contracted (slowly placing the book on the table). The same tension or resistance exists (the book doesn't change its mass if it is being lifted or put down) whether the muscle is being shortened or lengthened.

Isometric: This type of contraction does not affect the length of a muscle but rather the tension within the muscle. Try to push a brick wall. This is an example of an isometric contraction. The harder you push, the more tension is experienced in the muscle, however, the length of the muscle does not change.

Using the information, label the diagram using the following terms:

Isotonic Isometric Eccentric Concentric

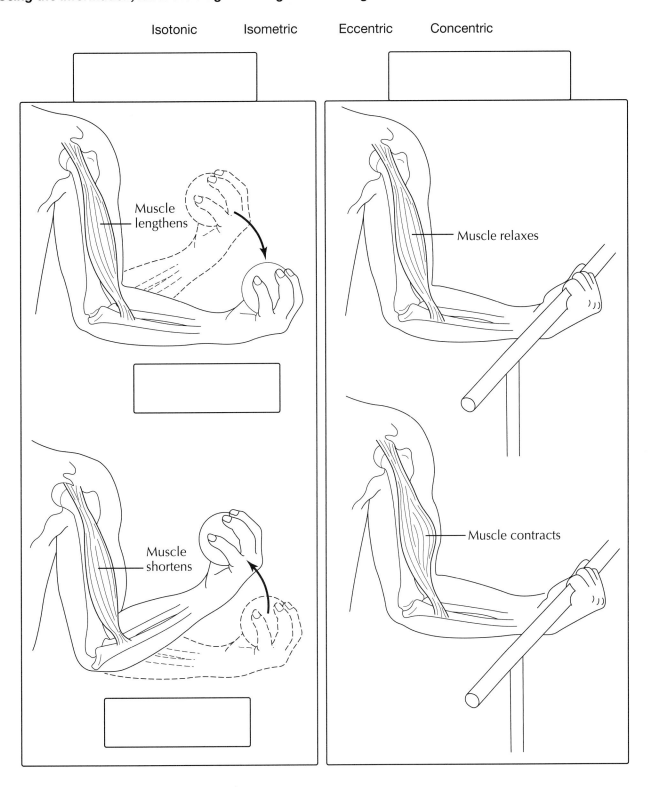

Muscle
lengthens

Muscle relaxes

Muscle
shortens

Muscle contracts

MUSCLE STRUCTURE

Let's go over muscle structure from the top down, starting with the whole muscle (attached to the tendon), the bundles of the muscle fibers, inside the fascicles, then the myofibrils, and again, to the thick and thin myofilaments of the myofibril fiber.

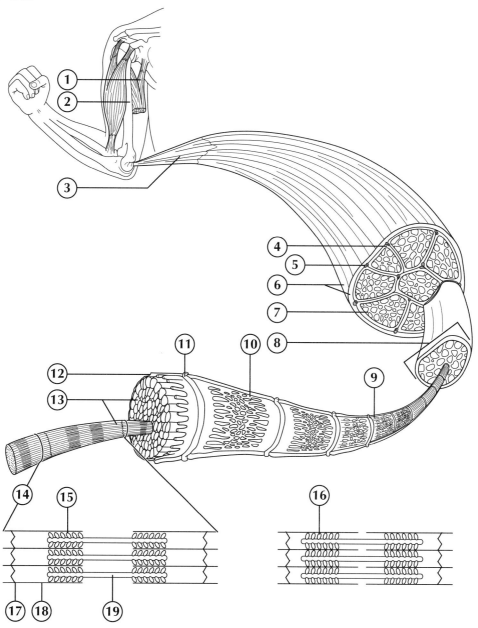

(1) Triceps muscle (cut) (5) Blood vessels (9) Muscle fiber (cells) (13) Myofibrils (17) Z disk

(2) Humerus (bone) (6) Epimysium (fascia) (10) Sacroplasmic reticulum (14) Sarcomere (18) Thin filament

(3) Tendon (7) Endomysium (11) T tubule (15) Myosin heads (19) Thick filament

(4) Perimysium (8) Fascicle (12) Cell membrane (sarcolemma) (16) Cross bridge

Look at the two sarcomeres shown in the contraction sequence at the bottom. Can you determine which is relaxed and which is contracted, based on the positions of the thick and thin filaments? How do you know? Label them Relaxed and Contracted.

STRUCTURE OF MYOFILAMENTS

It is important to understand the structure of myofilaments in order to fully understand how muscle fibers have the ability to powerfully contract. Four different types of protein molecules (myosin, actin, tropomyosin, and troponin) make up myofilaments. Thin filaments are made up of actin, tropomyosin, and troponin **(A)**. Thick filaments are made up of myosin alone **(B)**. The Z disk is where the thin filaments unite with each other and form a boundary line. The contractile unit of a muscle cell is called a sarcomere and is the length of a myofibril between two Z disks.

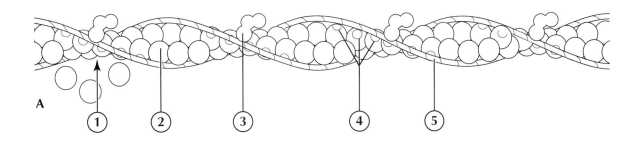

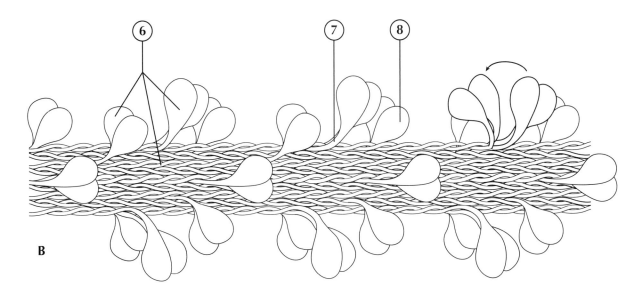

(1) Actin molecules (4) Active sites (7) Shaft

(2) Actin strands (5) Tropomyosin (8) Myosin head

(3) Troponin (6) Myosin

CASE STUDY

At the sound of the starting pistol, Jeremy burst forward out of the blocks, sprinting down the track. About 20 meters into the race, he suddenly felt a sharp pain along the backside of his right thigh. Wincing, he slowed down and hobbled to a stop.

1. What muscle or muscle group has Jeremy likely injured?
 A. Quadriceps femoris group
 B. Hamstrings group
 C. Gastrocnemius
 D. Triceps brachii

2. What muscle did Jeremy use when he closed his eyes in pain?
 A. Obicularis oris
 B. Masseter
 C. Buccinator
 D. Obicularis occuli

3. Jeremy made his way over to the grassy area beside the track and collapsed on his side. In an effort to control the pain, he concentrated on taking slow, deep breaths in and out. Which of the following muscles did Jeremy NOT use in breathing?
 A. Diaphragm
 B. External intercostals
 C. Latissimus dorsi
 D. Internal intercostals

4. Which of the following muscles would contract to pull him to a sitting position?
 A. Rectus abdominus
 B. Pectoralis major
 C. Trapezius
 D. Pronator teres

7 The Nervous System

The nervous system is one of the two communication systems of the body. Communication provides the means to control and integrate many different functions performed by organs, tissues, and cells. The two main divisions of the nervous system are the:

- Central Nervous System (CNS): the brain and spinal cord
- Peripheral Nervous System (PNS): the nerve pathways that go to and from the central nervous system

Fill in the color key below, then fill in the corresponding parts of the CNS with one color and the PNS with a different color.

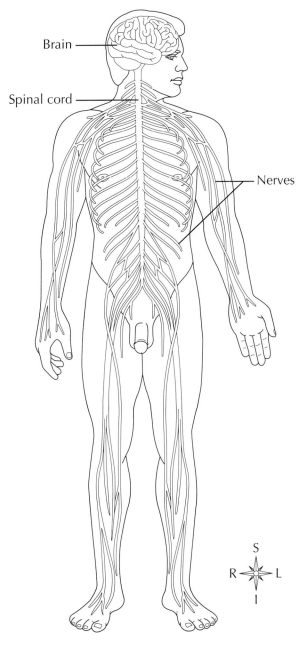

○ CNS
○ PNS

DIVISIONS OF THE CNS AND THE PNS

Both the CNS and PNS further branch into two additional sections.

The first section is the Somatic Nervous System (SNS). The term *soma* is a Greek word for body, meaning that the somatic nervous system deals with the parts of the nervous system that affect the body, which typically means "willful" or "purposeful." The second section is the Autonomic Nervous System (ANS). The term *autonomic* means involuntary or unconscious. The CNS participation in the ANS is specific to the integration (interpretation and command) of the signals received from the PNS.

In the PNS, the Autonomic Nervous System further divides into three different divisions. The first is the Visceral Sensory Division, which brings information from the body through its visceral receptors into the CNS to interpret if the stimulus requires an action to take place, and if so, what action. When the type of action is determined, the CNS then sends the "directions" to the body through either the second or third division of the ANS: sympathetic or parasympathetic. The sympathetic system is also known as the "fight or flight" response. It prepares the body to deal with immediate threats to the internal environment and is largely out of voluntary control. (*Think about how the body reacts when avoiding a car accident.*) The parasympathetic division is also known as the "rest and repair" division. (*Think about the changes the body goes through immediately after avoiding that car accident.*)

In the chart below, label the blanks after reading the material above, then fill in each of the sections specific to the CNS with one color and the sections specific to the PNS with another. Labels for the blanks are provided below.

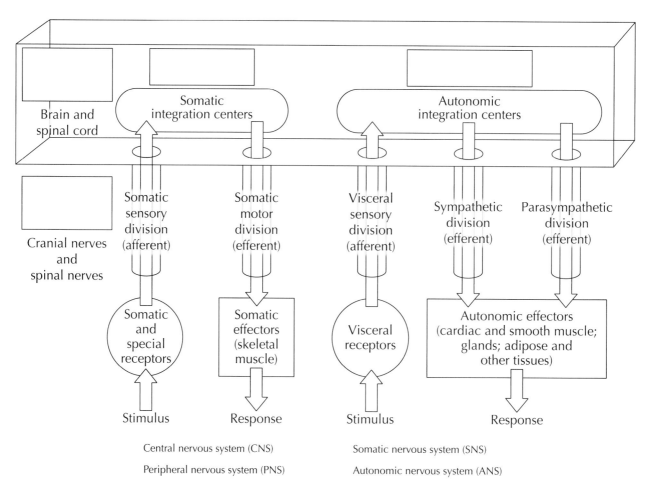

Central nervous system (CNS)

Peripheral nervous system (PNS)

Somatic nervous system (SNS)

Autonomic nervous system (ANS)

NEURONS AND GLIA

There are two principal types of cells that make up the nervous system:

- Neurons, which form the delivery system, or "wiring," for the nervous system's information circuits.
- Glia, which provide structural support for the neurons. The following are classified as glia: astrocytes, microglia, ependymal cells, and oligodendrocytes. Research their purposes as you color in the illustration below.

Color in the key and the corresponding parts of the illustration.

(1) Ependymal cells (4) Oligodendrocyte (6) Neurons

(2) Capillary (5) Myelin (cut) (7) Microglia

(3) Astrocyte

THE NEURON

The human brain is estimated to contain almost 100 billion neurons, or about half of the total number of nervous system cells in the brain. All neurons consist of a cell body and at least two processes: one axon and one or more dendrites. The cell body, which is the largest part of the nerve cell, contains a nucleus, cytoplasm, and various organelles found in other cells.

Fill in the key and color the corresponding structures of the neuron.

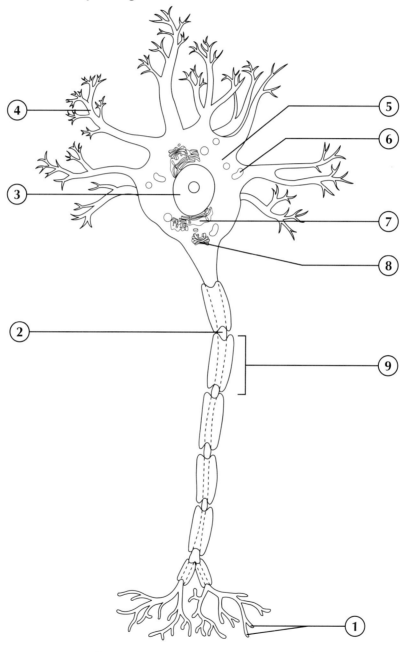

1 Synaptic knobs	**4** Dendrite	**7** Endoplasmic reticulum
2 Axon	**5** Cell body	**8** Golgi apparatus
3 Nucleus	**6** Mitochondrion	**9** Schwann cells

Copyright © 2014 by Mosby, an imprint of Elsevier Inc

THE NERVE

Nerves are bundles of peripheral nerve fibers held together by several layers of connective tissues. Each nerve contains axons bundled into fascicles. A fibrous endoneurium surrounds each axon and its Schwann cells within a fascicle. A perineurium surrounds each fascicle. The connective tissue epineurium wraps the entire nerve.

Color in the key and the corresponding parts of the illustration.

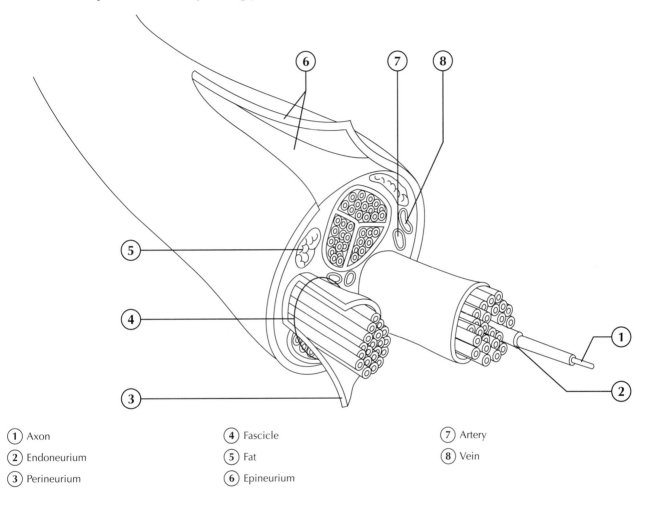

(1) Axon

(2) Endoneurium

(3) Perineurium

(4) Fascicle

(5) Fat

(6) Epineurium

(7) Artery

(8) Vein

STRUCTURE AND FUNCTION OF THE CRANIAL NERVES

Twelve pairs of cranial nerves connect to the undersurface of the brain, mostly on the brainstem. Both names and numbers identify the cranial nerves. Their names suggest their distribution (where they extend to or from). Their numbers indicate the order in which they connect to the brain from anterior to posterior. All cranial nerves are made up of axon bundles. Mixed cranial nerves contain axons of both sensory and motor neurons. Sensory cranial nerves contain sensory nerve axons. Motor cranial nerves contain motor nerve axons.

In the diagram below, color each of the cranial nerves using the following key:

◯ **Sensory—Yellow** ◯ **Motor—Green** ◯ **Mixed—Blue**

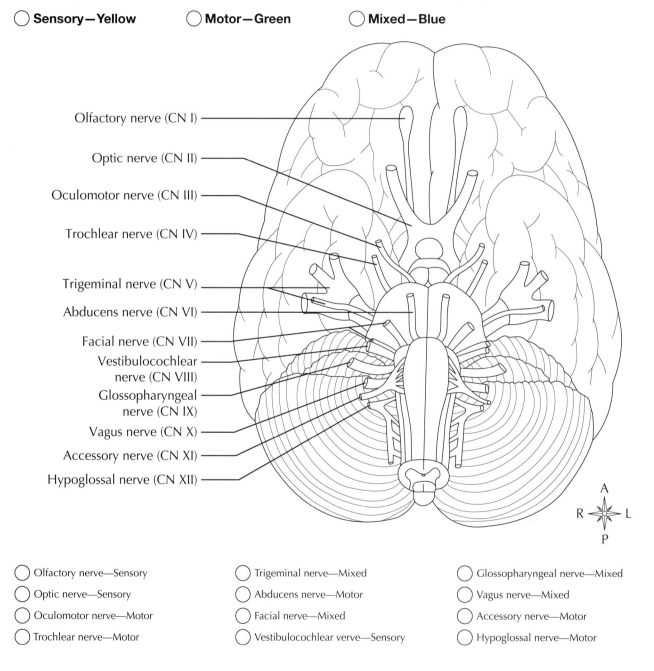

Olfactory nerve (CN I)
Optic nerve (CN II)
Oculomotor nerve (CN III)
Trochlear nerve (CN IV)
Trigeminal nerve (CN V)
Abducens nerve (CN VI)
Facial nerve (CN VII)
Vestibulocochlear nerve (CN VIII)
Glossopharyngeal nerve (CN IX)
Vagus nerve (CN X)
Accessory nerve (CN XI)
Hypoglossal nerve (CN XII)

A
R ✳ L
P

◯ Olfactory nerve—Sensory ◯ Trigeminal nerve—Mixed ◯ Glossopharyngeal nerve—Mixed
◯ Optic nerve—Sensory ◯ Abducens nerve—Motor ◯ Vagus nerve—Mixed
◯ Oculomotor nerve—Motor ◯ Facial nerve—Mixed ◯ Accessory nerve—Motor
◯ Trochlear nerve—Motor ◯ Vestibulocochlear verve—Sensory ◯ Hypoglossal nerve—Motor

PATELLAR REFLEX

The patellar reflex (or knee jerk reflex) is of clinical importance because it tests the "circuits" of the neural pathway, from the patellar ligament to the spinal cord and back, registered as a knee jerk. Observe the neural pathway involved below. If the patellar ligament is stimulated but no knee jerk occurs, the clinician is alerted something is wrong with the patient.

Color in the structures involved in the reflex and the accompanying action arrows.

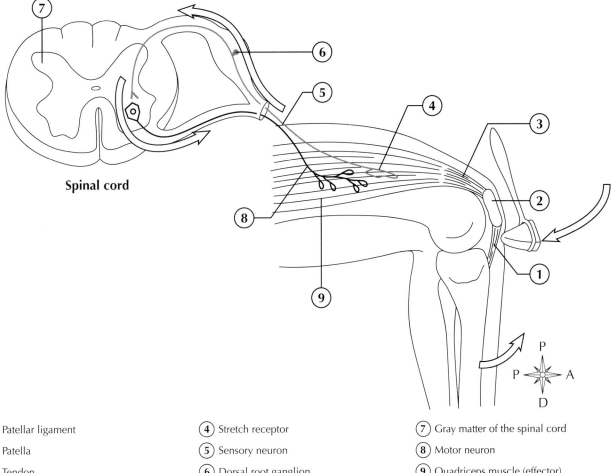

Spinal cord

① Patellar ligament ④ Stretch receptor ⑦ Gray matter of the spinal cord

② Patella ⑤ Sensory neuron ⑧ Motor neuron

③ Tendon ⑥ Dorsal root ganglion ⑨ Quadriceps muscle (effector)

THE SYNAPSE

In order for information to jump from one neuron to the next, the electrical signal carrying the information must be conducted through synapses.

Follow the steps listed below and color in the structures as they are mentioned in the four steps below.

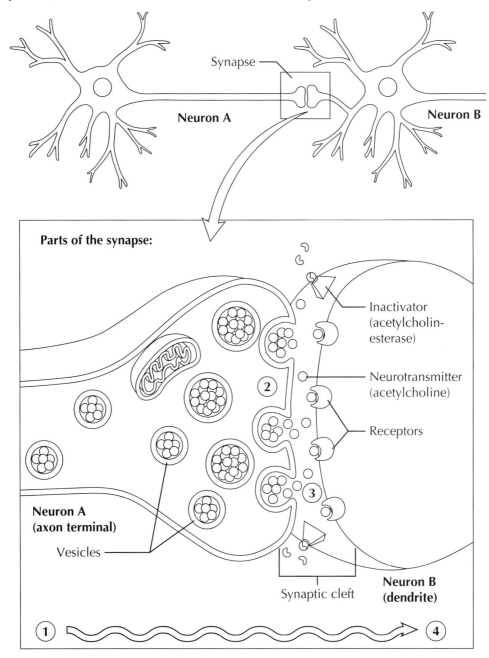

1. A nerve impulse travels along a neuron A (left) to its axon terminal.

2. The nerve impulse causes the vesicles to fuse with the membrane of the axon terminal. The vesicles open and release the neurotransmitter of the synaptic cleft.

3. The neurotransmitter diffuses across the synaptic cleft and binds to the receptor site. The binding of the neurotransmitter to the receptor site causes a change in the membrane potential of the dendrite of neuron B (right), thereby developing a nerve impulse. The neurotransmitter vacates the receptor and is degraded.

4. Electrical information travels toward the cell body and axon of neuron B. Information has been transmitted by chemicals (ACh) from neuron A to neuron B.

CROSS SECTION OF THE SPINAL CORD

The spinal cord performs two principal functions: (1) it provides the conduction routes to and from the brain and (2) it is the reflex center for all of the spinal reflexes. The right side illustrates a transverse section of the spinal cord shown in the broader view.

Color in the key and the corresponding parts of the illustration.

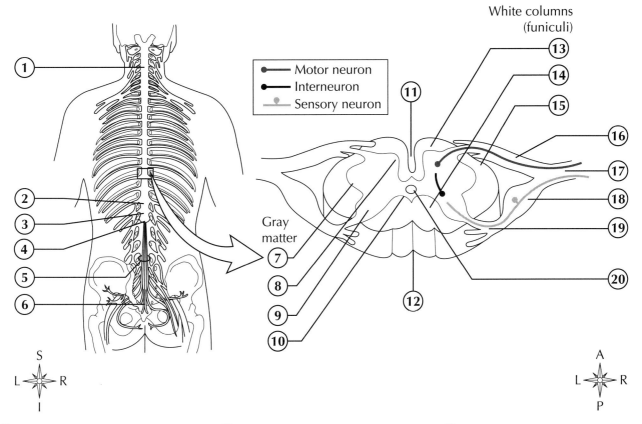

① Cervical enlargement	⑧ Anterior column	⑮ Lateral column
② Lumbar enlargement	⑨ Posterior column	⑯ Ventral (anterior) nerve root
③ Conus medullaris	⑩ Gray commissure	⑰ Spinal nerve
④ End of spinal cord	⑪ Anterior median fissure	⑱ Dorsal root ganglion
⑤ Cauda equina	⑫ Posterior median sulcus	⑲ Dorsal (posterior) nerve root
⑥ Filum terminale	⑬ Anterior column	⑳ Central canal
⑦ Lateral column	⑭ Posterior column	

COVERINGS AND ACCESSORY STRUCTURES OF THE SPINAL CORD

Because the brain and spinal cord are both delicate and vital, nature has provided them with two protective coverings. The outer covering consists of bone (vertebrae) and the inner covering consists of membranes known as meninges. Three distinct layers compose the meninges: (1) dura mater (translated as "tough mother"); (2) arachnoid mater (translated as spiderweb-like mother); and (3) pia mater (translated as pious or tender mother, because it is very delicate and is the innermost layer of meninges).

Color in the keys and the corresponding parts of the posterior and cross section views.

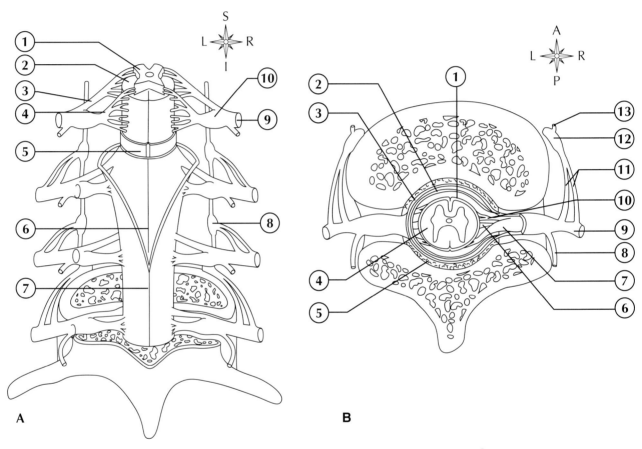

A

B

(1) Gray matter (6) Arachnoid mater

(2) White matter (7) Dura mater

(3) Ventral root (8) Sympathetic ganglion

(4) Dorsal root (9) Spinal nerve

(5) Pia mater (10) Dorsal root ganglion

(1) Pia mater (8) Dorsal ramus

(2) Arachnoid (9) Ventral ramus

(3) Dura mater (10) Ventral root

(4) Spinal cord (11) Rami communicantes

(5) Adipose tissue in epidural space (12) Autonomic (sympathetic) ganglion

(6) Denticulate ligament (13) Sympathetic chain

(7) Dorsal root ganglion

FOUR MAJOR AREAS OF THE BRAIN

The four major areas are (1) the cerebrum (largest part of the brain; controls sensations, memory, consciousness, emotions, and voluntary movements); (2) the diencephalon (the "between" brain, which contains the thalamus and the hypothalamus); (3) the brain stem (connects the spinal cord with the higher brain structures); and (4) the cerebellum (instrumental for movement).

Color in the key and the corresponding parts of the illustration.

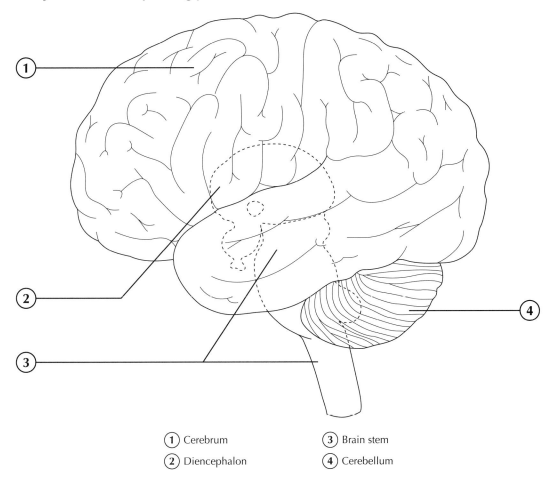

(1) Cerebrum (3) Brain stem

(2) Diencephalon (4) Cerebellum

BRAIN STEM, CEREBELLUM, AND DIENCEPHALON

Let's look at three of the major brain areas more closely and identify their components. The brainstem is composed of the medulla oblongata, the midbrain, and the pons. Ten of the twelve cranial nerves arise from the brainstem. The brainstem performs sensory, motor, and reflex functions. The cerebellum is sometimes referred to as the "little brain." It has more neurons than all of the other parts of the brain combined and has a lot of "computing" power. The cerebellum functions to complement, or assist, the cerebrum in many of its functions, which involve the planning and coordination of skeletal muscle activity and maintaining balance in the body. The diencephalon is located between the cerebrum and the midbrain. The structures that comprise the diencephalon include the thalamus, hypothalamus, and the pineal gland. The thalamus plays an important role in the mechanism responsible for sensations, emotions (by associating sensory impulses with feelings of pleasantness and unpleasantness), arousal and alerting, and it plays a role in the mechanisms that produce complex reflex movements. The hypothalamus functions as a link between the mind and the body. It also links the nervous system to the endocrine system. The pineal gland secretes the hormone melatonin and plays a vital role in the sleep cycle, which balances out the circadian rhythms.

Color in the key and the corresponding parts of the illustration.

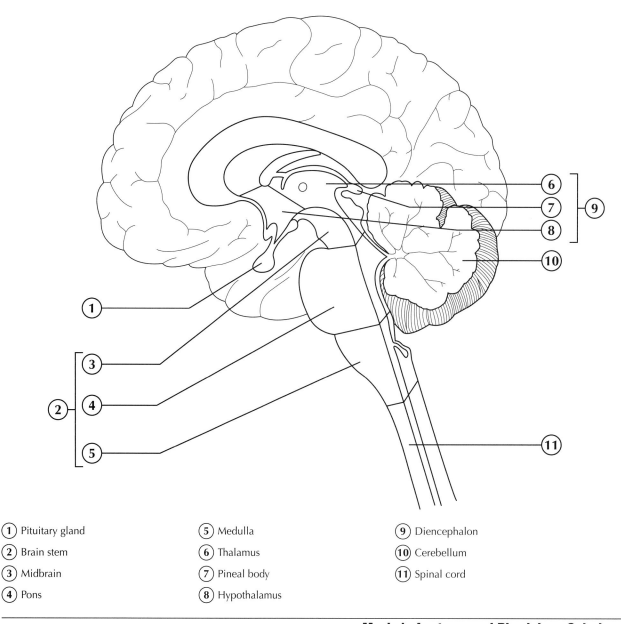

(1) Pituitary gland

(2) Brain stem

(3) Midbrain

(4) Pons

(5) Medulla

(6) Thalamus

(7) Pineal body

(8) Hypothalamus

(9) Diencephalon

(10) Cerebellum

(11) Spinal cord

LEFT HEMISPHERE OF CEREBRUM, LATERAL SURFACE

The cerebrum is the largest and uppermost division of the brain. It consists of two halves, the right and left cerebral hemispheres. The surface of the cerebrum—called the cerebral cortex—is made up of gray matter only 2–4 mm thick. The surface of the cerebral cortex looks like a group of small sausages. Each "sausage" is actually a convolution, or gyrus. While the exact capacity of the human brain and specifically the cerebrum remains a mystery, science has proven that certain areas of the cortex engage predominantly in one particular function, at least on average. The cerebrum is responsible for controlling consciousness, memory, sensations, emotions, and voluntary movements.

Color in the key and the corresponding parts of the illustration.

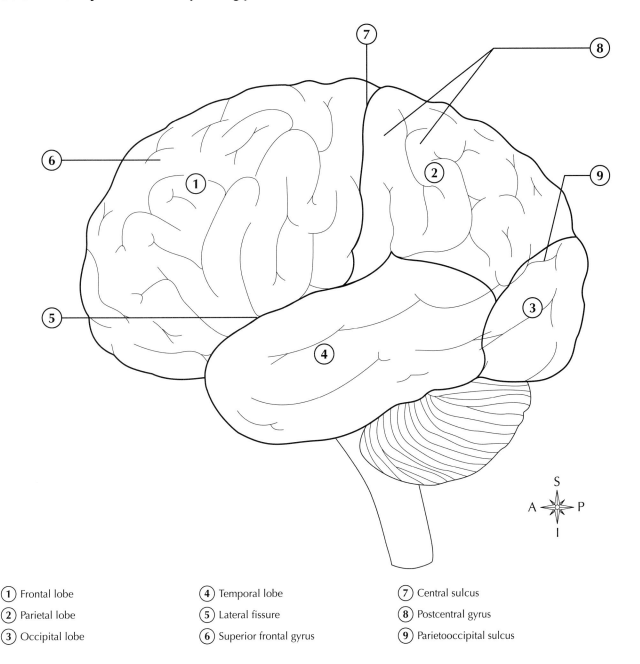

① Frontal lobe	④ Temporal lobe	⑦ Central sulcus
② Parietal lobe	⑤ Lateral fissure	⑧ Postcentral gyrus
③ Occipital lobe	⑥ Superior frontal gyrus	⑨ Parietooccipital sulcus

CASE STUDY

The store was only two blocks away, so Tomasina didn't think she really needed to wear her bike helmet. She jumped on her bike and peddled quickly to the grocery store. From out of nowhere, a car sped by and clipped Tomasina with the side mirror, knocking her to the ground. She hit her head sharply on the curb. When she regained consciousness, she was in the hospital. She was given some tests to see whether or not her cranial nerves had been affected by the head injury.

1. In one of the tests, Tomasina was asked to stick out her tongue. Which cranial nerve was being tested? Use the table below to help.
 A. Glossopharyngeal
 B. Hypoglossal
 C. Vagus
 D. Trigeminal

2. In a second test, Tomasina's hearing was evaluated. What cranial nerve is involved in the sense of hearing?
 A. Accessory
 B. Vagus
 C. Vestibulocochlear
 D. Trochlear

3. Tomasina was having difficulty focusing her eyes and following the doctor's finger on command. Which of the following cranial nerves does not control eye movement?
 A. Optic
 B. Oculomotor
 C. Trochlear
 D. Abducens

CRANIAL NERVES	FUNCTIONS	CRANIAL NERVES	FUNCTIONS
Olfactotry (CN I)	Smell	Facial nerve (CN VII)	Facial expressions, saliva and tear secretion, taste
Optic nerve (CN II)	Vision	Vestibulocochlear nerve (CN VIII)	Balance, hearing
Oculomotor nerve (CN III)	Eye movement, pupil regulation	Glossopharyngeal nerve (CN IX)	Tongue sensations, swallowing, saliva secretion, various reflexes, blood pressure and respiration
Trochlear nerve (CN IV)	Eye movements	Vagus nerve (CN X)	Sensations, organ movements
Trigeminal nerve (CN V)	Sensations of head and face, mastication	Accessory nerve (CN XI)	Shoulder and head movements
Abducens nerve (CN VI)	Abduction of eye	Hypoglossal nerve (CN XII)	Tongue movements

8 Sensory Systems

The body has millions of sense organs. They fall into two main categories: general sense organs and special sense organs. Of these, by far the most numerous are the general sense organs, or receptors. Receptors function to produce the general, or somatic, senses (for example, touch, temperature, pain) and to initiate various reflexes necessary for maintaining homeostasis. Special sense organs function to produce the special senses (vision, hearing, balance, taste, smell), and they too initiate reflexes important for homeostasis. Starting with the general sense organs, let's begin our journey through the senses.

SOMATIC SENSORY RECEPTORS

Sensory receptors make it possible for the body to respond to stimuli caused by changes occurring in our external or internal environment. This function is crucial to survival. The general function of receptors is to respond to stimuli by converting them into impulses. Special sense receptors of smell, taste, vision, hearing, and equilibrium are grouped into localized areas or into complex organs such as the eye and ear. General sense organs are widely distributed throughout the body in the skin, mucosa, connective tissue, muscles, tendons, joints, and viscera.

CLASSIFICATION OF SOMATIC SENSORY RECEPTORS

Receptors can be classified according to their location (exteroceptors, visceroceptors [interoceptors], and proprioceptors); the stimulus that causes them to respond (mechanoreceptors, chemoreceptors, thermoreceptors, nociceptors, photoreceptors, osmoreceptors), and their structure (free nerve endings and encapsulated nerve endings).

In the table below, use text books and online resources to fill in the missing information. Answers are provided on the next page, to compare to your findings.

STRUCTURE	LOCATION AND TYPE	ACTIVATION STIMULUS	SENSATION OR FUNCTION
FREE NERVE ENDINGS			
Nociceptor — Dendritic knobs	Either exteroceptor or visceroceptor— most body tissues	Almost any noxious stimulus; temperature change, mechanical	1.
Merkel disk meniscus — Tactile epithelial cell — Tactile disk	2.	Light pressure mechanical	Discriminative touch
Root hair plexus	Exteroceptor	3.	Sense of "deflection," type of movement of hair

(continued)

STRUCTURE	LOCATION AND TYPE	ACTIVATION STIMULUS	SENSATION OR FUNCTION
ENCAPSULATED NERVE ENDINGS: TOUCH AND PRESSURE RECEPTORS			
Meissner corpuscle	4.	Light pressure, mechanical	Touch, low-frequency vibration
Krause corpuscle	Exteroceptor; mucous membranes	5.	Touch, low-frequency vibration; textural sensation
Ruffini corpuscle	Exteroceptor; dermis of skin	Mechanical	6.
Pacini corpuscle	7.	Deep pressure; mechanical	Deep pressure, high-frequency vibration, stretch
ENCAPSULATED NERVE ENDINGS: STRETCH RECEPTORS			
Muscle spindles —Intrafusal fibers	Interoceptor; skeletal muscle	8.	Sense of muscle length
Golgi tendon receptors	9.	Force of contraction and tendon stretch; mechanical	10.

Do more research and find examples of these nerve endings in action.

Answers: 1. Pain; temperature; itch; tickle. 2. Exteroceptor 3. Hair movement; mechanical. 4. Exteroceptor; epidermis, hairless skin. 5. Mechanical. 6. Crude and persistent touch. 7. Exteroceptor; dermis of skin, joint capsules 8. Stretch; mechanical. 9. Interoceptor; tendon. 10. Sense of muscle tension

EXTEROCEPTORS

As the name implies, exteroceptors are located on or very near the body surface and respond most frequently to stimuli that arise external to the body itself. Receptors in this group are sometimes called cutaneous receptors because of their placement in the skin. Examples of exteroceptors include those that detect pressure, touch, pain, and temperature.

Color in the key and then the corresponding parts of the illustration.

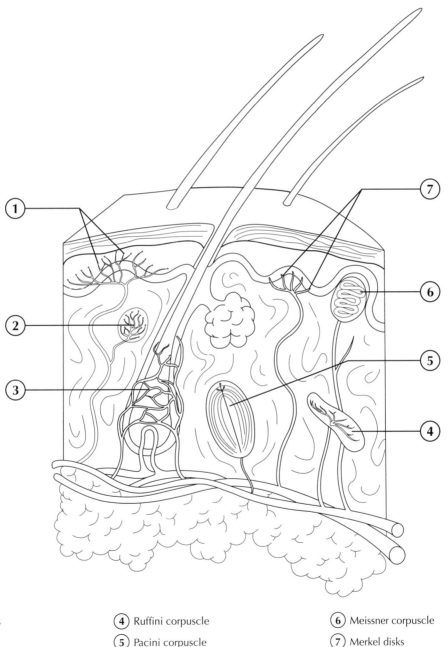

(1) Free nerve endings

(2) Krause end bulb

(3) Hair root plexus

(4) Ruffini corpuscle

(5) Pacini corpuscle

(6) Meissner corpuscle

(7) Merkel disks

PROPRIOCEPTORS

This special type of visceroreceptor is more specialized and is located in the skeletal muscle, joint capsules, and tendons. Proprioceptors provide us with information about body movement, orientation in space, and muscle stretch.

Color in the key and then the corresponding parts of the illustration.

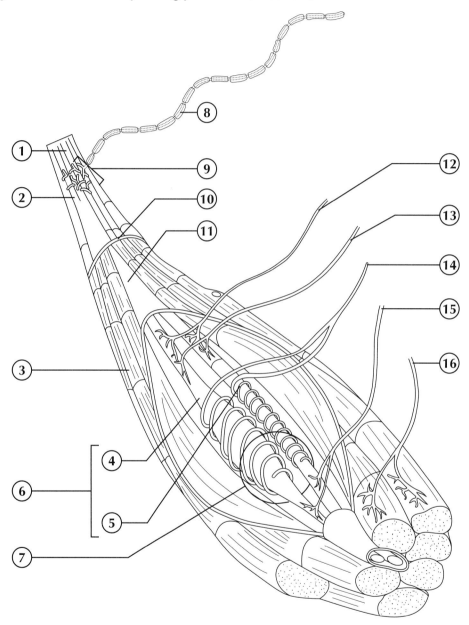

(1) Tendon

(2) Capsule

(3) Muscle fibers (extrafusal fibers)

(4) Nuclear bag fibers

(5) Nuclear chain fibers

(6) Intrafusal fibers

(7) Muscle spindle

(8) Type 1b sensory fiber

(9) Golgi tendon organ

(10) Perimysium of muscle fiber bundle

(11) Connective tissue capsule

(12) δ Efferent motor fiber

(13) Type II sensory ending

(14) Type Ia sensory ending

(15) Type II sensory ending

(16) α Efferent motor fiber

OLFACTORY STRUCTURES

The olfactory epithelium consists of yellow-colored epithelial support cells, basal cells, and bipolar-type olfactory sensory neurons. These neurons have unique olfactory cilia, which touch the surface of the olfactory epithelium lining the upper surface of the nasal cavity.

Color in the key and then the corresponding parts of the illustration.

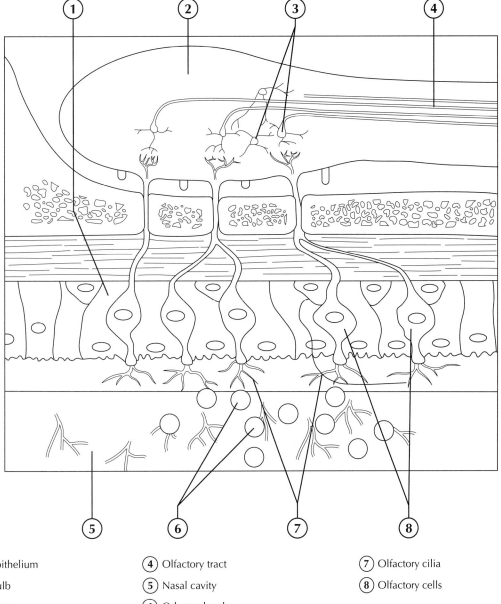

1. Olfactory epithelium
2. Olfactory bulb
3. Olfactory nerves
4. Olfactory tract
5. Nasal cavity
6. Odor molecules
7. Olfactory cilia
8. Olfactory cells

OLFACTORY PATHWAY

If the level of odor-producing chemicals dissolved in the mucus surrounding the olfactory cilia reaches a threshold level, a receptor potential and then an action potential will be generated and passed to the olfactory nerves in the olfactory bulb. From there, the impulse passes through the olfactory tract and into the thalamic and olfactory centers of the brain for interpretation, integration, and memory storage.

In the diagram below, color in the pathway that the odor-producing chemicals take from the external source to the olfactory complex in the brain.

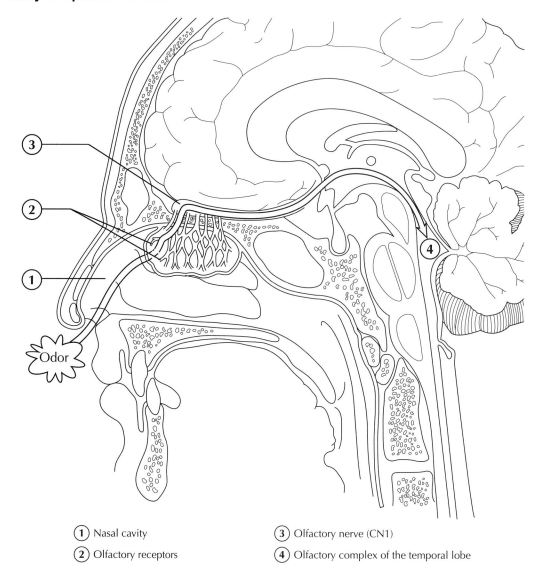

(1) Nasal cavity (3) Olfactory nerve (CN1)

(2) Olfactory receptors (4) Olfactory complex of the temporal lobe

SENSE OF TASTE

The taste buds are the sense organs that respond to taste (gustatory) stimuli. Although a few taste buds are located in the lining of the mouth and on the soft palate, most are associated with small, elevated projections on the tongue, called papillae. These papillae are classified by structure:

- *Fungiform papillae:* large, mushroom-shaped bumps found in the anterior two-thirds of the tongue surface; each contain one to a few taste buds.
- *Circumvallate papillae:* huge, dome-shaped bumps that form a transverse row near the back of the tongue surface; each one contains thousands of taste buds.
- *Foliate papillae:* red, leaflike ridges of mucosa on the lateral edges of the posterior tongue surface; each contains approximately one hundred taste buds.
- *Filiform papillae:* bumps with tiny, threadlike projections; these papillae are scattered among the fungiform papillae. They do not contain taste buds but allow us to experience food texture.

CHEMORECEPTORS IN THE TASTE BUDS

Taste buds house the chemoreceptors responsible for taste. They are stimulated by chemicals dissolved in the saliva. Each taste bud is like a banana cluster that contains 50 to 125 of these chemoreceptors, called gustatory cells, which are surrounded by a supportive epithelial cell capsule. Cilia, here called gustatory hairs, extend from each of the gustatory cells and project into an opening called the taste pore, which is bathed in saliva.

Fill in the keys and color in the corresponding elements in the illustrations.

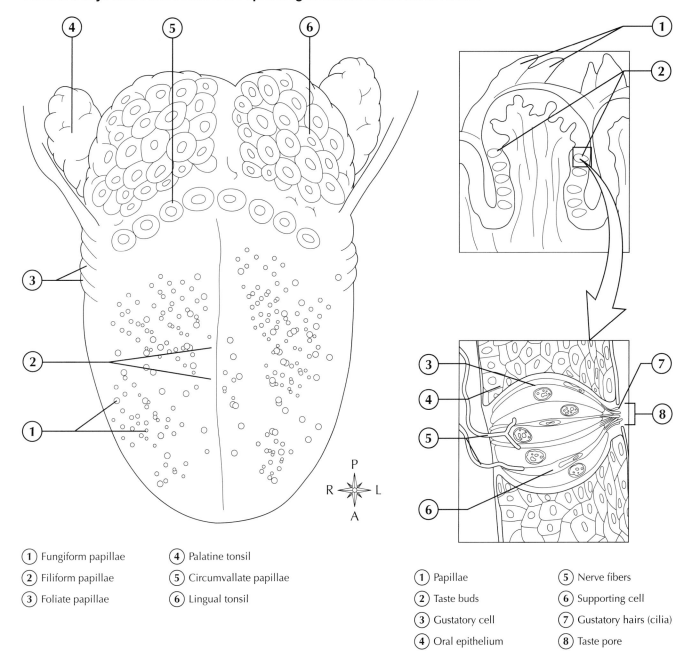

1 Fungiform papillae 4 Palatine tonsil
2 Filiform papillae 5 Circumvallate papillae
3 Foliate papillae 6 Lingual tonsil

1 Papillae 5 Nerve fibers
2 Taste buds 6 Supporting cell
3 Gustatory cell 7 Gustatory hairs (cilia)
4 Oral epithelium 8 Taste pore

THE EAR

The ear has dual sensory functions. In addition to its role in hearing, it also functions as the sense organ of balance, or equilibrium. The stimulation responsible for hearing and balance involves activation of mechanoreceptors called hair cells. Sound waves and fluid movement are the physical forces that act on hair cells to generate receptor potentials and then nerve impulses, which are eventually perceived in the brain as sound or balance. The ear is divided into three anatomical parts: external ear, middle ear, and inner ear.

In the diagram below, label the three anatomical parts, then fill in the key and the corresponding parts of the illustration.

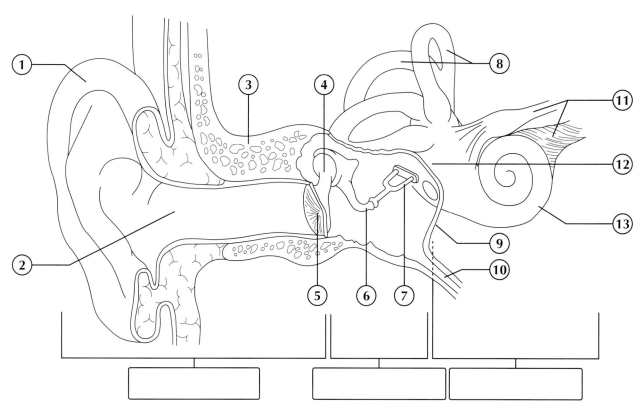

(1) Auricle (pinna)

(2) External auditory canal

(3) Bone

(4) Malleus

(5) Tympanic membrane

(6) Incus

(7) Stapes

(8) Semicircular canals

(9) Bony wall

(10) Eustachian tube

(11) Cranial nerve VIII

(12) Vestibule

(13) Cochlea

INNER EAR

The inner ear, also called the labyrinth because of its complicated shape, consists of two main parts: a body labyrinth, and inside this, a membranous labyrinth. The bony labyrinth consists of three parts: vestibule, cochlea, and semicircular canals. The membranous labyrinth consists of the utricle and the saccule inside the vestibule.

Fill in the key and color in the corresponding elements in the illustration.

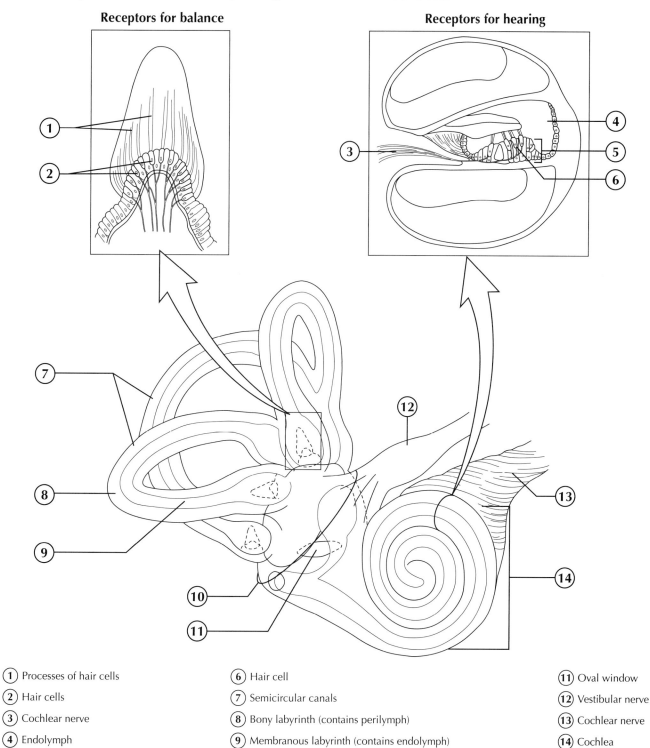

Receptors for balance

Receptors for hearing

1. Processes of hair cells
2. Hair cells
3. Cochlear nerve
4. Endolymph
5. Organ of Corti
6. Hair cell
7. Semicircular canals
8. Bony labyrinth (contains perilymph)
9. Membranous labyrinth (contains endolymph)
10. Vestibule
11. Oval window
12. Vestibular nerve
13. Cochlear nerve
14. Cochlea

Mosby's Anatomy and Physiology Coloring Book
Copyright © 2014 by Mosby, an imprint of Elsevier Inc

EFFECT OF SOUND WAVES ON COCHLEAR STRUCTURES

Sound is created by vibrations that may occur in air, fluid, or solid material. When we speak, for example, the vibrating vocal cords create sound waves by producing vibrations in air passing over them. Sound waves enter the external auditory canal with aid from the pinna. At the inner end of the canal, they strike against the tympanic membrane (ear drum), causing it to vibrate. Vibrations of the tympanic membrane move the malleus, whose handle attaches to the membrane. The head of the malleus attaches to the incus, and the incus attaches to the stapes. When the malleus vibrates, it moves the incus, which moves the stapes against the oval window. At this point, fluid conduction of sound waves begins. The pressure against the oval window interacts with the perilymph in the scala vestibuli of the cochlea. This ripple continues through the vestibular membrane to the organ of Corti. Finally, the ripple passes through the basilar membrane, through the scala tympani, and then expends itself against the round window.

Fill in the key and color in the corresponding structures and action arrows.

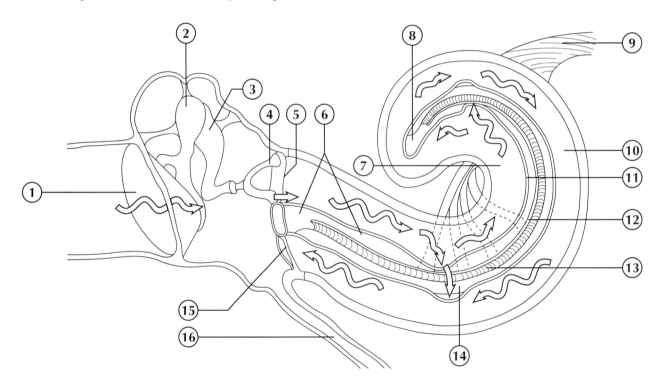

(1) Tympanic membrane

(2) Malleus

(3) Incus

(4) Stapes

(5) Oval window

(6) Cochlear duct

(7) Scala vestibuli

(8) Apex (of cochlear duct)

(9) Cochlear nerve

(10) Scala tympani

(11) Vestibular (Reissner) membrane

(12) Tectorial membrane

(13) Hair cells on organ of Corti (spiral organ)

(14) Basilar membrane (spiral membrane)

(15) Round window

(16) Auditory tube

Copyright © 2014 by Mosby, an imprint of Elsevier Inc

STRUCTURE OF THE EYEBALL

One of the most important sensations involved in maintaining homeostasis is vision. The eyeball lies recessed in the skull and is protected by the bony orbit with only one-sixth visible to the external environment. Three layers of tissues and their component parts or regions form the eyeball: 1) Fibrous layer, containing the sclera and cornea; 2) Vascular layer, containing the choroid, ciliary body, and iris; and 3) Inner layer, containing the retina, optic nerve, and retinal blood vessels. This illustration shows the anatomical structure of the eye.

Fill in the key and color in the corresponding structures.

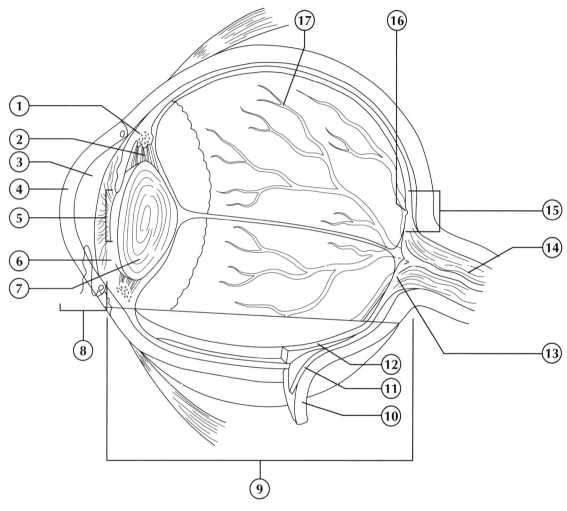

(1) Ciliary body	(6) Iris	(10) Sclera	(14) Optic nerve
(2) Ciliary muscles	(7) Lens	(11) Choroid	(15) Macula lutea
(3) Aqueous humor	(8) Anterior cavity	(12) Retina	(16) Fovea centralis
(4) Cornea	(9) Posterior cavity	(13) Optic disc	(17) Vitreous humor and blood vessels
(5) Pupil			

CELL LAYERS OF THE RETINA

The retina is the incomplete, innermost coat of the eyeball—incomplete, meaning that it has no anterior portion. Melanin-containing epithelial cells form the layer of the retina next to the choroid coat. This part of the retina is called the pigmented retina. Most of the retina, however, is made up of nervous tissue and is called the sensory retina. Three layers of neurons form the basic structure. Named in the order in which they conduct impulses, these neurons are the main photoreceptor cells, bipolar cells, and ganglion cells.

Fill in the key and color in the corresponding structures.

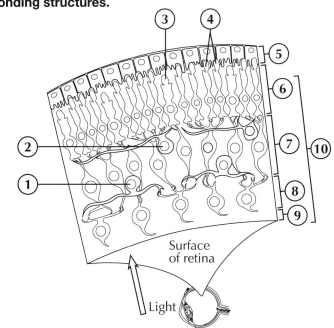

1. Amacrine cell
2. Horizontal cell
3. Cone
4. Rods
5. Pigmented retina
6. Main photoreceptor cells
7. Bipolar cells
8. Ganglion cells
9. Fiber to optic nerve
10. Sensory retina

RODS AND CONES

The distal ends of the dendrites of the main photoreceptor neurons have names that describe their shapes. Because some look like tiny rods and others look like cones, they are called rods and cones, respectively. Because they are sensitive to light rays, they act as our principal visual receptors. The membranous disks (rods and cones) are at the distal ends and are contained in the outer segments. The inner segments that are connected to the soma (body) of the neuron give rise to the synaptic endings, which transmit the incoming "messages" to the next neuron, and finally to the brain for interpretation.

Fill in the key and color in the corresponding structures.

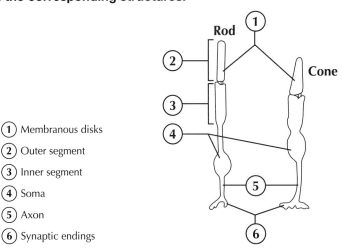

1. Membranous disks
2. Outer segment
3. Inner segment
4. Soma
5. Axon
6. Synaptic endings

CASE STUDY

Rita called her mother to find out if there was anything else she needed to pick up from the grocery store for dinner that evening. Rita's mother, Sue, was turning 79, and a special dinner was in order. When Sue answered the phone, Rita found herself having to speak very loudly in order for her mother to understand what she was saying. As she left the grocery store, Rita began thinking about the last time she visited her mother and recalled having to repeat herself several times when they were having a chat on the porch. When Rita arrived, she was delighted to smell the freshly baked bread that her mother just pulled out of the oven. As they sat down to eat, Sue told Rita that the homemade spaghetti sauce "just didn't taste like it used to."

1. What type of receptors in the ear were not working properly in Sue's ears?
 A. Mechanoreceptors
 B. Photoreceptors
 C. Thermoreceptors
 D. Chemoreceptors
2. What type of receptors were working overtime in Rita's nose as she smelled the fresh baked bread?
 A. Mechanoreceptors
 B. Photoreceptors
 C. Thermoreceptors
 D. Chemoreceptors
3. Sue commented on the sauce not tasting like it used to. Which sensory receptors are responsible for distinguishing different types of taste?
 A. Ruffini's corpuscles
 B. Taste buds
 C. Pacini corpuscles
 D. Krause's end bulbs

Endocrine System

As we learned in chapter 7, with its fast electrical impulses moving through the PNS, the nervous system is one of two systems that provide for communication, integration, and control of the human body. Its counterpart, the endocrine system, serves as the second system of communication and control, but it balances out the fast actions with more slow, sustained communication, integration, and control through the bloodstream by producing and releasing hormones. We will focus on the anatomy and physiology of major endocrine glands and their effect on the human body.

MAJOR ENDOCRINE GLANDS

Whereas the nervous system can only directly control muscles and glands that are innervated, the endocrine system can regulate most cells in the body as its hormones diffuse into the blood and are carried to nearly every point in the body.

Fill in the color key below, then color each gland a different color.

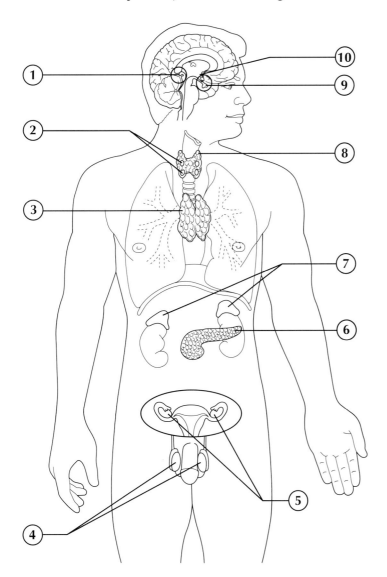

(1) Pineal gland (6) Pancreas (islets)
(2) Parathyroids (7) Adrenals
(3) Thymus (8) Thyroid
(4) Testes (male) (9) Pituitary
(5) Ovaries (female) (10) Hypothalamus

Mosby's Anatomy and Physiology Coloring Book
Copyright © 2014 by Mosby, an imprint of Elsevier Inc

STEROID HORMONE MECHANISM

Steroid hormones are lipids (fats), so they are not very soluable in blood plasma, which is largely made of water. Because of this, they attach themselves to a protein molecule to travel through the blood plasma (bloodstream). When this hormone-protein combination approaches a target cell, it detaches. Remember that because the plasma membrane of a cell is largely made of lipids, the lipid-soluable hormone can easily pass into the cell. Once in the cell, the hormone moves into the nucleus of the cell and binds to a specific site on a DNA molecule. When it communicates with that DNA molecule, it is able to copy, or "transcribe," the genetic information present at that site. Now it is called "mRNA" and it moves outside of the nucleus to find a ribosome, where it can create a new protein. When the "mixture" is complete, a new protein is formed. Think of egg whites and sugar mixing together. If sugar is sitting in a bowl alone, it cannot become meringue. BUT, if you introduce egg whites and stir briskly, a completely different structure is created. Once the new protein is formed, it slowly (from 45 minutes to several days) begins to have an effect on the regulation of the body.

In the diagram below, color in and follow along with the steps of the steroid hormone mechanism.

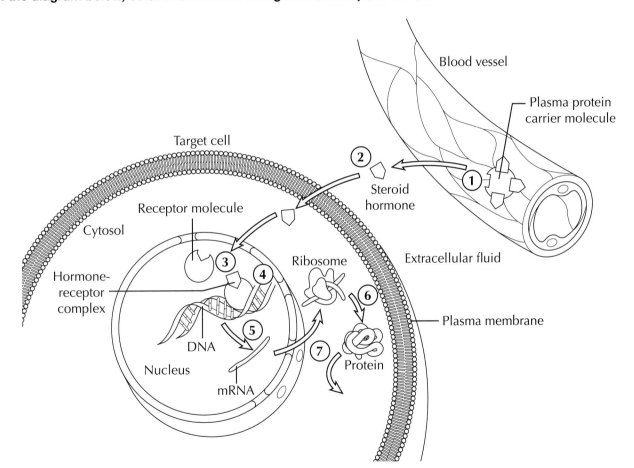

① Plasma protein carrier molecules travel through the blood vessel.

② The plasma protein carrier molecule loses a steroid hormone.

③ The steroid hormone easily penetrates the plasma membrane of the target cell and enters the nucleus.

④ The steroid hormone binds to a specific site on the DNA molecule. Transcription occurs.

⑤ The newly formed mRNA finds a ribosome to create a new protein.

⑥ The new protein is now formed, and leaves the plasma membrane to affect the receptors of a target cell.

⑦ The steroid may have secondary effects in the target cell.

STRUCTURE OF THE PITUITARY GLAND

This gland that measures only 1/2 inch in diameter and weighs 1/60 oz is so critical to the function of the body that it is often called the master gland. The pituitary gland appears to be only one gland; however, it is actually made up of two separate glands: the adenohypophysis, or anterior pituitary gland, and the neurohypophysis, or posterior pituitary gland. The pituitary gland is located within the sella turcica of the sphenoid bone and is directly connected to the hypothalamus.

Fill in the key and then color in the corresponding structures.

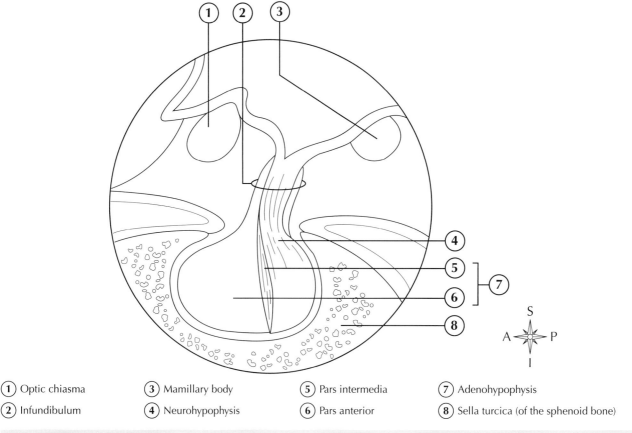

(1) Optic chiasma (3) Mamillary body (5) Pars intermedia (7) Adenohypophysis

(2) Infundibulum (4) Neurohypophysis (6) Pars anterior (8) Sella turcica (of the sphenoid bone)

PITUITARY HORMONES

There are eight major hormones that are released from the pituitary gland. Six of those hormones are released from the anterior pituitary. They include:

- Thyroid Stimulating Hormone. TSH promotes and maintains the thyroid gland, and also causes the thyroid gland to secrete the thyroid hormone.
- Adenocorticotrophic Hormone. ACTH promotes and maintains normal growth and development of the cortex of the adrenal gland, and stimulates the adrenal cortex to synthesize and secrete some of its hormones.
- Follicle-Stimulating Hormone. FSH stimulates the ovaries to grow toward maturity. It also stimulates the follicle cells in the ovary to synthesize and secrete estrogens in females. In males, FSH stimulates the development of the seminiferous tubules of the testes and maintains sperm production.
- Luteinizing Hormone. LH stimulates the formation and activity of the corpus luteum of the ovary. When stimulated by LH, the corpus luteum secretes progesterone and estrogens. LH also supports FSH in stimulating the maturation of follicles. In males, LH stimulates interstitial cells in the testes to develop and then synthesize and secrete testosterone.
- Growth Hormone. GH promotes bodily growth indirectly by stimulating the liver and other tissues to produce another hormone, which accelerates amino acid transport into cells and stimulates fat metabolism. It promotes the growth of bone, muscle, and other tissues.

Copyright © 2014 by Mosby, an imprint of Elsevier Inc

- Prolactin. PL promotes the development of breast tissue in anticipation of milk secretion, then after pregnancy, it stimulates milk secretion (lactation).

The posterior pituitary gland stores and releases two hormones. The hypothalamus actually produces both of the hormones:

- Antidiuretic Hormone. ADH prevents the formation of a large volume of urine. By doing so, it helps the body conserve water. In addition, ADH also stimulates the contraction of the small arteries. This increases blood pressure.
- Oxytocin. OT stimulates the rhythmic contraction of smooth muscles in the uterus, and it causes milk ejection from the breasts of lactating women.

In the diagram below, color the anterior and posterior pituitary glands two different colors. Then, color the arrows and hormone boxes the same color as the pituitary gland (anterior or posterior) that releases the hormone.

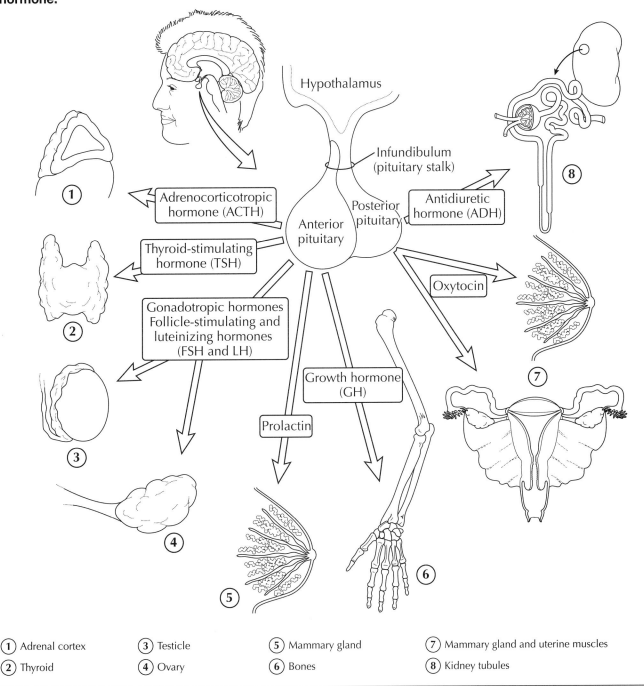

(1) Adrenal cortex (3) Testicle (5) Mammary gland (7) Mammary gland and uterine muscles

(2) Thyroid (4) Ovary (6) Bones (8) Kidney tubules

ACTION OF HYPOTHALAMIC HORMONES

Hypothalamic hormones cause the stimulation or inhibition of hormones to be released from the anterior pituitary gland. They also release certain hormones to be stored in the posterior pituitary gland, as we will see in **Hypothalamus and Neurohypophysis**.

In the diagram below, fill in the seven hypothalamic hormone boxes the same color. If the hormone stimulates (+) the target hormone in the anterior pituitary, fill in that arrow with green, and if it inhibits (−), fill the arrow in red. Next, shade in the five boxes containing the six anterior pituitary hormones the same color. Lightly shade the blood circulation rectangle red. Fill in the boxes containing the target glands and tissues with different colors.

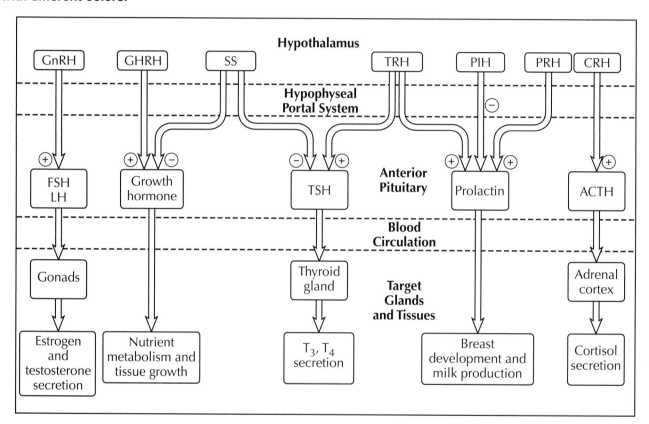

NEGATIVE FEEDBACK CONTROL BY THE HYPOTHALAMUS

As a reminder, a negative feedback (loop) is a control system in which the level of a variable is changed in the direction opposite to that of the initial stimulus. Through the negative feedback mechanisms, the hypothalamus adjusts the secretions of the anterior pituitary and the anterior pituitary adjusts the secretions of its target glands, which in turn adjust the activities of their target tissues. The example below shows the negative feedback control of the secretion of TSH and thyroid hormone (T_3 and T_4).

In the diagram below, circle the words "External and internal stimuli" to show where the initial information comes into the CNS. Then, color the arrows to show how the changes occur in the body to "oppose" or "negate" the initial stimulus. Notice that there are two different areas where the adenohypophysis (anterior pituitary) is affected by the negative feedback loop. The two short loops and the long loop come from the target tissues.

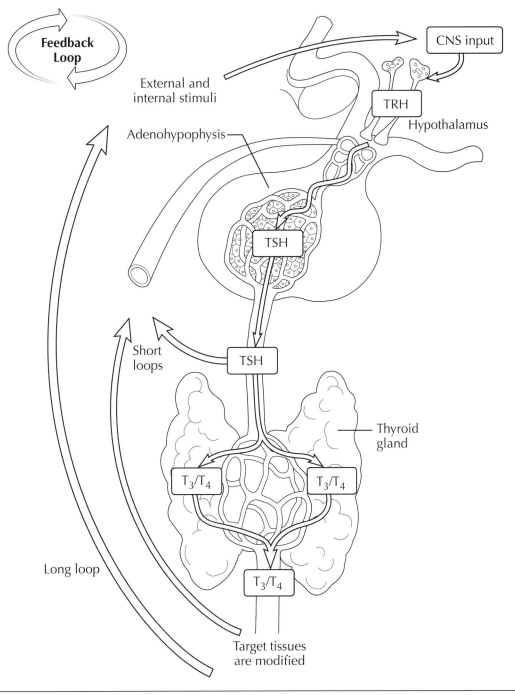

HYPOTHALAMUS AND NEUROHYPOPHYSIS (POSTERIOR PITUITARY GLAND)

The neurohypopysis serves as a storage and release site for two hormones: antidiuretic hormone (ADH) and oxytocin (OT). The cells of the neurohypopysis do not make these hormones. Instead, neurons whose bodies are in either the supraoptic or the paraventricular nuclei of the hypothalamus synthesize them. From the cell bodies of these neurons in the hypothalamus, the hormones pass down along axons into the neurohypophysis. Instead of the chemical-releasing factors that triggered secretion of hormones from the adenohypophysis, release of ADH and OT into the blood is controlled by nervous stimulation.

Color in the key and then the corresponding structures.

(1) Supraoptic nucleus (4) Posterior hypophyseal artery (6) Neurosecretory cells

(2) Optic chiasma (5) Neurohypophysis (7) Paraventricular nucleus

(3) Adenohypophysis

PINEAL GLAND

The pineal gland is located just above the corpora quadrigemina of the midbrain. Complete understanding of pineal gland function is not fully understood. However, it is clear that the tiny pineal gland is an important part of the body's circadian rhythms. This "rhythm" depends partly on the pineal gland varying its secretion of the hormone melatonin. Changing light in the day and night cycles trigger changes in the rate of melatonin secretion.

Fill in the color key then color the corresponding structures and action arrows.

Light

Internal timekeeping signal

S
A ✳ P
I

① Pineal gland
② Melatonin
③ Bloodstream
④ Spinal cord

⑤ Superior cervical ganglion
⑥ Paraventricular nucleus
⑦ Suprachiasmatic nucleus
⑧ Hypothalamus

⑨ Ganglion cell
⑩ Retina
⑪ Optic nerve

THYROID AND PARATHYROID GLANDS

By lightly applying pressure on each side of the trachea and swallowing, you will feel the thyroid gland slide underneath your fingers. This gland produces the thyroid hormone, which is actually two different hormones: thyroxine (T_4) and triiodothyronine (T_3). These hormones help regulate the metabolic rate of all cells, as well as the processes of cell growth and tissue differentiation. An additional thyroid hormone, calcitonin (CT), controls calcium content of the blood by increasing bone formation by osteoblasts and inhibiting bone breakdown by osteoclasts.

The parathyroid glands act as an antagonist to calcitonin, and together they help maintain the balance of calcium in the body. There are actually four to five parathyroid glands embedded on the posterior surface of the lateral lobes of the thyroid gland.

Fill in the key then color in the corresponding structures.

① Epiglottis

② Hyoid bone

③ Larynx (thyroid cartilage)

④ Superior parathyroid gland

⑤ Thyroid gland

⑥ Inferior parathyroid gland

⑦ Trachea

Copyright © 2014 by Mosby, an imprint of Elsevier Inc

SYNTHESIS, STORAGE, AND RELEASE OF THYROID HORMONE (T₃ AND T₄)

After synthesizing a preliminary form of its hormones, the thyroid gland stores considerable amounts of them before secreting them. This is unusual because none of the other endocrine glands stores its hormones in another form for later release. T_3 and T_4 form in the colloid of the follicles on globulin molecules, forming thyroglobulin complexes. When they are released, T_3 and T_4 detach from the globulin and enter into the blood.

Color in the diagram below and follow the steps. Pay close attention to the structures that are involved, as well as the different molecules.

Step 1: Iodide ions (I⁻) present in the blood enter follicular cells in the thyroid, then move into the thyroid follicle and are converted to iodine (I).

Step 2: At the same time, various amino acids (including tyrosine) enter follicular cells.

Step 3: Tyrosine amino acids move into the follicle.

Step 4: Some of the amino acids form a polypeptide, which is released into the follicle to be used as a structural "backbone" for thyroglobulin.

Step 5: The iodine and tyrosine molecules are added to the polypeptide backbone to form thyroglobulin.

Step 6: When needed, thyroglobulin molecules move into follicular cells by endocytosis, where they are digested and thus release free T_3 and T_4 molecules.

Step 7: T_3 and T_4 are secreted into the bloodstream, where they bind to plasma proteins and travel to other parts of the body.

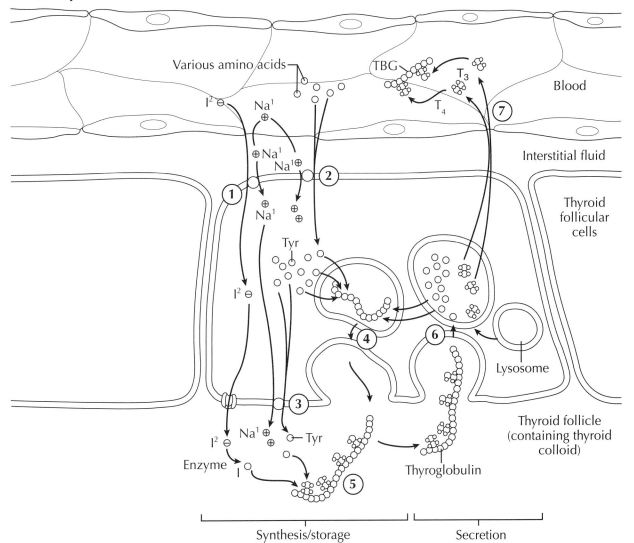

REGULATION OF BLOOD CALCIUM LEVELS

The maintenance of calcium homeostasis, achieved through the interaction of PTH and calcitonin, is very important for healthy survival. The diagram below illustrates the feedback loop that helps to regulate blood calcium levels. In a previous section, the balance between calcitonin and parathyroid hormones was discussed.

Color the left side of the diagram in the same color, illustrating what happens when there is a high blood calcium level. Color in the right side of the diagram in a different color, illustrating what happens when there is a low blood calcium level.

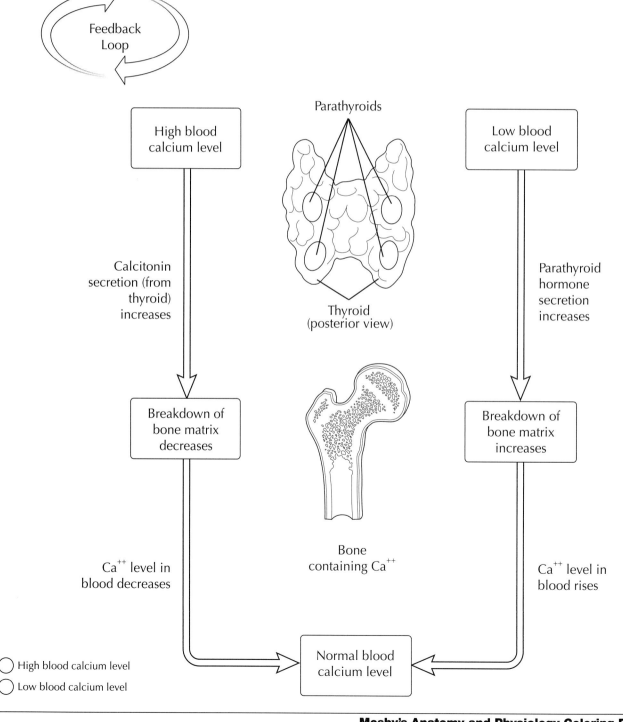

Feedback Loop

Parathyroids

High blood calcium level

Low blood calcium level

Calcitonin secretion (from thyroid) increases

Parathyroid hormone secretion increases

Thyroid (posterior view)

Breakdown of bone matrix decreases

Breakdown of bone matrix increases

Bone containing Ca^{++}

Ca^{++} level in blood decreases

Ca^{++} level in blood rises

Normal blood calcium level

○ High blood calcium level
○ Low blood calcium level

STRUCTURE OF THE ADRENAL GLAND

Sometimes referred to as the suprarenal glands, the adrenal glands are located on top of the kidneys. The outer portion is called the adrenal cortex and the inner portion is called the adrenal medulla. It is composed of three distinct layers and secretes four different hormones classified as mineralcorticoids (aldosterone), cortisol, adrenal androgens, and adrenal estrogens. The cortex is composed of regular endocrine tissue but the medulla is composed of neurosecretory tissue. This means that the tissue is composed of neurons that are adapted to secrete their products into the blood rather than across a synapse as with most neurons. When the sympathetic nervous system is activated, the medullary cells secrete their hormones directly into the blood. The two hormones that are secreted by the adrenal medulla are epinephrine (aka, adrenaline) and norepinephrine.

Fill in the key then color in the corresponding structures.

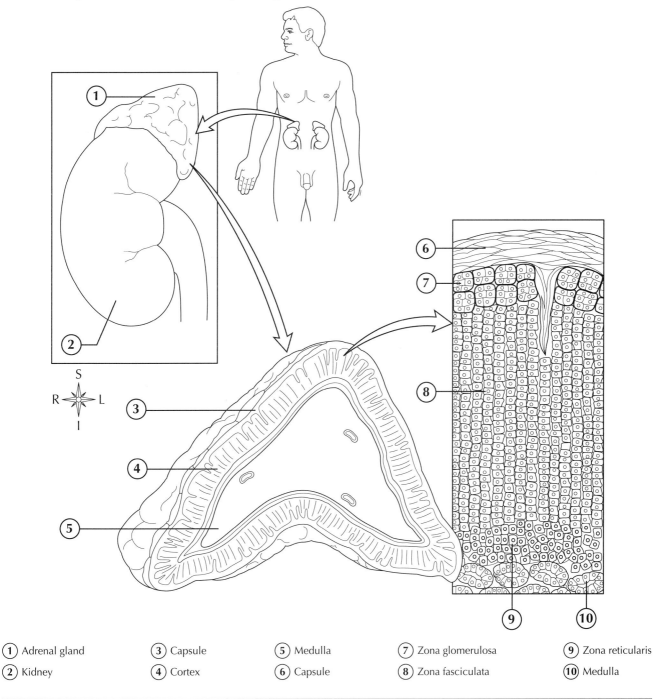

| (1) Adrenal gland | (3) Capsule | (5) Medulla | (7) Zona glomerulosa | (9) Zona reticularis |
| (2) Kidney | (4) Cortex | (6) Capsule | (8) Zona fasciculata | (10) Medulla |

PANCREATIC ISLETS

The pancreas is an elongated gland, whose "head" lies in the C-shaped beginning of the small intestine (duodenum), with its body extending horizontally behind the stomach and its "tail" touching the spleen. The tissue of the pancreas is composed of both endocrine and exocrine tissues. The exocrine enzymes secreted by the pancreas help break down carbohydrates, fats, proteins, and acids as they enter the small intestine. The endocrine portion contains tiny islands of cells, called pancreatic islets, also known as the islets of Langerhans. The endocrine cells include the alpha cells (secrete glucagon); beta cells (secrete insulin); delta cells (secrete somatostatin); pancreatic polypeptide cells (secrete pancreatic polypeptide); and epsilon cells (secrete ghrelin). The glucagon and insulin hormones help regulate blood sugar levels, while the hormone somatostatin prevents the release of glucagon and insulin.

Fill in the key then color in the corresponding structures.

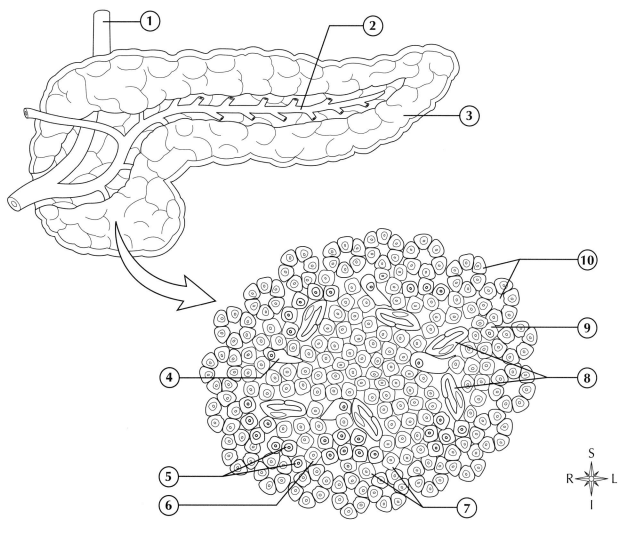

1. Common bile duct
2. Pancreatic duct (for digestive juice)
3. Pancreas
4. Delta cell
5. Alpha cells
6. Epsilon cell
7. Beta cells
8. Blood capillaries
9. PP cell
10. Acini (exocrine cells that produce digestive juice)

Copyright © 2014 by Mosby, an imprint of Elsevier Inc

CASE STUDY

Sharon hadn't been feeling like herself lately. After an appointment with her primary care physician, she was given a referral to an endocrinologist. After a series of questions, the new doctor began his examination. He started by placing his thumb and index finger on Sharon's throat and asking her to swallow. Next, he asked Sharon if she could describe her symptoms. She told the doctor that she felt tired most of the time, no matter how much sleep she had the night before. The doctor nodded his head and then said, "I noticed from your blood tests, that your calcium levels are low."

1. What endocrine gland was the doctor testing when he placed his finger and thumb on Sharon's throat and instructed her to swallow?
 A. Thymus
 B. Triiodothyronine
 C. Thyroid
 D. Parathyroid

2. The doctor suspected, based on questions and blood tests, that Sharon's thyroid gland was not normal. Based on her symptoms of being tired all of the time, no matter how much sleep she had the night before, how would you describe the function of her thyroid gland?
 A. Hyperactive
 B. Hypoactive
 C. Inactive
 D. Antagonist

3. Which thyroid hormone is responsible for the blood levels of calcium?
 A. Tetraiodothyronine
 B. Thyroxin
 C. Triiodothyronine
 D. Calcitonin

10 Digestive System

The organs of the digestive system together perform a vital function: preparing food for absorption and for use by the millions of body cells. Most food is in a form that cannot reach the cells, nor could it be used by the cells even if it could reach them. It must therefore be modified in both chemical and physical composition so that nutrients can be absorbed and used by the body cells. The complete process of altering the physical and chemical composition of ingested food material so that it can be absorbed and used by the body is called digestion. This complex process is the function of both the digestive tract and the accessory organs that make up the digestive system.

MAIN ORGANS OF DIGESTION

The main organs of the digestive system form a tube that goes all the way through the ventral cavities of the body. It is open at both ends and is referred to as the alimentary canal. Note, you may also hear this tube referred to as the gastrointestinal tract (GI tract), but this is incorrect. That term more specifically refers to the tract between the stomach and intestines.

Fill in the key and then color the corresponding structures.

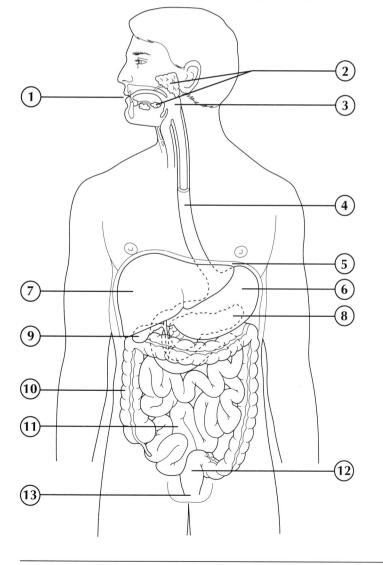

1. Mouth
2. Salivary glands
3. Pharynx
4. Esophagus
5. Diaphragm
6. Stomach
7. Liver
8. Pancreas
9. Gallbladder
10. Large intestine
11. Small intestine
12. Rectum
13. Anus

Mosby's Anatomy and Physiology Coloring Book
Copyright © 2014 by Mosby, an imprint of Elsevier Inc

WALL OF THE GI TRACT

The GI tract is essentially a tube with walls fashioned of four layers of tissues: a mucous lining, a submucous coat of connective tissue in which are embedded the main blood vessels of the tract, a muscular layer, and a fibroserous layer.

Fill in the key and then color in the various layers and structures.

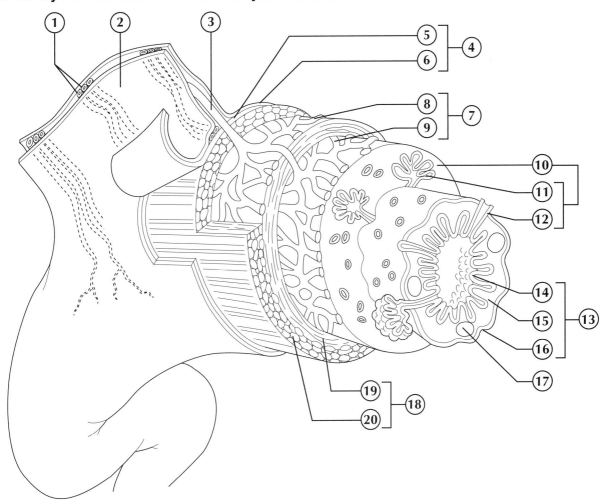

① Blood vessels	⑧ Myenteric plexus	⑮ Lamina propria
② Mesentery	⑨ Submucosal plexus	⑯ Muscularis mucosae
③ Nerve	⑩ Submucosa	⑰ Lymph nodule
④ Serosa	⑪ Gland in submucosa	⑱ Muscularis
⑤ Connective tissue layer	⑫ Duct from gland	⑲ Circular muscle layer
⑥ Peritoneum	⑬ Mucosa	⑳ Longitudinal muscle layer
⑦ Intramural plexus	⑭ Mucous epithelium	

ORAL CAVITY

The oral cavity is formed by the lips, the cheeks, the tongue, the hard palate, and the soft palate. Because the oral cavity is the beginning of the alimentary canal, digestion begins here. Food enters the mouth, mucous secretions soften food, and food is in position for mastication (chewing). Food is cut and ground up by specially designed teeth, and the food ball (bolus) is prepared for deglutition (swallowing).

Fill in the key and then color in the various structures.

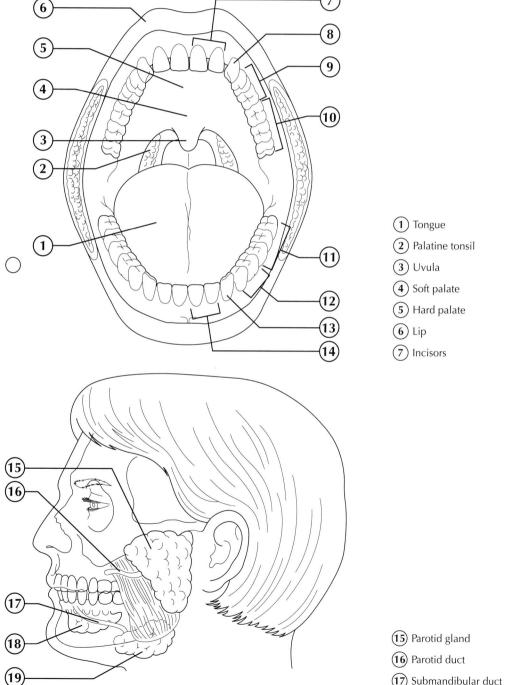

1. Tongue
2. Palatine tonsil
3. Uvula
4. Soft palate
5. Hard palate
6. Lip
7. Incisors
8. Cuspid
9. Bicuspids
10. Molars
11. Molars
12. Bicuspids
13. Cuspid
14. Incisors

15. Parotid gland
16. Parotid duct
17. Submandibular duct
18. Sublingual gland
19. Submandibular gland

PHARYNX AND ESOPHAGUS

As mentioned, food must be prepared for a process called deglutition (swallowing) to be moved down the alimentary canal. As the bolus leaves the mouth, it enters a structure called the pharynx (anatomical throat). The esophagus, which is about 10 inches in length, connects the pharynx to the stomach. In diagram A below, notice how the esophagus penetrates and passes through the diaphragm muscle. Diagram B shows the posterior view of the structures as they relate to the esophagus.

Fill in the keys and then color in the various structures.

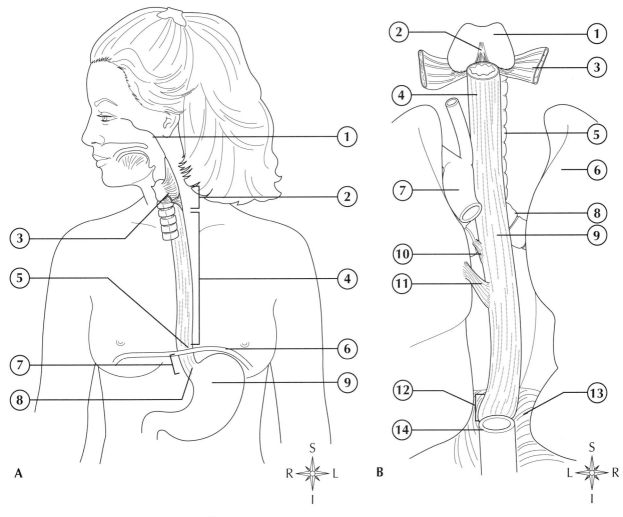

A

B

A

1. Pharynx
2. Cervical part of esophagus
3. Upper esophageal sphincter (UES)
4. Thoracic part of esophagus
5. Esophageal hiatus (of diaphragm)
6. Diaphragm
7. Abdominal part of esophagus
8. Lower esophageal sphincter (LES)
9. Stomach

B

1. Cricoid cartilage of larynx
2. Cricoesophageal tendon
3. Cricopharyngeus muscle
4. Cervical part of esophagus
5. Trachea
6. Lung
7. Aortic arch
8. Bronchus
9. Thoracic part of esophagus

10. Bronchoesophageal muscle
11. Pleuroesophageal muscle
12. Esophageal hiatus (of diagraphm)
13. Diaphragm
14. Abdominal aorta

STOMACH

Just below the diaphragm, the digestive tube dilates into an elongated pouchlike structure, the stomach. When food enters into the stomach, this strong muscular pouch is able to distend to accommodate the food. However, after the stomach is emptied, the walls partially collapse to the size of a large sausage. In adults the stomach volume is typically 1–1.5 liters. The stomach lies in the upper part of the abdominal cavity with approximately 5/6 of its mass to the left of the median line. There are three divisions of the stomach: 1) the fundus, 2) the body, and 3) the pylorus. The upper right curve of the stomach is known as the lesser curvature, while the lower left surface is known as the greater curvature. Two sphincter muscles regulate passage of material at both openings of the stomach. The cardiac sphincter (aka, lower esophageal sphincter or LES) is located where the esophagus and stomach meet; the pyloric sphincter is located where the pyloris of the stomach enters into the small intestine (duodenum, first portion).

Fill in the keys and then color in the various structures.

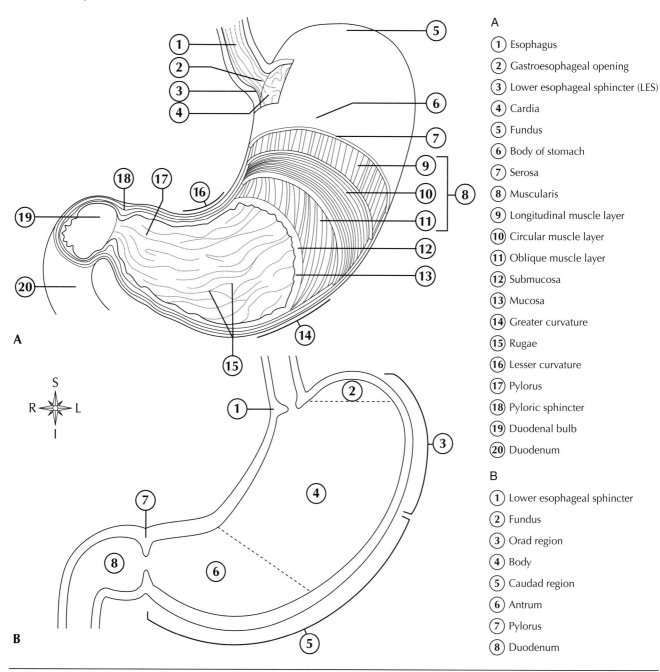

A

1. Esophagus
2. Gastroesophageal opening
3. Lower esophageal sphincter (LES)
4. Cardia
5. Fundus
6. Body of stomach
7. Serosa
8. Muscularis
9. Longitudinal muscle layer
10. Circular muscle layer
11. Oblique muscle layer
12. Submucosa
13. Mucosa
14. Greater curvature
15. Rugae
16. Lesser curvature
17. Pylorus
18. Pyloric sphincter
19. Duodenal bulb
20. Duodenum

B

1. Lower esophageal sphincter
2. Fundus
3. Orad region
4. Body
5. Caudad region
6. Antrum
7. Pylorus
8. Duodenum

CELLULAR COMPOSITION OF THE FUNDIC STOMACH AND FUNDIC GLANDS

Gastric pits are depressions in the epithelial lining of the stomach. At the bottom of each pit is one or more tubular gastric glands. Chief cells produce the enzymes of gastric juice, and parietal cells produce stomach acid. Endocrine cells secrete the appetite-boosting hormone ghrelin.

Fill in the key and then color in the various structures.

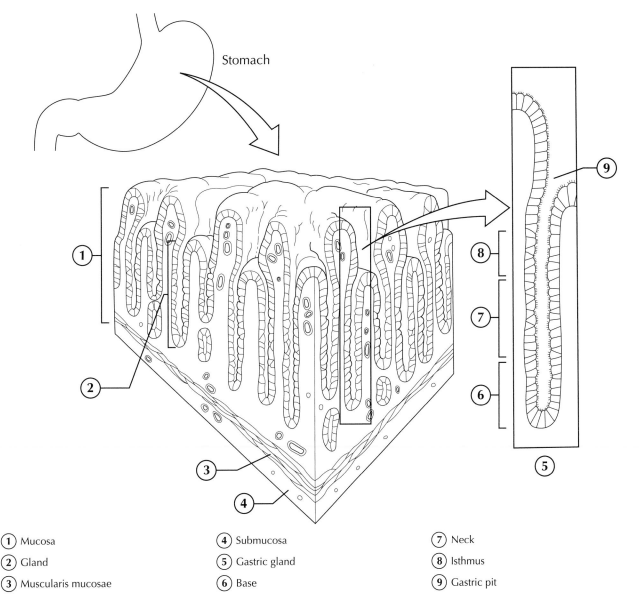

Stomach

(1) Mucosa	(4) Submucosa	(7) Neck
(2) Gland	(5) Gastric gland	(8) Isthmus
(3) Muscularis mucosae	(6) Base	(9) Gastric pit

SMALL INTESTINE

This amazing organ is approximately 20 feet long (in cadaver) and 1 inch in diameter. To put this in perspective, the average midsize car is 16 feet in length. The coiled loops of this organ fill most of the abdominal cavity. The small intestine is divided into three divisions: duodenum (uppermost 10 inches, connects to stomach); the jejunum (middle 8 feet); and the ileum (lowermost 12 feet). The walls of this unique organ have many "folds," called plica, which allow for a massive amount of surface area for absorption to take place. These plica are covered with finger-like projections called villi. These villi contain goblet cells, blood vessels, lacteals, and stem cells, which allow for the intestinal mucosa to be constantly supplied with fresh cells. This organ is known as the main organ for digestion and absorption.

Fill in the key and then color in the various structures.

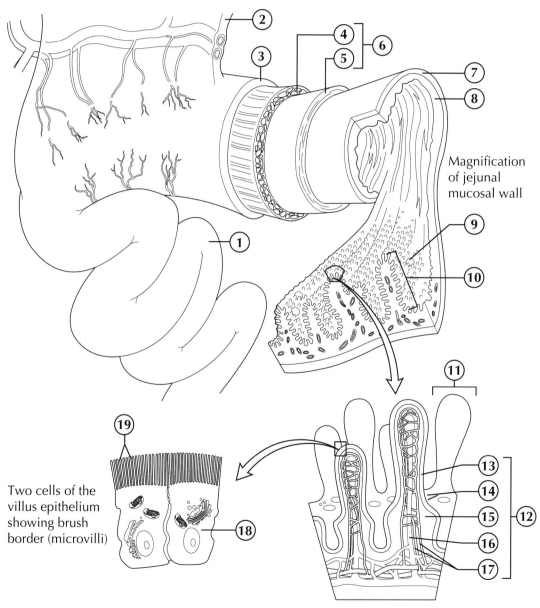

Magnification of jejunal mucosal wall

Two cells of the villus epithelium showing brush border (microvilli)

① Segement of jejunum	⑤ Circular muscle	⑨ Lymph nodule	⑬ Epithelium	⑰ Artery and vein
② Mesentery	⑥ Muscularis	⑩ Plica (fold)	⑭ Microvilli	⑱ Epithelial cell
③ Serosa	⑦ Submucosa	⑪ Single villus	⑮ Mucosa	⑲ Microvilli
④ Longitudinal muscle	⑧ Mucosa	⑫ Mucosal villi	⑯ Lacteal (lymph capillary)	

INTESTINAL VILLI AND CRYPTS

Intestinal crypts serve as a site of rapid mitotic cell division. Stem cells near the bottom of each crypt keep the intestinal mucosa continuously supplied with fresh cells. New differentiating daughter cells are produced by the stem cells and pushed upward toward the mouth of the crypt. As they differentiate into enterocytes, goblet cells, and endocrine cells, the older cells are pushed up and out of each crypt. Eventually they are moved to the distal end of a single villus, where they are shed. This allows for the intestinal mucosa to be continually renewed. At the base of each crypt, protective Paneth cells produce enzymes and other molecules that inhibit bacterial growth in the small intestine. The location of the Paneth cells makes them especially useful in protecting the vital stem cells.

Fill in the key and then color in the various structures and action arrows.

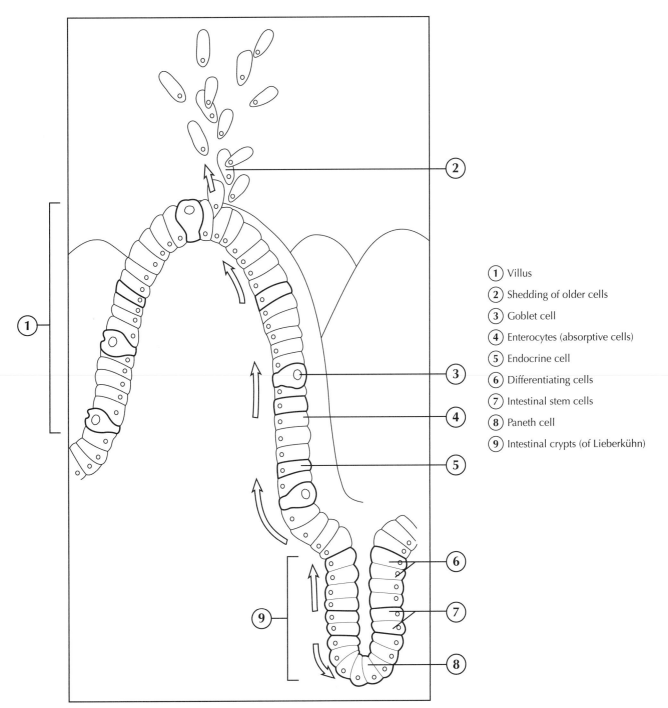

1. Villus
2. Shedding of older cells
3. Goblet cell
4. Enterocytes (absorptive cells)
5. Endocrine cell
6. Differentiating cells
7. Intestinal stem cells
8. Paneth cell
9. Intestinal crypts (of Lieberkühn)

DIVISIONS OF THE LARGE INTESTINE

The lower part of the alimentary canal bears the name large intestine (LI) because its diameter is noticeably larger than that of the small intestine (SI). Its length, however, is much less, about 5–6 feet. Its average diameter is approximately 2 1/2 inches, but the diameter decreases toward the lower end of the tube. The large intestine is divided into the cecum, the colon, and the rectum. The first 2–3 inches of the LI is the cecum. The next section, the colon, is divided into the ascending, transverse, descending, and sigmoid colon.

Between the ileum (SI) and the cecum (LI) is the ileocecal valve, which allows for material to pass from the ileum to the large intestine. The transverse colon extends from the hepatic flexure to the splenic flexure, the two points where the colon bends on 90 degree angles.

Fill in the key and then color in the various structures.

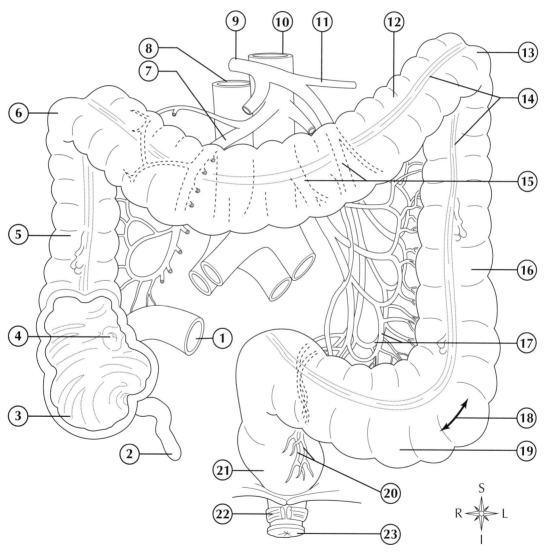

① Ileum	⑦ Superior mesenteric artery	⑬ Splenic (left colic) flexure	⑲ Sigmoid colon
② Vermiform appendix	⑧ Inferior vena cava	⑭ Taeniae coli	⑳ Superior rectal artery and vein
③ Cecum	⑨ Hepatic portal vein	⑮ Inferior mesenteric artery and vein	㉑ Rectum
④ Ileocecal valve	⑩ Aorta	⑯ Descending colon	㉒ External anal sphincter muscle
⑤ Ascending colon	⑪ Splenic vein	⑰ Sigmoid artery and vein	㉓ Anus
⑥ Hepatic flexure (right colic)	⑫ Transverse colon	⑱ Haustra	

THE RECTUM AND ANUS

The last 7–8 inches of the intestinal tube is called the rectum. Crescent-shaped transverse rectal folds (rectal valves) help slow down the flow of feces as it enters the rectum and holds the feces in place until defecation occurs. The terminal inch of the rectum is called the anal canal. Its mucous lining is arranged in numerous folds known as anal columns, each of which contains an artery and a vein. The opening of the canal to the exterior is guarded by two sphincter muscles—an internal smooth muscle sphincter and an external striated muscle sphincter called the anus.

Fill in the key and then color in the various structures.

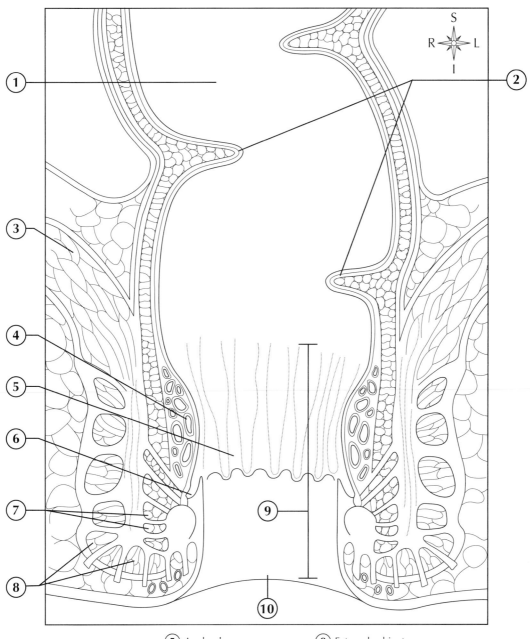

(1) Rectum

(2) Tranverse rectal folds (rectal valves)

(3) Levator ani muscle

(4) Internal hemorrhoidal plexus

(5) Anal column

(6) Rectal sinus

(7) Internal sphincters

(8) External sphincters

(9) Anal canal

(10) Anus

PROJECTIONS OF THE PERITONEUM

The peritoneum is a large, continuous sheet of serous membrane. It lines the walls of the entire abdominal cavity and also forms the serous outer coat of the organs. In several places, the peritoneum forms reflections, or extensions, that bind the abdominal organs together. The mesentery is a fan-shaped projection of the parietal abdominal wall and allows free movement of each coil of the intestine and helps prevent strangulation of the long tube. The transverse mesocolon attaches the transverse colon to the posterior abdominal wall. The greater omentum is a continuation of the serosa of the greater curvature of the stomach, and the first part of the duodenum to the transverse colon. The lesser omentum attaches from the liver to the lower curvature of the stomach and the first part of the duodenum. The falciform ligament extends from the liver to the anterior abdominal wall.

Fill in the keys and then color in the various structures.

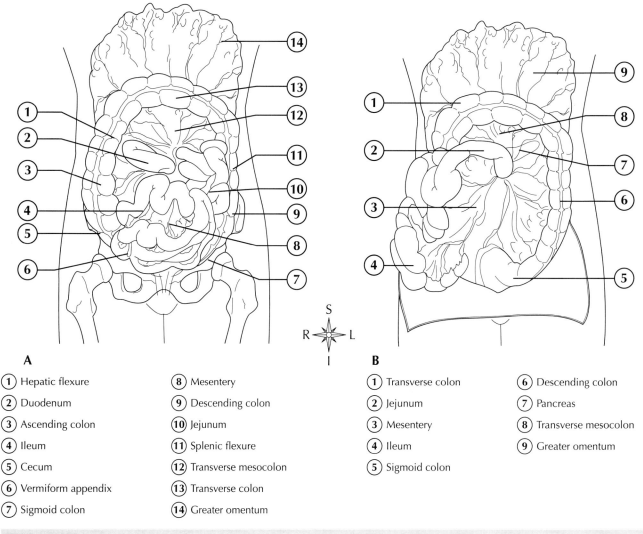

A

(1) Hepatic flexure	(8) Mesentery
(2) Duodenum	(9) Descending colon
(3) Ascending colon	(10) Jejunum
(4) Ileum	(11) Splenic flexure
(5) Cecum	(12) Transverse mesocolon
(6) Vermiform appendix	(13) Transverse colon
(7) Sigmoid colon	(14) Greater omentum

B

(1) Transverse colon	(6) Descending colon
(2) Jejunum	(7) Pancreas
(3) Mesentery	(8) Transverse mesocolon
(4) Ileum	(9) Greater omentum
(5) Sigmoid colon	

THE LIVER

The liver is one of the most vital organs in the body. Its main functions are to detoxify various substances; secrete bile; metabolize proteins, fats, and carbohydrates; store iron and vitamins A, B_{12}, and D; and produce important plasma proteins and blood cells during fetal development. It contains two lobes separated by the falciform ligament. The left lobe forms about one-sixth of the liver and the right lobe makes up the remainder. The hepatic lobules, the anatomical units of the liver, are tiny cylinders that have a small branch of the hepatic veins through the center. On the outer corners of each lobule, several sets of tiny tubes—branches of the hepatic artery, the portal vein, and the hepatic duct—are arranged. From these, irregular branches of the interlobular veins extend between

the radiating plates of hepatic cells to join the central vein. Minute bile canaliculi are formed by the spaces around each cell that collects bile secreted by the hepatic cells. The small bile ducts within the liver join to form two larger ducts that emerge from the undersurface of the organ as the right and left hepatic ducts. These ducts immediately join to form one common hepatic duct. The common hepatic duct merges with the cystic duct from the gallbladder to form the common bile duct.

Fill in the key and then color in the various structures. Diagram A shows the location of liver lobules relative to the overall circulatory scheme of the liver. Diagrams B and C give enlarged views of several lobules to show how blood from the hepatic portal veins and arteries flows through sinusoids and thus past plates of hepatic cells toward a central vein in each lobule. Hepatic cells form bile, which flows through bile canaliculi toward hepatic ducts that eventually drain the bile from the liver.

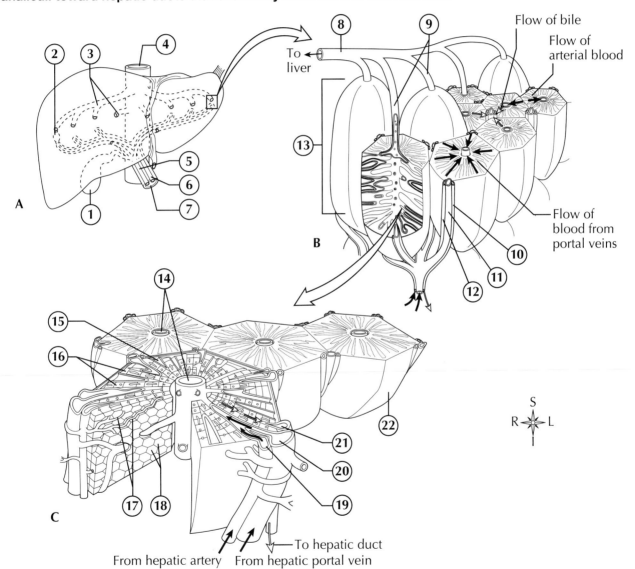

(1) Gallbladder	(7) Hepatic portal vein	(13) Lobule	(19) Interlobular artery (branch of hepatic artery)
(2) Lobule	(8) Hepatic vein	(14) Central (intralobular) veins	
(3) Hepatic veins	(9) Central (intralobular veins)	(15) Sinusoid	(20) Interlobular portal vein (branch of hepatic portal vein)
(4) Inferior vena cava	(10) Interlobular portal vein (branch)	(16) Plates of hepatic cells	
(5) Common bile duct	(11) Hepatic artery (branch)	(17) Bile canaliculi	(21) Interlobular bile duct
(6) Hepatic artery	(12) Interlobular bile duct	(18) Hepatic cells	(22) Lobule

THE GALLBLADDER AND BILE DUCTS

Serous, muscular, and mucous layers compose the wall of the gallbladder. The mucosal lining is arranged in folds called rugae, similar in structure to those of the stomach. The gallbladder stores bile that backs up into it. It concentrates bile five- to tenfold as it is stored. When partially digested material exits the stomach, the gallbladder contracts and ejects the concentrated bile into the duodenum.

Fill in the key and then color in the structures.

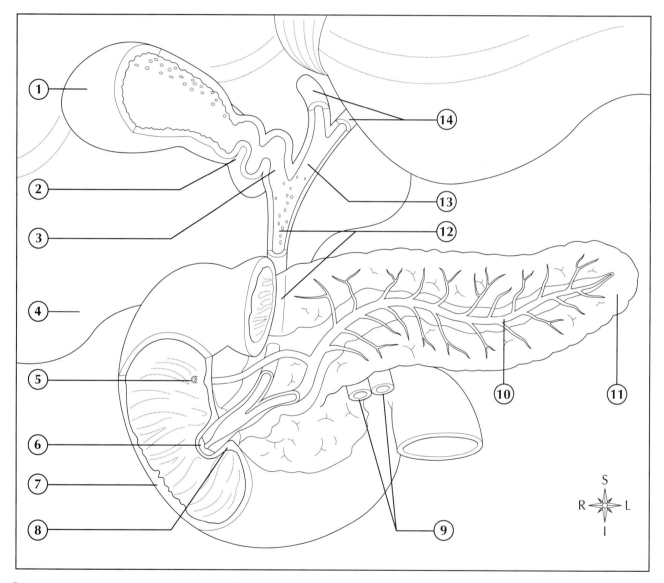

① Corpus (body) of gallbladder	⑥ Major duodenal papilla	⑪ Pancreas
② Neck of gallbladder	⑦ Duodenum	⑫ Common bile duct
③ Cystic duct	⑧ Sphincter muscles	⑬ Common hepatic duct
④ Liver	⑨ Superior mesenteric artery and vein	⑭ Right and left hepatic ducts
⑤ Minor duodenal papilla	⑩ Pancreatic duct	

PANCREAS

The pancreas is composed of exocrine and endocrine tissues. The pancreatic duct empties into the duodenum at the same point as the common bile duct at the major duodenal papilla. The exocrine function of the pancreas is to secrete pancreatic juice, which is mostly made up of water but also contains sodium bicarbonate for digestive functions. The endocrine function of the pancreas takes place in about a million pancreatic islets that secrete insulin from their beta cells and glucagon from their alpha cells.

Fill in the key and then color in the structures.

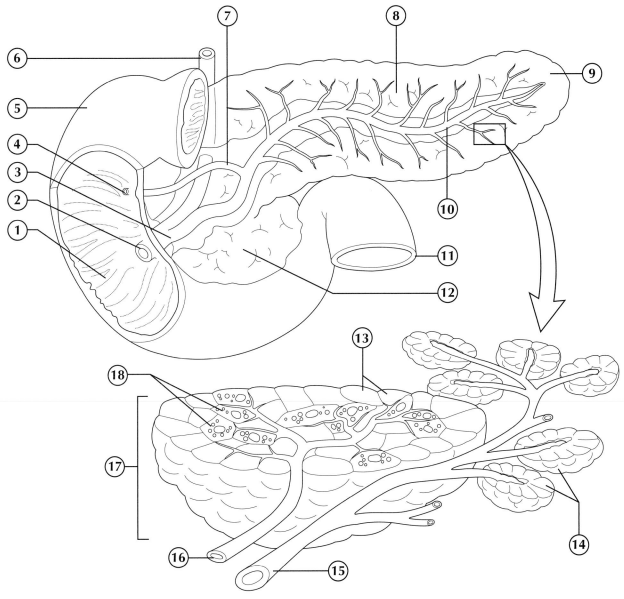

1. Plicae circulares
2. Major duodenal papilla
3. Hepatopancreatic ampulla
4. Minor duodenal papilla
5. Duodenum
6. Common bile duct

7. Accessory pancreatic duct
8. Body of pancreas
9. Tail of pancreas
10. Pancreatic duct
11. Jejunum
12. Head of pancreas

13. Beta cells (secrete insulin)
14. Acinar cells (secrete enzymes)
15. Pancreatic islet (to duodenum)
16. Vein
17. Pancreatic islet
18. Alpha cells (secrete glucagon)

OVERVIEW OF DIGESTIVE FUNCTION

To accomplish the function of making nutrients available to the body cells, the digestive system uses various mechanisms. Once food is ingested, it must be digested and moved throughout the body.

Label each figure with the correct term below that represents the function of the digestive organs.

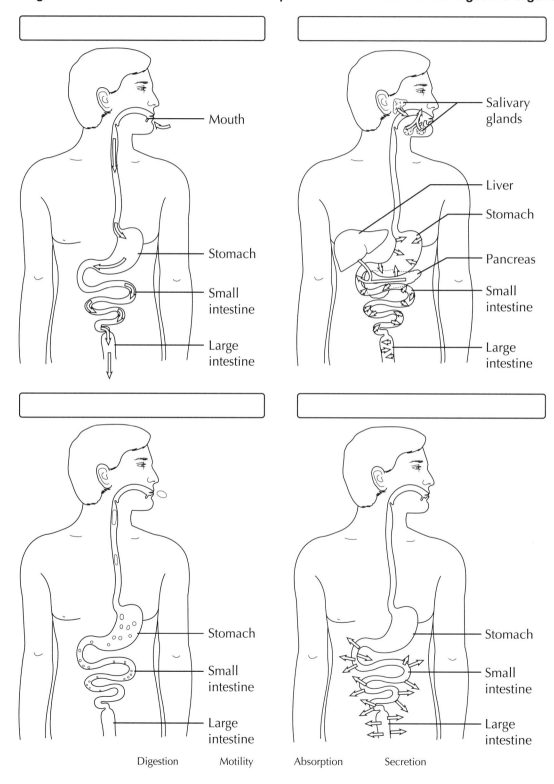

Digestion Motility Absorption Secretion

Next, in the table below, fill in the correct mechanism next to the description of its function in the digestive system, using the list of terms below.

\textbf{In the table below, fill in the missing information. Use the structure graphic as a clue to write in what is missing.}	
MECHANISM	**DESCRIPTION**
	Process of taking food into the mouth, starting it on its journey though the digestive tract.
	Group of processes that breaks complex nutrients into smaller ones.
	Movement by the muscular components of the digestive tube, including mechanical digestion (peristalsis, segmentation).
	Release of digestive juices.
	Movement of digestive nutrients through the GI mucosa and into the internal environment.
	Excretion of the residues of the digestive process (feces) from the rectum, through the anus (defecation).
	Coordination of digestive activity.

Regulation Ingestion Motility Secretion

Absorption Elimination Digestion

DIGESTION AND THE WHOLE BODY

The process of digestion, as with any other vital function, provides a means of survival for the entire body and also requires the function of other systems. Regulation of digestive motility and secretion requires the active participation of both the nervous system and the endocrine system. The body's framework (integumentary and skeletal) is required to support and protect the digestive organs. The skeletal muscles must function if ingestion, mastication, deglutition, and defecation are to occur normally. As you can see, the digestive system cannot operate alone.

With this in mind, review the diagram below and fill in the name of the organ/structure described in the info box, then shade in the box and corresponding organ.

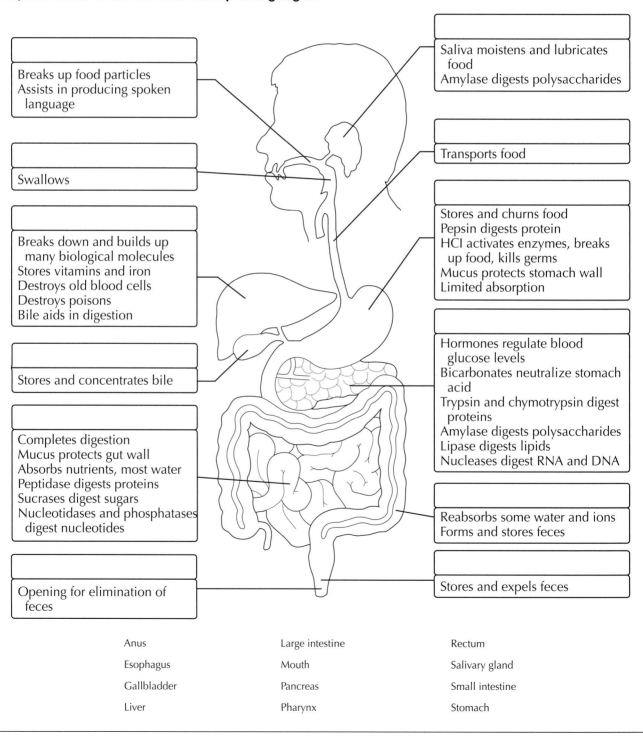

	Breaks up food particles Assists in producing spoken language			Saliva moistens and lubricates food Amylase digests polysaccharides
	Swallows			Transports food
	Breaks down and builds up many biological molecules Stores vitamins and iron Destroys old blood cells Destroys poisons Bile aids in digestion			Stores and churns food Pepsin digests protein HCl activates enzymes, breaks up food, kills germs Mucus protects stomach wall Limited absorption
	Stores and concentrates bile			Hormones regulate blood glucose levels Bicarbonates neutralize stomach acid Trypsin and chymotrypsin digest proteins Amylase digests polysaccharides Lipase digests lipids Nucleases digest RNA and DNA
	Completes digestion Mucus protects gut wall Absorbs nutrients, most water Peptidase digests proteins Sucrases digest sugars Nucleotidases and phosphatases digest nucleotides			Reabsorbs some water and ions Forms and stores feces
	Opening for elimination of feces			Stores and expels feces

Anus	Large intestine	Rectum
Esophagus	Mouth	Salivary gland
Gallbladder	Pancreas	Small intestine
Liver	Pharynx	Stomach

CASE STUDY

It only took three seconds. Angela turned away from her sewing basket to pick up her cell phone, and when she looked back, she saw a handful of buttons disappear into her two-year-old daughter Sophie's mouth. She quickly ran to her daughter and removed the buttons from her mouth, but Angela had no way of knowing how many had been swallowed. Angela immediately took Sophie to the emergency room, where they took x-rays of Sophie's neck and chest. On the x-ray, they found one button in Sophie's upper esophagus.

1. As the button moves down the alimentary canal, which organ will it enter next?
 A. Popliteal space
 B. Gastrofundibulum
 C. Stomach
 D. Duodenum
2. There are three sections of the small intestine that the button must travel through before entering the large intestine. Beginning with the end attached to the stomach, what is the order of the small intestine sections?
 A. Duodenum, veriform, cecum
 B. Duodenum, jejunum, ilium
 C. Jejunum, duodenum, ilium
 D. Ascending, transverse, descending
3. If a camera was inserted into Sophie's small intestine to determine the location of the button as it travels through the alimentary canal, small finger-like projections would be seen gently assisting the button on its journey. Those projections are called:
 A. Ciliary bodies
 B. Serrated mucosa
 C. Cilia
 D. Intestinal mucosa fingers

11 Blood and the Cardiovascular System

Homeostasis of the internal environment, and therefore survival, depends on continual transportation of essentials to and from body cells. This chapter discusses the major transportation fluid (blood) and the major transportation system (cardiovascular). We begin this chapter focusing on the blood, then progress to the cardiovascular system.

BLOOD

Blood is much more than the simple liquid it appears to be. It consists of a fluid known as plasma, but also contains cells that are called the formed elements. Blood makes up approximately 8% of the body weight, with the remaining 92% consisting of other fluids and tissues. Plasma, the liquid form of blood, contains 7% proteins, 91% water, and 2% of other solutes. The formed elements are comprised of thrombocytes (aka, platelets < 1%), leukocytes (aka, white blood cells < 1%), and erythrocytes (aka, red blood cells > 99%).

In the diagram below, fill in the missing information by using the key terms provided.

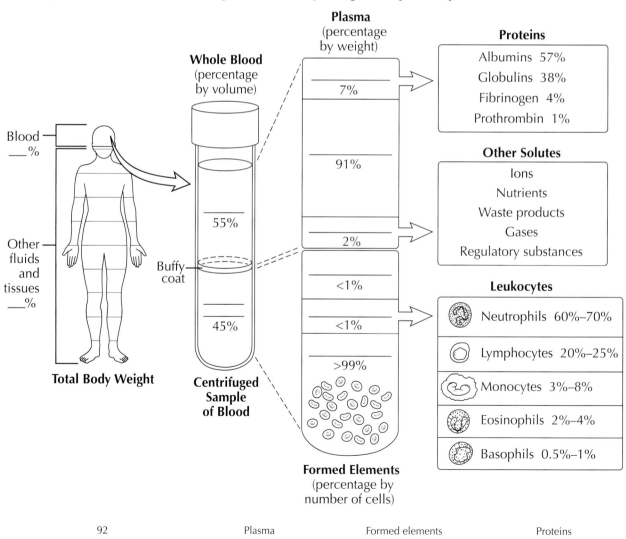

8	92	Plasma	Formed elements	Proteins
Water	Other solutes	Platelets	Leukocytes	Erythrocytes

Mosby's Anatomy and Physiology Coloring Book
Copyright © 2014 by Mosby, an imprint of Elsevier Inc

FORMED ELEMENTS OF THE BLOOD

As we mentioned, blood is much more than a mere liquid. Several "formed" elements located in the blood perform a variety of critical functions.

Fill in the name and draw your own version of the formed elements in the correct cells of the table. Use the graphic below the table to help you determine which go into the correct cells.

CELL TYPE	DESCRIPTION	FUNCTION	LIFESPAN
	7 μm in diameter; concave disk shape; entire cell stains pale pink; no nucleus	Transportation of respiratory gases (O_2 and CO_2)	105–120 days
	12–15 μm in diameter; spherical shape; multilobed nucleus; small, pink-purple-staining cytoplasmic granules	Cellular defense—phagocytosis of small pathogenic microorganisms	Hours to 3 days
	11–14 μm in diameter; spherical shape; generally two-lobed nucleus; large purple-staining cytoplasmic granules	Secretes heparin (anticoagulant) and histamine (important in inflammatory response)	Hours to 3 days
	10–12 μm in diameter; spherical shape; generally two-lobed nucleus; large, orange-red-staining cytoplasmic granule	Cellular defense—some phagocytosis; chemical attack of large pathogenic microorganisms (such as protozoa) and parasitic worms; helps regulate allergic reactions and other inflammatory responses	10–12 days
	6–9 μm in diameter; spherical shape; round (single-lobed) nucleus; small lymphocytes have scant cytoplasm	Humoral defense—secretes antibodies; involved in immune system response and regulation	Days to years
	12–17 μm in diameter; spherical shape; nucleus generally kidney-bean or horseshoe shaped with convoluted surface; ample cytoplasm often "steel blue" in color	Capable of migrating out of the blood to enter tissue spaces as a macrophage—an aggressive phagocytic cell capable of ingesting bacteria, cellular debris, and cancerous cells	Months
	2–5 μm in diameter; irregularly shaped fragments; cytoplasm contains very small, pink-staining granules	Releases clot-activating substances and helps in formation of actual blood clot by forming platelet "plugs"	7–10 days

Red Blood Cells (Erythrocytes)

Platelets (Thrombocytes)

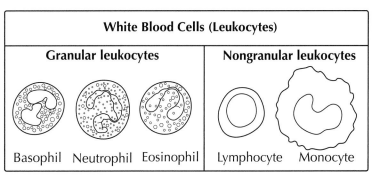

White Blood Cells (Leukocytes)

Granular leukocytes	Nongranular leukocytes
Basophil Neutrophil Eosinophil	Lymphocyte Monocyte

BLOOD TYPES AND THE Rh SYSTEM

The term blood type refers to the type of antigens (or cell markers) present on red blood cell (RBC) membranes. The presence or absence of antigens determines a person's blood type in the ABO system. Antigens A, B, and Rh are the most important blood antigens as far as transfusions and newborn survival are concerned. Every person's blood belongs to one of the four ABO blood types.

- Type A—antigen A on RBCs
- Type B—antigen B on RBCs
- Type AB—both antigen A and antigen B on RBCs
- Type O—neither antigen A nor antigen B are on RBCs

Because type O blood does not contain either antigen A or B, it has been referred to as universal donor blood, a term that implies that it can safely be given to any recipient. Universal recipient blood (Type AB) contains neither anti-A nor anti-B antibodies, so it cannot agglutinate (clump) type A or type B donor RBCs. This does not mean, however, that any type of donor blood may be safely given to an individual who has type AB blood without first cross-matching with the donor blood.

Label the diagram by using the key words below to indicate whether or not the antigens or antibodies are present.

Red blood cells	Type A	Type B	Type AB	Type O
Plasma				

Antibody B	Antibody A	Neither antibody A nor B	Antibodies A and B
Antigen A	Antigen B	Antigens A and B	Neither antigen A nor B

THE Rh SYSTEM

The term Rh-positive blood means that an Rh (or D) antigen is present on its RBCs. Rh-negative blood, on the other hand, is blood whose red blood cells have no Rh antigens present on them. Blood does not normally contain Rh antibodies. However, anti-Rh antibodies can appear in the blood of an Rh-negative person, provided that Rh-positive RBCs have at some time entered their bloodstream. One way this can happen is by giving an Rh-negative person a transfusion of Rh-positive blood. In a short time, the person's body makes anti-Rh antibodies, and these remain in the blood. The only other way in which Rh-positive RBCs can enter the bloodstream of an Rh-negative person is to a woman during pregnancy. This is a danger for a baby born to an Rh-negative mother and an Rh-positive father. If the baby inherits the Rh-positive trait from the father, the Rh factor on the RBCs may stimulate the mother's body to form anti-Rh antibodies. Then, if she later carries another Rh-positive fetus, the fetus may develop a disease called erythroblastosis fetalis.

The diagram below illustrates mixing of donor and recipient blood of the same type. Color the Type A blood of donor red and the antigens on that blood cell orange. Color the Type B antibody green.

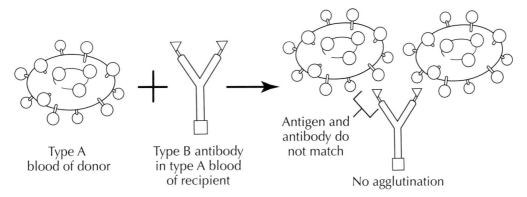

The diagram below illustrates what happens when type A donor blood is mixed with type B recipient blood. Color this diagram using corresponding colors as those used in the diagram above.

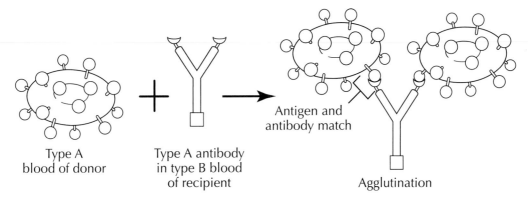

BLOOD CLOTTING

The primary purpose of blood clotting (coagulation) is obvious—to plug ruptured vessels to stop bleeding and prevent further loss of a vital body fluid (hemostasis). A secondary and less well-known function of the hemostasis mechanism is to help in defense against infection. When injury occurs, bacteria may find an opportunity to invade our tissues. However, a blood clot will hopefully trap and bind enough of them to prevent such an infection. The blood-clotting mechanism involves a series of chemical reactions that takes place in a definite and rapid sequence resulting in a net of fibers that traps RBCs. There are several coagulation factors, but there are four critical ones to review:

1. Prothrombin
2. Thrombin
3. Fibrinogen
4. Fibrin

The interactions between these components occur in what we designate as stage 2 and stage 3 (stage 1 is the injury itself). Using the key below, color and label the three steps in the clotting mechanism.

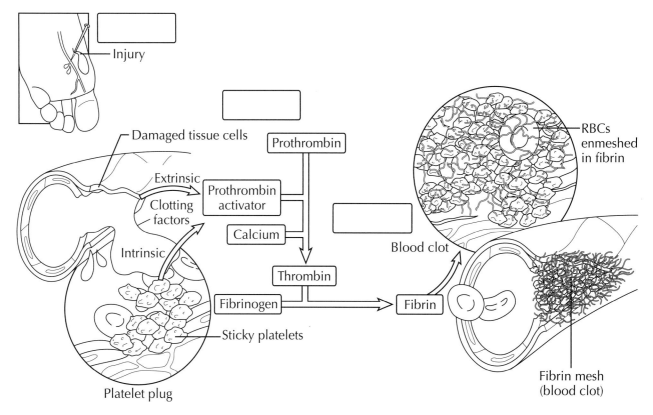

STAGE	DESCRIPTION OF ACTIVITY
1	Injury occurs. Release of clotting factors from both injured tissue cells and sticky platelets at the injury site form a temporary platelet plug.
2	A series of chemical reactions occurs that eventually results in the formation of thrombin.
3	The formation of fibrin and trapping of blood cells to form a clot.

THE CARDIOVASCULAR SYSTEM

The cardiovascular system (CVS) consists of the heart and blood vessels. This system maintains homeostasis by its continued and controlled movement of blood through the thousands of miles of blood vessels that reach every single cell in the body. If the human body was unable to maintain this renewable fluid system, we would not survive. Nutrients, gases, water, hormones, waste products, cells of immunity, and other materials are transported through the cardiovascular system. Transportation is only part of the story. The CVS must know when and how to transport the aforementioned particles. The heart, arteries, veins, and capillaries coordinate and cooperate to ensure that we have what we need, where we need it, when we need it.

THE HEART

The human heart is a four-chambered muscular organ. It is similar in shape and size to a closed fist. It lies in the mediastinum just behind the sternum, between the second and sixth ribs. Approximately two-thirds of the heart lies to the left of the sternum. The lower portion of the heart (apex) rests on the diaphragm. The heart lies directly between the right and left lungs.

Using the information above, label then color in each structure.

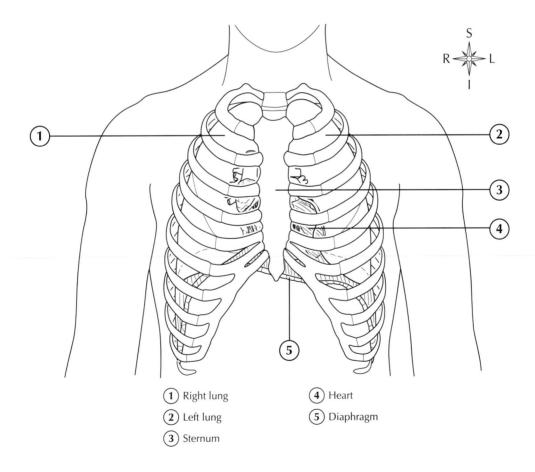

1. Right lung
2. Left lung
3. Sternum
4. Heart
5. Diaphragm

THE HEART—ANTERIOR VIEW

Color in the key and the corresponding structures.

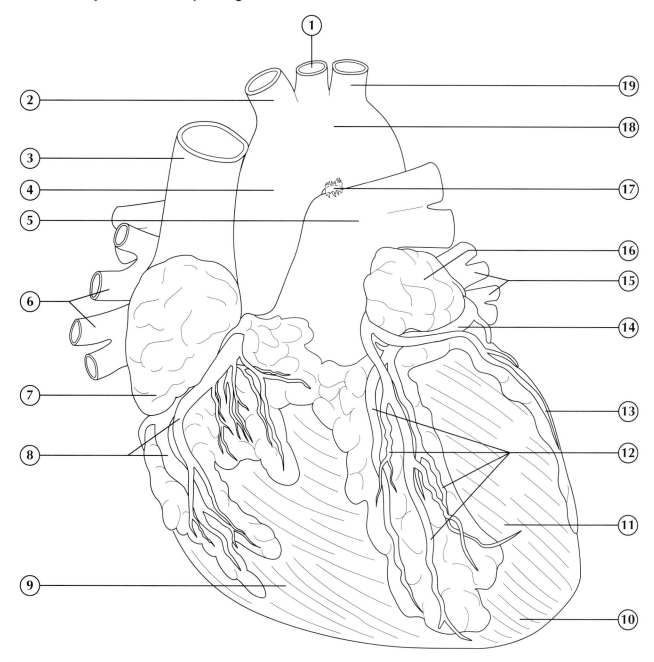

(1) Left common carotid artery

(2) Brachiocephalic trunk

(3) Superior vena cava

(4) Ascending aorta

(5) Pulmonary trunk

(6) Right pulmonary veins

(7) Auricle of right atrium

(8) Right coronary artery and cardiac vein

(9) Right ventricle

(10) Apex

(11) Left ventricle

(12) Anterior interventricular branches of left coronary artery and cardiac vein

(13) Circumflex artery

(14) Great cardiac vein

(15) Left pulmonary veins

(16) Auricle of left atrium

(17) Ligamentum anteriosum

(18) Arch of aorta

(19) Left subclavian artery

THE HEART—POSTERIOR VIEW

Color in the key and the corresponding structures. Can you locate some of the structures in the posterior view based on the anterior view?

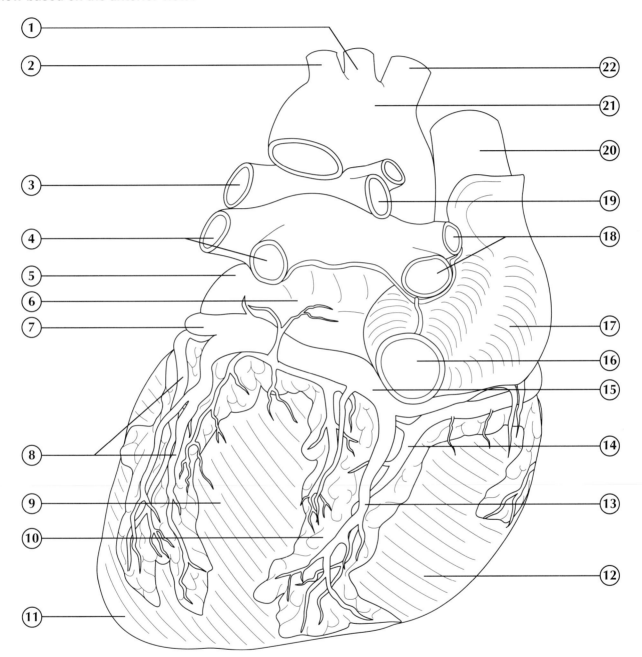

(1) Left common carotid artery	(7) Great cardiac vein	(12) Right ventricle	(17) Right atrium
(2) Left subclavian artery	(8) Posterior artery and vein of left ventricle	(13) Middle cardiac vein	(18) Right pulmonary veins
(3) Left pulmonary artery	(9) Left ventricle	(14) Posterior interventricular branch of right coronary artery	(19) Right pulmonary artery
(4) Left pulmonary veins	(10) Posterior interventricular sulcus	(15) Coronary sinus	(20) Superior vena cava
(5) Auricle of left atrium	(11) Apex	(16) Inferior vena cava	(21) Aortic arch
(6) Left atrium			(22) Brachiocephalic trunk

INTERIOR OF THE HEART

The interior of the heart is divided into four cavities, or chambers. The two upper chambers are called atria (atrium, singular), and the two lower chambers are called ventricles. A septum separates the two upper and lower chambers. The two upper chambers are called "receiving chambers" because they receive blood from the veins of the body. The two lower chambers are called "pumping chambers" because they are responsible for pumping blood out of the heart to the lungs and to the rest of the body.

In the figure below, fill in the color key and shade in each structure of the interior heart.

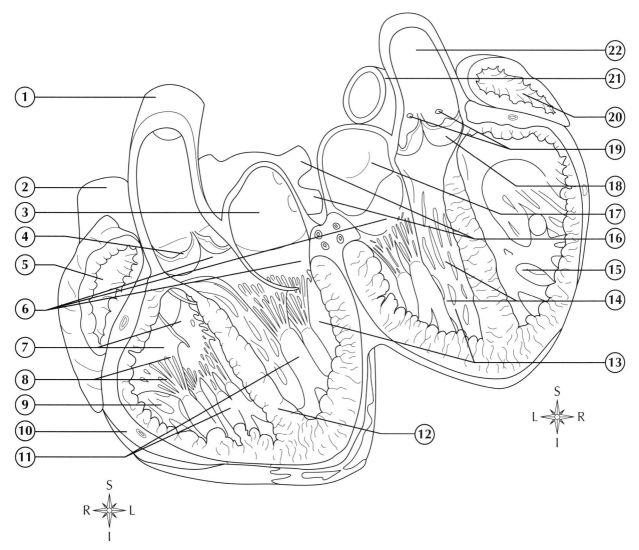

(1) Aorta

(2) Superior vena cava

(3) Left atrium

(4) Aortic (semilunar) valve

(5) Right atrium

(6) Left AV (mitral) valve

(7) Right AV (tricuspid) valve

(8) Chordae tendineae

(9) Right ventricle

(10) Fatty connective tissue

(11) Papillary muscle

(12) Interventricular septum

(13) Left ventricle

(14) Trabeculae carneae

(15) Right ventricle

(16) Pulmonary veins

(17) Left atrium

(18) Aortic (semilunar) valve

(19) Openings to coronary arteries

(20) Right atrium

(21) Pulmonary trunk

(22) Aorta

VALVES OF THE HEART

The four heart valves are structures that permit the flow of blood in one direction only, allowing the heart to act as a pump that forces the continuous flow of blood in one direction. The atrioventricular (AV) valve guards the openings between the left and right atria and the ventricles. They have pointed leaf-like flaps called "cusps" and are therefore called "cuspid" valves. The right AV valve is a tricuspid valve (three), and the left AV valve is a bicuspid valve (two). The other two valves are called "semilunar" valves because they resemble a half-moon shape. They are located where the trunk of the pulmonary artery joins the right ventricle (pulmonary semilunar valve) and where the aorta joins the left ventricle (aortic semilunar valve).

Color in the key and the corresponding structures.

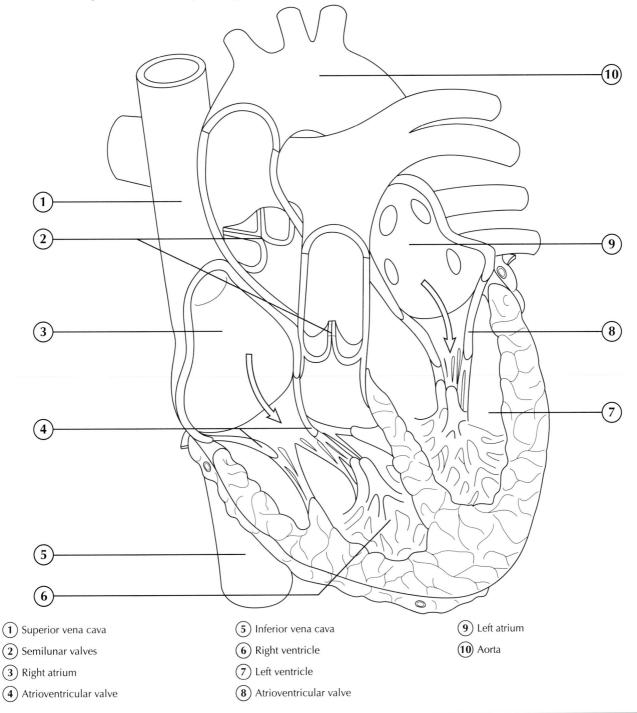

1. Superior vena cava
2. Semilunar valves
3. Right atrium
4. Atrioventricular valve
5. Inferior vena cava
6. Right ventricle
7. Left ventricle
8. Atrioventricular valve
9. Left atrium
10. Aorta

BLOOD FLOW THROUGH THE HEART

To fully understand the functional anatomy of the heart and the rest of the CVS, one should be able to trace the flow of blood through the heart. As we will discuss a little later, arteries carry blood away from the heart and veins carry blood to the heart. It is often thought that arterial blood is ALWAYS oxygenated, but that is not the case.

In the diagram below, trace the flow of blood through the heart in seven steps.

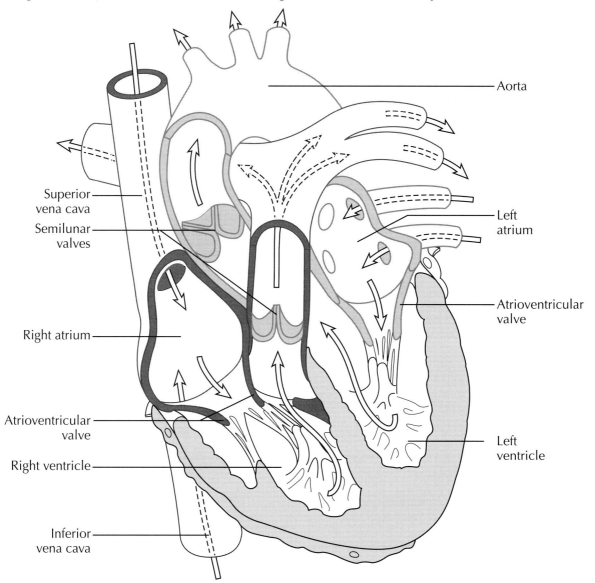

1. Deoxygenated blood enters the heart from the superior and inferior vena cavae (veins) and empties into the right atrium.
2. The blood passes through the tricuspid (right AV) valve into the right ventricle.
3. The right ventricle pumps the blood through the pulmonary semilunar valve into the pulmonary trunk, then through its right and left pulmonary arteries, where it is routed to the gas exchange tissues of the lungs.
4. The newly oxygenated blood is now routed into the left atrium from the pulmonary veins.
5. From the left atrium, blood flows through the left atrioventricular (mitral) valve into the left ventricle.
6. From the left ventricle, blood is pumped through the aortic semilunar valve into the aorta.
7. The aorta supplies all blood vessels of the body, except the gas-exchange tissues of the lungs.

BLOOD SUPPLY OF THE HEART TISSUE—CORONARY ARTERIES

Because the heart is the critical blood pump for the entire body, it is important to focus attention on the coronary arteries that supply the heart muscle with highly oxygenated blood and the coronary veins that remove the "used" blood.

The aorta divides into two main branches: the right coronary artery (RCA) and the left coronary artery (LCA). The RCA further divides into five coronary arteries; the LCA further divides into four coronary arteries.

Color in the key and the corresponding structures.

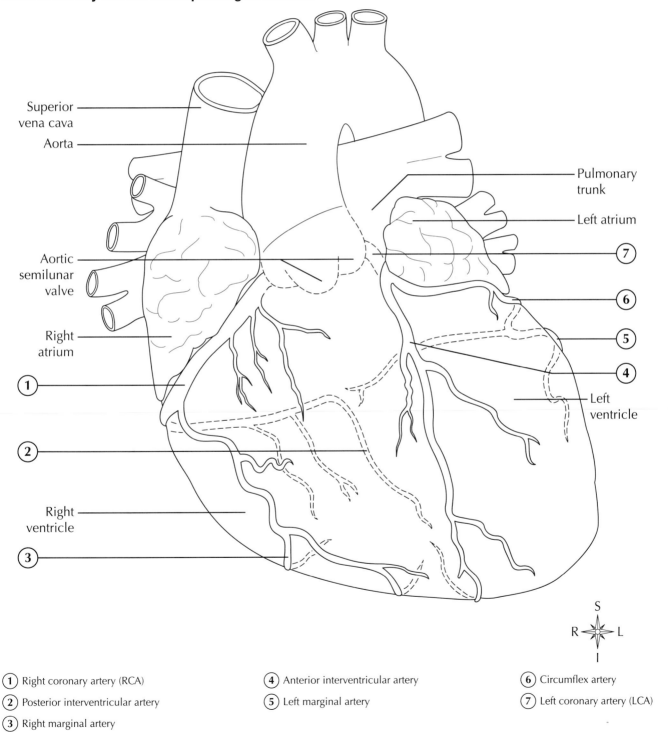

1 Right coronary artery (RCA)

2 Posterior interventricular artery

3 Right marginal artery

4 Anterior interventricular artery

5 Left marginal artery

6 Circumflex artery

7 Left coronary artery (LCA)

CORONARY VEINS

After blood has passed through the myocardium (heart muscle), it enters a series of cardiac veins before draining into the right atrium through a common venous channel called the coronary sinus. Several veins that collect blood from a small area in the right ventricle do not end in the coronary sinus but instead drain directly into the right atrium. As a rule, the cardiac veins follow a course that closely parallels that of the coronary arteries.

Color in the key and the corresponding structures.

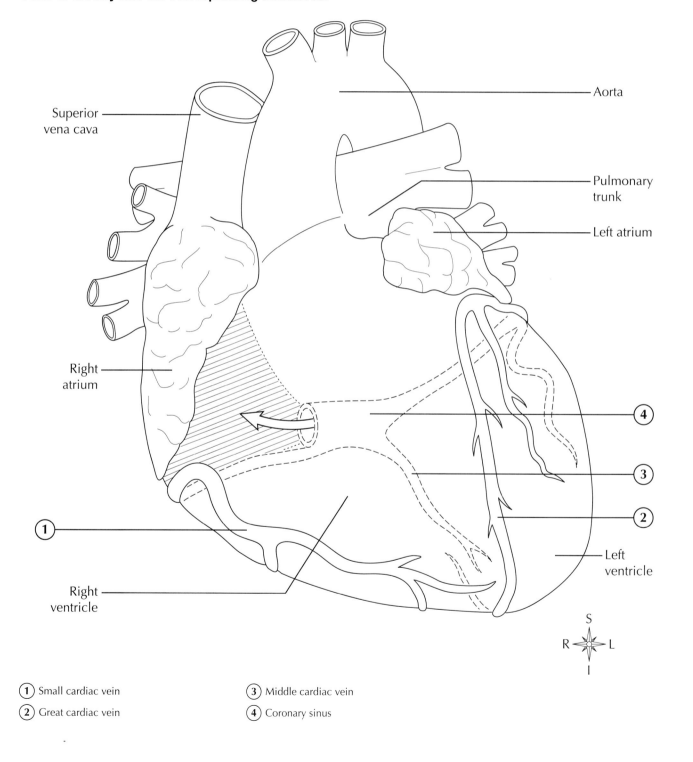

(1) Small cardiac vein (3) Middle cardiac vein

(2) Great cardiac vein (4) Coronary sinus

BLOOD VESSEL TYPES

If you are an average-sized adult, there are more than 60,000 miles of vessels carrying blood through your body right now. Arteries carry blood to the heart; veins carry blood away from the heart; and capillaries conduct blood through tissues and permit exchange of materials. Let's take a closer look at these types of blood vessels, beginning with the vessels that carry blood away from the heart—the arteries.

THE ARTERIES

Color in the numbered keys and the corresponding structures.

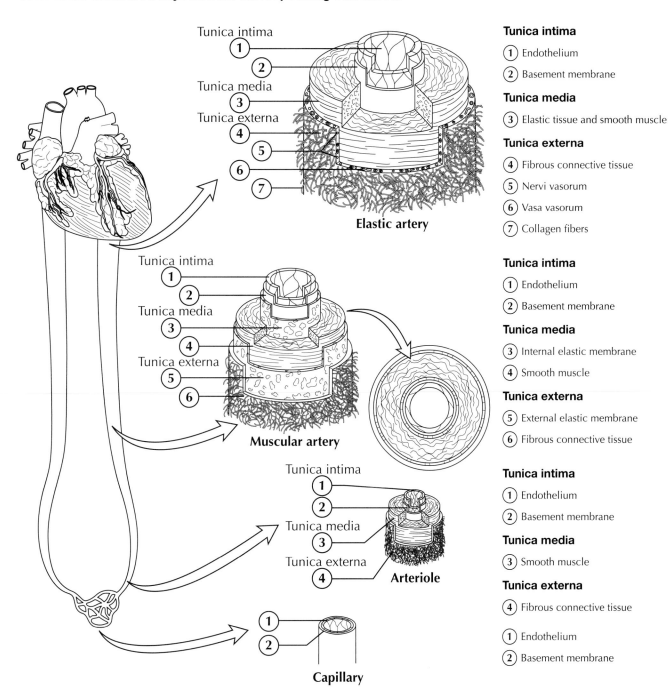

Tunica intima
1
2
Tunica media
3
Tunica externa
4
5
6
7
Elastic artery

Tunica intima
1
2
Tunica media
3
4
Tunica externa
5
6
Muscular artery

Tunica intima
1
2
Tunica media
3
Tunica externa
4
Arteriole

1
2
Capillary

Tunica intima
1 Endothelium
2 Basement membrane
Tunica media
3 Elastic tissue and smooth muscle
Tunica externa
4 Fibrous connective tissue
5 Nervi vasorum
6 Vasa vasorum
7 Collagen fibers

Tunica intima
1 Endothelium
2 Basement membrane
Tunica media
3 Internal elastic membrane
4 Smooth muscle
Tunica externa
5 External elastic membrane
6 Fibrous connective tissue

Tunica intima
1 Endothelium
2 Basement membrane
Tunica media
3 Smooth muscle
Tunica externa
4 Fibrous connective tissue

1 Endothelium
2 Basement membrane

THE VEINS

As we saw in the previous graphic, there are three different types of arteries which flow into the capillaries to allow for exchange of materials. The same is true for the veins.

Color in the numbered keys and the corresponding structures.

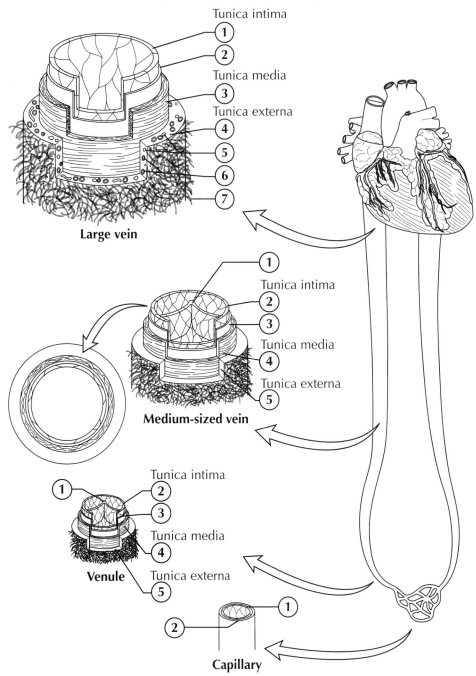

Tunica intima
1
2

Tunica media
3

Tunica externa
4
5
6
7

Large vein

1

Tunica intima
2
3

Tunica media
4

Tunica externa
5

Medium-sized vein

Tunica intima
2
3

Tunica media
4

Venule Tunica externa
5

1
2

Capillary

Tunica intima

(1) Endothelium

(2) Basement membrane

Tunica media

(3) Smooth muscle

Tunica externa

(4) Fibrous connective tissue

(5) Nervi vasorum

(6) Vasa vasorum

(7) Collagen fibers

(1) Valve

Tunica intima

(2) Endothelium

(3) Basement membrane

Tunica media

(4) Smooth muscle

Tunica externa

(5) Fibrous connective tissue

(1) Valve

Tunica intima

(2) Endothelium

(3) Basement membrane

Tunica media

(4) Smooth muscle

Tunica externa

(5) Fibrous connective tissue

(1) Endothelium

(2) Basement membrane

Copyright © 2014 by Mosby, an imprint of Elsevier Inc

SYSTEMIC ARTERIES

As you learn the names of the main arteries, keep in mind that these are only the major pipelines distributing blood from the heart to the various organs and that, in each organ, the main artery resembles a tree trunk in that it gives off numerous branches that continue to branch and rebranch, forming ever-smaller arterioles, which also branch, forming microscopic vessels known as the capillaries.

In the diagram below, color the various arteries using the instructions provided. Note, this is not an all-inclusive representation of the systemic arteries.

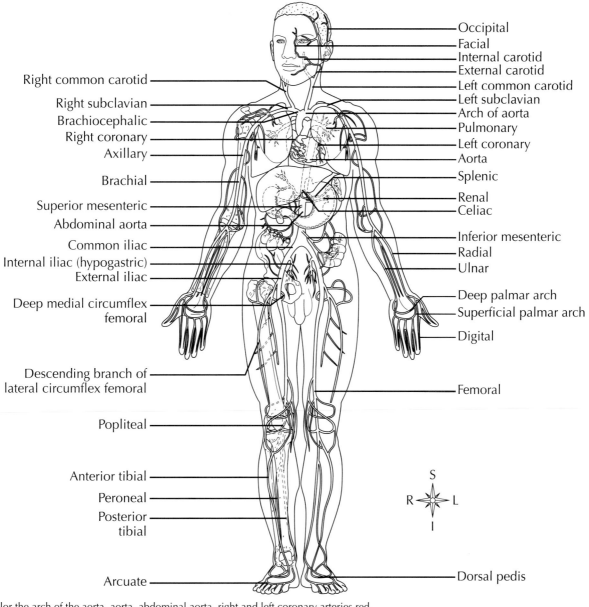

Labels (left side): Right common carotid, Right subclavian, Brachiocephalic, Right coronary, Axillary, Brachial, Superior mesenteric, Abdominal aorta, Common iliac, Internal iliac (hypogastric), External iliac, Deep medial circumflex femoral, Descending branch of lateral circumflex femoral, Popliteal, Anterior tibial, Peroneal, Posterior tibial, Arcuate

Labels (right side): Occipital, Facial, Internal carotid, External carotid, Left common carotid, Left subclavian, Arch of aorta, Pulmonary, Left coronary, Aorta, Splenic, Renal, Celiac, Inferior mesenteric, Radial, Ulnar, Deep palmar arch, Superficial palmar arch, Digital, Femoral, Dorsal pedis

○ Color the arch of the aorta, aorta, abdominal aorta, right and left coronary arteries red.

○ Color the pulmonary arteries blue.

○ Color the brachiocephalic, right and left common carotid, left internal carotid, left external carotid, facial, and occipital arteries the same color.

○ Color the right and left subclavian, axillary, brachial, ulnar, radial, superficial, and deep palmar arches and digital arteries the same color.

○ Color the celiac, gastric, common hepatic, splenic, superior and inferior mesenteric, renal, and internal and external iliac arteries the same color.

○ Color the common iliac, external iliac, lateral circumflex, femoral, popliteal, anterior and posterior tibial, peroneal, arcuate, and dorsal pedis arteries the same color.

SYSTEMIC VEINS

As with arteries, you may find it easier to learn the names of veins and their anatomical relation to each other from the diagrams than from a narrative description. Keep in mind that veins are the ultimate extensions of capillaries, just as capillaries are the eventual extensions of arteries.

In the diagram below, color the various veins using the instructions provided. Note, this is not an all-inclusive representation of the systemic veins.

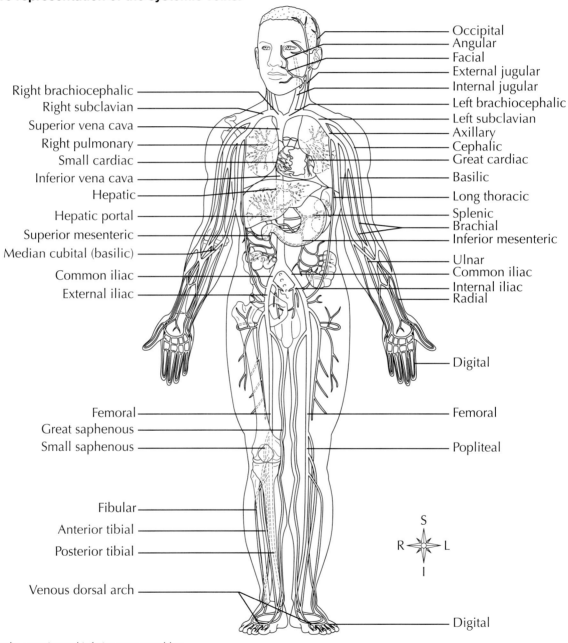

○ Color the superior and inferior vena cava blue.

○ Color the right pulmonary, small cardiac, and great cardiac vein red.

○ Color the right and left brachiocephalic, internal and external jugular, occipital, angular, and facial veins the same color.

○ Color the right and left subclavian, cephalic, axillary, brachial, radial, ulnar, basilic, long thoracic, median cubital, and digital veins the same color.

○ Color the hepatic, hepatic portal, splenic, superior and inferior mesenteric, common iliac (x2), and internal and external iliac veins the same color.

○ Color the femoral, great and small saphenous, popliteal, fibular, anterior and posterior tibial, venous dorsal arch, and digital veins the same color.

Mosby's Anatomy and Physiology Coloring Book
Copyright © 2014 by Mosby, an imprint of Elsevier Inc

HEPATIC PORTAL CIRCULATION

Veins from the spleen, stomach, pancreas, gallbladder, and intestines do not pour their blood directly into the inferior vena cava, as do the veins from the other abdominal organs. They send their blood to the liver via the hepatic portal vein. Here, the blood mingles with the arterial blood in the capillaries and is eventually drained from the liver by the hepatic veins that join the inferior vena cava. This type of circulation is called "portal" because venous blood flows through a second capillary network before returning to the heart. It is used here because the liver is a gateway through which blood returning from the digestive tract must pass before it returns to the heart.

Color in the key and the corresponding structures.

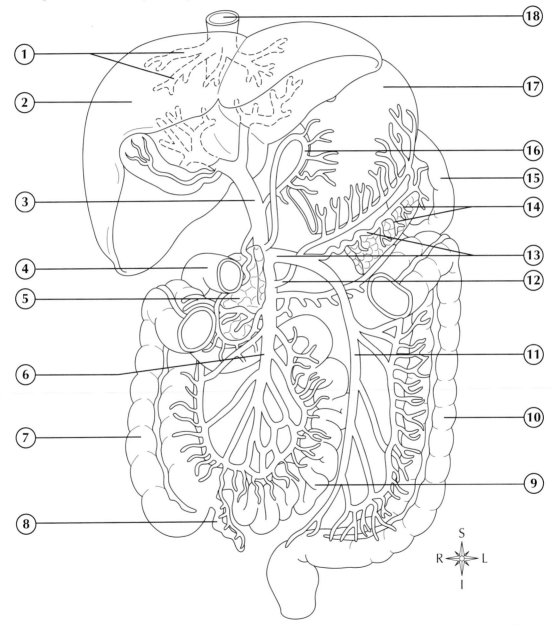

① Hepatic veins	⑤ Pancreas	⑨ Small intestine	⑬ Splenic vein	⑰ Stomach
② Liver	⑥ Superior mesenteric vein	⑩ Descending colon	⑭ Pancreatic veins	⑱ Inferior vena cava
③ Hepatic portal vein	⑦ Ascending colon	⑪ Inferior mesenteric vein	⑮ Spleen	
④ Duodenum	⑧ Appendix	⑫ Gastroepiploic vein	⑯ Gastric vein	

FETAL CIRCULATION

Circulation in the body before birth necessarily differs from circulation after birth for one main reason—fetal blood secures oxygen and food from maternal blood instead of from fetal lungs and digestive organs. Obviously, then, there must be additional blood vessels in the fetus to carry the fetal blood into close approximation with the maternal blood and return it to the fetal body. These structures are the two umbilical arteries, the umbilical vein, and the ductus venosus.

Color in the key and the corresponding structures.

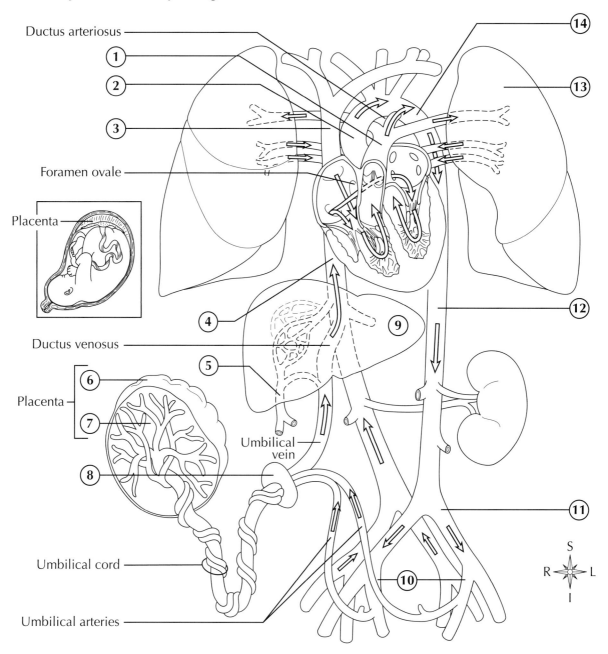

① Pulmonary trunk	⑤ Hepatic portal vein	⑨ Liver	⑬ Left lung
② Ascending aorta	⑥ Maternal side of placenta	⑩ Internal iliac arteries	⑭ Aortic arch
③ Superior vena cava	⑦ Fetal side of placenta	⑪ Common iliac artery	
④ Inferior vena cava	⑧ Fetal umbilicus	⑫ Abdominal aorta	

Copyright © 2014 by Mosby, an imprint of Elsevier Inc

CONDUCTION SYSTEM OF THE HEART

In the previous exercises, we learned that the heart consists of chambers and valves that move the blood through the heart to the lungs and to the rest of the body. In order for the heart to pump effectively, the impulses (action potentials) that trigger myocardial contraction must be coordinated carefully. This requires a system for generating rhythmic impulses and distributing them quickly to the different regions of the myocardium along impulse-conducting pathways. Without such a system, different regions of the myocardium (heart muscle) would be contracting too slowly and at slightly different rates. Four structures make up the core of the electrical conduction system of the heart:

1. Sinoatrial (SA) node
2. Atrioventricular (AV) node
3. AV bundle (bundle of His)
4. Subendocardial branches (Purkinje fibers)

In the diagram below, label and color each of the structures associated with the conduction system of the heart. Next, color in the direction of the electrical impulses represented by the arrows.

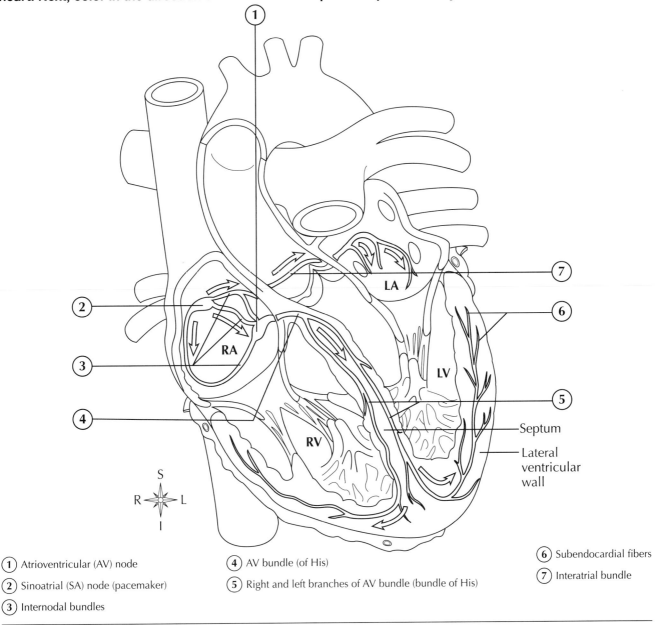

① Atrioventricular (AV) node

② Sinoatrial (SA) node (pacemaker)

③ Internodal bundles

④ AV bundle (of His)

⑤ Right and left branches of AV bundle (bundle of His)

⑥ Subendocardial fibers

⑦ Interatrial bundle

CARDIAC BARORECEPTORS

Receptors sensitive to changes in pressure (baroceptors) are located in two places near the heart. These two baroceptors are called the aortic and carotid baroceptors, and they send afferent nerve fibers to cardiac control centers in the medulla oblongata. These stretch receptors are located in the aorta and carotid sinus.

Color in the key and the corresponding structures.

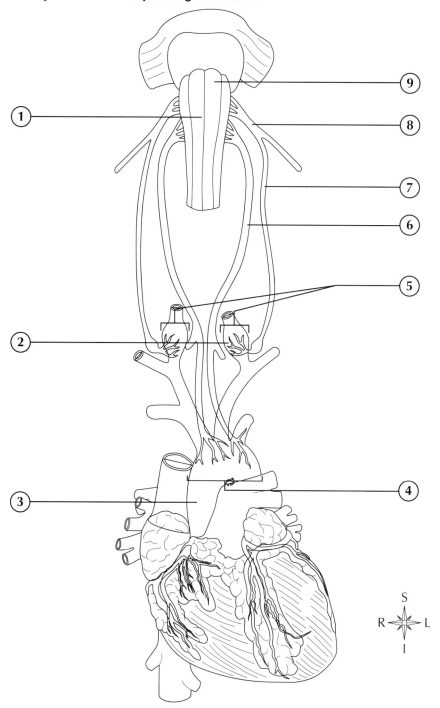

1. Cardiac control center
2. Carotid sinus
3. Aorta
4. Aortic baroreceptors
5. Carotid baroreceptors
6. Vagus (cranial nerve X)
7. Nerve of Hering
8. Glossopharyngeal nerve (cranial nerve IX)
9. Brainstem

PULSE

Pulse is defined as the alternate expansion and recoil of an artery. Two factors are responsible for the existence of a pulse that can be felt: (1) The intermittent burst of blood into the aorta, and (2) the elasticity of the arterial walls. The pulse can be felt wherever an artery lies near the surface of the body, and/or over a bone.

There are nine main pulse points that are typically palpable on every human. Six of the nine are critical in emergency situations where arterial bleeding is an issue (temporal, facial, common carotid, subclavian, brachial, and femoral.)

Use the table below to complete the blanks in the illustration.

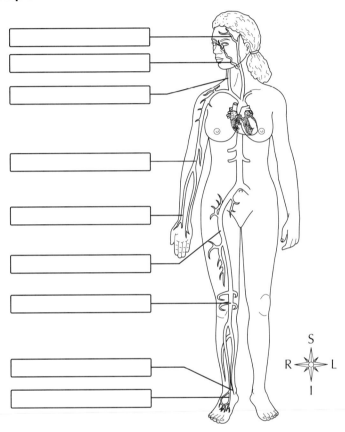

ARTERY	PALPATION DIRECTIONS
Radial	At wrist.
Superficial temporal	In front of ear (emergency) or above and to outer side of eye.
Carotid	Along anterior edge of sternocleidomastoid muscle at lower margin of thyroid cartilage. (Emergency location same, with pressure back against spinal column.)
Facial	At lower margin of mandible on line with corners of mouth, and in groove about a third of the way forward from angle. (Normal and emergency.)
Brachial	At bend of elbow along inner margin of biceps. (Emergency—few inches above elbow on inside of arm pressing against humerus.)
Femoral	In the middle of groin, where artery passes over pelvic bone.
Popliteal	Behind the knee.
Posterior tibial	Behind the medial malleolus.
Dorsalis pedis	On dorsum of foot.

CASE STUDY

Kyle (45 years old) finally gave in to his wife's insistence and stopped by his doctor's office. He had been having some minor chest pain for a couple of days, but he had been telling himself that the pain was just sore muscles caused by a recent weight-lifting workout. As Kyle described his symptoms to the nurse, he mentioned some chest pain, a little sweating, and slight nausea. As soon as the nurse heard these symptoms, she immediately left the room, returned with a wheelchair, and took Kyle to a different room to have his blood pressure, heart rate, and electrical activity of his heart measured (by performing an ECG). "What's going on?" he asked the doctor a few minutes later. "Based on your symptoms, we think you may have some blockage in your coronary arteries. We'd like to do an angiogram to see what's going on."

1. The doctor suspects the potential blockage is in what part of Kyle's body?
 A. His brain
 B. His liver
 C. His heart
 D. His neck

2. In the procedure room, the nurses began to prepare Kyle for a cardiac catheterization. Kyle was confused as to why they were cleaning his leg when it seemed like his heart was the problem. Into which artery will the catheter be inserted?
 A. Brachial
 B. Popliteal
 C. Tibial
 D. Femoral

3. After some dye was injected, the screen monitor showed that Kyle's right coronary artery was partially blocked. The surgeon entered a balloon through the catheter, which was then inflated to press against the sides of the artery to enlarge its diameter. Next, a metal stent was inserted to keep the artery open. The coronary arteries supply oxygen and nutrients for cardiac muscle contraction. Kyle's right coronary artery supplies the right side of the heart muscle, which nourishes his right atrium and right ventricle. Based on what you know about the anatomy of the heart, the right atrium and right ventricle (respectively) are responsible for:
 A. Receiving blood from the head; pumping blood to the body
 B. Receiving blood from the superior and inferior vena cava; pumping blood to the body
 C. Receiving blood from the superior and inferior vena cava; pumping blood to the lungs
 D. Receiving blood from the superior and inferior mesenteric arteries; pumping blood to the lungs

12 The Lymphatic System

The lymphatic system serves various functions in the body. The two most important functions of this system are maintenance of fluid balance in the internal environment and immunity. A third somewhat less important function is the absorption of lipids from digested food in the small intestine and their transport to the large systemic veins. The lymphatic system can be considered a component of the cardiovascular system because it consists of a moving fluid (lymph) derived from the blood and tissue fluid and a group of vessels (lymphatics) that return the lymph to the blood. In general, the lymphatic vessels that drain the peripheral areas of the body parallel the venous return.

In addition to lymph and the lymphatic vessels, the system includes various structures that contain lymphoid tissue, a type of reticular tissue that contains lymphocytes and other defensive cells. For example, lymph nodes, Peyer's patches (isolated nodules of lymphatic tissue in the intestinal wall), and nodules of the veriform appendix are all parts of the lymphatic system. Additional lymphoid structures include the tonsils, thymus, spleen, and bone marrow.

Although it serves as a transport system in the body by returning tissue fluid, proteins, fats, and other substances to the general circulation, lymph flow differs from the true circulation of blood seen in the cardiovascular system. Unlike the blood vessels, lymphatic vessels do not form a closed ring, or circuit, but instead begin blindly in the intercellular spaces of the soft tissue in the body.

In the diagram below, label and color each structure involved in fluid balance of the body in the lymphatic system, and the arrows depicting flow.

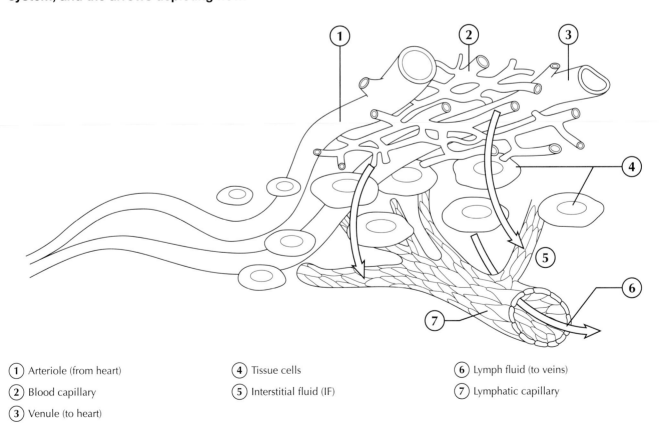

(1) Arteriole (from heart)

(2) Blood capillary

(3) Venule (to heart)

(4) Tissue cells

(5) Interstitial fluid (IF)

(6) Lymph fluid (to veins)

(7) Lymphatic capillary

PRINCIPAL ORGANS OF THE LYMPHATIC SYSTEM

The principal organs of the lymphatic system were briefly discussed in the chapter introduction. They include the tonsils, red bone marrow, thymus gland, spleen, cisterna chyli (origination of what eventually becomes the thoracic duct), and the lymph nodes. Note, we will look closely at the lymph nodes of the head and neck. While not technically considered organs, the right lymphatic duct and thoracic duct are inserted into this diagram for placement.

Fill in the key and then color in the corresponding structures.

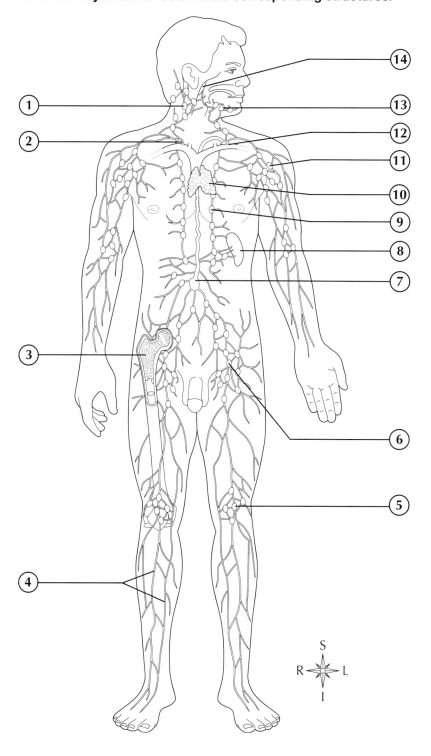

1. Cervical nodes
2. Right lymphatic duct
3. Red bone marrow
4. Lymphatic vessels
5. Popliteal nodes
6. Inguinal nodes
7. Cisterna chyli
8. Spleen
9. Parasternal nodes
10. Thymus
11. Axillary nodes
12. Thoracic duct
13. Submandibular nodes
14. Tonsils

LYMPH DRAINAGE

The right lymphatic duct drains lymph from the upper right quarter of the body into the right subclavian vein at its junction of the internal jugular vein. The thoracic duct drains lymph from the rest of the body into the left subclavian vein at its junction with the internal jugular vein.

In the full body diagram:

◯ Shade the areas of the body that are drained by the thoracic duct yellow

◯ Shade the areas drained by the right lymphatic duct orange

In the inset:

◯ Color the thoracic duct green

◯ Color the left and right subclavian veins blue

◯ Color the right lymphatic duct red

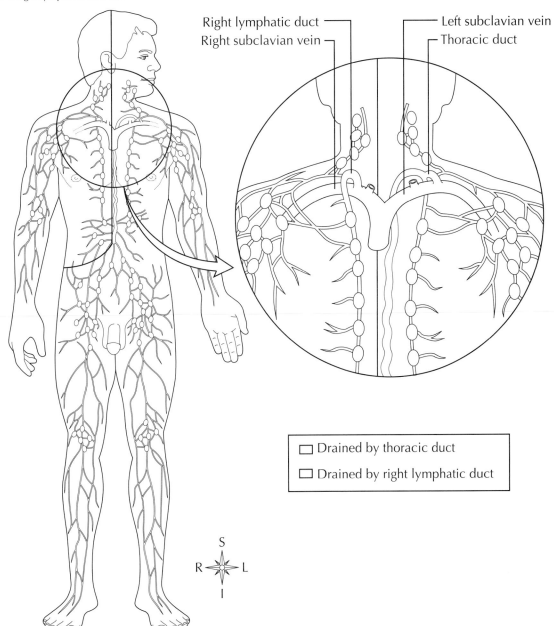

Right lymphatic duct ————
Right subclavian vein ┐

Left subclavian vein
Thoracic duct

☐ Drained by thoracic duct

☐ Drained by right lymphatic duct

S
R ⟵✴⟶ L
I

LYMPHATIC PUMP

Although there is no muscle working with the lymphatic vessels to force lymph onward, as the heart forces blood, lymph still manages to flow slowly and steadily. Lymph flows through the thoracic duct and reenters the general circulation at the rate of about three liters per day. This occurs despite the fact that most of the flow is against gravity. It moves through the system in the right direction because of the large number of valves that permit fluid flow only in the central direction. How does this happen? Through the external pressure of muscle contraction and relaxation. When we breathe, walk, exercise, receive massage, or engage in any other type of activity that causes muscle movement, we are "pumping" our lymphatic system.

In the diagram below, color each of the structures and arrows associated with the lymphatic pump and lymph movement. Follow the text below.

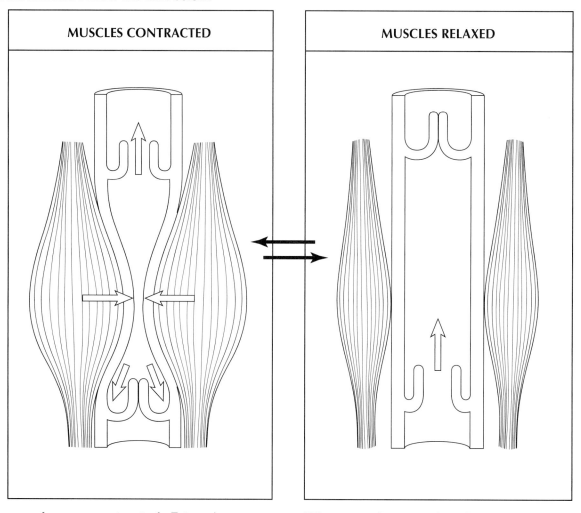

When muscles are contracted: External pressure from muscle contraction increases lymphatic pressure, pushing it past one-way lymphatic valves.

○ Color the muscles, arrows, and open valve red.

Simultaneously... Because the valves prevent backflow, the system becomes a pump that keeps lymph moving in one direction.

○ Color the closed valve and arrows blue.

○ Draw in and color the lymph yellow.

When muscles are relaxed: When the external muscles relax, the lymph moves into the open space via the lower lymphatic valve.

○ Color the muscles, arrow, and open valve red.

Simultaneously... The superior valve closes to prevent excessive movement of lymph.

○ Color the closed valve blue.

○ Draw in and color the lymph yellow.

Copyright © 2014 by Mosby, an imprint of Elsevier Inc

FUNCTIONS OF LYMPH NODES

Lymph nodes perform at least two distinct functions: hematopoiesis and defense. Hematopoiesis is the process of blood cell making. The lymphoid tissue of lymph nodes serves as the site of the final stages of maturation for some types of lymphocytes and monocytes that have migrated from the bone marrow. In addition, small aggregates of diffuse lymphoid tissue and other lymphatic cell types are found throughout the body, especially in connective tissues and other mucous membranes. For defense, the structure of the sinus channels within the lymph nodes slows the lymph flow through them. This gives the cells lining the channels time to remove the microorganisms and other injurious particles—soot, for example—from the lymph and phagocytose them. Lymph nodes physically stop particles from progressing farther in the body—a process called mechanical filtration. Because lymph nodes also make use of biological processes such as phagocytosis to destroy particles, biological filtration also occurs here.

EXTERNAL STRUCTURE OF A LYMPH NODE

Lymph nodes are oval- or bean-shaped structures. Some are as small as a pinhead. Others are as large as a lima bean. Each lymph node is enclosed by a fibrous capsule. Lymph moves into a node by way of afferent lymphatic vessels and emerges by one or more efferent vessels. To help remember the difference between afferent (or affect) and efferent (or effect), learn this: to "affect" is to make a difference to, or influence something; the "effect" is the change that results, or the consequences of an "affect." You will see these terms throughout anatomy and physiology, as well as in everyday life!

Fill in the key and the corresponding structures.

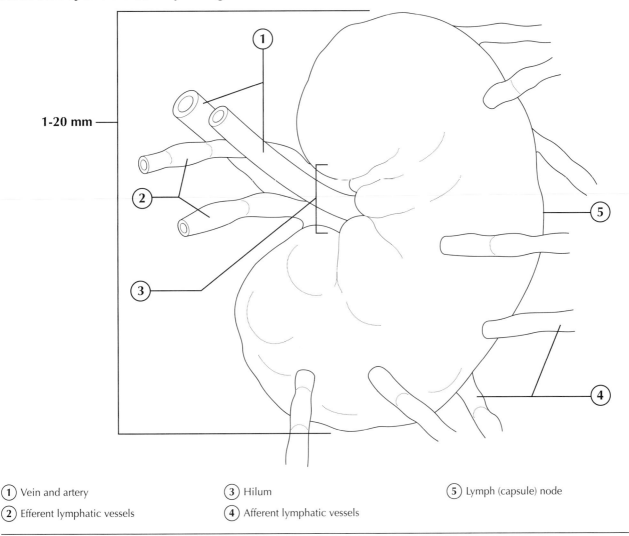

1-20 mm

(1) Vein and artery (3) Hilum (5) Lymph (capsule) node

(2) Efferent lymphatic vessels (4) Afferent lymphatic vessels

INTERNAL STRUCTURE OF A LYMPH NODE

The internal structure of a lymph node can appear to be very complex, but it is actually constructed similar to a "primitive" coffee maker. Think of a lymph node as a biological "coffee" filter placed along the paths of the afferent lymph vessels. Once lymph (like coffee) enters the node (or is placed on top of the filter), it "percolates" slowly through the spaces, being pushed through the node (filter) by interstitial fluid (water). The large particles in lymph (like coffee grounds) are made smaller by the force of the fluid through the filter. One-way valves in both afferent and efferent vessels keep lymph flowing in one direction. Fibrous septums (trabeculae) extend inward from the covering toward the center of the node and separate the cortical nodules. Each of these nodules is packed with lymphocytes (white blood cells), and in the center of the nodule, the germinal center. This is the very place where the role of fluid balance meets the role of immune function in the lymphatic system. We will discuss the immune system in the next chapter. For now, just understand that the germinal center forms, produces, and releases lymphocytes to help fight infection.

Fill in the key, then color in the corresponding structures. Once you have completed coloring, extend the arrows of the afferent vessels all the way through the node and out of the efferent lymph vessel.

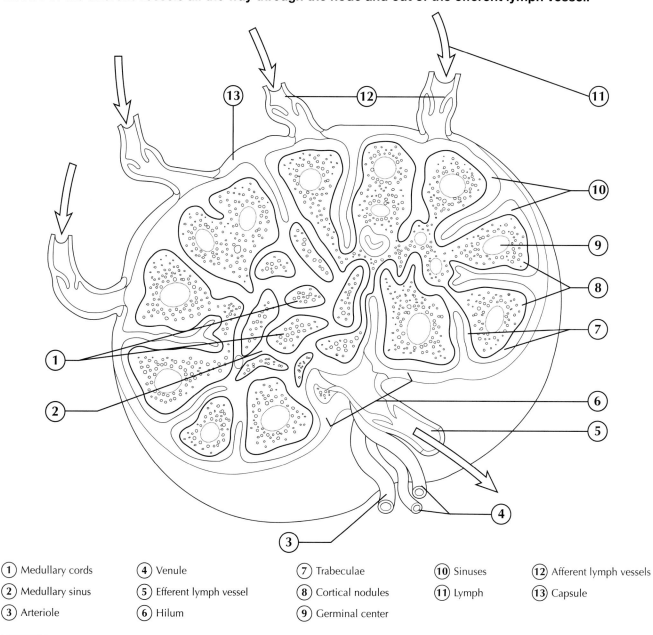

(1) Medullary cords	(4) Venule	(7) Trabeculae	(10) Sinuses	(12) Afferent lymph vessels
(2) Medullary sinus	(5) Efferent lymph vessel	(8) Cortical nodules	(11) Lymph	(13) Capsule
(3) Arteriole	(6) Hilum	(9) Germinal center		

LOCATION OF LYMPH NODES

With the exception of a comparatively few single nodes, most lymph nodes appear in clusters in certain areas. The groups of greatest clinical importance are represented in the table below.

NAME OF CLUSTER	LOCATION AND DRAINAGE
Periauricular	In front of the ear; these drain the superficial tissues and skin on the lateral side of the head and face.
Submental and Submandibular (Submaxillary)	In the floor of the mouth; these drain lymph from the nose, lips, and teeth.
Superficial Cervical	In the neck, along the sternocleidomastoid muscle; drain lymph from the head and neck after they have already passed through other nodes.
Superficial Cubital (Supratrochlear)	Above the bend of the elbow; drain lymph from the forearm.
Axillary	20–30 large nodes clustered deep within the underarm and upper chest; drain lymph from the upper arm, upper part of the thoracic wall, including the breast.
Iliac and Inguinal	In the pelvis and groin; drain lymph from the pelvic organs, legs, and external genitals.

LYMPHATIC DRAINAGE OF THE HEAD AND NECK

The head and neck contain many lymph nodes and associated lymph vessels that are often of clinical significance in certain infections and cancers.

Label and color the various lymph nodes which drain the head and neck.

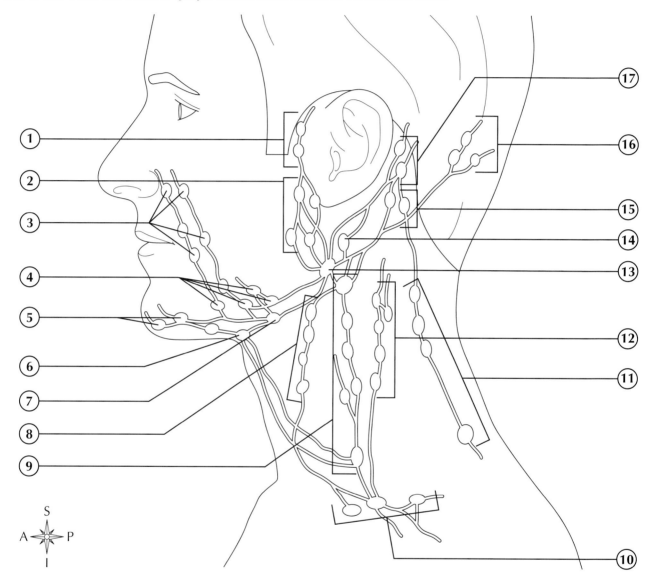

(1) Preauricular nodes

(2) Parotid nodes

(3) Facial nodes

(4) Submandibular nodes

(5) Submental nodes

(6) Suprahyoid node

(7) Thyrolinguofacial node

(8) Anterior deep and superficial cervical nodes

(9) Internal jugular chain

(10) Supraclavicular nodes

(11) Posterior superficial cervical chain

(12) Posterior cervical spinal nerve chain

(13) Retropharyngeal (tonsillar) node

(14) External jugular node

(15) Sternomastoid nodes

(16) Occipital nodes

(17) Posterior auricular (mastoid) nodes

LYMPHATIC DRAINAGE OF THE BREAST

Cancer of the breast is one of the most common forms of malignancy in women. Unfortunately, cancerous cells from a single "primary" tumor in the breast often spread to other areas of the body through the lymphatic system. Breast infections (mastitis) are also a serious health concern, especially among women who are nursing. Breast infections, like cancer, can also spread easily through the lymphatic pathways associated with the breast. The breast (mammary glands and surrounding tissues) is drained by two sets of lymphatic vessels: lymphatics that originate in and drain the skin over the breast with the exception of the areola and nipple, and lymphatics that originate in and drain the underlying substance of the breast itself, as well as the skin of the areola and nipple. Superficial vessels that drain lymph from the skin and surface areas of the breast converge to form a diffuse cutaneous lymphatic plexus (CLP). Communication between the CLP and large lymphatics that drain the secretory tissue and ducts of the breast occurs in the subareolar plexus (plexus of Sappey) located under the areola surrounding the nipple.

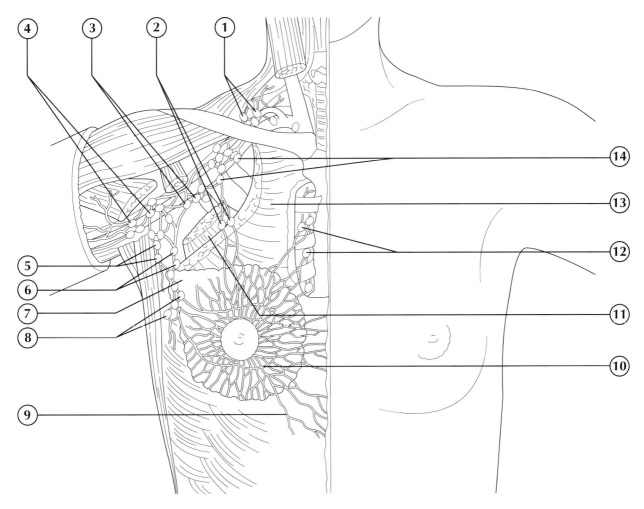

1. Supraclavicular nodes
2. Interpectoral (Rotter) nodes
3. Midaxillary nodes
4. Lateral axillary (brachial) nodes
5. Subscapular nodes
6. Anterior axillary (pectoral) nodes
7. Axillary tail
8. Paramammary nodes
9. Pathways to subdiaphragmatic nodes and liver
10. Cross-mammary pathways to opposite breast
11. Pectoralis minor muscle
12. Parasternal nodes
13. Pectoralis major muscle
14. Subclavicular nodes

Mosby's Anatomy and Physiology Coloring Book
Copyright © 2014 by Mosby, an imprint of Elsevier Inc

THE TONSILS

Masses of lymphoid tissue located in a protective ring under the mucous membranes in the mouth and back of the throat help to protect against bacteria that may invade tissues in the area around the openings between the nasal and oral cavities. This "pharyngeal lymphoid ring" is better known as the tonsils. The palatine tonsils are located on each side of the throat. The pharyngeal tonsils (adenoids when swollen) are near the posterior opening of the nasal cavity. The lingual tonsil is near the base of the tongue. Outside of the ring, there is a fourth type of tonsil (tonsillar crypt) that is located near the opening of the eustachian tubes. The tonsils serve as the first line of defense from the exterior.

Fill in the color key and then color in the corresponding structures.

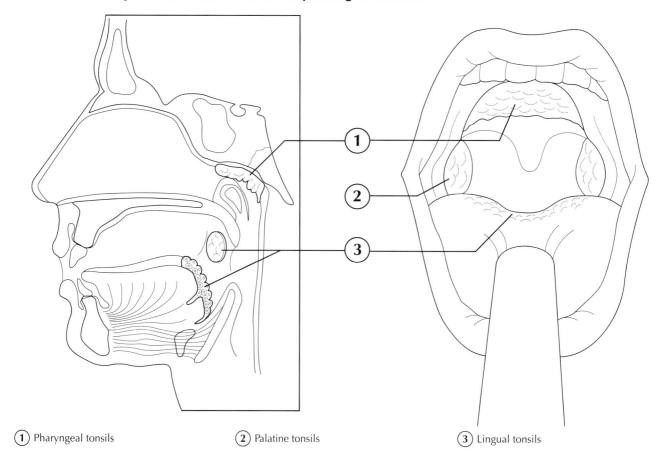

(1) Pharyngeal tonsils (2) Palatine tonsils (3) Lingual tonsils

THE THYMUS

The thymus gland is an unpaired organ consisting of two pyramidal lobes with delicate and finely lobulated surfaces. It is located in the mediastinum, extending back into the neck as far as the lower edge of the thyroid gland, and inferiorly as far as the fourth costal cartilage. Interestingly, its size relative to the rest of the body is largest at the age of two. Its absolute size is largest at puberty when it weighs approximately 35–40 grams (less than a pound). From that point on, it gradually atrophies until it may be largely replaced by fat, less than 10 grams, and is barely recognizable. It serves as the final site of lymphocyte development before birth. After birth, it begins to secrete a group of hormones collectively called *thymosin* and other regulators that enable leukocytes to develop into mature T cells. Because T cells attack foreign or abnormal cells, the thymus functions as an important part of the immune mechanism.

In the figure below, identify the thymus, as well as the surrounding structures and color each structure a different color.

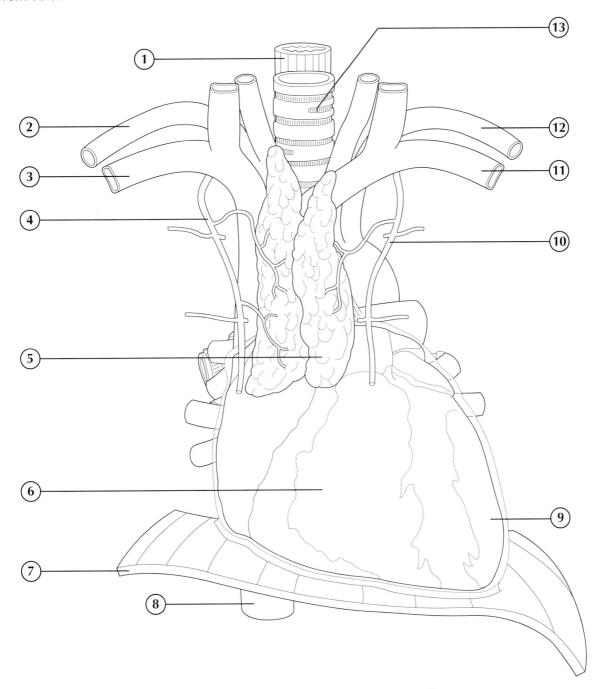

(1) Pharynx

(2) Right common carotid artery

(3) Superior vena cava

(4) Right internal thoracic artery

(5) Thymus gland

(6) Heart

(7) Diaphragm

(8) Aorta

(9) Pericardial sac

(10) Left internal thoracic artery

(11) Superior vena cava

(12) Left common carotid artery

(13) Trachea

THE SPLEEN

The spleen is located directly below the diaphragm, just above most of the left kidney and the descending colon, and behind the fundus of the stomach. The functions of the spleen include defense, hematopoiesis, RBC and platelet destruction, and to serve as a blood reservoir. At any given point in time, the pulp of the spleen and its venous sinuses contain a considerable amount of blood (approximately 350 mL). This is important because in less than one minute after sympathetic stimulation, the spleen can rapidly force 200 mL of its blood reserve into circulation. This "self-transfusion" occurs, for example, as a response to stress imposed by hemorrhage or by a fight-or-flight response to a physical threat. Although the spleen's functions make it very useful, it is not a vital organ. In fact, because of the large volume of blood that is in splenic reserve, accidental rupture could cause significant internal bleeding and death.

Fill in the key and then color in the corresponding structures.

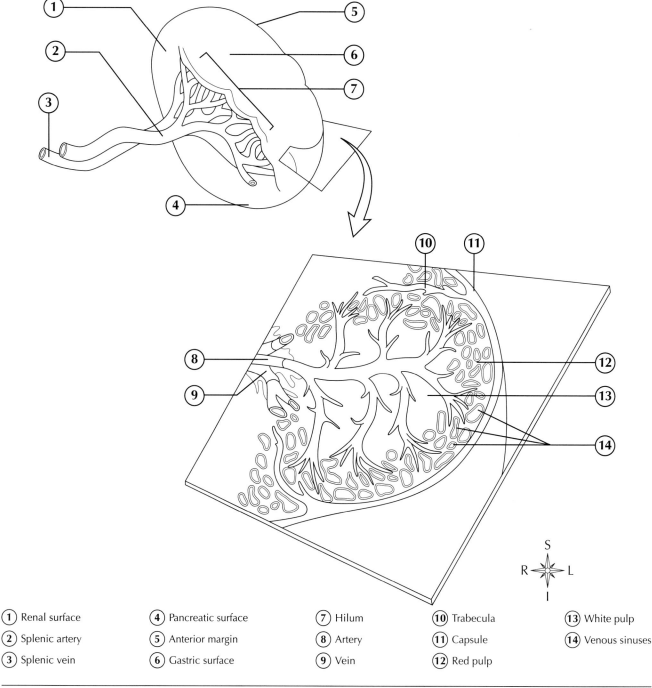

(1) Renal surface	(4) Pancreatic surface	(7) Hilum	(10) Trabecula	(13) White pulp
(2) Splenic artery	(5) Anterior margin	(8) Artery	(11) Capsule	(14) Venous sinuses
(3) Splenic vein	(6) Gastric surface	(9) Vein	(12) Red pulp	

Mosby's Anatomy and Physiology Coloring Book
Copyright © 2014 by Mosby, an imprint of Elsevier Inc

CASE STUDY

Courtney, a dental hygiene student, was in Ghana with several of her classmates. Each summer, the students had an opportunity to combine study abroad with volunteering at a dental clinic in Accra. On their second day at the clinic, Courtney met Juba, a local farmer's daughter. Juba's right foot and leg below the knee were extremely swollen, seemingly blown up like a balloon. In contrast, Juba's left leg had no swelling at all and appeared quite normal. One of the local dentists told Courtney that Juba had elephantiasis, a type of lymphedema caused by a blockage.

1. With Juba's condition, what vessels are blocked?
 A. Arteries
 B. Veins
 C. Capillaries
 D. Lymphatic vessels
2. Which of the following is NOT a function of the lymphatic system?
 A. Removing excess fluid from the blood
 B. Absorbing lipids from the small intestine
 C. Returning fluid from the interstitial areas back to the bloodstream
 D. Filtering lymph to remove foreign organisms and particulates
3. Before Juba's leg became affected by this disorder, the lymph would have passed first through which nodes:
 A. Cervical
 B. Axillary
 C. Inguinal
 D. Mediastinal

13 Immune System

Enemies of many types and in great numbers assault the body during a lifetime. Among the most threatening are hordes of microorganisms. We live our lives in a virtual sea of protozoa, fungi, bacteria, viruses, and other pathogens. So ever-present and potentially lethal are these small but formidable foes that no newborn could live through infancy, much less survive to adulthood, without effective defenses against them. We are also threatened by enemies from within. Inside the body, abnormal cells appear on an irregular but continual basis. If allowed to survive, these abnormal cells reproduce and form a tumor. At the very least, a tumor can damage surrounding tissues and become life-threatening as it continues to enlarge. There is always the possibility that a tumor could become cancerous and spread (metastasize) to other locations within the body. Without an internal "security force" to deal with such abnormal cells when they first appear, we would live very short lives. This chapter presents a brief overview of the system that provides defenses against both external and internal enemies.

Before we begin studying the specifics of immunity, we need to spend a moment mapping out the overall defensive strategy of the immune system.

It is important to note that cells, viruses, and other particles have unique molecules and groups of molecules on their surfaces that can be used to identify them. These molecular markers are called antigens (think of an insignia on a military aircraft). The insignia is very important during battles because it identifies if the aircraft is on "our side" or an "enemy." Likewise, our cells have unique markers embedded in our plasma membranes that identify each of our cells as "self." Foreign cells or particles have "non-self" molecules that serve as recognition markers for our immune system.

In our society, any good security force employs numerous and varied strategies to guard its territory and take action if necessary. So, too, does the body's "society of cells" employ a system that uses many different kinds of mechanisms to ensure the integrity and survival of the internal environment. All of these defense mechanisms can be categorized into one of two major categories: innate (nonspecific) immunity and adaptive immunity.

Okay generals, let's review our strategy and our troops!

INNATE AND ADAPTIVE IMMUNITY

Innate (meaning inborn or natural) immunity is "in place" before a person is exposed to the enemy particles, viruses, pathogens, and so on. It is considered to be "nonspecific" immunity because it is very generalized in what it attacks. Its defensive weapons are barriers, complements, interferon, phagocytes, and a process called inflammation. Adaptive immunity, on the other hand, is more like a team of snipers. This type of immunity recognizes specific threats and then adapts to the threats (or responds) by targeting activity against these agents and these agents alone. You will note in the diagram below that innate (nonspecific) immunity has a relatively quick reaction time, whereas its counterpart, adaptive (specific) immunity, takes significantly longer. This is due to the fact that it takes adaptive immunity agents some time to recognize their target. But when they do, they react with sufficient force to overcome the threat, at least on their first exposure.

Mosby's Anatomy and Physiology Coloring Book
Copyright © 2014 by Mosby, an imprint of Elsevier Inc

In the diagram below, shade in the various components of innate and adaptive immunity. To differentiate between innate and adaptive immunity, use two different colors to fill in the letters.

INNATE IMMUNITY

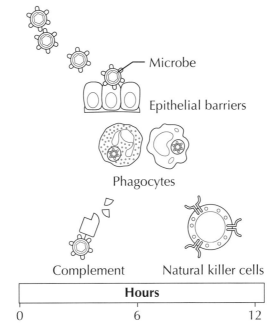

Microbe

Epithelial barriers

Phagocytes

Complement　　　Natural killer cells

| **Hours** | | |
| 0 | 6 | 12 |

ADAPTIVE IMMUNITY

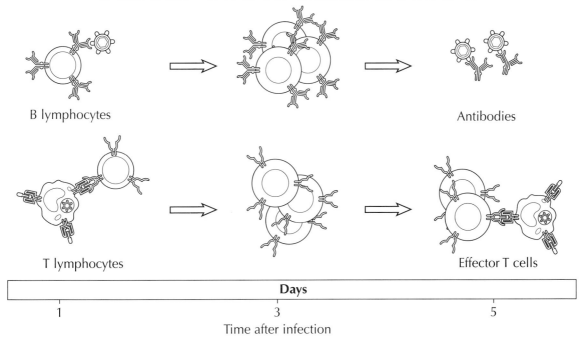

B lymphocytes

Antibodies

T lymphocytes

Effector T cells

| **Days** | | |
| 1 | 3 | 5 |

Time after infection

Mosby's Anatomy and Physiology Coloring Book
Copyright © 2014 by Mosby, an imprint of Elsevier Inc

INNATE IMMUNITY—A CLOSER LOOK

As we learned in the previous exercise, we are born with innate immunity, and that allows us to overcome the on-slaught of bacteria, protozoa, viruses, and so on that we face each and every day. Innate immunity appears in the human body with five different approaches, and we need to have an understanding of each of these approaches so that we can help support the "troops."

APPROACHES	INNATE IMMUNITY
	Skin and mucous membranes Fluids
	Complement Bacteria Rupture
	Virus Viral invasion Interferon released Cells protected
	Redness, swelling, pain

Using the pictures as clues, fill in the correct approach. Your choices appear below.

Inflammation

Barriers

Promotes phagocytosis and inflammation; causes bacterial cells to rupture

Remove debris and pathogens

Interferon

LINES OF DEFENSE

There are three main lines of defense utilized by the body to protect itself from foreign or abnormal cells causing damage to its environment.

1. First Line
 Mechanical barriers: Cutaneous membrane (skin) and mucous membranes form a continuous wall that separates the internal and external environment.
 Chemical barriers: Secretions such as sebum, mucus, enzymes, and acids chemically inhibit the activity of pathogens.

2. Second Line
 Inflammatory response: Isolates the pathogens and stimulates the speedy arrival of immune cells. Fever, which happens as a result of the inflammatory response, may enhance immune reactions and inhibit pathogens.
 Phagocytosis: Ingestion and digestion of pathogens by phagocytic cells such as neutrophils and macrophages.

3. Third Line
 Specific immune responses: Plasma proteins cause lysis of foreign cells (can be triggered by innate or adaptive), and membrane receptors recognize nonspecific patterns in microbial molecules that trigger many of the responses listed above.
 Natural killer cells: Lymphocytes that kill cells infected with viruses and tumor cells.

Fill in the key and then the corresponding parts of the illustration.

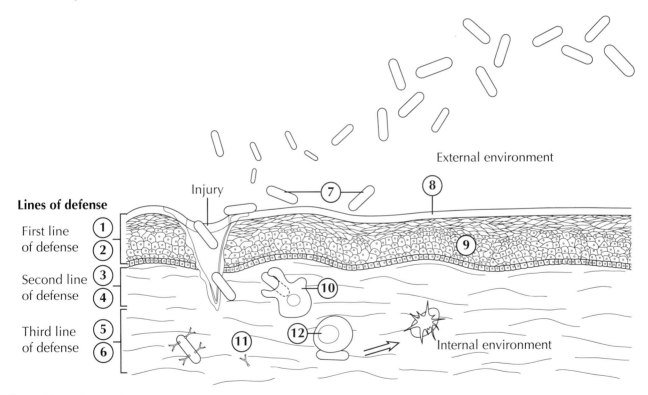

LINES OF DEFENSE

First line of defense	**Second line of defense**	**Third line of defense**		
① Mechanical barriers	③ Inflammation response	⑤ Specific immune responses	⑦ Bacteria	⑩ Macrophage
② Chemical barriers	④ Phagocytosis	⑥ Natural killer cells	⑧ Secretion	⑪ Antibody
			⑨ Cutaneous or mucous membrane	⑫ T cell

THE INFLAMMATORY RESPONSE

If bacteria or other invaders break through the chemical and mechanical barriers formed by the membranes and their secretions, the body has a second line of defense at the ready. When tissue damage occurs, a host of responses counteract the injury and promote a return to normalcy. The "host of responses" is the cumulative action that together creates the inflammatory response. Our diagram below breaks the inflammatory response into eight steps.

Follow the eight-step inflammatory response below as it occurs when one has a splinter in a finger. Color the arrow of each step a different color, using the key below.

○ Phase 1: Entry of bacteria on the splinter of wood

○ Phase 2: Tissue damage occurs

○ Phase 3: Release of chemical mediators (complement, histamine, etc.)

○ Phase 4a: Chemotaxis (neutrophils and macrophages attract to area)
4b: Vasodilation increases blood flow to area (causes redness and warmth)
4c: Increased capillary permeability (causes swelling, which causes pain)

○ Phase 5: Increased number of phagocytes in the area

○ Phase 6: Offending agents are phagocytized

○ Phase 7: Either no or some bacteria remain

○ Phase 8: If no bacteria remain, tissue is repaired; if some bacteria remain, phase 3 reinitiates

PHAGOCYTOSIS OF BACTERIA

A major component of the body's second line of defense is the mechanism of phagocytosis—the ingestion and destruction of microorganisms or other small particles. There are many types of phagocytes in the body. When phagocytes approach a microorganism, they extend footlike projections (pseudopods) toward it. Soon, the pseudopods encircle the organism and form a complete sac, called a phagosome, around it. The phagosome then moves into the interior of the cell, where a lysosome fuses with it. The contents of the lysosome, chiefly digestive enzymes and hydrogen peroxide, drain into the phagosome and destroy the microorganisms within it. Phagocytes are classified as innate agents because they defend us against a large variety of pathogens. They also, however, cross over to play an important role in adaptive immunity. After digesting the pathogen, the phagocyte will often process the proteins and display bits of the protein (peptides) on the surface of the phagocyte. These peptides are then recognized by antigens, thus possibly triggering an adaptive immune response.

The diagram below illustrates the phagocytosis of bacteria. Beginning at step 1, label the various structures involved in phagocytosis and color each. Make sure to shade in the arrows different colors to visualize the various steps of phagocytosis.

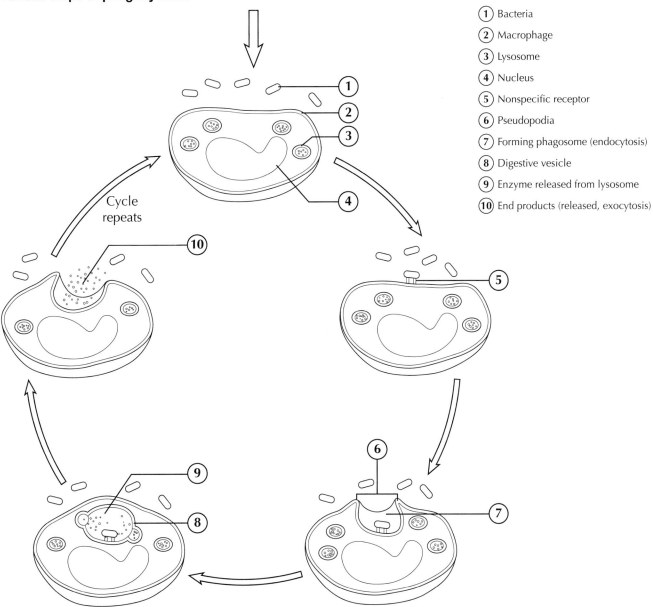

1. Bacteria
2. Macrophage
3. Lysosome
4. Nucleus
5. Nonspecific receptor
6. Pseudopodia
7. Forming phagosome (endocytosis)
8. Digestive vesicle
9. Enzyme released from lysosome
10. End products (released, exocytosis)

Cycle
repeats

OVERVIEW OF ADAPTIVE IMMUNITY

We have discussed innate, or nonspecific, immunity. Now it's time to get more familiar with our "special forces"—adaptive immunity, or specific immunity. This third line of defense is orchestrated by two different classes of a type of white blood cell (WBC) called the lymphocyte.

Lymphocytes are first formed in the red bone marrow of the fetus. Like all blood cells, they derive from hemopoietic stem cells. The stem cells destined to become lymphocytes of the adaptive immune system follow two developmental paths and differentiate into two different major classes of lymphocytes: B lymphocytes (cells) and T lymphocytes (cells).

B cells do not attack pathogens but instead produce antibodies that attack the pathogens, or direct other cells, such as phagocytes, to attack. (Think "Those who can't, teach." This will make sense later.)

B cells are often classified as antibody-mediated immunity.

T cells attack pathogens more directly, and therefore they are often classified as cell-mediated immunity.

Remember when we learned about phagocytes earlier in the chapter? If so, you'll remember that lymphocytes express proteins on their surfaces (surface markers). This becomes very important in adaptive immunity. Adaptive immunity requires activation of lymphocyte populations, which then begin their immune attack of specific antigens (or cells/viruses bearing those antigens).

Let's look at a few graphics that will reinforce your understanding visually.

DEVELOPMENT OF B CELLS AND T CELLS

Both B and T lymphocytes (cells) originate from stem cells in the red bone marrow of a fetus. Pre-B cells, which are formed by dividing stem cells, develop in the "bursa equivalent" tissues in the yolk sac, fetal liver, and bone marrow. Likewise, pre-T cells migrate to the thymus, where they continue developing. Once they are formed, B and T cells circulate to the lymph nodes and spleen.

Color each of the structures different colors and trace the development cycle of these cells. Fill in each box with the correct label.

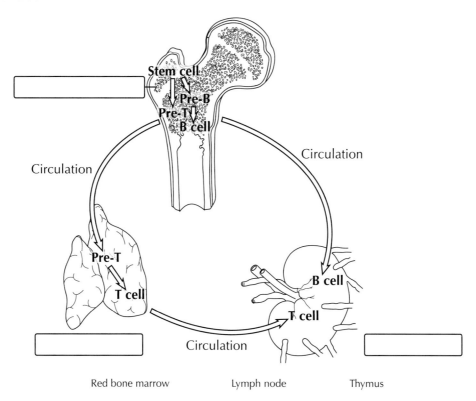

Red bone marrow Lymph node Thymus

B CELLS AND ANTIBODY-MEDIATED IMMUNITY

The development of the lymphocytes called B cells occurs in two stages. In humans, the first stage of B cell development is in the yolk sac and fetal liver, then later in the red bone marrow. After completing the first developmental stage, the B cells are then known as naive B cells. These cells synthesize antibody molecules but secrete few if any of them. Instead, they insert on the surface of their plasma membranes perhaps 100,000 antibody molecules. The combining sites of these surface antibody molecules serve as receptors for a specific antigen if encountered. The second major stage of B cell development occurs when the naive B cells become activated. Activation of a B cell must be initiated by an encounter with a naive B cell and its specific antigen (one whose epitopes fit the combining sites of the B cell's surface antibodies).

A series of mitotic divisions occur, thus producing a family of identical B cells or plasma cells. Plasma cells synthesize and secrete huge amounts of antibodies. Memory B cells do not secrete antibodies, but if they are later exposed to the antigen that triggered their formation, they produce more plasma cells.

Using the information above as a guide, fill in the spaces in the chart on the left with the missing content on the right.

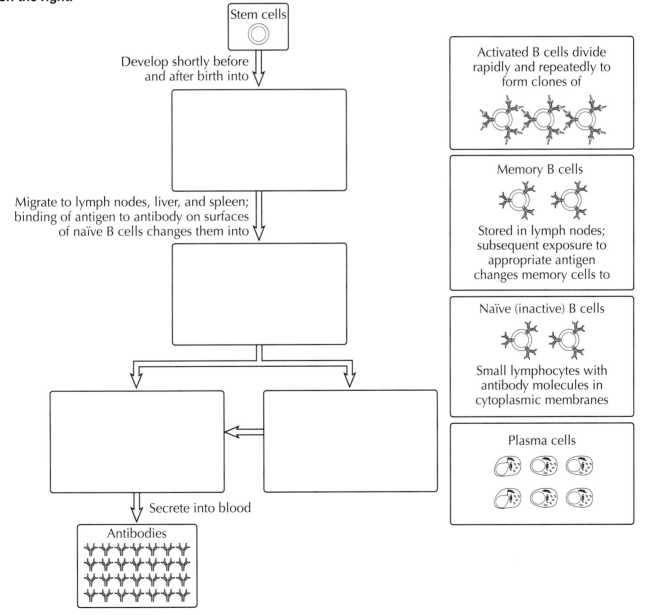

T CELLS AND CELL-MEDIATED IMMUNITY

T cells are lymphocytes that have made a detour through the thymus gland before migrating to the lymph nodes and spleen. Each T cell, like each B cell, displays antigen receptors on its surface membrane. When an antigen, preprocessed and presented by phagocytes, encounters a naive T cell whose surface receptors fit the antigen's epitopes, the antigen binds to the T cell's receptors. In antibody-mediated immunity (B cells), the antibodies can react to soluable antigens dissolved in the plasma; in cell-mediated immunity, the T cells can only react to proteins on the surfaces of infected cells. Literally, this means that T cells can only react to infected cells or those that have already engulfed the antigen. Once a T cell becomes sensitized by the presence of an antigen, the T cell divides repeatedly to form a clone of identical sensitized T cells that form effector T cells and memory T cells. Effector T cells include cytotoxic T cells, also known as killer T cells. Memory T cells remain in the red bone marrow until they produce additional active T cells.

Using the information above as a guide, fill in the spaces in the chart on the left with the missing content on the right.

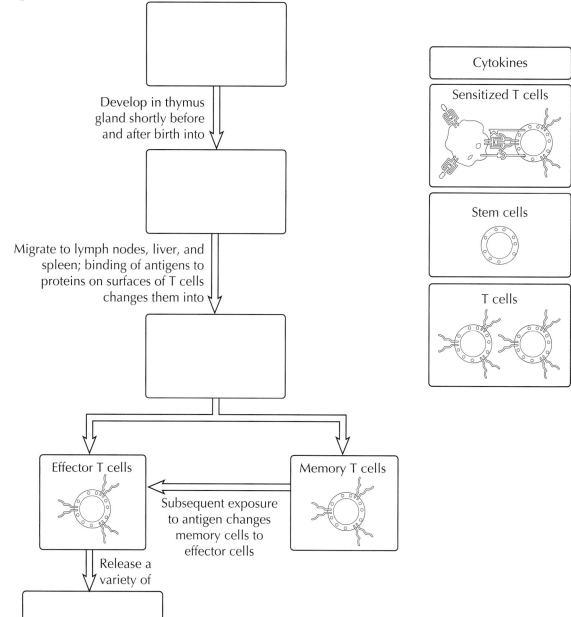

LYMPHOCYTE FUNCTIONS

The diagram below summarizes the main functions of the major classes of lymphocytes. B and T lymphocytes participate in adaptive immunity and natural killer cells participate in innate immunity. Because there are many different names to identify the same basic structures, the immune system cells can be somewhat overwhelming. This simplified chart will help reinforce your understanding and provide a gauge of what you have retained from the previous sections in this chapter.

In the table below, fill in the proper term based on the descriptions. Review previous graphics in this chapter if necessary.

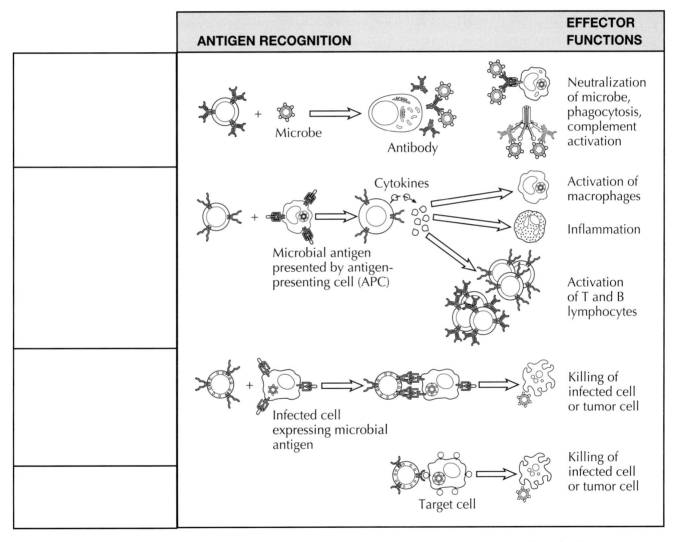

	ANTIGEN RECOGNITION	EFFECTOR FUNCTIONS
	Microbe Antibody	Neutralization of microbe, phagocytosis, complement activation
	Microbial antigen presented by antigen-presenting cell (APC) Cytokines	Activation of macrophages Inflammation Activation of T and B lymphocytes
	Infected cell expressing microbial antigen	Killing of infected cell or tumor cell
	Target cell	Killing of infected cell or tumor cell

Natural killer (NK) cell B lymphocyte Cytotoxic T lymphocyte Helper T lymphocyte

MECHANISMS OF HIV INFECTION

Immune deficiency is the failure of immune system mechanisms to defend against pathogens. Immune system failure usually results from disruption of lymphocyte function. The chief characteristic of immune deficiency is the development of unusual or recurring severe infections or cancer. Although immune deficiency by itself does not cause death, the resulting infections or cancer can.

Acquired immune deficiency develops after birth and is not related to genetic defects. Many factors can contribute to acquired immune deficiency: nutritional deficiencies, immunosuppressive drugs, or other medical treatments, trauma, stress, or viral infection. One of the best-known examples of acquired immune deficiency is acquired immune deficiency syndrome (AIDS). This syndrome is caused by the human immunodeficiency virus, or HIV. HIV is a retrovirus containing RNA that produces its own DNA inside of cells.

The graphic below visually describes the mechanism of HIV infection in eight steps. Label the various structures involved in HIV infection using the eight step boxes as a guide. Labels are below.

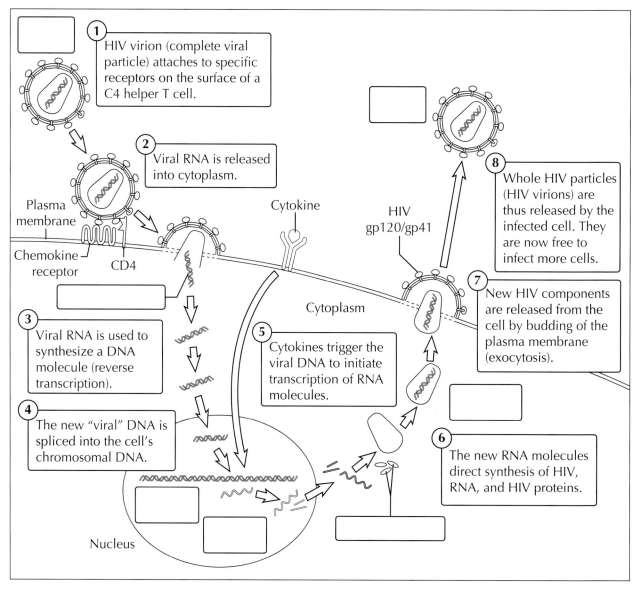

1. HIV virion (complete viral particle) attaches to specific receptors on the surface of a C4 helper T cell.

2. Viral RNA is released into cytoplasm.

Plasma membrane

Chemokine receptor CD4

Cytokine

HIV gp120/gp41

8. Whole HIV particles (HIV virions) are thus released by the infected cell. They are now free to infect more cells.

3. Viral RNA is used to synthesize a DNA molecule (reverse transcription).

4. The new "viral" DNA is spliced into the cell's chromosomal DNA.

Cytoplasm

5. Cytokines trigger the viral DNA to initiate transcription of RNA molecules.

7. New HIV components are released from the cell by budding of the plasma membrane (exocytosis).

6. The new RNA molecules direct synthesis of HIV, RNA, and HIV proteins.

Nucleus

HIV viron HIV RNA genome HIV DNA provirus HIV RNA transcript

HIV proteins HIV core structure New HIV viron

Copyright © 2014 by Mosby, an imprint of Elsevier Inc

CASE STUDY

Karl remembered getting the flu last winter. Coughing, fever, body aches, watery eyes, and fatigue—he felt awful! This year, he was going to get a flu vaccination, but he didn't understand how it worked. His doctor explained that a flu vaccine is a combination of several inactivated (killed) viruses injected into muscles of your arm. No live viruses are injected. Some people have a mild immune reaction that can be mistaken for the flu, but this is not typical.

1. Which of Karl's cells will respond to the flu antigens introduced?
 A. Erythrocytes
 B. Thrombocytes
 C. Lymphocytes
 D. Platelets
2. Karl had a fever during his previous flu that was caused by the release of _____ molecules, which help increase his body's "set point" to higher than normal.
 A. Vulcanogens
 B. Histamine
 C. Pyrogens
 D. Nanobodies
3. What would you call the specific type of immunity Karl developed as a result of the vaccination?
 A. Innate immunity
 B. Artificial immunity
 C. Inter-antigen immunity
 D. Intra-antigen immunity

14 Respiratory System

The respiratory system functions as an air distributor and a gas exchanger so that oxygen can be supplied to and carbon dioxide can be removed from the body's cells. This is not as simple as inhaling and exhaling. Because most of our trillions of cells lie too far away from air to exchange gases directly, air must first exchange gases with blood; the blood must circulate; and finally, the blood and cells must exchange gases. Clearly, oxygen is the star of the gas exchange, but just as important is the removal of carbon dioxide. All parts of the respiratory system function as air distributors except the microscopic-sized sacs called alveoli. In addition to exchanging gases, the system also filters, warms, and humidifies the air we breathe. The respiratory system helps to produce sounds, including spoken words. It makes the sense of smell possible and plays a very important role in the regulation of pH in the body.

STRUCTURAL PLAN OF THE RESPIRATORY SYSTEM

In order to allow for a more clear understanding of the respiratory system structures, we will divide them into two separate tracts, the upper and the lower respiratory tracts. The organs of the upper respiratory tract include those organs located outside of the thorax: nose, nasophayrnx, oropharynx, laryngophayrnx, and larynx. The organs of the lower respiratory tract are located almost entirely within the thorax: trachea, bronchial tree, and the lungs. There are several accessory structures serving the respiratory system, including the oral cavity, rib cage, and respiratory muscles, including the diaphragm.

Fill in the key and then color in the corresponding structures.

(1) Upper respiratory tract
(2) Lower respiratory tract
(3) Nasal cavity
(4) Pharynx
(5) Nasopharynx
(6) Oropharynx
(7) Laryngopharynx
(8) Larynx
(9) Trachea
(10) Left and right primary bronchi
(11) Bronchioles
(12) Alveoli
(13) Alveolar duct
(14) Bronchioles
(15) Capillary
(16) Alveolar sac

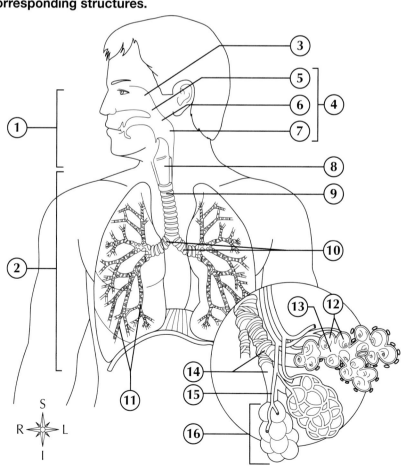

Mosby's Anatomy and Physiology Coloring Book
Copyright © 2014 by Mosby, an imprint of Elsevier Inc

ORGANS AND ACCESSORY STRUCTURES OF THE UPPER RESPIRATORY TRACT

The organs of the upper respiratory tract include the nose, the pharynx, and their associated structures. Accessory organs in the upper respiratory tract include the paranasal sinuses, larynx, and vocal cords. We will review these structures in the next few sections.

Fill in the key and then color in the corresponding structures.

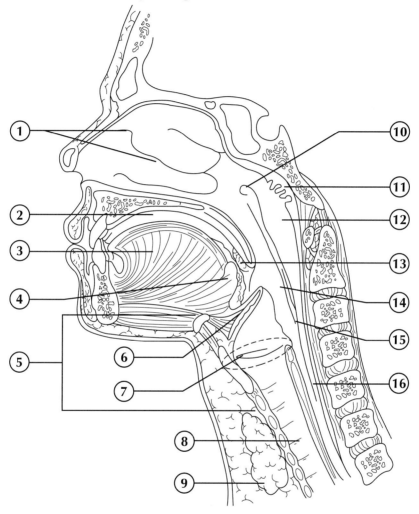

(1) Nasal cavities (5) Larynx (9) Thyroid gland (13) Palatine tonsil

(2) Oral cavity (6) Epiglottis (10) Auditory tube (Eustachian tube) (14) Oropharynx

(3) Tongue (7) Vocal cords (11) Pharyngeal tonsil (adenoids) (15) Laryngopharynx

(4) Lingual tonsil (8) Trachea (12) Nasopharynx (16) Esophagus

LARYNX, THYROID CARTILAGE, AND VOCAL CORDS

The larynx (voice box) lies between the root of the tongue and the upper end of the trachea, just below and in front of the lowest part of the pharynx. The triangle-shaped larynx consists largely of cartilages that are attached to one another and to surrounding structures by muscles or by fibrous and elastic tissue. The cavity of the larynx extends from its triangle-shaped inlet at the epiglottis to the circular outlet at the lower border of the cricoid cartilage. Two folds are located inside of the larynx: upper folds are called false vocal folds; the lower pair serve as the vocal folds, which produce sounds needed for speech and other vocalizations. The vocal folds and the space between them are together designated as the glottis.

Mosby's Anatomy and Physiology Coloring Book
Copyright © 2014 by Mosby, an imprint of Elsevier Inc

Color in the key and then the corresponding structures.

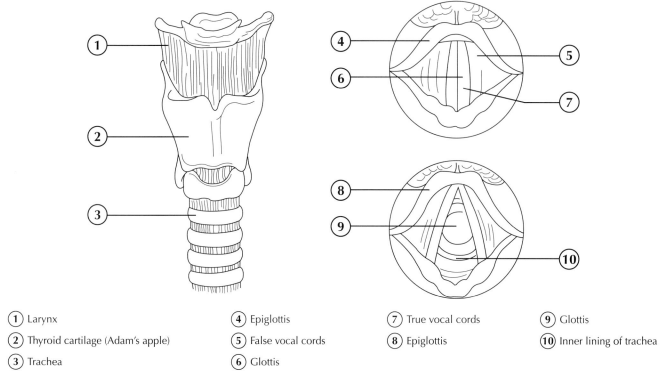

① Larynx ④ Epiglottis ⑦ True vocal cords ⑨ Glottis
② Thyroid cartilage (Adam's apple) ⑤ False vocal cords ⑧ Epiglottis ⑩ Inner lining of trachea
③ Trachea ⑥ Glottis

THE PARANASAL SINUSES

The paranasal sinuses are air-containing spaces that lighten the weight of the skull and open into the nasal cavity. If necessary, the sinuses can also drain contents into the nasal cavity. They are named for the skull bones in which they are located. The four pairs of nasal sinuses are the frontal sinuses, maxillary sinuses, ethmoid sinuses, and sphenoid sinuses. Like the nasal cavity, each paranasal sinus is lined with respiratory mucosa. The mucous secretions produced in the sinuses are continually being swept into the nose by the ciliated surface of the respiratory membrane.

Fill in the key and then color in the corresponding structures.

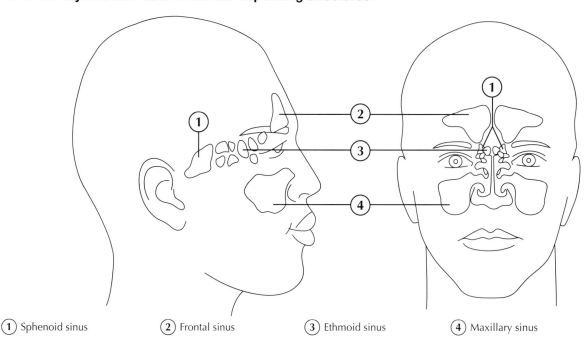

① Sphenoid sinus ② Frontal sinus ③ Ethmoid sinus ④ Maxillary sinus

ORGANS OF THE LOWER RESPIRATORY TRACT

The lower respiratory tract is almost entirely contained in the thorax, or chest. The trachea, bronchi, alveoli, and lungs make up the organs of the lower respiratory tract. Because the lungs are considered a vital organ and are in close proximity with the heart, special care is taken to protect them. The bony case, which protects these vital organs, includes the clavicles, the scapula, the thoracic cage, and the thoracic vertebrae. The layer of protective mucus that covers a large portion of the membrane that lines the respiratory tree serves as the most important air purification system. More than 125 mL (about half a cup) of respiratory mucus is produced daily. It forms a continuous sheet, called a mucus blanket, that covers the lining of the air distribution tubes in the respiratory tree.

Study the table and label the illustration using the information as your guide.

	STRUCTURE	DESCRIPTION	FUNCTION
	Trachea	Also known as the windpipe; extends from larynx to primary bronchi; supported by c-shaped cartilage rings; lined with respiratory mucosa.	Conducts air between trachea and lungs; ciliary escalator removes contaminants.
	Bronchi	23 levels of treelike branching of airways; supported by cartilage rings; lined with respiratory mucosa.	Conduct air between trachea and lungs.
	Primary Bronchi	Right and left branch from trachea, one to each lung.	Conduct air to/from the lungs.
	Secondary Bronchi	Branches to the primary bronchi; three from the right, two from the left.	Conduct air between trachea and lungs.
	Tertiary Bronchi	Branches of the secondary bronchi.	Conduct air to/from the various bronchopulmonary segments of lungs.
	Bronchioles	Smallest branches (20 levels).	Conduct air to/from alveoli.
	Alveoli	Microscopic air spaces at terminals of bronchial tree; Lined with simple squamous epithelium that joins with pulmonary capillary endothelium to form the respiratory membrane.	Exchange of gases (CO_2, O_2) between air and pulmonary blood; surfactant lining alveoli prevents collapse of air spaces.

THE LUNGS

The paired, cone-shaped lungs completely fill the pleural portion of the thoracic cavity. They extend from the diaphragm to a point slightly above the clavicles and lie against the ribs both anteriorly and posteriorly. The medial surface of each lung is roughly concave to allow room for the heart. The primary bronchi and pulmonary blood vessels enter each lung through a slit on its medial side called the hilum. The broad, inferior surface of the lung is called the base, and the pointed superior margins of the lungs are called the apex. Each lung is divided into lobes by fissures. The left lung is divided into two lobes (superior and inferior) and the right lung is divided into three lobes (superior, middle, inferior). After the primary bronchi enter the lungs, they branch into secondary (lobar) bronchi that enter each lobe, then further branch into bronchioles whose smaller branches connect to the alveolar sacs.

The lungs perform two functions—air distribution and gas exchange. Gas exchange between air and blood is the joint function of the alveoli and the vast networks of blood capillaries that envelop them. These two structures—one part respiratory system, and one part circulatory system—together serve as highly efficient gas exchangers. Why? Because together they provide an enormous surface area—the respiratory membrane—where the very thin-walled alveoli and the equally thin-walled pulmonary capillaries come in contact.

Fill in the key and then color in the corresponding structures.

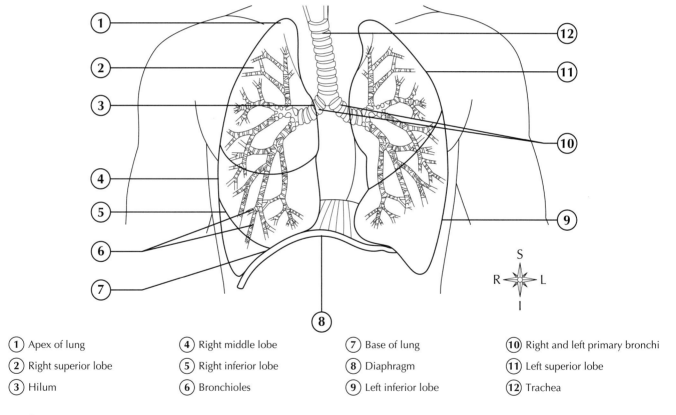

(1) Apex of lung	(4) Right middle lobe	(7) Base of lung	(10) Right and left primary bronchi
(2) Right superior lobe	(5) Right inferior lobe	(8) Diaphragm	(11) Left superior lobe
(3) Hilum	(6) Bronchioles	(9) Left inferior lobe	(12) Trachea

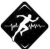

OVERVIEW OF RESPIRATORY PHYSIOLOGY

Functionally, the respiratory system is composed of an integrated set of regulated processes that include the following:

- **External respiration:** pulmonary ventilation (breathing) and gas exchange in the pulmonary capillaries of the lungs.
- **Internal respiration:** gas exchange in the systemic blood capillaries and cellular respiration.
- **Transport** of gases by the blood.
- **Regulation** of respiration.

The figure below graphically illustrates the processes of respiratory physiology. The divisions are external and internal respiration, transport, and regulation of respiration. Fill in the key and then color in the corresponding structures.

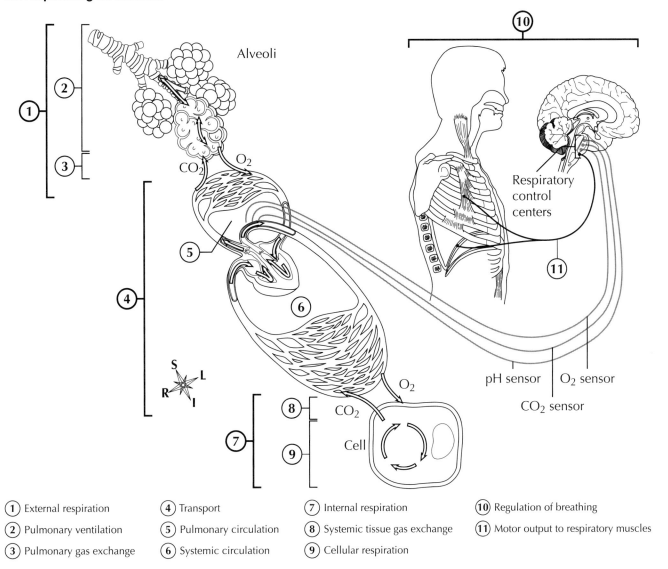

Alveoli

O_2

CO_2

S
L
R
I

O_2

CO_2

Cell

Respiratory control centers

pH sensor O_2 sensor

CO_2 sensor

(1) External respiration (4) Transport (7) Internal respiration (10) Regulation of breathing
(2) Pulmonary ventilation (5) Pulmonary circulation (8) Systemic tissue gas exchange (11) Motor output to respiratory muscles
(3) Pulmonary gas exchange (6) Systemic circulation (9) Cellular respiration

FACTORS THAT INFLUENCE BREATHING

Hemostasis of blood gases is maintained primarily by means of changes in ventilation—the rate and depth of breathing. The main integrators that control the nerves that affect the inspiratory and expiratory muscles are located within the brainstem and are together simply called the respiratory centers. The basic rhythm of the respiratory cycle of inspiration and expiration seems to be generated by the medullary rhythmicity area (MRA). This area is further divided into two regions of control centers: the dorsal respiratory group (DRG) and the ventral respiratory group (VRG). The apneustic center regulates the length and depth of inspiration. The pontine respiratory group (PRG, formerly known as the pneumotaxic center) regulates both the apneustic center and the MRA. Sensors throughout the nervous system and other control centers send information back to the brainstem.

Fill in the key and then color in the corresponding structures. Next, color the arrows that provide input or send output to influence breathing.

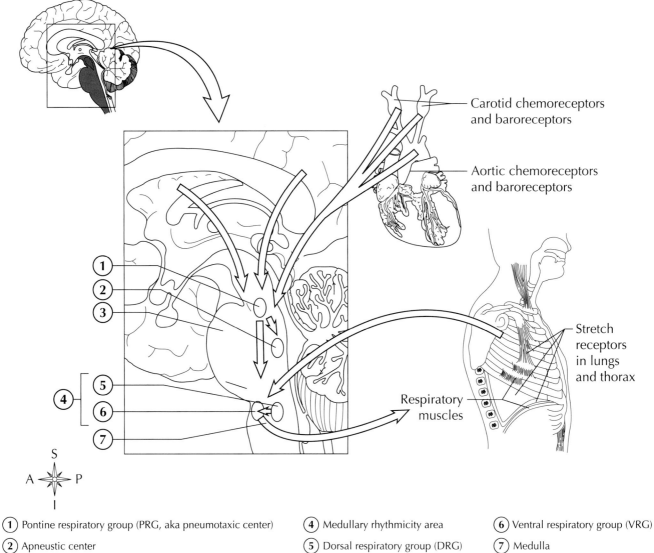

Carotid chemoreceptors and baroreceptors

Aortic chemoreceptors and baroreceptors

Stretch receptors in lungs and thorax

Respiratory muscles

S
A ⬥ P
I

① Pontine respiratory group (PRG, aka pneumotaxic center) ④ Medullary rhythmicity area ⑥ Ventral respiratory group (VRG)

② Apneustic center ⑤ Dorsal respiratory group (DRG) ⑦ Medulla

③ Pons

THE MECHANICS OF BREATHING

Pulmonary ventilation is a technical term for what most of us call breathing. Inspiration moves air into the lungs, and expiration moves air out of the lungs. Under normal conditions, air in the atmosphere exerts a pressure of 760 mm Hg (millimeters of mercury). Air in the alveoli at the end of one expiration and before the beginning of another inspiration also exerts a pressure of 760 mm Hg. This explains why, at that moment, air is neither entering nor leaving the lungs. The pulmonary ventilation system must establish two gas pressure gradients—one in which alveolar pressure is lower than atmospheric (barometric) pressure to produce inspiration, and one in which it is higher than atmospheric pressure to produce expiration. How are those gradients established? By changing the size of the thoracic cavity using our muscles of respiration, we are able to inspire and expire air.

The figures below show the movement of the diaphragm and the external intercostal muscles to cause the size, or volume, of the thoracic cavity to increase. Fill in the key and color in the corresponding structures of inspiration and expiration below. Color in the arrows to show the direction of breath.

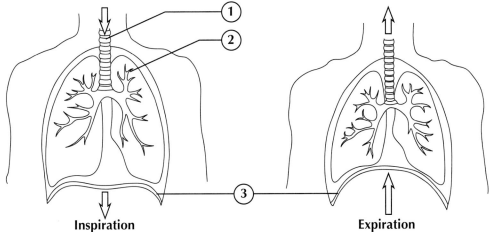

Inspiration

A During inspiration, the diaphragm contracts, increasing the volume of the thoracic cavity. Air moves into the lungs.

Expiration

B During expiration, the diaphragm relaxes, decreasing the volume of the thoracic cavity. Air moves out of the lungs.

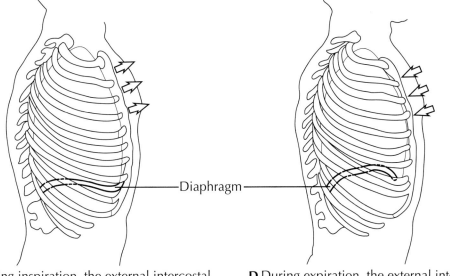

① Trachea

② Lung

③ Diaphragm

Diaphragm

C During inspiration, the external intercostal muscles contract, pulling the thoracic cage upward and outward. The volume of the thoracic cavity increases.

D During expiration, the external intercostal muscles relax, decreasing the volume of the thoracic cavity.

NOW FOR AN EXPERIMENT...

As strange as it sounds, most people do not breathe "correctly." We go through our days randomly taking in oxygen and exhaling carbon dioxide without much thought. When we actually do breathe correctly (diaphragmatically), we can make ourselves feel dizzy! Try this. Stand in front of a mirror, take a deep breath in, and hold it. Now, watch your shoulders as you exhale. Did they fall? If so, you are not fully utilizing your diaphragm to breathe; rather, you are relying on the neck and shoulder muscles to elevate your thoracic cage. Still standing in front of a mirror, place your hands partially on the lower ribs with the remaining parts of your hands on your stomach. This time when you inhale, pretend that an elephant is sitting on your shoulders and all of the air you take in is blown into your "belly," or abdomen. You'll notice that your shoulders do not elevate at all, or very little. You probably also feel like you didn't get enough oxygen! This is likely because your diaphragm muscle needs a workout! Practice diaphragmatic breathing for 5–10 minutes each day, gradually building up your ability to breathe this way most of the time. You will be amazed at the difference!

MECHANISM OF INSPIRATION

As we've already learned, the diaphragm is the main muscle of inspiration. Its contraction alone is enough to make the thoracic cavity longer, thereby forcing air into the lungs. Contraction of the external intercostal muscles (*inter* = in between; *costal* = costal cartilage connecting ribs to sternum) pulls the anterior end of each rib up and out. Contraction of the sternocleidomastoid (*sterno* = sternum; *cleido* = clavicle; *mastoid* = mastoid process of the temporal bone), pectoralis minor, and serratus anterior (not shown below) muscles aid in the elevation of the sternum during forceful inspiration (like sniffing your nose when you have nasal drainage). Remember that while the accessory muscles of respiration are present to "assist," they are not required for normal inspiration.

Based on your knowledge of the musculoskeletal system, can you find your attachments to the sterno-cleidomastoid muscle, which helps to elevate the sternum during forceful inspiration? Now, looking at the diagram below:

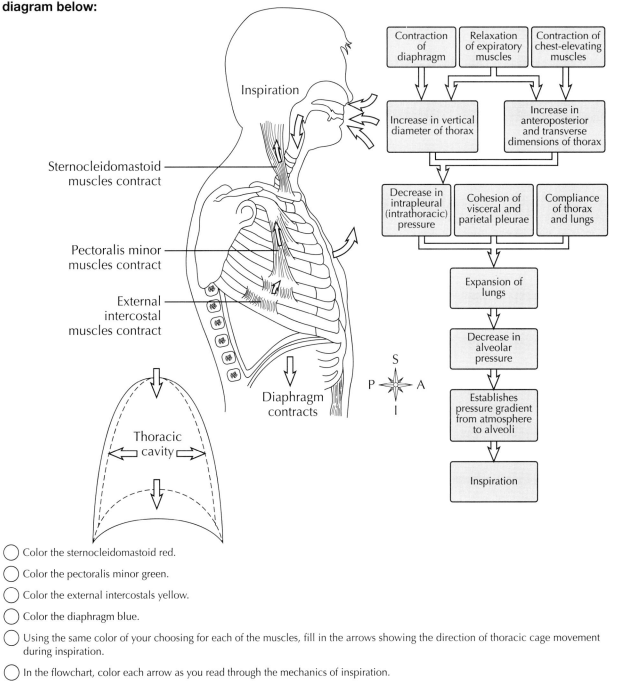

◯ Color the sternocleidomastoid red.

◯ Color the pectoralis minor green.

◯ Color the external intercostals yellow.

◯ Color the diaphragm blue.

◯ Using the same color of your choosing for each of the muscles, fill in the arrows showing the direction of thoracic cage movement during inspiration.

◯ In the flowchart, color each arrow as you read through the mechanics of inspiration.

MECHANISM OF EXPIRATION

Quiet expiration is ordinarily a passive process that begins when the pressure gradients that resulted in inspiration are reversed. The internal intercostal muscles, which lie directly underneath the external intercostal muscles, contract to help depress the thoracic cage; abdominal muscles contract slightly, but if contracted forcefully, they can speed up the expiration process. The tendency of the thorax and lungs to return to their pre-inspiration volume is a physical phenomenon called elastic recoil. If a disease condition reduces the elasticity of pulmonary tissues, expirations must become forced, even at rest. Note that the internal intercostals are illustrated in the same position as the external intercostals in the previous exercise. The external intercostals are NOT shown in this graphic, and due to the location of the internal intercostals, it appears that they are in the same position, when in fact, they lie directly beneath the externals.

In the diagram below:

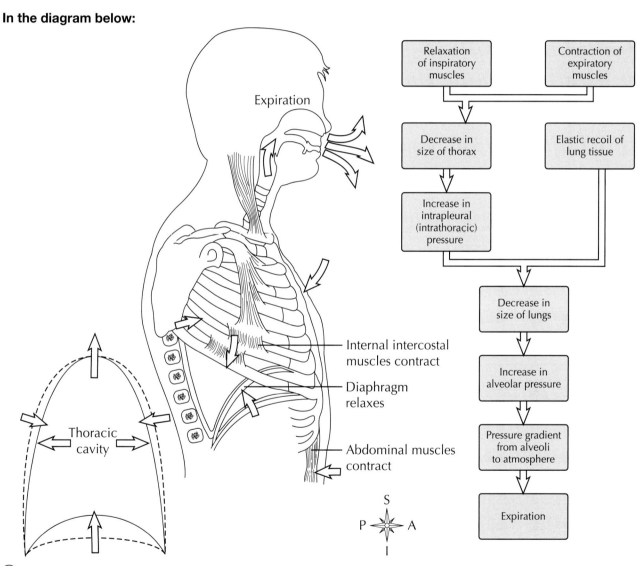

○ Color the sternocleidomastoid and the pectoralis minor black (to acknowledge their place in the diagram but to remove them from expiration activity).

○ Color the internal intercostals orange.

○ Color the diaphragm blue.

○ Using the same color of your choosing for each of the muscles, fill in the arrows showing the direction of thoracic cage movement during inspiration.

○ In the flowchart, color each arrow as you read through the mechanics of expiration.

TYPES OF BREATHING

Have you ever noticed that you don't always breathe the same way, even when you are in a healthy state? Of course you have! There are also times when the way we breathe can indicate that a disease process is present.

The table below names and describes the various types of breathing that can occur in humans. Try reading the descriptions and see if you can match each with the illustration of the spirogram result in the key, then put the correct number into the spirograph result column. If necessary, do a quick image search online to find examples. Answers are below.

TYPE OF BREATHING	SPIROGRAPH RESULT	DESCRIPTION
Eupnea		Normal, rhythmic, quiet breathing.
Hyperventilation		Increased ventilation *in excess* of the need of oxygen; sometimes a conscious effort preceding exertion or from psychogenic factors (hysterical hyperventilation).
Hypoventilation		Decrease in ventilation due to elevated CO_2 levels; (i.e., blowing into paper bag to stop hyperventilation).
Apnea		Temporary cessation of breathing at the end of normal expiration (may occur during sleep).
Cheyne-Stokes		Cycles of gradually increasing tidal volume (TV) for several breaths, followed by several breaths with decreasing TV; often seen in terminally ill patients.
Biot's breathing		Repeated sequences of deep gasps and apnea; see with increased intracranial pressure.

Answers: Eupnea = 1; Hyperventilation = 2; Hypoventilation = 3; Apnea = 4; Cheyne-Stokes = 5; Biot's breathing = 6.

GAS EXCHANGE STRUCTURES OF THE LUNG

The alveoli are the primary gas exchange structures of the respiratory tract. They are very effective in exchanging carbon dioxide (CO_2) and oxygen (O_2) because each alveolus is extremely thin walled, lies in contact with blood capillaries, *and there are millions of them in each lung!* Alveoli are grouped together like a bunch of hollow grapes to form an alveolar sac. Approximately 300 million alveoli are present in the two lungs.

Fill in the key and then color in the corresponding structures. There are three alveoli presented in the cross section.

Fill in the key and color each structure in the inset. Next, color the arrow showing the exchange of O_2 in red and the arrow showing the exchange of CO_2 in blue.

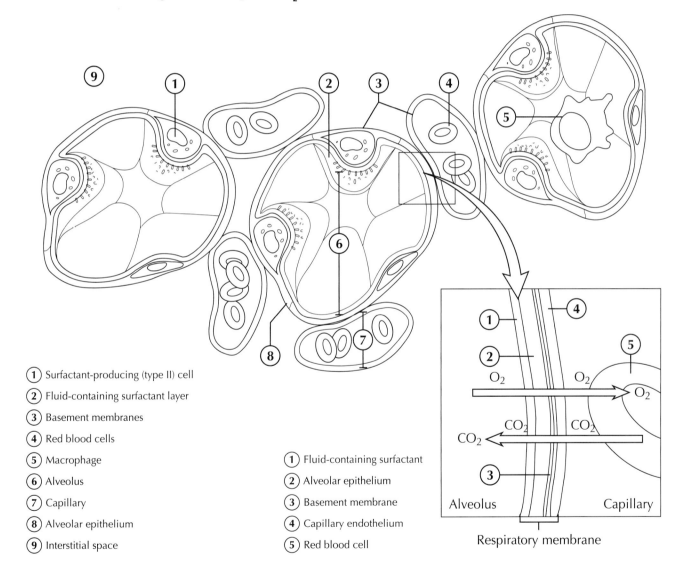

1. Surfactant-producing (type II) cell
2. Fluid-containing surfactant layer
3. Basement membranes
4. Red blood cells
5. Macrophage
6. Alveolus
7. Capillary
8. Alveolar epithelium
9. Interstitial space

1. Fluid-containing surfactant
2. Alveolar epithelium
3. Basement membrane
4. Capillary endothelium
5. Red blood cell

The alveolar epithelium, capillary endothelium, and joined basement membranes together form the respiratory membrane. The surface of the respiratory membrane inside each alveolus is coated with a fluid containing surfactant. Surfactant helps reduce surface tension of the fluid. This helps prevent each alveolus from collapsing and "sticking shut" as air moves in and out during respiration.

CASE STUDY

After having surgery to remove a stomach tumor, Derrick woke up in the recovery room in extreme pain. It hurt to move; it hurt to blink; it hurt to take a little breath, and here was this nurse demanding that he take a deep breath and cough. Was she crazy?

1. Which of these muscles would not contract when Derrick complied with his nurse's instructions?
 A. Diaphragm
 B. Serratus anterior
 C. Rectus abdominis
 D. External intercostals

2. Which statement best describes the "mechanics" of Derrick's inhalations?
 A. The thoracic cavity decreases in size, lowering the alveolar pressure, and air flows from high atmospheric pressure to low alveolar pressure.
 B. The thoracic cavity increases in size, lowering the alveolar pressure, and air flows from high atmospheric pressure to low alveolar pressure.
 C. The thoracic cavity increases in size when the diaphragm relaxes, increasing alveolar pressure, and air flows from low atmospheric pressure.
 D. The thoracic cavity decreases in size, increasing the alveolar pressure, and air flows from the lungs.

3. How is carbon dioxide (CO_2) transported in Derrick's blood?
 A. Dissolved in the plasma
 B. Bound to hemoglobin
 C. In the form of bicarbonate
 D. All of the above

15 Urinary System

While the urinary system is a "urine producer," it would more appropriately be described as a "blood plasma balancer." Filtration of plasma through the kidneys, maintenance of the water balance in the body, and even the pH of the blood are managed or adjusted as a result of the system. This chapter will explore the basic principles of urinary structure and function.

EXCRETION

The urinary system's chief function is to regulate the volume and composition of body fluids and excrete unwanted material. But it is not the only system in the body that is able to excrete unneeded substances. We have already discussed the other systems with excretory functions, and although all of those systems contribute to the body's effort to remove wastes, only the urinary system can finely adjust the water and electrolyte balance to the degree required for normal homeostasis of body fluids. The table below compares the excretory functions of several systems.

In the table below, fill in the system that is responsible for the excretion of certain waste products. (Hint: some waste is removed by more than one system.)

	SYSTEM	ORGAN	EXCRETION
Skin — Lungs — Liver — Kidneys — Large intestine — Bladder		Kidney	Nitrogen compounds Toxins Water Electrolytes
		Skin—sweat glands	Nitrogen compounds Electrolytes Water
		Lung	Carbon dioxide Water
		Intestine	Digestive wastes Bile pigments Salts of heavy metals

ORGANS OF THE URINARY SYSTEM

The principal organs of the urinary system are the kidneys, which process blood and form urine as a waste to be excreted from the body. Externally, the kidney is rather unremarkable. This lima bean-shaped organ measures approximately 5×3×1 inches. The left kidney is usually slightly larger than the right. Both are located against the posterior wall of the abdomen at the level of T12–L3 vertebrae.

In order for urine to be excreted, it must leave the kidneys and travel through accessory organs that ultimately terminate in an external opening. Those accessory organs are paired ureters (tubes that provide a pathway for urine to flow, then connect to the urinary bladder, where urine is stored). Finally, as the level of stored urine reaches an uncomfortable volume, the urine passes through the urethra and exits the body.

INTERNAL STRUCTURE OF THE KIDNEY

The medial surface of each kidney has a concave notch called the hilum, which allows for the renal blood vessels and other structures to enter or leave through this notch. The kidney is basically divided into two regions. The renal cortex is the outer region and is fairly easy to discriminate within the structure. The renal medulla, in contrast, causes confusion for those new to anatomy of the kidney. Simply put, everything in the outer region is in the cortex, and everything in the inner region is in the medulla. Picture the renal cortex as a yard and the renal medulla as a house. Within the renal medulla are several "hallways," which provide entry to the rooms—renal pyramids. These are bordered on each side by renal columns.

Fill in the key and then the corresponding structures.

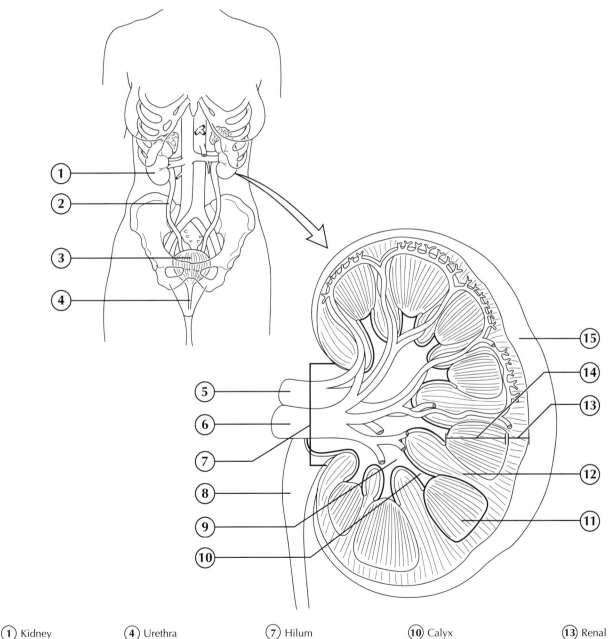

① Kidney	④ Urethra	⑦ Hilum	⑩ Calyx	⑬ Renal cortex					
② Ureter	⑤ Renal artery	⑧ Ureter	⑪ Renal pyramid	⑭ Medulla					
③ Bladder	⑥ Renal vein	⑨ Renal pelvis	⑫ Renal column	⑮ Fibrous capsule					

Copyright © 2014 by Mosby, an imprint of Elsevier Inc

SAGITTAL VIEW OF URINARY TRACT

The urinary tracts of males and females are largely the same from a structural perspective. The names of the organs are the same: kidneys, ureters, urinary bladder, urethra. The main difference between the two lies with the length of the urethra and the dual function it plays in males. The urethra is a small tube lined with mucous membrane that leads from the floor of the bladder to the exterior of the body. In females, it lies directly behind the pubic symphysis and anterior to the vagina as it passes through the muscular floor of the pelvis. It extends down and forward from the bladder for approximately 1.2 inches and ends at the external urinary meatus. In contrast, the male urethra extends along a winding path for about 8 inches. The male urethra passes through the center of the prostate gland, where it is joined by two ejaculatory ducts. After leaving the prostate, the urethra extends down, forward, then up to enter the base of the penis. It then travels through the center of the penis and ends the urinary meatus at the tip of the penis. Because the male urethra is joined by the ejaculatory ducts, it serves as a pathway for semen (fluid containing sperm) as it is ejaculated out of the body through the penis. Thus it is part of both the male urinary and the male reproductive systems.

Fill in the keys and color in the corresponding structures of the female and male urinary tracts.

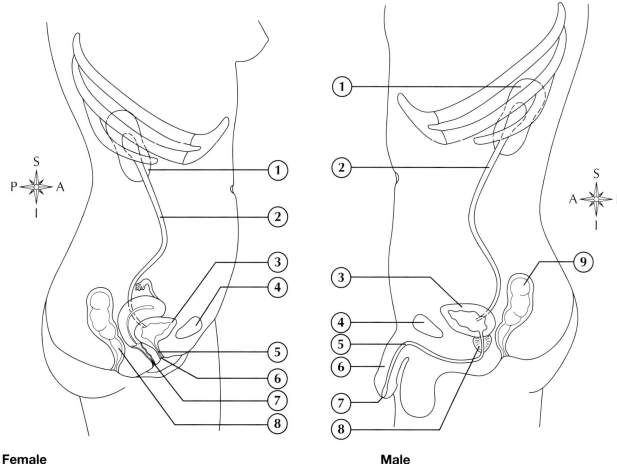

Female

1. Kidney
2. Ureter
3. Bladder
4. Pubic symphysis
5. Urethra
6. Urinary meatus
7. Vagina
8. Rectum

Male

1. Kidney
2. Ureter
3. Bladder
4. Pubic symphysis
5. Urethra
6. Penis
7. Urinary meatus
8. Prostate gland
9. Rectum

STRUCTURE OF THE URINARY BLADDER

The urinary bladder is a muscular, collapsible bag that is located directly behind the pubic symphysis and in front of the rectum. It lies below the parietal peritoneum, which covers only its superior surface. The wall of the bladder is made mostly of smooth muscle tissue. Often called the detrusor muscle, the muscle layer is formed by a network of crisscrossing bundles of smooth muscle fibers. The bladder is lined with mucous transitional epithelium that forms folds called rugae. There are three openings in the floor of the bladder, two from the right and left ureters at the posterior corners of the triangle-shaped floor called the trigone. The last opening lies at the anterior lower corner and opens to the urethra. The urinary bladder serves as a reservoir for urine before it leaves the body, and aided by the urethra, it expels urine from the body.

Fill in the key and then color the corresponding structures of the male urinary bladder.

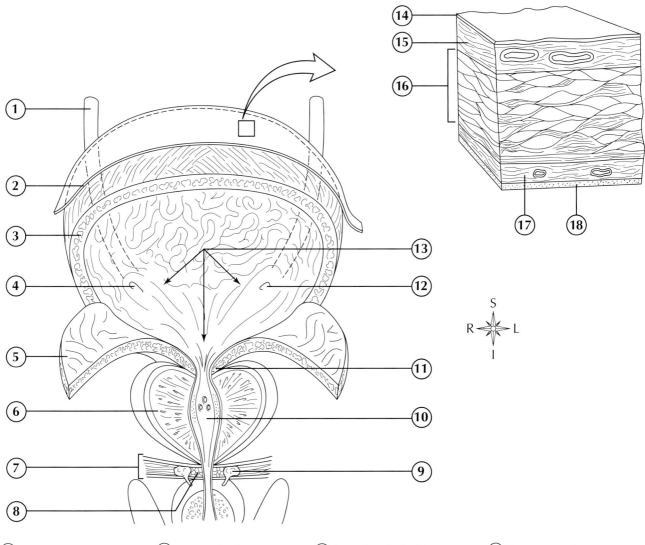

① Ureter	⑥ Prostate gland	⑪ Internal urethral sphincter	⑯ Detrusor muscle
② Cut edge of peritoneum	⑦ Pelvic floor	⑫ Opening of ureter	⑰ Submucosa
③ Smooth muscle (detrusor)	⑧ External urethral sphincter	⑬ Trigone	⑱ Mucosa (transitional epithelium)
④ Opening of ureter	⑨ Bulbourethral gland	⑭ Serosa (peritoneum)	
⑤ Rugae	⑩ Prostatic urethra	⑮ Adventitia (connective tissue)	

NEPHRON

Over one million microscopic structures called nephrons make up the bulk of each kidney. The shape of the nephron is unusual, unmistakable, and uniquely suited to its function of blood plasma processing and urine formation. It resembles a tiny funnel with a long, winding stem about 1.2 inches long. Each nephron is made up of two main regions: the renal corpuscle and the renal tubule. Fluid is filtered out of the blood in the renal corpuscle, then the remaining filtrate flows through the renal tubule and collecting duct, where much of the filtrate is returned to the blood. The remaining filtrate leaves the collecting duct as urine.

The nephron is composed of two main sections: the renal corpuscle (consisting of the glomerulus and glomerulus capsule) and the renal tubule (consisting of the proximal convoluted tubule, loop of Henle, and distal convoluted tubule). Because the nephron is the functional unit of the kidney, meaning that as a result of its function, the kidney is able to perform its duties, we need to take a very close look at this structure. We will first look at the tubular and vascular structures of the nephron unit as a whole, then we will take an even closer look at the renal corpuscle and renal tubule in subsequent graphics.

Fill in the key and then color the corresponding structures. Use the arrows to follow the movement in the nephron unit.

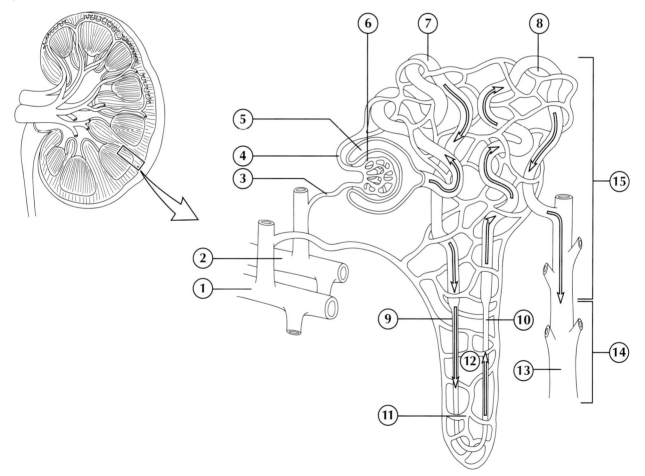

(1) Renal vein

(2) Renal artery

(3) Afferent arteriole

(4) Efferent arteriole

(5) Glomerular (Bowman's) capsule

(6) Glomerulus

(7) Proximal convoluted tubule

(8) Distal convoluted tubule

(9) Descending limb

(10) Ascending limb

(11) Peritubular capillaries

(12) Loop of Henle

(13) Collecting duct

(14) Medulla

(15) Cortex

THE RENAL CORPUSCLE

Figure A shows a close-up view of the renal corpuscle, the first part of the nephron, which is made up of the glomerular capsule (aka, Bowman's capsule) and the glomerulus. Understand that the glomerulus is simply a collection of capillaries that fills the glomerular (Bowman's) capsule. Figure B illustrates a close-up of the glomerular capsule wall. The capsule is the cup-shaped mouth of a nephron, whose wall is formed of two different layers, separated by a capsular space. The parietal wall is the outer wall, and the visceral wall is the inner wall of the capsule. Between these two walls lies the capsular space. Fluids, waste products, and electrolytes that pass through the porous glomerular capillaries enter the capsular space and become filtrate, which will be processed in the nephron to become urine.

Fill in the keys and then color the corresponding structures.

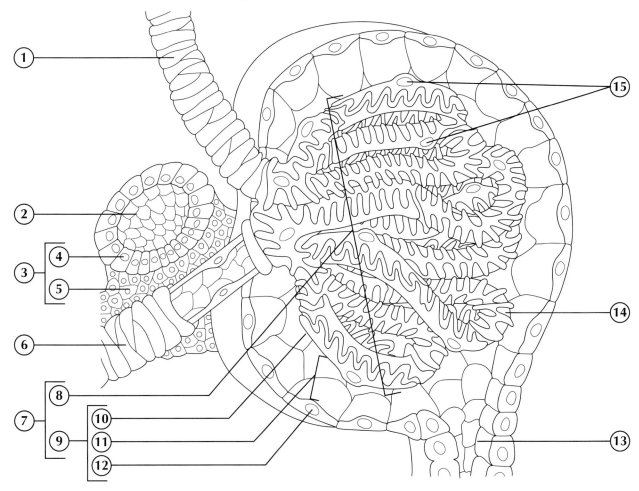

Figure A

① Efferent arteriole

② Distal convoluted tubule (DCT)

③ Juxtaglomerular apparatus

④ Macula densa

⑤ Juxtaglomerular (JG) cells

⑥ Afferent arteriole

⑦ Renal corpuscle

⑧ Glomerulus

⑨ Glomerular (Bowman's) capsule

⑩ Visceral wall

⑪ Capsular space

⑫ Parietal wall

⑬ Proximal convoluted tubule (PCT)

⑭ Medulla

⑮ Podocytes

Copyright © 2014 by Mosby, an imprint of Elsevier Inc

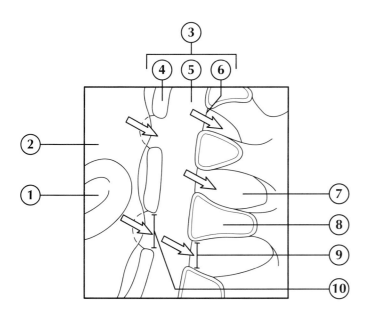

Figure B

1. Red blood cell
2. Plasma
3. Glomerular (Bowman's) capsule membrane
4. Capillary endothelium
5. Basement membrane
6. Visceral wall of glomerular (Bowman's) capsule
7. Capsular space
8. Podocyte cell processes of capsule
9. Filtration slit
10. Fenestration

RENAL TUBULE

The renal tubule is a winding, hollow tube composed of cells that are able to respond to changes in the composition and flow of fluid to regulate the growth and functioning of the tubule. The renal tubule extends from the renal corpuscle to the end of the nephron, where it joins a collecting duct shared in common with other nearby nephrons. The renal tubule is divided into three different regions: the proximal convoluted tubule (PCT), the Henle loop, and the distal convoluted tubule (DCT). The PCT wall contains thousands of microvilli that form the brush border and greatly increase the surface area. The Henle loop (aka loop of Henle or nephron loop) consists of a thin descending limb, a sharp turn, and an ascending limb that is further divided into a thin ascending loop of Henle and the thick ascending limb. The length of the Henle loop is important in the production of highly concentrated or very dilute urine. Finally, the DCT conducts filtrate out of the nephron and into a collecting duct. The juxtaglomerular apparatus (structure near the glomerulus) is found at the point where the afferent arteriole brushes past the DCT. Large smooth muscle cells in the walls of the afferent arteriole called juxtaglomerular (JG) cells contain renin granules. Modified distal convoluted tubule cells in the juxtaglomerular apparatus form a dense, tightly packed structure called the macula densa, whose cells can sense the concentration of solute materials in the fluid passing through the tubule. Acting together, both cell types in the juxtaglomerular apparatus contribute to homeostasis of renal function by influencing the ability of the kidney to produce concentrated urine.

Fill in the key and then color the corresponding structures.

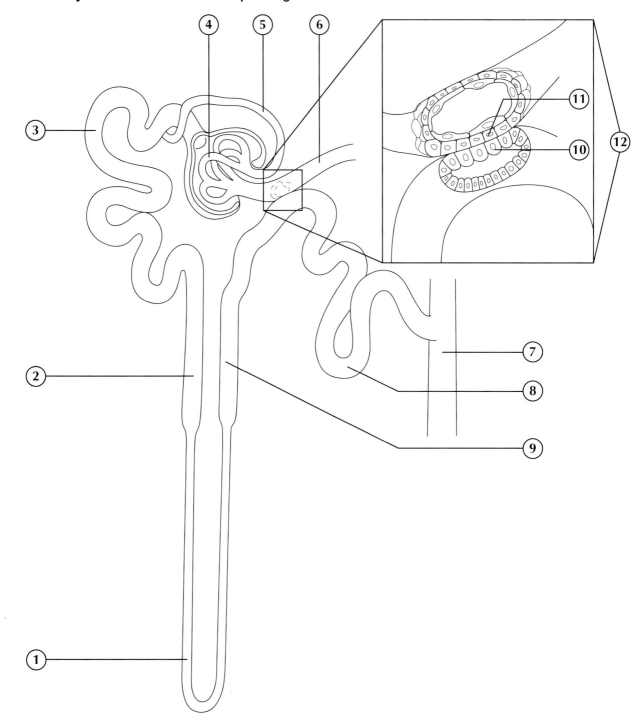

1. Thin ascending limb of Henle (tLAH)
2. Descending limb
3. Proximal convoluted tubule
4. Glomerulus

5. Efferent arteriole
6. Afferent arteriole
7. Collecting ducts
8. Distal convoluted tubule

9. Ascending limb
10. Macula densa
11. Juxtaglomerular cells
12. Juxtaglomerular apparatus

OVERVIEW OF URINE PRODUCTION FROM FILTRATION TO EXCRETION

The basic functional unit of the kidney is the nephron. Its two main parts, the renal corpuscle and the renal tubule, form urine by means of three processes: filtration, tubular reabsorption, and tubular secretion.

Process One: *Filtration* is the movement of water and protein-free solutes from plasma in the glomerulus, across the glomerular capsule membrane, and into the capsular space of the glomerular (Bowman's) capsule.

Process Two: *Tubular reabsorption* is the movement of molecules out of the various segments of the tubule and into the peritubular blood. These are the molecules that the body can recycle, or reuse, and so they are not included in the waste.

Process Three: *Tubular secretion* is the movement of molecules out of the peritubular blood and into the tubule for excretion. This is the waste that will be removed from the body.

Color the arrows and the associated structures in the different stages.

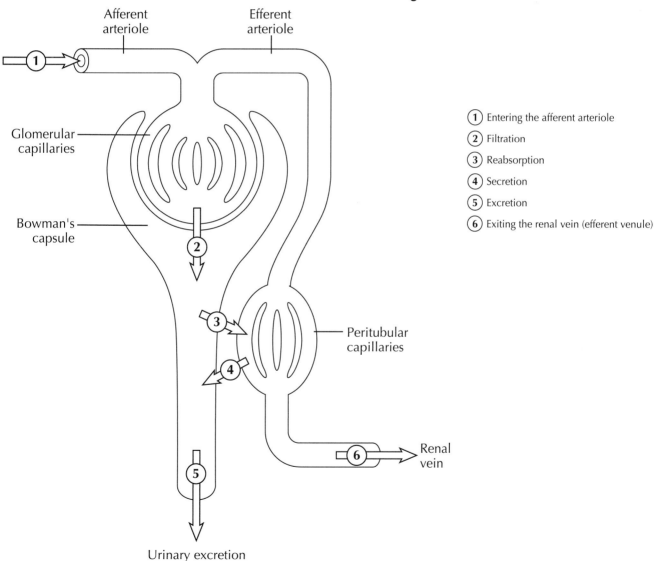

1. Entering the afferent arteriole
2. Filtration
3. Reabsorption
4. Secretion
5. Excretion
6. Exiting the renal vein (efferent venule)

Excretion = Filtration – Reabsorption + Secretion

CASE STUDY

Nhung felt like he was going to throw up, the pain was so intense. His lower back ached on both sides with a sharp, jabbing pain. He took some aspirin, but it didn't help at all. Finally, he gave in and went to his naturopath, someone who uses natural remedies to treat illnesses. After hearing about Nhung's symptoms, the naturopath suggested a urine check. He had Nhung urinate in a cup, then dipped a stick into the cup. As he expected, the test was positive for red blood cells. Looking at the urine from the cup under a microscope, they could both see very small particles that looked like crystals.

1. Nhung probably has kidney stones. What is most likely causing Nhung's pain?
 A. Failure of his kidneys
 b. Cramping of muscles in the ureter wall
 C. Blockage of the urethra
 D. Irritation of the urinary bladder
2. For a kidney stone to "pass" from the body, it will have to navigate through the following structures in which order?
 A. Ureter, calyces, urethra, renal pelvis, bladder
 B. Urethra, renal pelvis, bladder, ureter, calyces
 C. Bladder, ureter, urethra, calyces, renal pelvis
 D. Calyces, renal pelvis, ureter, bladder, urethra

Copyright © 2014 by Mosby, an imprint of Elsevier Inc

16 Reproductive Systems

Ordinarily, body systems function to maintain the relative stability and survival of the individual organism. The reproductive system, in contrast, involves the anatomical structures and complex control mechanisms intended to ensure survival of our genes. These systems in men and women are adapted structurally and functionally for the specific sequence of events that permits development of sperm or ova, followed by fertilization, normal development, and birth of a baby. This chapter begins with a brief description of the anterior pituitary hormones that act on both male and female reproductive systems, then provides a brief overview of the male and female reproductive systems and concludes with full-term pregnancy in the female.

PITUITARY HORMONES AND THEIR REPRODUCTIVE SYSTEM TARGET HORMONES

As we learned earlier in the endocrine system, the pituitary gland secretes hormones, which causes the hypothalamus to secrete hormones, which causes changes to occur in various organs throughout the body. The reproductive system is affected in the same manner. The gonadotroph cells—cells that stimulate the growth and maintenance of the gonads—of the anterior pituitary gland secrete follicle-stimulating hormone (FSH), which stimulates structures within the ovaries (primary follicles) to grow toward maturity. FSH also stimulates the follicle cells to synthesize and secrete estrogens in females. In males, FSH stimulates the development of the seminiferous tubules of the testes and maintains spermatogenesis by them. Luteinizing hormone (LH) stimulates the formation and activity of the corpus luteum of the ovary. LH also supports FSH in stimulating the maturation of follicles. In males, LH stimulates interstitial cells in the testes to develop and then synthesizes and secretes testosterone. Prolactin (PRL), a lactogenic hormone, is also secreted by the anterior pituitary gland for the purposes of generating or initiating milk secretion during lactation. The posterior pituitary gland produces and secretes oxytocin (OT), which also plays a role in lactation by causing milk ejection from the breasts of lactating women. OT (translation, "swift birth") also stimulates rhythmic contraction of smooth muscles in the uterus, allowing for the strong, muscular labor contractions that occur during childbirth by a positive feedback loop.

○ Color the anterior pituitary gland yellow, along with the organs its hormones target.

○ Color the posterior pituitary gland blue, along with the organs its hormones target.

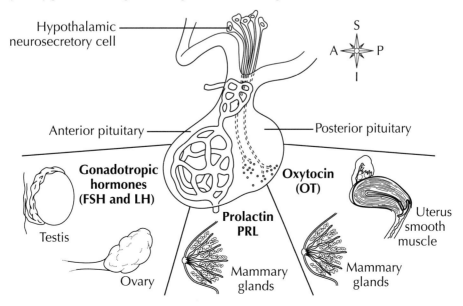

THE MALE REPRODUCTIVE SYSTEM

Organs of the reproductive system can be classified as essential (those which produce gametes, or sex cells), or as accessory organs that play some type of supportive role in the reproductive process. The gonads of the male are the testes. The male accessory organs of reproduction include:

- *Genital ducts* that convey sperm to the outside of the body. The ducts are a pair of epididymides (epididymis, singular), the paired vas deferens, a pair of ejaculatory ducts, and the urethra.
- *Accessory glands* in the reproductive system produce secretions that serve to nourish, transport, and mature sperm. The glands are a pair of seminal vesicles, one prostate, and a pair of bulbourethral glands.
- *Supporting structures* include the scrotum, the penis, and a pair of spermatic cords.

Fill in the key and then color in the corresponding structures.

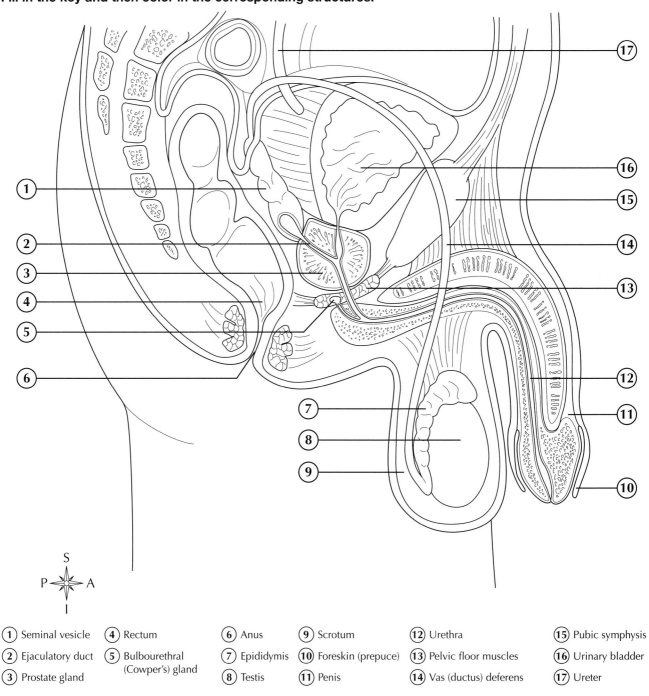

1 Seminal vesicle	4 Rectum	6 Anus	9 Scrotum	12 Urethra	15 Pubic symphysis
2 Ejaculatory duct	5 Bulbourethral	7 Epididymis	10 Foreskin (prepuce)	13 Pelvic floor muscles	16 Urinary bladder
3 Prostate gland	(Cowper's) gland	8 Testis	11 Penis	14 Vas (ductus) deferens	17 Ureter

SAGITTAL SECTION OF A TESTIS

The testes are small, ovoid glands that are somewhat flattened from side to side, measure about 4–5 cm in length, and weigh 10–15 grams each. They are both located in a supporting sac called the scrotum. The left testis is generally located 1 cm lower in the scrotal sac than the right. Both are suspended in the pouch by attachment to scrotal tissue and by the spermatic cords. Note that testicular blood vessels reach the testes by passing through the spermatic cord. A dense, fibrous capsule called the tunica albuginea encases each testis and then enters the gland, sending out partitions that radiate through its interior, dividing it into 200 or more cone-shaped lobules. Each lobule of the testes contains one to three tiny coiled seminiferous tubules. A series of sperm ducts called efferent ducts then drain the testes and pierce the tunica albuginea to enter the head of the epididymis.

The elongated, tail-bearing spermatozoa pass through the genital ducts before ejaculation. Parts of the sperm include the tail, body, head, and the acrosomal (head) cap.

Fill in the key and color the corresponding structures.

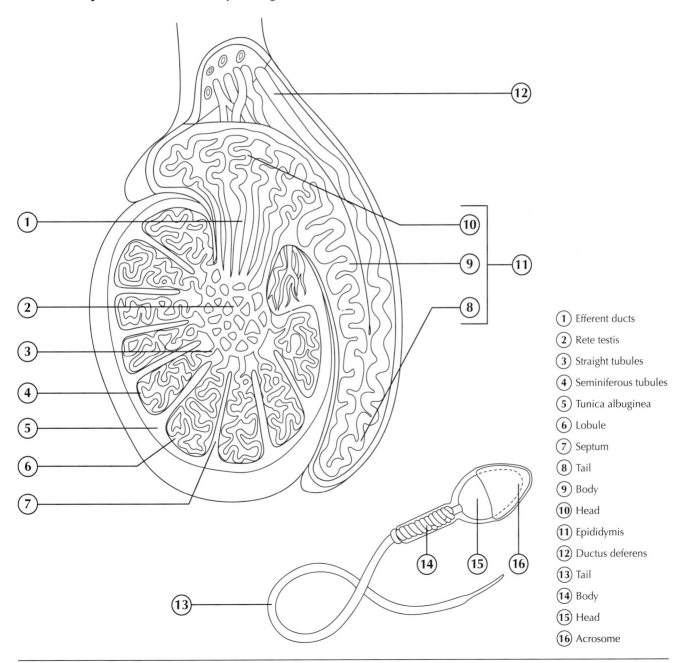

1. Efferent ducts
2. Rete testis
3. Straight tubules
4. Seminiferous tubules
5. Tunica albuginea
6. Lobule
7. Septum
8. Tail
9. Body
10. Head
11. Epididymis
12. Ductus deferens
13. Tail
14. Body
15. Head
16. Acrosome

SPERMATOGENESIS

Spermatogenesis is the production of spermatazoa (sperm), the male gametes, or reproductive cells. The seminiferous tubules produce the sperm. The small circular figure shows the cross section of a seminiferous tubule in which two meiotic divisions result in a reduction of chromosomes from 46 in the spermatogonia (germ cells) to 23 in spermatids and mature sperm. The section on the right shows the enlarged wedge of the area indicated in the figure on the left. In the enlarged figure, the sperm cells represent the center of the seminiferous tubule.

Fill in the key and color the structures of the cross section.

In right section:

◯ Color the spermatagonia (germ cells) with a color of your choice (as for all four).

◯ Color in the actions taking place in Meiosis I, including the secondary spermatocytes.

◯ Color in the actions representing what occurs in Meiosis II.

◯ Color to represent the final product of mature sperm cells.

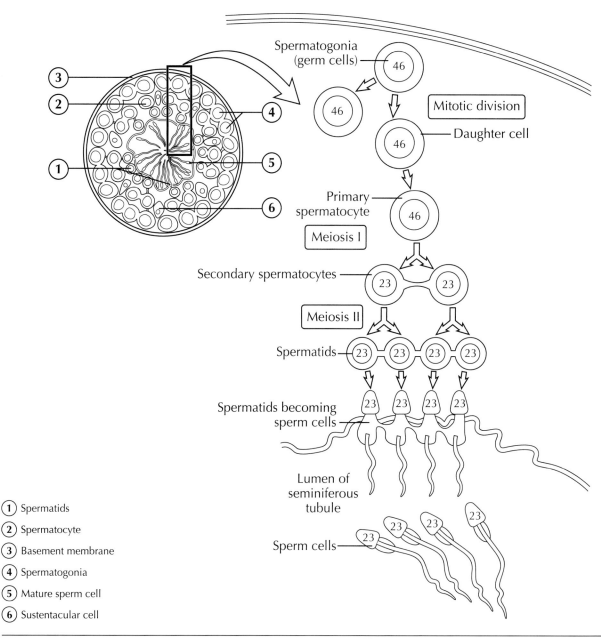

(1) Spermatids

(2) Spermatocyte

(3) Basement membrane

(4) Spermatogonia

(5) Mature sperm cell

(6) Sustentacular cell

THE MALE REPRODUCTIVE SYSTEM

The illustration below shows all the structures that have an essential, supporting, or accessory function in male reproduction. You may be surprised to see the urinary bladder in the illustration; however, remember that as the urethra leaves the urinary bladder, it passes through the prostate gland and serves a dual function for urine excretion as well as sperm ejaculation.

Fill in the keys and color the corresponding structures.

1. Ureter
2. Urinary bladder
3. Prostate gland
4. Prostatic portion of urethra
5. Pelvic floor muscles
6. Bulbourethral gland
7. Spongy portion of urethra
8. Vas (ductus) deferens
9. Penis
10. Epididymis
11. Head of epididymis
12. Body of epididymis
13. Tail of epididymis
14. Testis
15. Glans penis
16. External urinary meatus
17. Scrotum (skin)
18. Dartos fascia and muscle
19. Tunica vaginalis
20. Cremaster muscle
21. Genital nerve
22. Venous plexus
23. Testicular artery
24. Vas (ductus) deferens
25. Internal spermatic fascia
26. Spermatic cord
27. Inguinal canal
28. Ejaculatory duct
29. Seminal vesicle
30. Vas (ductus) deferens
31. Ampulla of vas (ductus) deferens

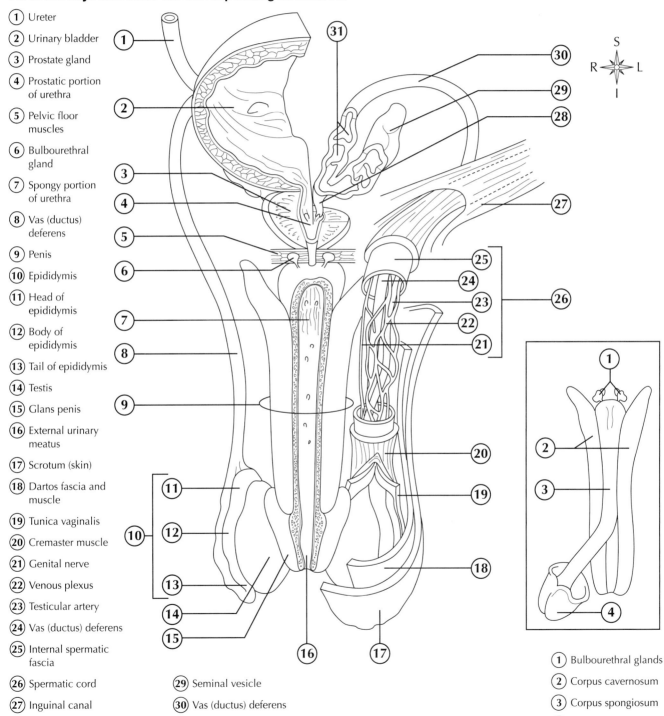

1. Bulbourethral glands
2. Corpus cavernosum
3. Corpus spongiosum
4. Glans penis

THE FEMALE REPRODUCTIVE SYSTEM

The focus of the female reproductive system in this chapter will be limited in terms of the physiological role in production of offspring and continued existence of the genetic code. The female reproductive system produces gametes that may unite with a male gamete to form the first cell of the offspring. The function of conception emphasizes the similarity between the male and female reproductive systems. Unlike the male system, however, the female reproductive system also provides protection and nutrition to the developing offspring up to several years after conception.

Fill in the key and then color in the corresponding structures.

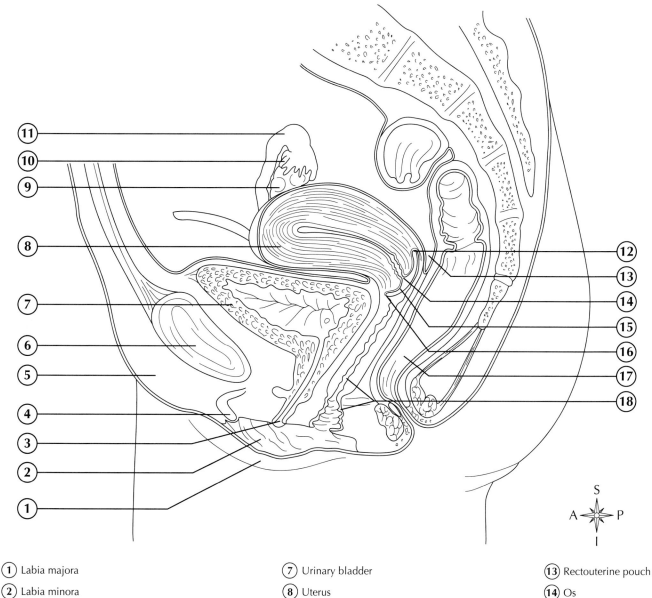

(1) Labia majora

(2) Labia minora

(3) Urethral meatus

(4) Clitoris

(5) Mons pubis

(6) Symphysis pubis

(7) Urinary bladder

(8) Uterus

(9) Ovary

(10) Fimbria

(11) Fallopian tube

(12) Posterior fornix

(13) Rectouterine pouch

(14) Os

(15) Cervix

(16) Anterior fornix

(17) Rectum

(18) Vagina and rugae

Copyright © 2014 by Mosby, an imprint of Elsevier Inc

INTERNAL FEMALE REPRODUCTIVE ORGANS—POSTERIOR VIEW

The female gonads (ovaries) are homologous to the testes in the male. They are nodular glands that, after puberty, present a puckered, uneven surface, resemble large almonds in size and shape, and are located one on each side of the uterus, below and behind the uterine tubes. Each ovary is attached to the posterior surface of the broad ligament by a structure called the mesovarium. (We will discuss the ovary in more detail next.) The uterus is located in the pelvic cavity between the urinary bladder in front and the rectum behind. Between birth and puberty, the uterus descends gradually from the lower abdomen to the true pelvis. The wall of the uterus is divided into three layers: 1) inner endometrium; 2) middle myometrium; and 3) external (outer) perimetrium. The uterine tubes (fallopian tubes) are about 4 inches long and are attached to the uterus at its upper outer angles. A funnel-shaped terminal component of the tubes called the infundibulum extends laterally over the ovary and opens directly into the peritoneal cavity. The fringe-like projections (fimbriae) extend from the infundibulum; however, the ovarian fimbriae is the only one that attaches to the ovary. The cervix is the inferior end of the uterus and serves as an opening to the vagina. The vagina is a collapsable, tubular organ about 3 inches long, capable of great distention.

Fill in the key and color in the corresponding structures.

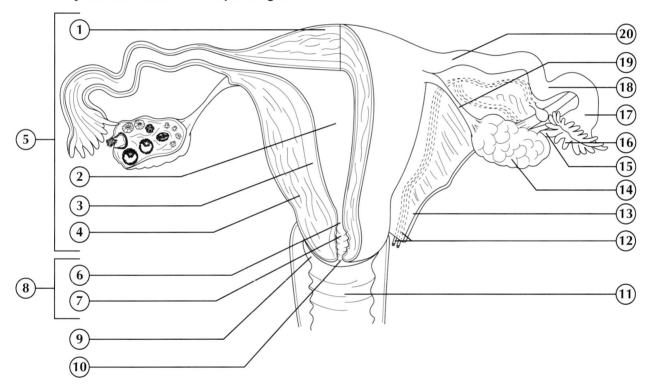

① Fundus of uterus	⑧ Cervix of uterus	⑮ Ovarian fimbria
② Uterine body cavity	⑨ Fornix of vagina	⑯ Fimbriae
③ Endometrium	⑩ External os of vaginal cervix	⑰ Infundibulum of uterine tube
④ Myometrium	⑪ Vagina	⑱ Ampulla of uterine tube
⑤ Body of uterus	⑫ Uterine artery and vein	⑲ Ovarian ligament
⑥ Internal os of cervix	⑬ Broad ligament	⑳ Isthmus of uterine tube
⑦ Cervical canal	⑭ Ovary	

STAGES OF OVARIAN FOLLICLE DEVELOPMENT

The ovary, like a number of other organs in the body, consists of two major layers of tissue—an outer cortex and an inner medulla. A tough, connective tissue layer called the tunica albuginea covers the ovarian cortex. Scattered throughout and embedded in the connective tissue matrix of the cortex are thousands of ovarian follicles. The ovarian medulla contains supportive connective tissue cells, blood vessels, nerves, and lymphatics. Initially, the primary follicle is surrounded by a single layer of granulosa cells. As maturation proceeds (secondary follicles), the number of granulosa cell layers increases and the cells begin secreting increasing amounts of an estrogen-rich fluid that pools around the oocyte in a space called an antrum. Ultimately this results in the actual development of the ovarian follicle. Ovulation occurs when the ova is released from the tough cortex of the ovary.

Fill in the key and then color in the corresponding structures at the various stages of development.

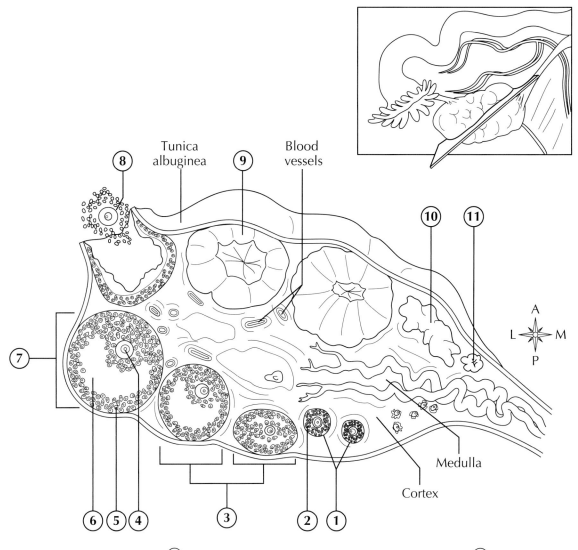

1. Primary follicles
2. Granulosa cells
3. Secondary follicle
4. Oocyte
5. Granulosa cells
6. Antrum
7. Vesicular ovarian follicle (graafian follicle)
8. Ovulation
9. Corpus luteum
10. Degenerating corpus luteum
11. Corpus albicans

THE FEMALE BREAST—SAGITTAL AND ANTERIOR VIEWS

The breasts lie over the pectoral muscles and are attached to them by a layer of connective tissue (fascia). Breasts are made up of mammary glands, which are present in all mammals, along with extensive supporting tissues. The ductules inside of the various lobules of the breasts unite to form a single lactiferous duct for each lobe. A comparatively large amount of adipose tissue is deposited around the surface of the breast, just under the skin and between the lobes. Suspensory ligaments throughout the connective tissue of the breast help to support the glandular and connective tissues of the entire structure, anchoring them to the coverings of the underlying pectoral muscles.

The nipples are bordered by a circular pigmented area, the areola, which contains numerous sebaceous glands that appear as small nodules under the skin.

Fill in the keys and then color in the corresponding structures.

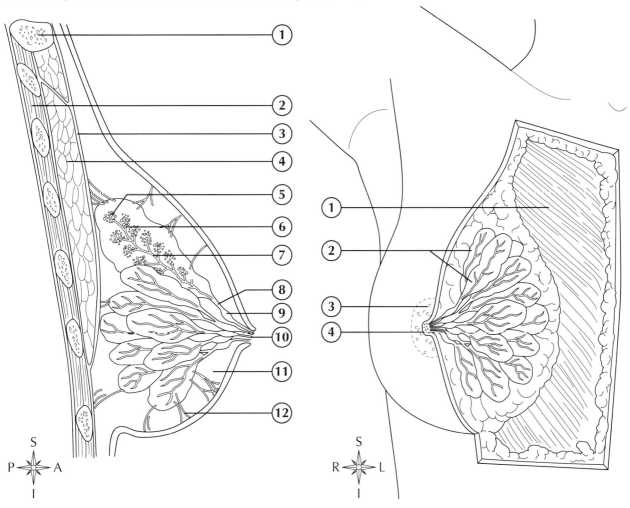

Sagittal View

1. Clavicle
2. Intercostal muscle
3. Fascia of pectoral muscles
4. Pectoralis major muscle
5. Alveolus
6. Ductule
7. Duct
8. Lactiferous duct
9. Lactiferous sinus
10. Nipple pores
11. Adipose tissue
12. Suspensory ligaments (of Cooper)

Anterior view

1. Pectoralis major muscle
2. Alveoli
3. Areola (with areolar glands)
4. Nipple

LACTATION

The function of the mammary glands is lactation, that is, the secretion of milk for the nourishment of newborn infants. Estrogens and progesterones act on the breasts to make them structurally ready to secrete milk. Shedding of the placenta after delivery of the baby cuts off a major source of estrogens. As this occurs, it stimulates the anterior pituitary to secrete prolactin. Prolactin stimulates lactation. Oxytocin stimulates the myoepithelial cells in the alveoli of the breasts to eject milk into the ducts, thereby making it accessible for the infant to remove by suckling.

Below you see two graphics. The first illustrates what is happening in a visual representation to allow for lactation to occur. The flowchart breaks down the simultaneous processes that take place to allow for effective and efficient suckling to occur. Color in the various processes by focusing on the arrows and using the flowchart as a guide.

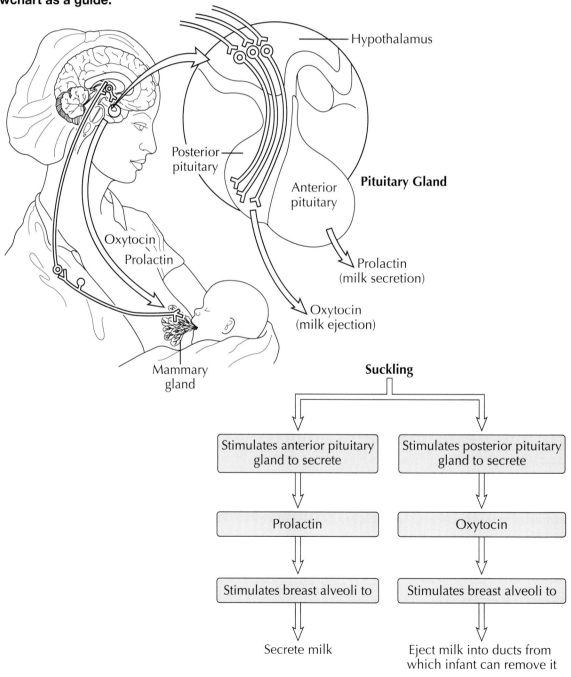

OOCYTES AND OOGENESIS

Oogenesis is the process by which primitive female sex cells, or oogonia, become mature ova. As you read through this instructional paragraph, follow along with the illustration on the next page. There are three basic "phases" in a female life with regard to oogenesis development. Interestingly, the most important of these phases, the phase that builds the foundation for female reproductive health, occurs before birth.

Phase 1: During the fetal period, oogonia in the ovaries undergo mitotic division to form primary oocytes—about 500,000 by the time a baby girl is born. Most of the primary oocytes develop to prophase I of meiosis before birth. There they stay until puberty. This is known as arrested development of the oocyte. **Color in phase 1 by filling in the oogonium, the primary oocyte, and the time of "arrested development."**

Phase 2: During childhood, granulosa cells develop around each primary follicle, and although several thousand primary oocytes do not survive into puberty, by the time a female child reaches sexual maturity, about 400,000 primary oocytes remain. In other words, a female fetus, while still in utero, has all of the primary oocytes she will have for the rest of her life. **Color in phase 2 by shading in the inactive ovary section.**

Phase 3: Beginning at puberty, during each menstrual cycle, about 1,000 primary oocytes resume meiosis. Their surrounding follicles begin to mature and some of the outer granulosa cells differentiate to become theca cells. Theca cells produce androgen. At this point, meiosis I produces a secondary oocyte and the first polar body. Now, in metaphase, meiosis II begins just before ovulation, and meiosis halts again—another "arrested development." Meiosis II only resumes *if* the head of a sperm cell enters the secondary oocyte. If it does not, then the ovum degenerates. If fertilization does occur, then meiotic division continues and produces a second polar body. Then, a mature, fertilized ovum called the zygote is created. **Color in phase 3 by filling in the arrows and shading in the structures created and involved in the phase.**

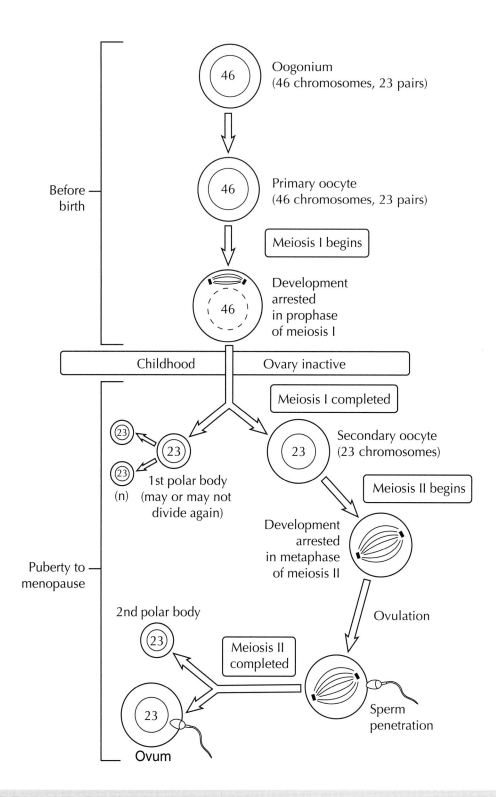

STAGES OF EARLY EMBRYONIC DEVELOPMENT, FROM ZYGOTE TO BLASTOCYST

So now we have a fertilized ovum and a zygote has been created. It is time for implantation. The figure illustrates the many different actions that must occur successfully in order for implantation to occur. The science of the development of the individual before birth is called embryology. The prenatal period of development begins at the time of fertilization and ends approximately 39 weeks later, at birth.

Read and follow the steps as a guide, then color in the stages and fill in the boxes with the following terms:
Fertilization Mitosis Ovulation Implantation

Step 1: At ovulation, the ovary releases an egg, or ovum.

Step 2: The sperm cell penetrates the ovum, fertilization occurs, and a genetically complete zygote is formed, representing the first cell of a new individual. Time, nourishment, and a proper prenatal environment are all that is needed for expression of characteristics such as sex, hair, and skin color that were determined at the time of fertilization.

Step 3: Once the zygote is formed, it immediately begins to cleave, or divide for about three days, until a solid mass of cells called a morula is formed. As they continue to divide, the morula begins to form an inner cavity, and by the time the developing embryo reaches the uterus, it is a hollow ball of cells called a blastocyst. This process takes approximately 7 days.

Step 4: Approximately 10 days after fertilization, the embryo is completely implanted in the uterine lining, before nutrients from the mother are available to nourish it. The blastocyst consists of an outer layer of cells called the trophoblast. As the blastocyst develops further, the inner cell mass forms a structure with two cavities called the yolk sac and the amniotic cavity.

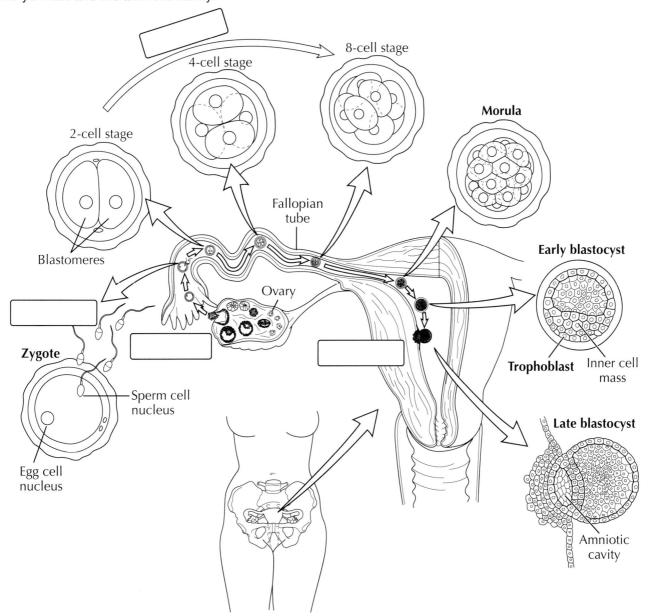

DEVELOPMENT OF THE CHORION AND AMNIOTIC CAVITY TO 4 MONTHS OF GESTATION

The amniotic cavity becomes a fluid-filled, shock-absorbing sac, sometimes called the "bag of waters." The chorion develops from the trophoblast to become an important fetal membrane in the placenta. The chorionic villi are extensions of the blood vessels of the chorion that bring the embryonic circulation to the placenta. The yolk sac is most important in animals such as birds, which depend heavily on yolk as a nutrient for the developing embryo. Because the uterine lining provides nutrients to the developing embryo in humans, the function of the yolk sac is not a nutritive one. Instead, it has other functions including the production of blood cells.

Color the structures, then identify and write in the various time frames associated with the different graphics below.

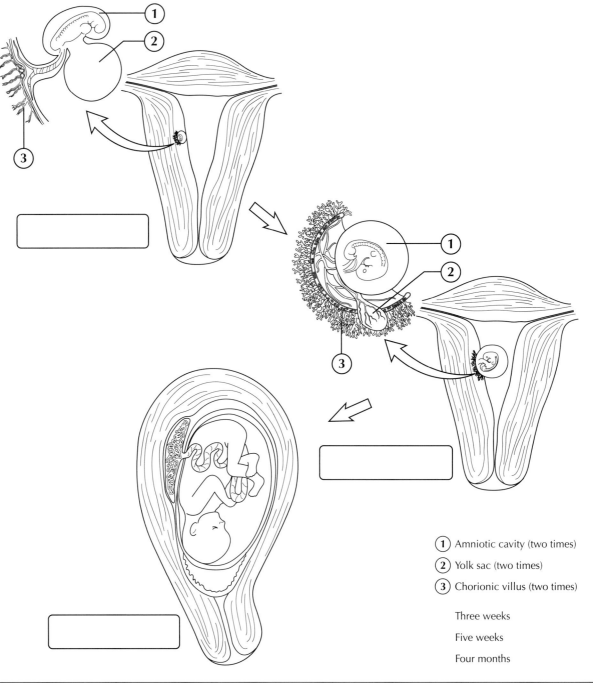

1 Amniotic cavity (two times)

2 Yolk sac (two times)

3 Chorionic villus (two times)

Three weeks

Five weeks

Four months

Mosby's Anatomy and Physiology Coloring Book
Copyright © 2014 by Mosby, an imprint of Elsevier Inc

FULL-TERM PREGNANCY

The figure below shows the normal intrauterine portion of a fetus just before birth in a full-term pregnancy. The large size of the pregnant uterus toward the end of pregnancy affects the normal function of the mother's body greatly. You'll notice that the woman's center of gravity is shifted forward, making walking and other movements difficult. The pregnant uterus presses on the rectum, on the bladder, and upward pressure pushes the abdominal organs against the diaphragm, making deep breathing difficult and sometimes causing the stomach to protrude into the thoracic cavity, a condition called hiatal hernia.

Fill in the key and the corresponding parts of the illustration.

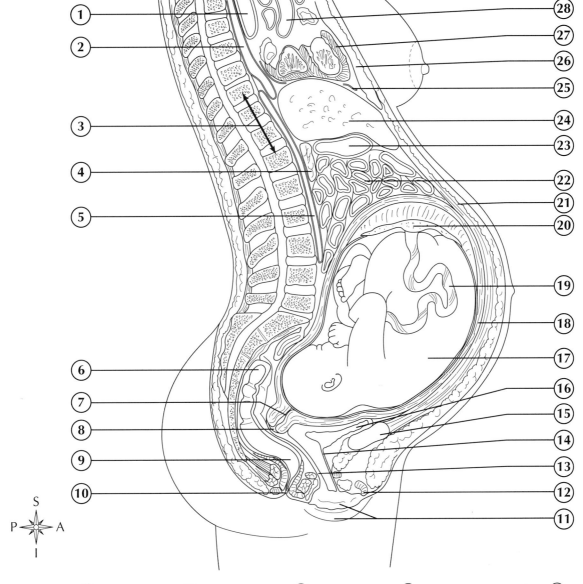

(1) Trachea	(6) Sigmoid colon	(11) Labia	(16) Urinary bladder	(21) Rectus abdominis muscle	(26) Sternum
(2) Esophagus	(7) Cervical canal	(12) Clitoris	(17) Fetus	(22) Small intestine	(27) Heart
(3) Vertebral column	(8) Cervix	(13) Vagina	(18) Uterus	(23) Stomach	(28) Aortic arch
(4) Pancreas	(9) Rectum	(14) Urethra	(19) Umbilical cord	(24) Liver	
(5) Abdominal aorta	(10) Anus	(15) Pubic symphysis	(20) Placenta	(25) Diaphragm	

CASE STUDY

Carlos and his wife had been trying for years to have a baby with no success. After a visit to an infertility specialist, they found that Carlos had a low sperm count. Before suggesting a solution, the physicians also checked Rebecca's reproductive system. One of the tests they ordered was a hysterosalpingogram, which involves injecting a dye inside the cervix to confirm there exists an open pathway for the egg.

1. Assuming there is no obstruction, which areas should the dye used for the hysterosalpingogram enter?
 A. Cervix, uterus, uterine tubes, ovaries
 B. Cervix, uterine tube, uterus, vulva
 C. Cervix, uterine tube, ovaries, peritoneal cavity
 D. Cervix, uterus, uterine tube, peritoneal cavity
2. After ovulation, the follicular cells first transform into what?
 A. Corpus lucidum
 B. Corpus luteum
 C. Corpus rubrum
 D. Corpus albicans
3. Where in the female reproductive tract should the sperm and the oocyte meet (to complete the process of fertilization)?
 A. in the cervix
 B. in the uterus
 C. in the uterine tubes
 D. in the ovaries

Answers to Case Studies

Chapter 1
1: A; 2: B; 3: D

Chapter 2
1: C; 2: D; 3: B

Chapter 3
1: A; 2: B

Chapter 4
1: A; 2: C; 3: C

Chapter 5
1: D; 2: D

Chapter 6
1: B; 2: D; 3: C; 4: A

Chapter 7
1: B; 2: C; 3: A

Chapter 8
1: A; 2: D; 3: B

Chapter 9
1: C; 2: B; 3: D

Chapter 10
1: C; 2: B; 3: C

Chapter 11
1: C; 2: D; 3: C

Chapter 12
1: D; 2 B; 3: C

Chapter 13
1: C; 2: B; 3: B

Chapter 14
1: B; 2: B; 3: D

Chapter 15
1: B; 2: D

Chapter 16
1: D; 2: B; 3: C